Riches of the Rylands

Manchester University Press

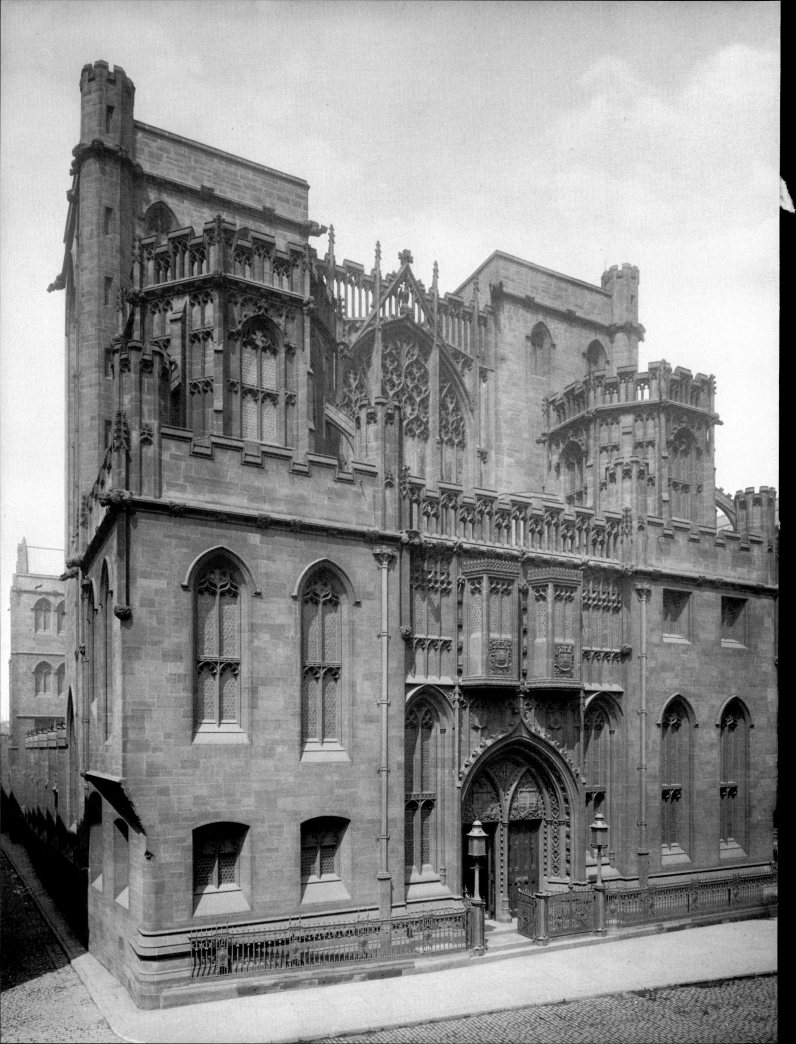

Riches of the Rylands

The Special Collections of
The University of Manchester Library

With a foreword by Jan Wilkinson

Manchester University Press

Published by Manchester University Press
Altrincham Street, Manchester M1 7JA, UK
www.manchesteruniversitypress.co.uk

British Library Cataloguing-in-Publication Data
A catalogue record for this book is available from the British Library

Library of Congress Cataloging-in-Publication Data applied for

ISBN 978 07190 9635 8 hardback

First published 2015

Typeset in Adobe Arno Pro
by Carnegie Book Production, Lancaster
Printed by Gutenberg Press, Malta

Front endpaper: Thomas Malory, *Thus endyth this noble & ioyous boke entytled Le morte Dathur* (Westminster: Wynkyn de Worde, 1498), with bookplate of the John Rylands Library, and Bibliotheca Spenceriana book-label. Spencer 15396

Frontispiece: photograph by Bedford Lemere and Co. of the Deansgate elevation of the John Rylands Library, 1900. JRL/7/8/1

Rear endpaper: Earlier Version Wycliffe New Testament, end 14th/beginning 15th century, with bookplates of Lea Wilson, the Earl of Ashburnham's Appendix and the John Rylands Library. English MS 81

Contents

Foreword

Riches of the Rylands explores and celebrates the remarkable Special Collections of rare books, manuscripts, archives and visual materials to be found within The University of Manchester Library. The following pages illustrate their astonishing breadth and depth, spanning five thousand years, six continents, and a plethora of formats and subjects. Many of the items featured here derive from the superlative collections purchased by Enriqueta Rylands for the magnificent library she founded as a memorial to her husband John. Some were separately accrued by The University of Manchester prior to its merger with the John Rylands Library in 1972. Yet others are of recent acquisition, and demonstrate our commitment continually to enhance our research resources. In this endeavour we have been supported by many generous benefactors, who have donated or deposited collections, funded endowments or provided financial assistance for individual purchases.

Breath-taking architecture and world-class collections count for nothing if they are inaccessible to researchers and to the wider community. Enriqueta was determined to create a 'live library', not a fusty repository of rare books: 'this library shall be of use in the widest sense of the word: for young students as well as for advanced scholars. It is not to be a mere centre for antiquaries and bibliographers'. This succinct 'mission statement' remains valid: we continue to fulfil Enriqueta's ambition of a library accessible to all, and to realise the 'potencie of life' that pulses through our collections.

The publication of this book coincides with a period of unparalleled change and development at The University of Manchester Library. The 'Unlocking the Rylands' project of 2004–7, generously supported by the Heritage Lottery Fund and many public and private benefactors, initiated the ongoing transformation of the John Rylands Library into one of Manchester's premier attractions. Over 140,000 visitors a year now encounter the building's spectacular architecture and engage with the outstanding collections it houses; many more experience the Library virtually.

Equal attention is now being focused on the Library's core mission of supporting research. Despite intensive effort over many years to catalogue and promote the Special Collections,

much remains to be done to fulfil their true potential. The John Rylands Research Institute was therefore established in 2013 to 'uncover, explore, unravel and reveal' hidden ideas and knowledge contained within our Special Collections. This partnership between the Library and the University is already yielding a rich harvest. Leading scholars are working closely with our curators and specialists in digital imaging and collection care, producing startling discoveries amongst thousands of ancient papyrus fragments, for example, and 'surfacing' previously neglected collections. Several members of the Institute have contributed to this book. I hope that it will encourage many others to explore hitherto unregarded aspects of our collections, and to reinterpret the more familiar elements in innovative and provocative ways.

Special Collections everywhere are the subject of renewed academic interest, for the ubiquity of online information is now causing researchers to focus on the unique and the esoteric, while collections are also benefiting from the application of new technologies and the exposure that the internet brings. Here in Manchester we feel a strong obligation – and a major opportunity – both to cherish and grow our Special Collections, and to embrace new techniques to investigate, interpret and promote them. We are working with the scientists who created Graphene, to ensure that their archives capture the story of how this revolutionary material was discovered and developed at The University of Manchester. And we are pioneering ways to preserve and manage emails and other evanescent digital formats. We face many challenges, not least to secure resources sufficient to match our ambitions, but I have no doubt that we will rise to them, and that future generations will be able to acclaim even greater riches of the Rylands. In the meantime, I invite you to explore a selection of the wondrous objects we are already privileged to hold, to listen to their manifold voices, and to be inspired.

Jan Wilkinson

University Librarian and Director of the John Rylands Library

Acknowledgements

This book is made up of a substantial introductory essay and thirteen themed chapters. The items described in each chapter were selected in order to illustrate the strength and variety of the books, manuscripts, archives, maps and visual materials held in this great library. We have not chosen just our renowned iconic items; care has been taken to show you some of our little known but no less remarkable material. There is something for everyone in this compilation, and we owe a huge debt of gratitude to the chapter editors for their innovative selections: Fran Baker, Caroline Checkley-Scott, Dorothy Clayton, Elizabeth Gow, Stella Halkyard, John Hodgson, James Peters, Julie Ramwell, Professor Ian Rogerson, Donna Sherman, Julianne Simpson and Janet Wallwork. Within the thirteen chapters, over 140 items from The University of Manchester Library's collections have been described by eighty different contributors.

A volume such as this is essentially a summation of the work of countless scholars and Library colleagues who have worked on the collections over many years. These people must share any credit due for the value of the publication as a whole. Particular gratitude should be expressed to former Librarians and Heads of Special Collections who were responsible for acquiring so many of the treasures displayed and described in the following pages.

We are very fortunate to have a specialist Heritage Imaging team in the Library, managed by Carol Burrows, and this book would not have been possible without the expertise of our photographers, Gwen Riley Jones and James Robinson, and the organisational skills of Suzanne Fagan. As we have chosen items and viewed them, we have called upon the expert services of our conservators and we thank Caroline Checkley-Scott and her Collection Care team for their work on individual items.

The final stages of the preparation of this book were undertaken by an editorial group consisting of Rachel Beckett, Dorothy Clayton, Matthew Frost and John Hodgson, whose commitment and passion have shaped and finessed the volume.

We have been greatly assisted in producing this book by our publishers, Manchester University Press, whose guidance and support have been invaluable. Matthew Frost piloted us through the editorial process with aplomb, while Katie Hemmings and Lianne Slavin steered the book through the press.

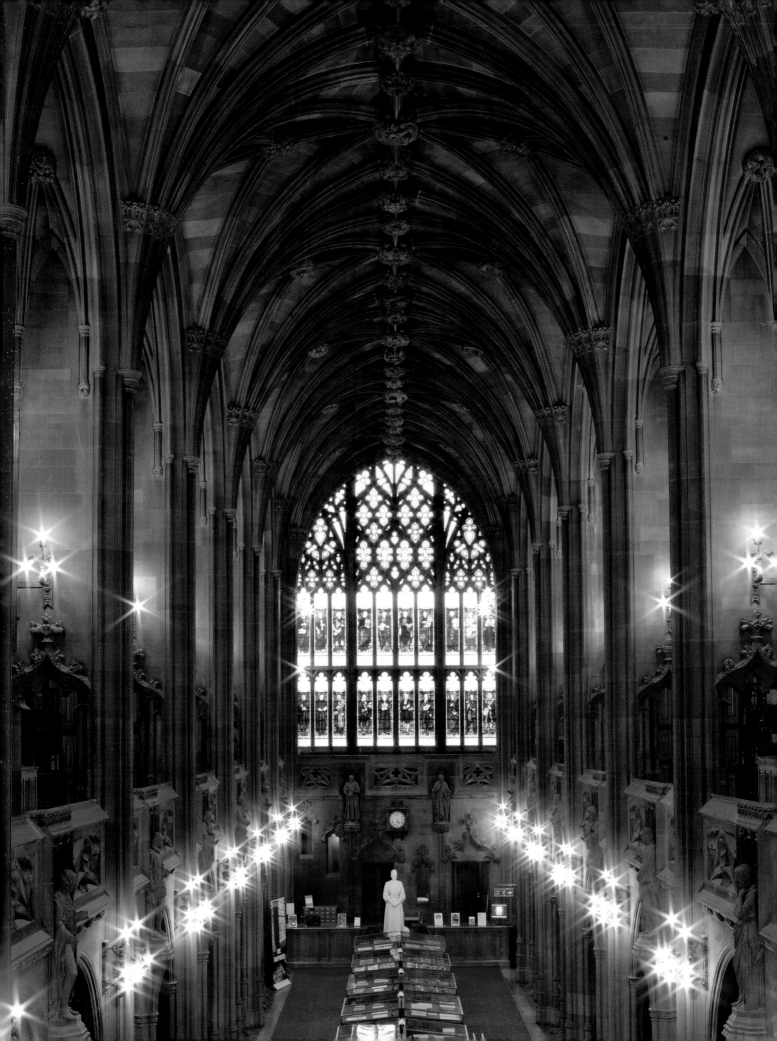

Introduction

THIS BOOK celebrates the cornucopia of wonder and delight contained within the Special Collections of The University of Manchester Library. Comprising more than one million items and extending over twenty-five kilometres of shelving, these collections of rare books, manuscripts, archives and visual materials are of exceptional importance, whether they are judged by their research potential, their cultural and religious significance or their literary and artistic merit. They are also astonishingly diverse: they span almost five thousand years, from Babylonian clay tablets to contemporary emails; they range over six continents; they encompass a vast range of civilisations and belief systems; and they include almost every format ever used for written communication. They 'speak' to many audiences, from primary-school children to senior academics, and we continually strive to unlock their potential and give them voice, through improved documentation and interpretation. This small selection of more than 140 items, chosen to represent the richness and diversity of the collections, is but a snowflake on top of the iceberg; it could be expanded manifold without the slightest risk of repetition or diminution of quality.

'It is my wish that this library shall be of use in the widest sense of the word: for young students as well as for advanced scholars.'
Enriqueta Rylands

Our Special Collections have been blended from the combined resources of the formerly independent John Rylands Library, which opened in 1900, and the Library of the University of Manchester, whose origins reach back to 1824. Countless collectors, librarians, archivists and researchers have contributed to these collections, and this is their story: two centuries of taste, scholarship, ambition and the enlightened application of wealth for the common good. Fulfilling the vision of the Library's founders, these collections are at the heart of a global community of scholars and others, curious and engaged, who are continually reinterpreting the collections, finding new meanings, challenging old orthodoxies and helping us to develop the collections for future generations.

The John Rylands Library is named after Victorian Manchester's most successful cotton manufacturer, but it stands witness to the devotion and ambition of his third wife and widow, Enriqueta Augustina Rylands. John built the family firm, Rylands and Sons, into the largest

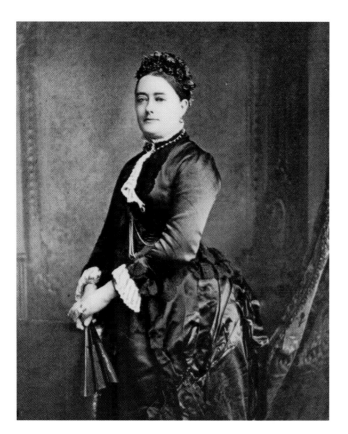

Enriqueta Augustina
Rylands, from Henry Guppy,
*The John Rylands Library,
Manchester, 1899–1935*
(1935)

cotton enterprise in Britain; when he died in 1888, at the age of eighty-seven, Enriqueta inherited a fortune of over £2.5 million (equivalent to £250 million today), overnight becoming the richest woman in Britain. John was a down-to-earth Lancastrian, whose life was dedicated to the business of making money, to private study and to undertaking unobtrusive charitable works. Enriqueta, by contrast, was a cosmopolitan woman; she was born in Cuba and spent some of her formative years in New York and Paris, before moving to Manchester as the companion to John's second wife, Martha; she became the third Mrs John Rylands a few months after Martha's death in 1875. Within a year of John's death Enriqueta had decided to commemorate her husband with a library, which would be open to the people of Manchester. She purchased a site on Deansgate in the city centre, and commissioned the leading architect Basil Champneys to create a building in the Gothic style; Champneys had previously designed Mansfield College in Oxford, a foundation with which she had been closely associated.

Enriqueta's choice of a library to memorialise her husband was unparalleled in Britain, but was influenced by her own and John's passion for education and self-improvement. Although he would never have described himself as a bibliophile, John had developed a modest working library at Longford Hall in suburban Stretford, with an emphasis on religious literature; he also collected some sixty thousand hymns. The couple were devout Congregationalists, and Enriqueta intended the memorial library to have a strong bias towards Nonconformity; it would be a place 'where the theological worker should find all the material necessary to his study and research'.[1]

We should also situate the John Rylands Library within the context of the city's economic and social development in the second half of the nineteenth century. This was a period when Manchester – the world's first industrial city – was making concerted efforts to dispel its 'muck and brass' reputation and to transform itself into the cultural capital of the North of England. The John Rylands Library was part of this project, and must be viewed alongside the city's other cultural offspring such as the Hallé Orchestra, the City Art Gallery, Manchester Museum and Owens College (forerunner of The University of Manchester). The choice of Gothic architecture for the building was significant: it offered comfortable associations with an idealised pre-industrial society, far removed from the grim realities of Victorian Manchester; it also helped to elide Enriqueta's Hispanic (and Catholic) origins and to reinforce her Anglo-Saxon Protestant credentials. In short, she was creating for Manchester a library that would emulate, if not surpass, the ancient college and university libraries of Oxford and Cambridge.

Champneys claimed to have produced his outline drawings within a week, but the building took nine years to complete, at a cost of £250,000, and did not finally open to the public until 1 January 1900. The delays were due in part to the uneasy relationship between the architect and his client, and to Enriqueta's frequent changes of mind over many aspects of the design. While the building was slowly emerging, she set about the task of acquiring books to stock the Library. In this she was assisted by advisers such as William Carnelley and William Linnell (both directors of Rylands and Sons), J. Arnold Green and A. B. Railton of the booksellers Sotheran and Co., although she had the final say in all major purchases. By July 1892 Green had spent £20,000 on theological books, an indication of the scale of the operation. However, even at this early stage Enriqueta's purchases encompassed a broad range of subjects and formats. For example, in 1891

she acquired a set of John James Audubon's mighty double-elephant folio *Birds of America*, a copy of Caxton's *Golden Legend* and the autograph collections of the Congregational minister Rev. Thomas Raffles (1788–1863).

Enriqueta's ambitions for her library expanded dramatically and unexpectedly in 1892, when the finest privately owned book collection in the world was offered for sale: the Spencer library from Althorp Hall in Northamptonshire. The library had been assembled by George John, 2nd Earl Spencer (1758–1834), between 1789 and the early 1820s. This was at the height of bibliomania, the 'book madness' which infected a generation of aristocrats and gentleman-collectors and pushed prices to unparalleled heights. Spencer had built up his library through a series of spectacular purchases of entire collections, as well as continual accretions of single books. In 1789 he agreed to buy the library of the Hungarian nobleman Count Karl Reviczky, for £1,000 plus an annuity of £600 payable to Reviczky for life. It turned out to be a bargain as the Count conveniently died only four years later, by which time Spencer had paid out a mere £2,500. He bought extensively at the Duke of Roxburghe's sale in 1812, although he famously lost Valdarfer's 1471 edition of Boccaccio to his cousin, the Marquess of Blandford, who secured it for £2,260; this was a record price for any book that stood until 1884 and the event was celebrated by the foundation of the exclusive Roxburghe Club. The following year Spencer purchased the library of the late Stanesby Alchorne, former Controller of the Mint, although many of the books proved to be defective, and in 1820, during a tour of Europe in search of bibliographical rarities, he purchased almost the entire library of a Neapolitan nobleman, the Duke di Cassano Serra, which was rich in early Italian printing.

Each of these major acquisitions inevitably created some duplication with his existing holdings, and Spencer would regularly winnow out inferior copies; for example, most of the Alchorne books were quickly sold on. Like many collectors of the time, Spencer was not averse to 'improving' books, perfecting a copy from two or more incomplete ones and swapping leaves with fellow collectors. For example, it has recently been shown by Eric Marshall White that the Spencer copy of the 36-line Bible (probably printed in Bamberg by Albrecht Pfister) is actually composed of parts of three separate copies. Spencer was also in the habit of having his books rebound. As a result, the John Rylands Library has important collections of bindings by Spencer's favourite

> 'For books are not absolutely dead things, but do contain a potencie of life in them to be as active as that soul was whose progeny they are'.
> John Milton, *Areopagitica*

The Spinningfield elevation of the John Rylands Library by Basil Champneys, with amendments shown in red ink and Chinese-white, 1890. JRL Archive, JRL/5/2/10

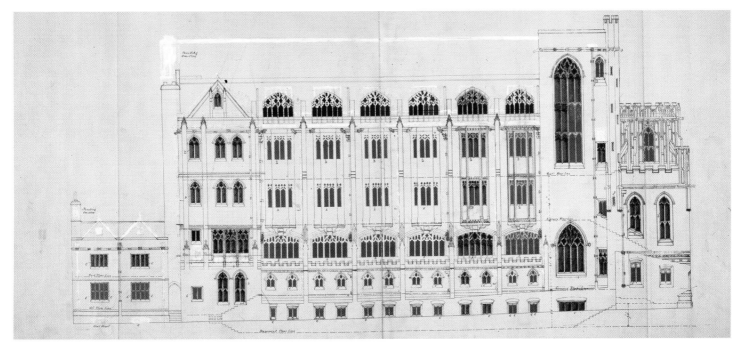

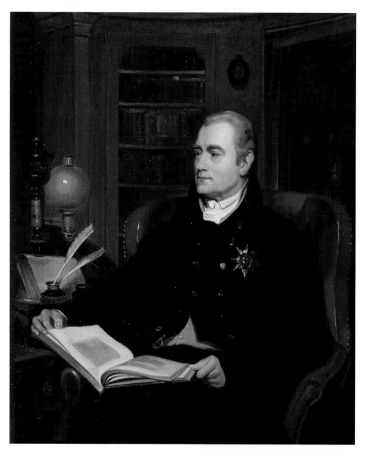

craftsmen, Roger Payne (see 4.8), Charles Lewis and Charles Hering, while fifteenth- and sixteenth-century bindings are quite rare. In his book dealings Spencer was advised and assisted by the quixotic chronicler of the age of bibliomania, Rev. Thomas Frognall Dibdin (1776–1847).

The fortunes of the Spencer family, like many aristocrats, declined sharply in the last quarter of the nineteenth century, as a result of a prolonged agriculture depression. Thus on 17 June 1892 *The Times* published a leader announcing with regret that the 5th Earl, John Poyntz Spencer, intended to sell his grandfather's library. Amid much speculation that it would be broken up or sold *en bloc* to America, Enriqueta secretly negotiated for its purchase (through Sotheran's and her trusty agent J. Arnold Green), for the unprecedented sum of £210,000; she had been prepared to pay as much as £250,000. This single transaction brought her over forty thousand volumes, including almost all of the major landmarks of European printing. The books were packed into six hundred cases, and conveyed in special railway wagons to Manchester. This massive influx of stock caused major logistical problems – the building on Deansgate had barely reached first-floor level and would not be completed for another seven years – and Longford Hall underwent extensive modification to accommodate the books.

George John, 2nd Earl Spencer, by Jacob Thompson, undated

The Long Library at Althorp, showing part of the Spencer Collection, 1892, JRL 6/1/3/9

What attracted Enriqueta to the Spencer Collection? Certainly the hundreds of printed Bibles, from the Gutenberg Bible onwards, held great appeal, while the collection was also rich in theological literature, including many works from the Reformation. These conformed to Enriqueta's original, narrow vision of a theological library. But there was no question of cherry-picking the Spencer Collection; Enriqueta immediately saw an opportunity for transforming her foundation into an internationally important research library with major holdings across a broad range of subjects. In his obituary of Enriqueta Rylands, Henry Guppy, Librarian from 1900 until 1948, wrote:

> She had acquired for Manchester a collection of books which in many respects was unrivalled, but in doing so she had enlarged considerably the scope of her original plan, and decided to establish a library that should be at once 'a place of pilgrimage for the lover of rare books,' and a 'live library' for genuine students whether in the departments of theology, philosophy, history, philology, literature, or bibliography, where they would find not merely the useful appliances for carrying on their work, but an atmosphere with a real sense of inspiration, which would assist them to carry it on in the highest spirit.

Whenever one attempts a description of the Spencer Collection, one quickly runs out of superlatives. Spencer's interests included English 'black-letter' printing, especially the works of

Hand-coloured woodcuts from Historie von Joseph, Daniel, Judith und Esther *(Bamberg: Albrecht Pfister, after 1 May 1462). Spencer 9375, 18v–19r*

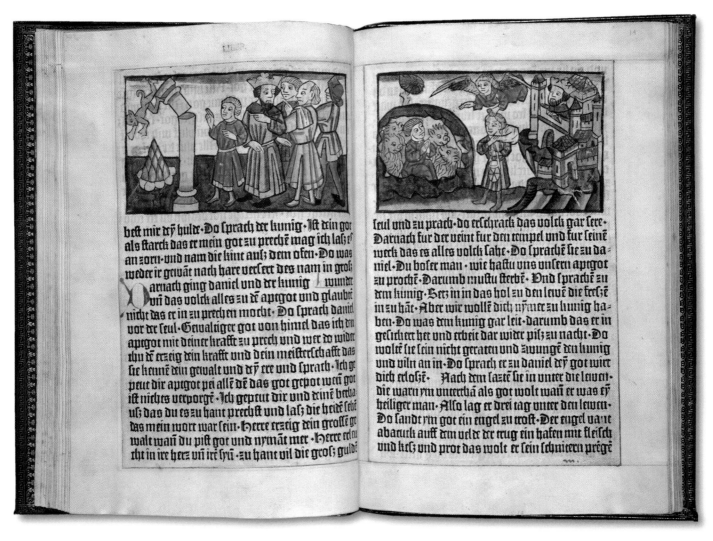

William Caxton, of which the John Rylands Library holds the second largest collection in the world; continental incunables (books printed before 1501), including a remarkable collection of works by the first generation of German printers, such as Gutenberg, Fust, Schöffer and Pfister; first editions of the Greek and Latin Classics, with *editiones principes* of no fewer than fifty authors including a vellum copy of Cicero's *De officiis*, printed by Fust and Schöffer at Mainz in 1465, the first edition of any Classical author; and books printed in Venice by Aldus Manutius and his successors at the Aldine Press, of which the Library now holds arguably the finest collection in the world. However, Spencer also collected finely printed and illustrated books of later periods, and was a subscriber to many contemporary publications. He had a particular fondness for landmark works of English literature, such as the First Folio edition of Shakespeare's plays (1623), and first editions of *Shake-speares Sonnets* (1609), *The Workes of Benjamin Jonson* (1616), John Donne's *Poems* (1633) and George Herbert's *The Temple* (1633). Very few libraries could offer a comparable conspectus of the whole history of printing in Europe.

Although the Spencer Collection transfigured Enriqueta's plans for her foundation, she was determined that the John Rylands Library should not be subsumed by the Bibliotheca Spenceriana. Instead, the Spencer books were assimilated into the Library, branded with the 'JR' monogram and labelled with the imposing Rylands bookplate. While parts of the collection, such as the Bibles, Aldines and incunables were (and largely still are) kept together, most of the Spencer books were physically dispersed within a subject classification scheme.

The Spencer Collection contained a number of early and important editions of Dante, but our holdings of the great Italian poet expanded dramatically in 1905, when Enriqueta purchased a

Rylands Library bookplate and 'E Bibliotheca Spenceriana' label, inside the front cover of William Caxton, *Vocabularius* (1480). Spencer 15383

collection of editions and critical works of all periods, formed by Count Giuseppe L. Passerini of Florence and comprising some five thousand volumes. Today the Library boasts one of the finest Dante collections in the world, containing all but one of the fifteen incunable editions of the *Divina Commedia* (3.7).

While amassing works for the John Rylands Library, Enriqueta also bought books for her own pleasure and interest, although the distinction between private and institutional collecting was not always clear-cut. In his obituary Henry Guppy recorded that Enriqueta 'gathered around her' books 'not alone for her own pleasure, but with a view to the ultimate enrichment of the library on a side where it was but indifferently equipped'.[2] Her tastes were catholic and modern. She delighted in the latest private press books, especially the neo-Gothic creations of William Morris's Kelmscott Press, *editions de luxe*, colour-plate books such as John Gould's magnificent ornithological series, and grangerised (extra-illustrated) books, as well as autograph collections and the occasional glittering Book of Hours. Longford Hall must have looked like Baron Edmond de Rothschild's Parisian salon translated to suburban Manchester. Many of these 'boudoir books' remained at Longford Hall until 1908, when they were bequeathed to the John Rylands Library.

Of course, collecting at the John Rylands Library did not cease with Enriqueta's death. Her generous endowment of £200,000 ensured that, in the early years at least, the Library authorities were major patrons of Europe's leading booksellers and auction houses, purchasing a combination of rare books

and more mundane reference works and periodicals. From an initial stock of seventy thousand volumes in 1900, the holdings grew at the rate of ten thousand per annum to reach four hundred thousand by 1935. This rapid expansion necessitated the recall of Basil Champneys to design a major extension at the back of the original building, with storage capacity for 150,000 books, which opened in 1920.

As well as making extensive purchases, the John Rylands Library also benefited from a number of generous gifts of books and other printed material. David Lloyd Roberts, a distinguished Manchester physician and bibliophile, bequeathed some five thousand volumes to the Library in 1920. They include numerous fine bindings from the fifteenth and sixteenth centuries, such as those produced for Jean Grolier and the 'Apollo and Pegasus' bindings of Giovanni Battista Grimaldi, as well as landmark editions of English and Italian literature. In 1924 David Lindsay, 27th Earl of Crawford, donated a superlative collection of French Revolution material that had been assembled at Haigh Hall by him, his father and his grandfather. It consists of some twenty thousand proclamations, placards, broadsides, bulletins, laws and decrees from the Revolutionary and Napoleonic periods, but also including some earlier and later documents. It rivals the collections of the Bibliothèque nationale de France in size and quality, and yet its research potential has still not been fully realised. We hope that the recently established John Rylands Research Institute, a unique partnership between

Binding by Walter and Mary Crane on *The Tale of King Florus and the Fair Jehane* (Hammersmith: printed by William Morris at the Kelmscott Press, 1893). No. 17 of 73 copies in unique bindings commissioned by James and Mary Lee Tregaskis, all of which were purchased by Enriqueta Rylands

Steel bookcases and glass floors in the 1920 extension. Reproduced in Henry Guppy, *The John Rylands Library, Manchester, 1899–1924* (1924)

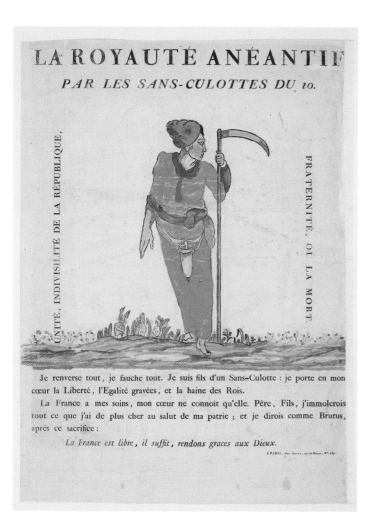

the Library and The University of Manchester, will reinvigorate academic interest and activity in this and many other areas of the collections.

Gradually the value of the John Rylands Library's endowments was eroded by inflation and the declining fortunes of the Lancashire cotton industry, in which the funds were imprudently invested. By the 1930s the Library's acquisitions fund was greatly reduced, and after the Second World War the Library struggled to meet even its basic running costs. Formal and informal links with The University of Manchester had always been strong, and staff and students of the University comprised a high proportion of the readership. Therefore, the sensible decision was made to unite the John Rylands Library and the University Library into a single institution, under the rather cumbersome title of the John Rylands University Library of Manchester; the merger was officially ratified on 19 July 1972. The building on Deansgate retains the name of the John Rylands Library and is now home to most of the Special Collections of the combined library. The 'Unlocking the Rylands' project of 2004–7 involved the restoration of the Grade-I listed historic building, together with the construction of a new entrance wing combining a welcoming reception area and amenities for visitors with a bespoke reading-room, conservation studio and world-class collection storage facilities.

French Revolution proclamation celebrating the overthrow of the monarchy by the 'Sans-culottes' or urban revolutionaries: 'La Royauté Anéantie par les Sans-Culottes du 10' (Paris: Auger, 1792). Proclamations, 1789–99, Box 9

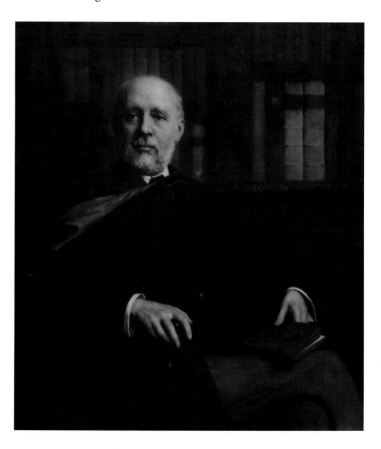

Richard Copley Christie, by Thomas Benjamin Kennington, undated

Prior to 1972 the University Library had built up its own collections of rare books, although not on the same scale as the Rylands. Two of the most important were those of Richard Copley Christie (1830–1901), an enlightened scholar and leading light at Owens College, and Walter Llewellyn Bullock, Professor of Italian Studies from 1935 until his death in 1944. Christie formed his collection 'with a view of illustrating and enabling its owner to study the Renaissance, and especially the classical Renaissance of Italy and France, … and the lives, labours and works of a certain limited number of scholars upon whose lives and labours I had at one time hoped to write something'.[3] As well as being rich in French and Italian literature, the Christie Collection contains an unrivalled set of virtually all the Greek texts published in the fifteenth and sixteenth centuries. Likewise, the Bullock Collection illustrates the literature and social life of Italy, with over 2,600 sixteenth-century works. Christie and Bullock were scholars, not rich collectors; unlike Lord Spencer, they could not afford the finest, cleanest copies of texts, and their books are all the more interesting because they contain evidence of early readership and because they retain original or early bindings.

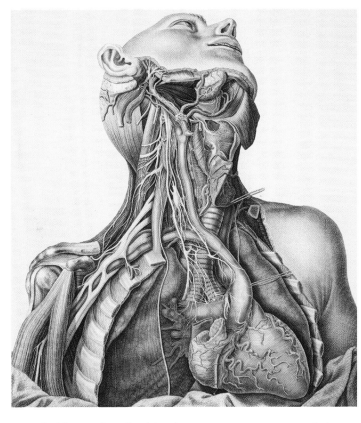

Antonio Scarpa, *Tabulae neurologicae ad illustrandum historiam anatomicam* (*Neurological Tables to Illustrate Anatomical History*) (Ticini: apud Balthassarem Comini, 1794), table 3. Medical Collection, C5.1.S18

Another great strength of the University Library was its holdings of medical books, as befitted an important centre of medical education. They derived largely from the library of the Manchester Medical Society which, under the direction of the librarian, John Windsor, and later of his son Thomas, had amassed an impressive collection of rare and early medical texts. Printed medical collections now include some three thousand books printed before 1701 (among them two hundred incunables) and a further four thousand eighteenth-century items. Another influential learned society, the Manchester Geographical Society, deposited its library of two hundred atlases and four thousand printed books at the University Library in 1970, complementing major Rylands holdings in this field. The separate Booker and Mills map collections, first deposited in the 1920s, contain hundreds of English county maps and ornamental examples of the French and Dutch colonial mapping of Asia.

Since 1972, almost all pre-1801 printed books have been transferred from the University to the John Rylands Library. In a recent project we have combined our outstanding holdings of Aldine Press publications – both genuine editions and contemporary counterfeits – into a single sequence and embarked on a major recataloguing and conservation exercise. In the process we have discovered that our holdings are far larger than had been supposed, over two thousand volumes, with many editions being represented by multiple copies.

The Spencer library contained a few manuscripts. During the 1890s Enriqueta had also purchased a number of handwritten volumes on her own account, including fourteen Wycliffite texts from the so-called Ashburnham Appendix, for which she paid £1,260 in 1897. However, when the John Rylands Library opened its doors in 1900, it was essentially a library of printed works, with almost nothing that predated the development of printing in Europe in the mid-fifteenth century. This omission was rectified in 1901, when Enriqueta purchased the manuscript portion of the Bibliotheca Lindesiana. This remarkable library has been assembled by the 25th and 26th Earls of Crawford at Haigh Hall near Wigan, just twenty miles north-west of Manchester. For a mere

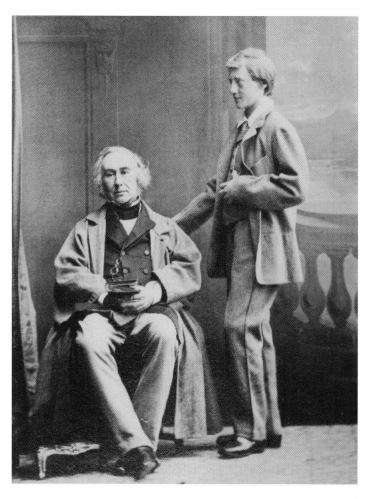

Crawford Lindsay, 25th Earl of Crawford and 8th Earl of Balcarres; James Ludovic Lindsay, 26th Earl of Crawford and 9th Earl of Balcarres; by Camille Silvy, albumen print, 17 February 1863. © National Portrait Gallery, London

£155,000, Enriqueta obtained a collection of manuscripts to match the Spencer library in quality and significance, if not in size. Although she intended the manuscripts for the John Rylands Library, she was overjoyed with them and extremely possessive towards them; indeed, the majority were transferred only after her death in 1908 and several scholars complained about the restrictions on access. Lord Crawford's librarian described visiting Enriqueta at Longford Hall, soon after the purchase: 'I found her delighted with her new treasures. She told me she has one case opened at a time and examines every book and checks them off by the list and reads the descriptions in the catalogues.'[4]

The Crawford library was the creation of Alexander Lindsay (1812–80), known as Lord Lindsay until he became the 25th Earl of Crawford, and his son (James) Ludovic Lindsay (1847–1913), the 26th Earl. Lord Lindsay was one of the most learned men of his generation, a genius perhaps, who had a fervent interest in the development of Christian thought and civilisation, and especially in the art of medieval and Renaissance Italy. John Ruskin hailed him as 'the head and captain of all literature relating to early Italian painting'.[5] As a collector his watchwords were discipline and utility. He wanted to build a working library to serve his and his family's needs. He was determined to avoid the excesses of bibliomania, although when it suited he could justify to himself the purchase of a Gutenberg Bible. Thus he acquired representative examples of illuminated manuscripts, but generally avoided the obvious attractions of fifteenth- and sixteenth-century Books of Hours and other examples of bibliophilic 'bling'.

So, despite his interest in the Italian Renaissance, Lindsay acquired only a few manuscripts from the Peninsula, but they were all of the highest quality. One of his first purchases, in 1859, was a splendid copy of the poems of Dante and Petrarch, commissioned by Lorenzo di Carlo Strozzi, who died in 1383. In 1866 he spent £200 on a three-volume manuscript of Nicolas de Lyra's Bible Commentary, written at the Franciscan convent at Pesaro in 1402. It is a superb, if idiosyncratic, example of Italian illumination. Two years later the London bookseller Thomas Boone offered Lindsay what he claimed to be 'the *finest Illuminated* Book ever offered for sale', the six-volume Missal of Cardinal Pompeio di Girolamo Colonna, made for the Sistine Chapel in Rome.[6] For once, booksellers' hyperbole was not misplaced, for it is a truly remarkable piece of High Renaissance art. Lindsay eventually agreed to pay the astonishing price of £1,500. However, when a seventh volume turned up in 1895, his son Ludovic refused to purchase it, and for next 116 years it led a peripatetic life. Lindsay's English manuscripts range from the glorious Missal of Henry of Chichester, written in the scriptorium at Salisbury around 1250, to a small, tattered and greasestained volume which is in fact one of the earliest surviving medieval cookery books, the *Forme of Cury*, compiled by the master chefs of Richard II around 1390, and containing 194 recipes.

The Earls of Crawford were unrivalled in the scope and ambition of their collecting of Oriental manuscripts. Their interest in the East spanned the whole of Victoria's reign, the period when the British Empire reached its zenith. They assembled major collections of Middle Eastern manuscripts in Arabic, Persian, Turkish and Samaritan; South Asian manuscripts in Sanskrit and numerous modern Indian languages; Chinese and Japanese printed books and manuscripts; texts on palm-leaf, bamboo, bone and copper from South-East Asia; papyri from Egypt; as well

as Syriac, Armenian, Coptic and Ethiopic Christian codices (manuscript books). When Enriqueta bought the collection, she obtained over three thousand Oriental books and manuscripts, plus several thousand papyri, in comparison to just 475 Western manuscripts. The Crawford manuscripts thus formed one of the largest and most diverse collections of Oriental texts in Britain.

Lord Lindsay acquired most of the Oriental manuscripts in a series of large-scale purchases of entire collections, many of which were obtained through Bernard Quaritch, the 'Napoleon of booksellers'. For example, when the library of Pierre Léopold van Alstein was sold at Ghent in 1863, Quaritch bought the whole collection of Oriental manuscripts for Lindsay, conspiring with the auctioneer to outwit the hapless librarian of the Royal Library in Brussels, who had received a grant to buy it. The van Alstein collection included many Chinese and Japanese books. Lindsay was the first person in Britain to collect Japanese books on a large scale (9.5). During the 1860s he also built up one of the most important collections of Chinese books and manuscripts; many were obtained for him by missionaries in China (8.4). In 1866 Lindsay purchased the Oriental manuscripts of Nathaniel Bland, a gentleman-scholar of Persian literature. Unfortunately he was also a compulsive gambler who fled to the continent to escape his creditors, and shot himself in 1865. Bland's collection contained some 650 manuscripts in Persian, Arabic, Turkish and South Asian languages, as well as a number of Chinese and Japanese items, many of which had previously belonged to eminent European scholars; it cost Lindsay just £850.

'For truly a well-illuminated missal is a fairy cathedral full of painted windows'.
John Ruskin, *Praeterita*

Miniature of Petrarch and Laura, from Petrarch and Dante, *Sonetti e canzoni*, late 14th century. Italian MS 1

The lover Majnun visited by the camel-rider, from Ali Shir Nawa'i, *Layla wa Majnun* (*Layla and Majnun*) (1485), manuscript formerly belonging to Nathaniel Bland. Turkish MS 3, detail

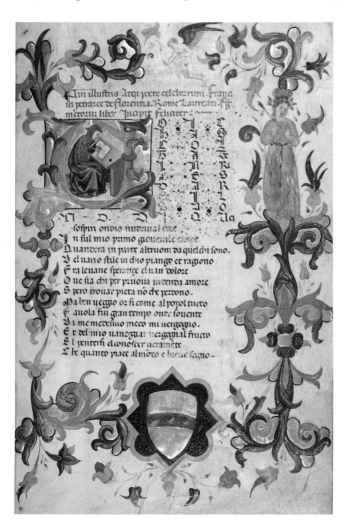

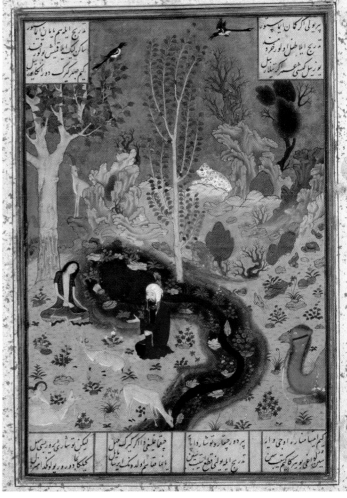

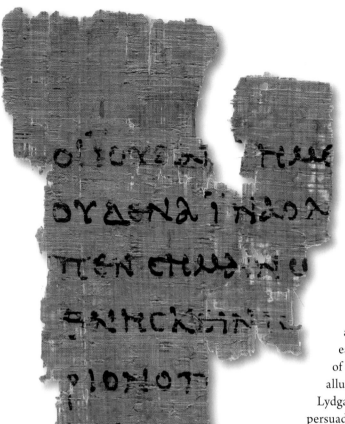

Fragment of St John's Gospel, first half of the 2nd century. Greek Papyrus 457

There was a close connection between the collecting of Oriental manuscripts and what has been termed 'muscular imperialism'. Although Lindsay was not directly involved in colonial exploits himself, he certainly benefited from them. For example in July 1868 he purchased over seven hundred Arabic, Persian and Turkish manuscripts from the executors of Colonel George William Hamilton, who had served with the East India Company. The manuscripts were said to have been looted from libraries in Lucknow in northern India. Simultaneously Lindsay obtained through Quaritch a collection of Ethiopic manuscripts from the so-called Magdala hoard, booty from the Anglo-Indian expedition to Abyssinia.

Ludovic inherited the earldom and responsibility for the Bibliotheca Lindesiana on the death of his father in 1880. He was quite unlike Lindsay: a man of action, impulsive in his collecting, and eclectic in his tastes. He was fond of jewelled bindings, and early manuscripts, whether from Visigothic Spain or the empires of Charlemagne and his successors. He was highly susceptible to the allure of spectacular volumes, such as the magnificent copy of John Lydgate's *Troy Book*, which Quaritch had repeatedly tried and failed to persuade his father to buy (12.2). Ludovic also developed the library in new directions. He was particularly interested in the literature of South-East Asia, collecting a pot-pourri of exotic manuscripts written on palm-leaf, bamboo, bone, bark and copper.

Another innovation was Ludovic's enthusiasm for ancient fragments of papyrus. These had been preserved in the arid climate of Egypt and were now being excavated by peasant farmers, bounty hunters and archaeologists. Ludovic visited Cairo in the winter of 1898–99, and purchased several thousand Greek, Coptic and Arabic fragments from local dealers. Later he commissioned the Oxford papyrologists Bernard Grenfell and Arthur Hunt to buy material in Egypt on his behalf, with a strong preference for Classical literature and early Christian texts. This practice was continued by Enriqueta Rylands (who even visited Egypt towards the end of her life) and the governors of the John Rylands Library, after the Crawford manuscripts were transferred to Manchester. Indeed, the most famous item in our entire holdings, a fragment of the Gospel of St John, was part of an uncatalogued collection of fragments acquired by Grenfell for the Library in 1920. Only in the 1930s was it identified and dated to the second century AD, thus establishing a strong claim to its being the earliest surviving piece of the New Testament. The John Rylands Library is now home to many thousands of papyri, in the ancient Egyptian languages (Hieratic, Hieroglyphic and Demotic), as well as Arabic, Coptic and Greek (see 1.2, 7.1, 7.2).

We also hold a collection of over eleven thousand fragments from the Genizah (or document store) of the Ben Ezra Synagogue in Old Cairo. The Genizah was discovered in the 1890s and the fragments distributed amongst libraries and collectors in Europe and the United States. Our collection was purchased in 1954 from the estate of Moses Gaster (1856–1939), Chief Rabbi of the Sephardic Communities in Britain. The fragments, mainly on paper, cover a vast timespan – from the tenth century to the nineteenth – and range of subjects; they provide extraordinary insights into Jewish religious practices and beliefs and everyday life in Egypt (see 7.3 and 8.2).

Despite his expansive tastes, Ludovic drew the line at cuneiform clay tablets, which are among the oldest forms of writing to have survived. The Rylands collection of over eleven hundred tablets in Sumerian and Akkadian scripts was built up in the first two decades of the twentieth century, first through the efforts of Hope W. Hogg, Professor of Semitic Languages

and Literature at Manchester until his death in 1912, and later by his pupil Charles L. Bedale; six hundred tablets were donated to the Library by Bedale's widow in 1919. The collection contains material from the dawn of recorded history, dating back to the middle of the third millennium BC (see 1.1).

The foundations for the third major component of the Library's collections were laid down in 1922 when Henry Guppy invited local landed families to donate or deposit their archives. At a time when many estates were being broken up and houses abandoned, Guppy realised that 'there is a grave danger lest valuable documents of great historic interest, the importance of which may not yet have been realised, should be lost sight of, and perhaps accidentally destroyed … [or] suffer irreparable damage from damp and neglect.'[7] It should be remembered that today's network of local-authority record offices was not established until after the Second World War, and very few libraries were able and willing to offer sanctuary to archives. Through this enlightened appeal the Library acquired by gift or loan some two dozen family archives, principally from Cheshire, a county rich in gentry families. Among the most significant are the muniments of the Warburton family of Arley Hall in Cheshire, the Tatton family of Wythenshawe (now swallowed up by the suburbs of south Manchester),

'The past is like a great ship that has gone ashore, and archivist and writer must gather as much of the rich cargo as they can.'
George Mackay Brown

Grant from Ranulf II, Earl of Chester, to Alan Silvester of Storeton and Puddington, c.1130–40. Rylands Charter 1807

Elizabeth Gaskell, autograph manuscript of the *Life of Charlotte Brontë*, 1857. Gaskell Collection, University MSS

the Legh family from Lyme Hall on the edge of the Peak District, and the Bromley Davenports of Capesthorne near Macclesfield. The last was held on deposit for over sixty years, but was accepted by the government in lieu of tax in 2008 and permanently allocated to the Library. A more recent acquisition is the archive of the Earls of Stamford, from Dunham Massey Hall near Altrincham. Roger, the bachelor 10th Earl, bequeathed the hall and estate to the National Trust in 1976, one of the most generous benefactions that the Trust has ever received. Roger had been a trustee of the John Rylands Library, and the National Trust duly fulfilled his wish that the archive should be deposited at the Library; it also jointly funded a major cataloguing and conservation project on the collection in the 1990s.

Between the wars, while the John Rylands Library's financial stability was slowly being eroded, the governors were still able to approve a number of major purchases of archives and papers across a broad range of subjects. For example, we acquired the remarkable archive of Hester Lynch Piozzi (1741–1821), friend of Samuel Johnson and centre-point of a brilliant literary circle in late Georgian London. The Library now holds the largest collection of Hester's papers anywhere in the world: around 1,500 letters written by her (including 150 to the 'Great Cham' himself), 1,300 received by her, and numerous journals, notebooks and manuscripts (10.6). The bulk of the archive was purchased from Hester's great-great-granddaughter, Rosamund Colman, in 1931 for a mere £600. By way of comparison, in 2009 a single letter from Hester to Johnson sold in New York for $7,320.

Nineteenth-century literary papers have been a key element of our holdings since the 1930s, when the executors of Elizabeth Gaskell's daughter, Meta, presented her mother's surviving archive (10.7). It includes the autograph manuscripts of the novel *Wives and Daughters* and her *Life of Charlotte Brontë*, as well as extensive correspondence with Charles Dickens, Charlotte and Patrick Brontë, William Makepeace Thackeray and Walter Savage Landor. We continue to augment our Gaskell holdings whenever the opportunity arises. For example, in 2006 the Gaskell scholar J. G. Sharps bequeathed to the Library his papers, which include sixteen autograph letters by Gaskell; and in 2008 we purchased the rich archive of the Jamison family, which includes sixteen letters written by Gaskell and twenty-six by her daughters Florence and Julia, providing fresh insights into the novelist's life and her extensive social and literary networks.

Few figures had such a profound influence upon Victorian cultural life as John Ruskin (1819–1900); Enriqueta Rylands herself seems to have been inspired by his evangelical calls for social improvement and aesthetic reform. Our holdings of Ruskin papers were built up in piecemeal fashion, through gifts and auction purchases, throughout the 1950s and 1960s; they comprise some two thousand items relating to Ruskin, his work and his contemporaries. The papers complement a comprehensive collection of printed works by and about Ruskin, many of which were purchased by Enriqueta before the foundation of the Library.

In recent years the Library has acquired the papers of other nineteenth-century literary and artistic luminaries, such as George Gissing, Harrison Ainsworth and Walter Crane. However, there has been greater focus on developing our modern literary archives, with a

definite emphasis on recent and contemporary poetry. Clustered around the immense and enormously important archive of Carcanet Press, the Manchester-based publisher of poetry and works in translation, is a constellation of collections relating to such figures as Elaine Feinstein, L. P. Hartley, dom sylvester houédard, Norman Nicholson, Jeff Nuttall, Michael Schmidt, Wallace Stevens and Katharine Tynan. More broadly, the fields of drama and screen studies are represented by the archives of Robert Donat (famous for his Oscar-winning performance in *Goodbye Mr Chips*), Annie Horniman (an early supporter of the repertory movement, first at Dublin's Abbey Theatre and later at the Gaiety in Manchester) and Basil Dean (a British pioneer of 'talkies' and wartime director of the Entertainments National Service Association or ENSA).

Prior to the merger with the John Rylands Library in 1972, the University Library had built up its own archive resources, reflecting the University's rich heritage in scientific, technical and medical research and education. Major scientific figures of the nineteenth century whose archives reside at the Library include John Dalton and Henry Enfield Roscoe (chemistry), William Boyd Dawkins (geology) and James Prescott Joule and Arthur Schuster (physics). More recently, Manchester's pioneering role in the development of computers – the world's first stored-program computer, the 'Baby', was built here in 1948 by a team led by Tom Kilburn and F. C. Williams – was recognised in 1987 with the establishment of the National Archive for the History of Computing. The construction of the iconic Jodrell Bank Radio Telescope in Cheshire, under the leadership of Bernard Lovell, is documented in a substantial archive from the observatory, as well as Lovell's personal papers. The Manchester Medical Collection documents many aspects of the medical history of the area, with biographies of over 5,500 local medical practitioners. It is complemented by the archives of a score of local medical associations, as well as the papers of individual physicians such as the orthopaedic surgeon Sir Harry Platt, and the neurosurgeon Sir Geoffrey Jefferson. Although science and medicine were the focus of the University Library's collecting, other academic disciplines were not entirely neglected, as the archives of Samuel Alexander (philosophy), William Stanley Jevons

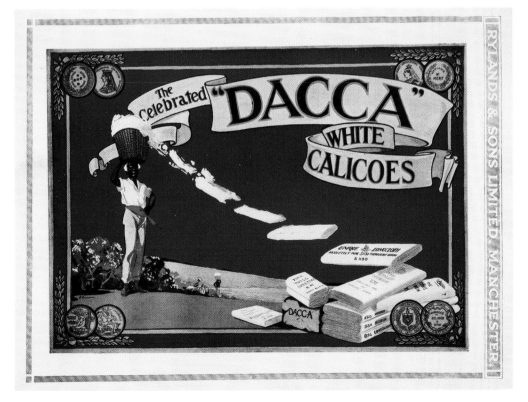

Advertisement for Rylands and Sons: 'The celebrated "Dacca" white calicoes', 1923. RYL/1/3/2

(logic, philosophy and economics), John Strachan (Greek and Celtic studies), and T. F. Tout and James Tait (history) testify.

It should come as no surprise that the Lancashire cotton industry is very well represented in our archive collections. In fact the archive of Rylands and Sons itself is but a sad remnant, an accidental survival discovered in a warehouse in Leeds during the 1980s. Thankfully other firms' archives are more complete, including several pioneers of the factory system, such as McConnel and Kennedy and Samuel Oldknow. The archives of employers' organisations and trades unions provide contrasting evidence of working conditions, industrial relations and the belated (and largely futile) attempts to reorganise the industry in the face of increasing foreign competition. Wider social trends of the nineteenth and twentieth centuries are reflected in several archives and printed collections relating to the anti-slavery campaigns and the women's suffrage movement, while the archive of the radical *Manchester Guardian* newspaper offers in-depth coverage of myriad political, military, economic, social and technological developments in the last one hundred and fifty years.

Britain's military and colonial history is documented in numerous archives. The Clinton Papers, which unfortunately remain uncatalogued, constitute a remarkable record of the Napoleonic Wars, especially the Peninsular Campaign in Spain and Portugal. They are centred on the distinguished careers of the brother-generals Sir Henry and Sir William Henry Clinton. We also hold several important collections relating to the East India Company and the administration of British India, including papers of Governor-General Warren Hastings.

Streams of Nonconformity have always run deep within the John Rylands Library, reflecting its founder's devout Congregationalism. Our already-rich holdings in this field were dramatically expanded in 1977, when the Methodist Church of Great Britain transferred its Connexional archives and printed collections to Manchester. Thus the Library is now home to the world's largest collection of papers of the founders of Methodism, John and Charles Wesley, and many other pioneers of the movement, as well as the Church's institutional records. Other denominations are also abundantly represented, such as Congregationalism, Unitarianism and the Brethren movement, as well as several ecumenical and evangelical groups. It is no exaggeration to claim that the Library is now the world's leading repository of Nonconformist archives and print collections. However, it is important to emphasise that these collections are of profound importance across a wide range of research fields, beyond the confines of church history and religious doctrine.

The John Rylands Library is home to a cornucopia of visual materials – photographs, prints, paintings, drawings, sculptures, textiles, ceramics and glass, as well as countless books and manuscripts illustrated in a wide variety of media, from painted miniatures to lithography.

'I know of no other Christianity and of no other Gospel than the liberty both of body & mind to exercise the Divine Arts of Imagination'.
William Blake, *Jerusalem*

There are also three-dimensional objects, from writing sets, typewriters and cameras to locks of hair and other bodily appendages. Some of these items are embedded within larger printed collections and archives, but there are also several discrete visual collections, such as the Hiero von Holtorp collection of over 2,500 specimens of early printing, woodcuts, engravings and etchings, purchased by Enriqueta Rylands in 1906; the Lawson collection of Wesleyan ceramics and other memorabilia; and the Manchester Geographical Society's collection of Victorian lantern-slides, containing many thousands of photographic images from around the world. Other objects live in splendid isolation, such as an imposing marble bust of Elizabeth Gaskell by Hamo Thornycroft, and the famous 'Grafton Portrait', an oil-on-panel image of an unnamed young man whom some have claimed to be Shakespeare himself.

Until recently these remarkable resources had been strangely neglected; falling in the interstices between curatorial departments and research disciplines, they defy easy categorisation

and unsettle the comfortable domains of professional and academic expertise. Many collections and individual objects lie hidden in the darkest recesses of the Library, awaiting discovery and description. A new curatorial department is now addressing these challenges and breathing life into the collections. The ongoing 'Burning Bright' project – an innovative collaboration between Special Collections and the University's Art History and Visual Studies Department – has revealed a hitherto unsuspected wealth of imagery by the visionary artist and poet William Blake. Many more visual riches await discovery by curators and researchers.

Every special collections library and archive must continually endeavour to build its collections, in order to rejuvenate itself, to stimulate the interest of researchers, to support new fields of study and to address gaps in its holdings. The University of Manchester Library is no exception. While we are no longer blessed with Enriqueta's almost bottomless purse, the Library has had considerable success in developing its collections in recent years, with a series of notable acquisitions, guided by a clear and accessible 'content development policy'.

In the last five years major accessions have included the parochial library from Nantwich in Cheshire, which was founded at the end of the seventeenth century and includes one of only three surviving copies of Wynkyn de Worde's 1502 Sarum Hymnal, *Expositio hymnorum*; the papers of Sir Edward Frankland, first professor of chemistry at Owens College, who developed the concept of valency and pioneered organometallic chemistry; an important, previously unknown set of letters of the scientist John Dalton, famous for his atomic theory; a suite of Crimean War photographs by Roger Fenton, who was commissioned to record the war by Thomas Agnew, the leading Manchester fine-art publisher; the outstanding archive of

'St Eustace', engraving by Albrecht Dürer, *c*.1501. Holtorp Collection

'Insecurity of life', from Edward Young, *The Complaint, and the Consolation: or, Night Thoughts* (1797), engraved and hand-coloured by William Blake. Spencer 16123

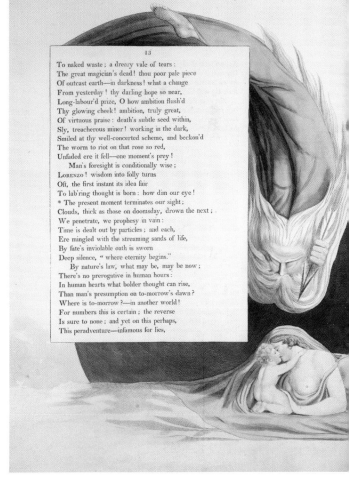

'The most profound enchantment for a collector is the locking of individual items within a magic circle in which they are fixed as the final thrill, the thrill of acquisition, passes over them.'
Walter Benjamin,
'Unpacking My Library'

Mary Hamilton, governess to George III's daughters, diarist and bluestocking, whose friends included Hannah More, Frances Burney and Mrs Garrick; and a set of unpublished letters of Mrs Hester Lynch Piozzi, which augment our renowned Thrale-Piozzi Collection. In 2011 it was particularly gratifying to purchase the 'missing' seventh volume of the Colonna Missal, and thus reunite it with the six volumes that were acquired by Enriqueta Rylands with the Crawford Collection in 1901.

So-called 'born-digital' records (emails, spreadsheets, databases and the like) have become an increasingly significant element of archives in recent years, and one that presents archivists with considerable challenges, given the rapid obsolescence of hardware and software. The ever-expanding paper archive of Carcanet Press has recently been augmented through the 'ingest' of hundreds of thousands of items of email correspondence. The Library is now at the forefront of endeavours to capture, preserve and make accessible this fleeting, protean medium.

In recent years there have been a number of unhappy dispersals from public and private institutional libraries in Britain, and we have been fortunate to purchase several early printed books discarded by other libraries. Although we cannot hope to make good the losses incurred in the infamous Rylands sale of 1988, when one hundred so-called 'duplicate' printed books were sold at Sotheby's, it is satisfying to note that we are once more actively developing our early print collections. Other major printed acquisitions have included Bruce Rogers's 1935 Oxford

Network graph, or visual representation of Professor Michael Schmidt's incoming emails within the Carcanet Press Archive, 2001–4: each dot represents a single correspondent or group of correspondents; the Library is pioneering the digital preservation of over two hundred thousand emails in the archive

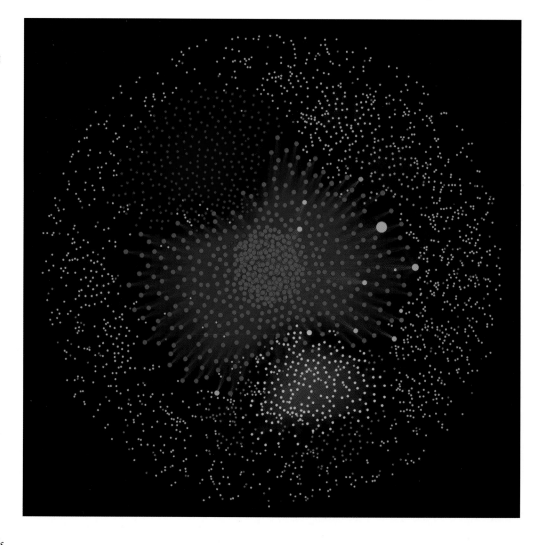

Lectern Bible – a landmark in both the history of typography and the printing of the Bible – and a copy of the third Aldine edition of Baldassare Castiglione's *Il Libro del Cortegiano* (*The Book of the Courtier*), published in 1541 and once owned by Henry Howard, Earl of Northampton (1540–1614). Many of our major purchases in recent years, such as *Il Libro del Cortegiano* and the Colonna Missal, have been generously funded by public bodies and charitable trusts, such as the Art Fund, Friends of the National Libraries, Heritage Lottery Fund, Pilgrim Trust, Society of Dilettanti Charitable Trust, V&A Purchase Grant Fund, and Friends of the John Rylands, as well as by numerous individual benefactors. While the Library has a dedicated acquisitions budget for Special Collections, supplemented by historical endowments, the inexorable rise in the price of rare books, manuscripts and archives means that our collecting ambitions will always exceed our own limited resources and we will continue to seek external support to develop the collections.

Of course, acquisitions must be matched by investment in collection care, to ensure that items are in a suitable condition for display and consultation by researchers, and in cataloguing and digitisation, in order to realise the full research potential of the material. We now have a much better awareness of the very real costs associated with these activities, and we try to factor them into decisions over whether to acquire material. Moreover, the Library has an international reputation as a centre of excellence in heritage imaging, collection care and documentation, using state-of-the-art technology and vast staff expertise to protect and promote our collections. I passionately believe that we have an obligation to hand the collections to the next generation in a better state – augmented, preserved and documented – than when we inherited them from our predecessors. There is every reason to be confident that if a similar book is published in twenty-five or fifty years' time, it will feature many extraordinary objects that we can as yet scarcely dream of residing in the John Rylands Library.

<div align="right">John R. Hodgson</div>

Notes

1 Henry Guppy, 'In Memoriam: Mrs Enriqueta Augustina Rylands', *Bulletin of the John Rylands Library*, 1:6 (1908), 351–9 (p. 352).
2 Guppy, 'In Memoriam', p. 358.
3 Charles W. E. Leigh, *Catalogue of the Christie Collection: Comprising the Printed Books and Manuscripts Bequeathed to the Library of the University of Manchester by the Late Richard Copley Christie* (Manchester: Manchester University Press, 1915), ix.
4 Letter from J. P. Edmond to A. B. Railton, 1 October 1901. John Rylands Library, A. B. Railton Papers, ABR/2/58.
5 John Ruskin, 'Editor's Note on the Vision of St Christopher', *Library Edition of the Works of John Ruskin*, edited by E. T. Cook and Alexander Wedderburn, vol. 32 (London: George Allen, 1907), 220.
6 Letter from Thomas Boone to Lord Lindsay, 19 June 1868. National Library of Scotland, Edinburgh, Crawford Library Letters, June–December 1868, f. 277.
7 [Henry Guppy], 'Library Notes and News', *BJRL*, 6:4 (1922), 371–83 (p. 382).

The Line of Beauty

1

Beyond books:
From papyrus to pixels

THE *Oxford English Dictionary* defines a library as an 'establishment, charged with the care of a collection of books, and the duty of rendering the books accessible to those who require to use them'. The University of Manchester Library undoubtedly conforms to this notion of a library since it is home to millions of books and these books are routinely consulted and used by diverse audiences for many purposes. The range and type of books found within the Special Collections, in both printed and manuscript forms, are prized for their rarity. Their myriad variety will be examined in more detail in a number of the chapters that follow.

Yet books are only one part of the story of Special Collections in The University of Manchester Library, which also houses and collects a dazzling array of texts, records and objects in a wide variety of other media. So this chapter will challenge some of the conventional assumptions of what a library is and what a library can contain by exploring examples from the collections that exist in non-book form.

Celebrating the hybridity of the material culture in the Library's holdings is important because the range and depth of these collections is one of the things that makes our Special Collections distinctive. It is also necessary because the form taken by an object, text or record crucially affects the way it transmits information and ideas and how it evokes emotional responses from the people who engage with it. Forms inform the way knowledge is communicated, understood and experienced because the meanings of 'things', as Arun Appadurai notes, are 'inscribed in their forms'.

The 'things' that are explored in this chapter tell three types of story. The first will investigate some of the formats that have been used to preserve written and spoken culture. The second will present some of the works of art that have found their home in Special Collections, whilst the third will explore some of the Library's collections of objects. Crossing a period of five thousand years, these journeys will traverse verbal and visual cultures and connect the analogue to the digital, from the papyrus of the past to pixel of the present.

Not all written texts have, throughout history, been preserved in book format. As the historian Roger Chartier has observed, 'orally produced works and numerical or computer-processed

data are "non-book texts" that mobilise the resources of language without belonging to the class of print objects'. In Special Collections written texts and records, embedded in archives and embodied in manuscripts, are made in a variety of materials that includes clay, papyrus, palm-leaf, paper, silk, bark, bamboo and bone. They are also preserved in a range of formats, a selection of which would include tablets, scrolls, rolls, title deeds, letters, wills, minute books, diaries and typescripts. The spoken word, and other 'non-verbal texts' (like music) are also represented in the archives within Special Collections in the form of audio recordings. Most recently the Library has begun to 'ingest' born-digital materials as well as those in analogue formats, including the emails of living writers and publishers as part of the Carcanet Press Archive.

Throughout its history the Library has acquired and accumulated works of art alongside its other collections. These are in the form of Fine Art (paintings, drawings, sculpture and prints), and Decorative Art (ceramics, textiles and metalwork). The collections of art span millennia from the papyrus of the Ancient Egyptian Book of the Dead to contemporary digital photographs. They are international in their scope, and include, for example, substantial collections of Chinese paintings, and Indian drawings, as well as works by Western artists as varied as Albrecht Dürer, William Blake and Ian Hamilton Finlay.

The Fine Art Collection also covers a range of artistic genres. The Library's portraits are especially rich and exist in a range of media including paintings, drawings, sculptures, photographs, ceramics, wax and bone. The range of individuals depicted come from a variety of cultures and historical periods. Some of these portraits enjoy iconic status, like the 'Grafton Portrait', which is included in this chapter.

Special Collections is also home to a significant collection of photography, which spans a conspectus of subjects from art to zoology, covers a wide range of photographic styles and contains a full complement of analogue formats and processes. These range from stellar objects like the calotype prints made in the 1840s by the inventor of negative-positive photography, William Henry Fox Talbot to contemporary Polaroid 'snapshots'. The Library is also developing extensive born-digital collections of 'Object photography' through its Imaging programme.

As well as holding significant works of art and visual culture, the Library also houses collections of objects. These relate to the histories and technologies of writing and printing and include styli, quill pens, ink, typewriters and writing desks as well as woodblocks, copper-plates, printing presses and type. Other objects in the collections have been preserved because they have associational or personal value. They include the baby shoes of a twentieth-century poet, the handbag of one of Lord Byron's cast-off loves, a Zen-Catholic monk's liturgical vestments and locks of hair that once graced the heads of the scientist John Dalton, the poet William Wordsworth and the novelist Marcel Proust. These intimate and evocative objects remind us that language alone cannot capture the range and depth of human existence and that objects too have the power to connect life to history, or in Proust's words, to make 'history more alive'.

Stella K. Halkyard

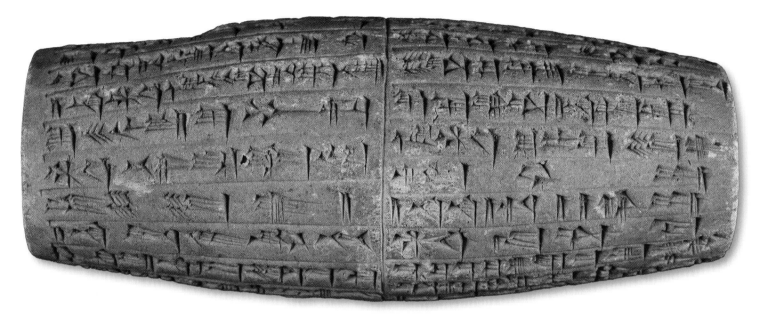

1.1 Technologies of writing: clay

Clay cylinder
Commemorative inscription, Nebuchadnezzar II's reign (605–562 BC)
130 × 50 × 160 mm (length × diam. × circum.)
Cuneiform 1095

The John Rylands Library has over one thousand cuneiform manuscripts. Originating in Sumer (Southern Iraq) during the fourth millennium BC, cuneiform is one of the earliest known writing systems. Its name derives from the characteristic 'wedge shape' impressed by a reed stylus into clay. Cuneiform was used to write a variety of languages, including Sumerian and Akkadian, until the second century AD, by which time it had been replaced by the Phoenician alphabet.

Most of the Library's collection emanates from the great temples of Drehem and Umma and dates from the Ur III dynasty (twenty-second to twenty-first centuries BC). There are also First Babylonian Dynasty fragments (twentieth to seventeenth centuries BC), and much later Babylonian and Assyrian pieces. Whilst most of the tablets are administrative,

legal or agricultural documents, there are also letters and literary texts.

This piece is a royal inscription from the New Babylonian period (626–539 BC) written in two columns on a hollow barrel-shaped cylinder. It commemorates the rebuilding of the Ebabbar temple at Sippar by the Babylonian king Nebuchadnezzar II, who ruled from 605 to 562 BC. In return for the magnificent temple, Nebuchadnezzar beseeches the sun god Shamash to grant him a long life, victories in battle and a secure succession for his descendants. The cylinder would probably have been buried in the foundations, only to be discovered and read by future kings when the temple needed repair.

Dorothy J. Clayton

1.2 Technologies of writing: papyrus

Papyrus fragment
Homer, *The Odyssey*, 3rd century AD
120 × 130 mm
Greek Papyrus 546

Papyrus, a paper-like material made from the pith of the *Cyperus papyrus* reed, was the most widespread writing medium in antiquity. The Library's collection of Greek papyri numbers some two thousand items, of which only seven hundred have been fully catalogued. They range in date from the third century BC to the seventh century AD. The content of the documents is varied and includes Classical, Biblical, liturgical and medical texts, as well as administrative documents, government records and business papers.

Greek Papyrus 546 is an example of a Classical text. The Homeric poems, the *Iliad* and *Odyssey*, were the end-product of a long process of oral composition and were probably first written down during the late eighth century BC. Some scholars have suggested that the Greek alphabet was invented specifically so that the Homeric poems could be written down, and they have exerted enormous influence on European literature ever since.

In Ancient Greece the study of Homer was of paramount importance in a boy's education. This fragment of papyrus is written carefully but in an immature hand; it was probably copied out by a schoolboy.

Dorothy J. Clayton

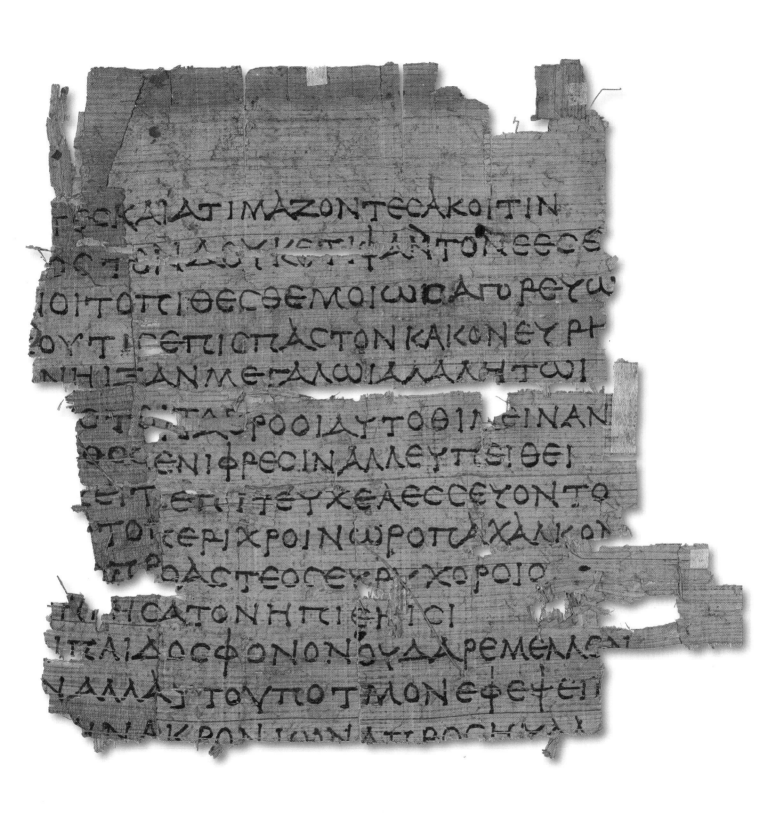

1.3 Scrolls in the Jewish tradition

Scroll of Esther (*Megillah Esther*), illuminated on vellum, Ferrara, before 1618

4,250 × 295 mm

Hebrew MS 22

Esther, a Jewish servant-girl, became the second wife of Ahasuerus, King of Persia (identified as Xerxes I or Artaxerxes). She skilfully contrived to prevent a massacre of the Jews initially authorised by the king. She is the subject of the eponymous Old Testament book.

The Jewish Feast of Purim is celebrated by the public reading in the synagogue of the Scroll of Esther. The 'story' of Esther was well known throughout the Middle Ages, and it was represented in both Christian and Jewish art, almost always in illuminated manuscripts. Although there is evidence that the Book of Esther appeared as a text written on a scroll (*megillah*) before the Common Era, no illustrated or even decorated *megillah* survive from before the late fifteenth century.

Strict Rabbinic rules governed the writing of an Esther Scroll. Text had to be written in columns, all of equal length and breadth, and all in the same scroll. The only spaces at the disposal of the illustrator were the upper and lower borders of the scroll and the spaces between the text columns.

The dating of the Rylands *Megillah* is problematic. The colophon (the scribe's closing statement) gives the date of 12 Adar 5271 (AD 1511), but this is presumably a scribal error for 5371 (AD 1611). The illustrations provide important evidence for dating the manuscript: banqueting and court scenes reflect court life and fashions of the early seventeenth century, as do the armour and helmets worn by the soldiers, and the scene of the synagogue interior. The manuscript was certainly produced before 1618 when it passed into the possession of Benjamin of Castel-Bolognese, making it the earliest known example of an Italian illustrated *megillah*.

Here the story of Esther is told in 'strip-cartoon' fashion, in twenty-eight frames along the scroll's upper margins, reading from right to left. In frame 16, five Jews, their heads covered with the traditional prayer-shawl, are praying in the synagogue. Frame 17 illustrates Esther and fashionably dressed noblemen and women before King Ahasuerus. In frame 18, Ahasuerus is in bed and being attended by two courtiers, one of whom is reading to him.

Dorothy J. Clayton

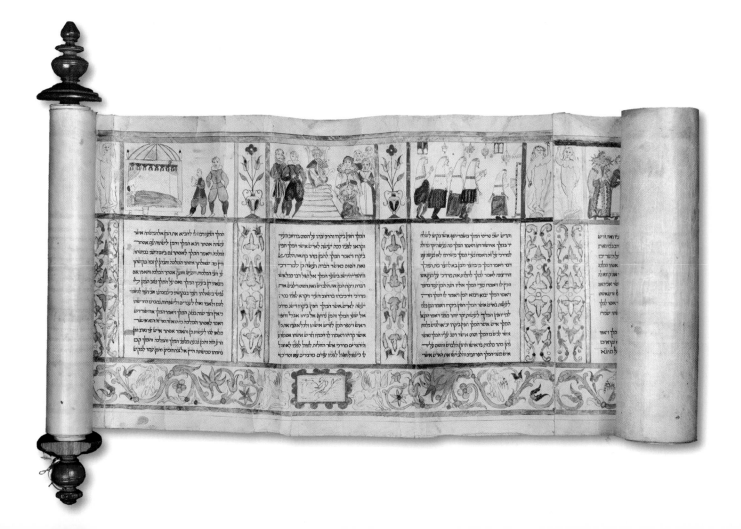

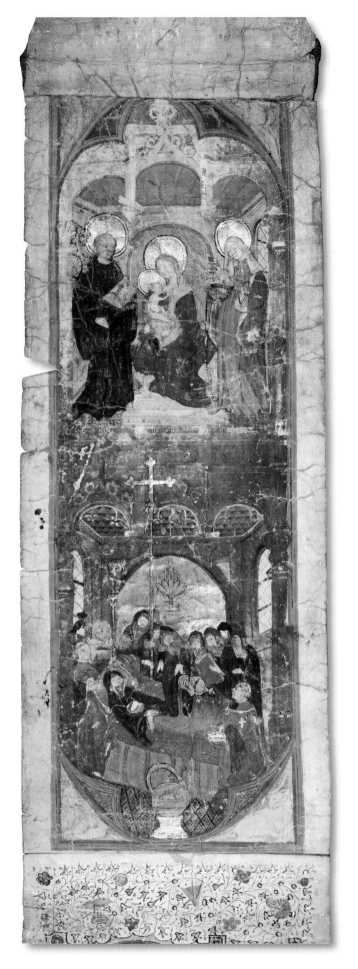

1.4 Scrolls in the Christian tradition

Mortuary Roll, illuminated painting on vellum, 15th century
305 × 185 mm (12,956 × 185 mm overall)
Latin MS 114, detail

The mortuary roll commemorating the death of Elisabeth 'sConincs (d. 1458), Abbess of the Abbey of Fôret or Forest, near Brussels, consists of nineteen pieces of vellum, including the frontispiece, a letter announcing her death (the encyclical), and seventeen pages of signatures. Imagery is found on the slightly damaged frontispiece, appropriate for an object used to encourage and embody the exchange of prayers by the living for the dead, and on the encyclical. The upper register presents the images of three saints: the Virgin and Child, to whom the abbey was dedicated; St Benedict on the left – the founder of the order to which the nuns belonged; and St Elisabeth on the right – the Abbess's patron saint. The lower register features an image of the dying abbess and her community at Forest, along with the priests necessary to conduct the daily religious rituals in the convent. The enlarged representations of liturgical instruments (cross, censer, incense-ship and the monstrance), all illuminated in gold, emphasise the ritual activity appropriate at death. The encyclical features an illuminated initial with a Virgin and Child. From 1458 to 1459, part of the roll was carried by Johannes Leonis, who collected from religious communities 390 signatures of promised prayers for Elisabeth and her dead religious sisters, travelling between Brussels and Ghent, Maastricht, Liège, Utrecht, Cologne, Bonn, Aachen, Namur, Lille, Bruges, St-Omer, Nivelles and Braine.

Stacy Boldrick

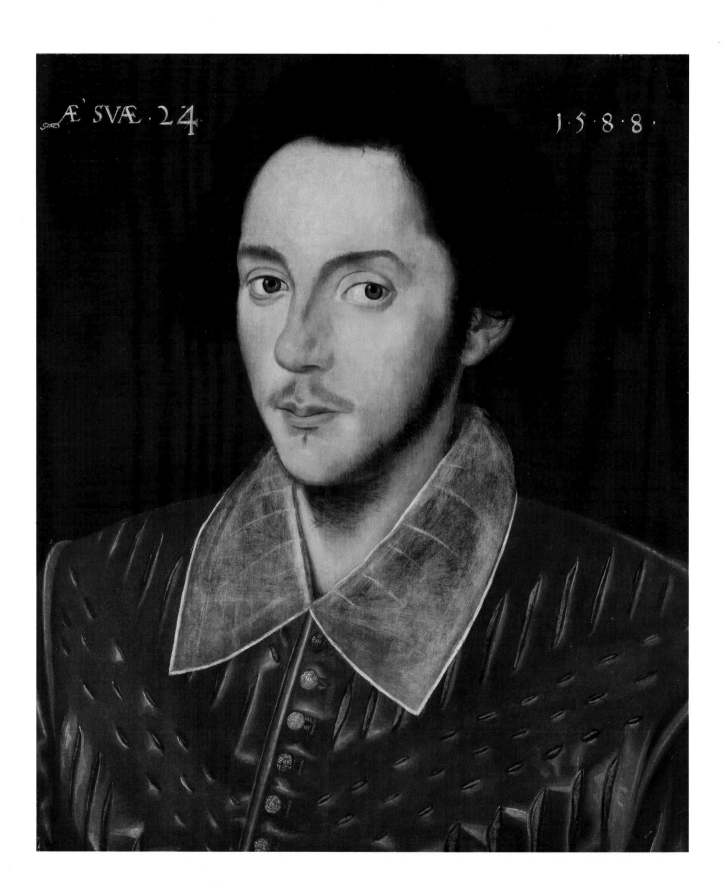

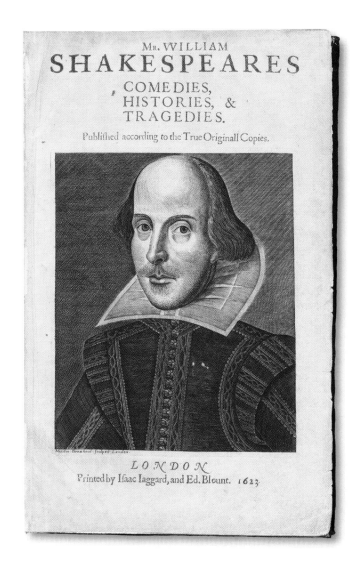

1.5 a & b Portraits

Unknown English artist
Portrait of a young man, known as the 'Grafton Portrait'
Oil on panel, 1588
445 × 385 mm
Fine Art Collection

Martin Droeshout
Portrait of William Shakespeare
Engraving on paper, c.1623
192 × 162 mm
Spencer 8123

These well-known images are associated with Shakespeare. The painting, in oil, is on a single wooden panel by an unknown artist. Experts have been able to establish that the tree from which it was hewn is oak and probably came from Surrey. It is painted in the linear style employed by English painters in the late sixteenth century.

Throughout the twentieth century it was accepted as a representation of William Shakespeare but recent scholarship has been unable to substantiate this claim. Given the lack of information about Shakespeare's life, it is perhaps not surprising that people might wish to suppose that the handsome young man in the portrait, resplendent in the crimson satin usually accorded only to royalty, is of the playwright from Stratford-upon-Avon.

By contrast, the engraved portrait by Droeshout also shown here, which is from the title page of the famous First Folio edition of Shakespeare's plays (1623), has always carried the stamp of authenticity. Yet engravings were never worked from life but from the intermediary of a painting or drawing. So even when faced with a true likeness we are still, like Shakespeare's character Leontes from *The Winter's Tale*, 'mocked by art'. All portraits, even those stamped with the authority of true likenesses, mask their fictions through art.

Stella K. Halkyard

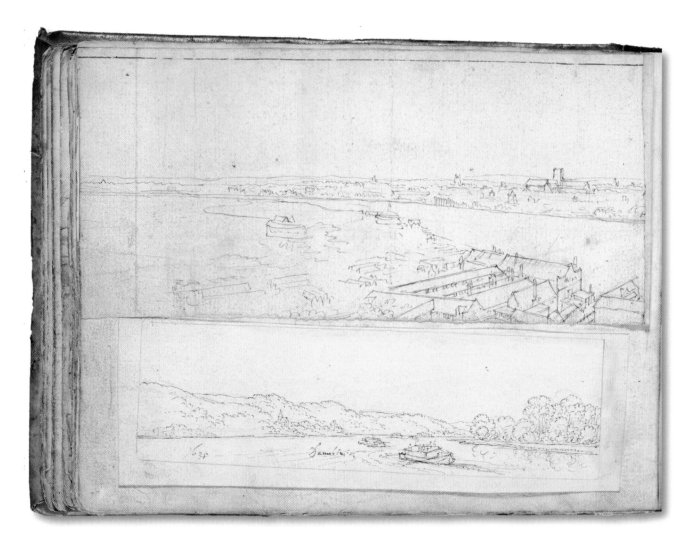

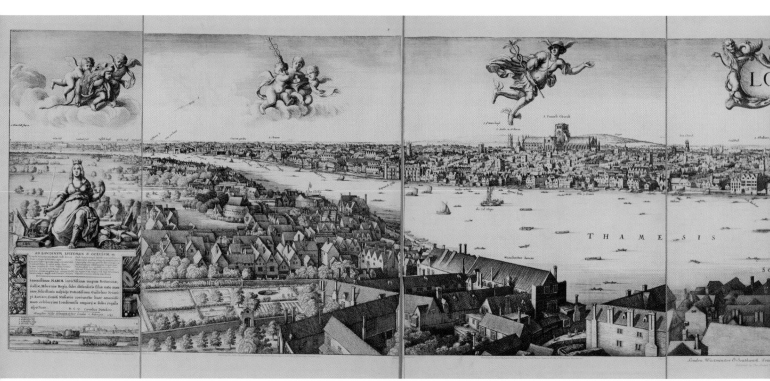

Riches of the Rylands

1.6 a & b Landscapes

Wenceslaus Hollar
View of the Thames
Pencil, pen and ink drawing on paper, c.1620–40s
80 × 190 mm
English MS 883

Wenceslaus Hollar
'The Long View of London from Bankside', 1647
Facsimile by Emery Walker, 1906
620 × 2,580 mm
Map Collection

This slight but deliberate rendering of London from the South Bank of the Thames is the work of Wenceslaus Hollar. Born in Prague in 1607, Hollar left Bohemia to avoid religious persecution. Whilst living in Frankfurt he was employed as an etcher in the workshop of Matthäus Merian. There he learned the techniques of topographic and cartographic printing. He settled in England under the patronage of the collector Lord Arundel. Between 1620 and 1640 this and other drawings were produced which are now held in the Rylands. 'View of the Thames' is a preliminary drawing that is closely associated with two other drawings that survive in the Paul Mellon Collection at the Yale Center for British

Art in America. All three were probably used as sources for his panoramic etching, 'The Long View of London from Bankside', 1647.

Hollar's print (shown here in a facsimile produced by the Arts and Crafts designer Emery Walker) had written inscriptions added to it in the printer's workshop to indentify some of the landmarks. Unhappily for Hollar these well-intentioned printers mistook Shakespeare's Globe for a 'beere beyting' house and instead identified the Hope 'threatre' (which did indeed double up as a bear-baiting house) as the Globe.

Stella K. Halkyard

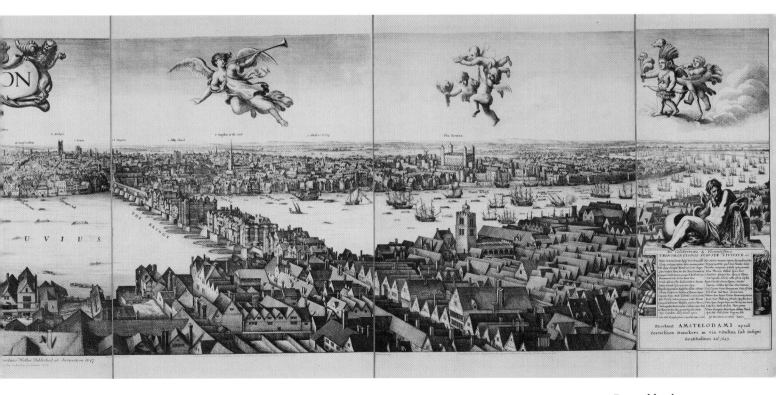

1.7 a & b Technologies of writing: bark and bamboo

Batak bamboo pole, 19th century
*c.*65 × *c.*280 mm (length)
Batak MS 23

Batak magic book (*pustaha*), 19th century
270 × 170 mm
Batak MS 1

The Library has a collection of twenty-six Batak manuscripts: fourteen are written on bast fibre from the alim tree; nine on bamboo; and three on paper. All date from the second half of the nineteenth century. The Batak population of the northern part of the Indonesian island of Sumatra today numbers some five million, but they remain a culturally distinct and isolated people. It is only since the late nineteenth century that scholars have studied the Batak language and been able to understand the contents of Batak texts.

Batak MS 1 (below) was made from a long strip of alim tree bast, smoothed and prepared with a rice flour paste, cut to size, folded in concertina fashion and attached to wooden covers. A Batak book written on bast is known as a *pustaha*. All these texts deal with magic and divination. Essentially the pustaha is the notebook of a Batak medicine-man (*datu*), dictated

to his pupils or copied by them as a supplement to oral instruction. Many pustahas are badly written and contain the pupil's hurried and careless script. In Batak MS 1 the main subjects covered are *pagar* (protective magic) and *dorma* (alluring magic, e.g. a love-philtre). The text, written in lines parallel to the folds, is in black ink. The illustrations are in black ink, with some red ink and earth pigments.

Batak MS 23 (left) is a spelling manual written on a bamboo pole. The letters have been incised with a sharp knife and then blackened with soot to make them more legible. The Batak alphabet consists of nineteen letters, each consonant accompanied by all the different vowels. Scholars believe the earliest Batak script developed out of the ancient Javanese Kawi script, which in turn is derived from Indian models. It is written from top to bottom, left to right.

Dorothy J. Clayton

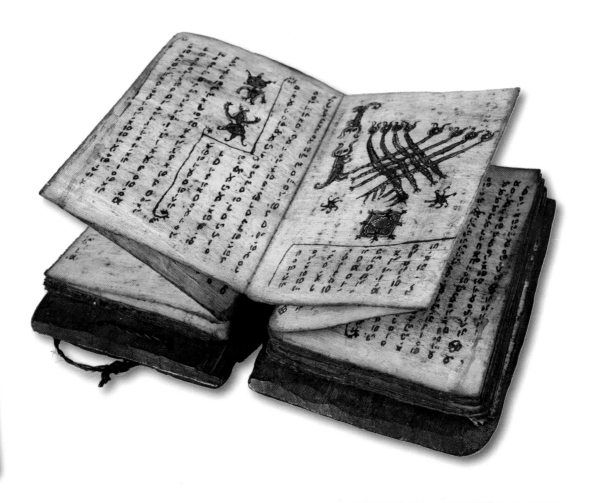

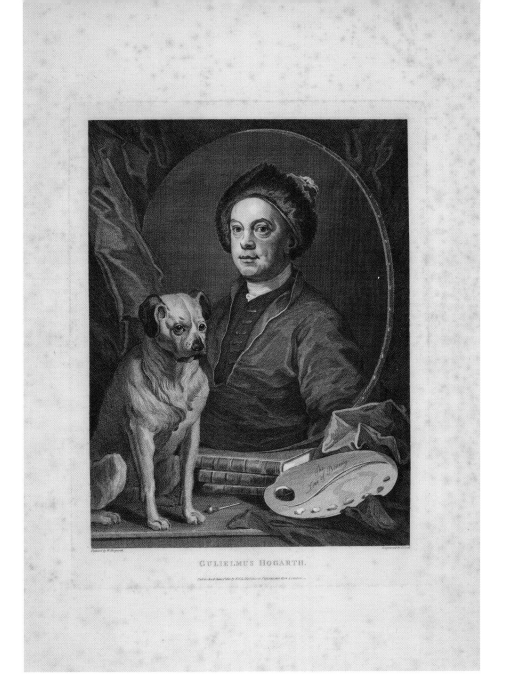

GULIELMUS HOGARTH.

1.8 Self-portraits

William Hogarth
'The Painter and His Pug'
Engraving on paper, printed by
Thomas Cook, 1801
570 × 445 mm
R183036.4

Dating from 1801, this is a print of one of William Hogarth's best-known oil paintings entitled 'The Painter and His Pug'. In this self-portrait, Hogarth (1697–1764) projects an image of himself as an artist, gentleman and intellectual with broad cultural interests. His portrait is shown in an oval frame supported by a pile of books which include the works of Shakespeare, Milton and Swift, who were acknowledged as the greatest English writers. Alongside, and equal to, the works of these literary giants Hogarth represents the trappings of his own 'trade' as an artist in the form of his palette and his engraving tools. His palette is inscribed with the words 'the Line of Beauty'. This refers to his own treatise *The Analysis of Beauty* (1753) which articulates his theories of art and aesthetics.

Prominently placed in the foreground of the composition is a portrait of Trump, the best known of Hogarth's pugs. Presented as an exact likeness from life, Trump's portrait pays tribute to his master's abilities to practise his theory that art should arise from the close observation of nature. It also acts as a visual joke by emphasising the physical resemblance between the artist and his pug and is also suggestive of Hogarth's pugnacious character.

The print shown here was produced by Thomas Cook (1744/5–1818) who worked for various publishers engraving portraits and frontispieces for books. He was, however, most famous for his reproductions of the works of Hogarth of which this print is an example.

Stella K. Halkyard

1.9 Early photography

Roger Fenton
From 'The Crimean War Series'
Salt paper print on board,
1855–56
190 × 160 mm
Photography Collection

Known as 'The Council of War', this early photograph portrays the commanders of the British, Turkish and French forces – Lord Raglan, Omar Pasha and General Pélissier – during the Crimean War (1853–56). Before our eyes they plan what would prove to be their successful assault on the Russian fortifications at Mamelon.

This compelling image is one of four in the Rylands collection of photography. They form part of a larger body of work that was made by the celebrated Lancastrian photographer Roger Fenton (1819–69). Comprising 350 negatives, produced by the 'wet collodion' process on glass plates of various sizes, the sequence was shot using five cameras. Under enemy fire, in temperatures and conditions wholly uncongenial to the practice of photography, they were then printed as salt-paper and albumen photographs in a darkroom inventively fashioned from a converted wine merchant's wagon. They were then published in Exchange Street, Manchester, by the leading international art dealers and print publishers, Thomas Agnew and Sons.

They are the first photographs to have been made by a named photographer, of any nationality, in a theatre of war.

Stella K. Halkyard

1.10 Sculpture

William Hamo Thornycroft
Portrait bust of Elizabeth Cleghorn Stevenson (after David Dunbar)
Marble, c.1895
670 × 770 mm
Fine Art Collection

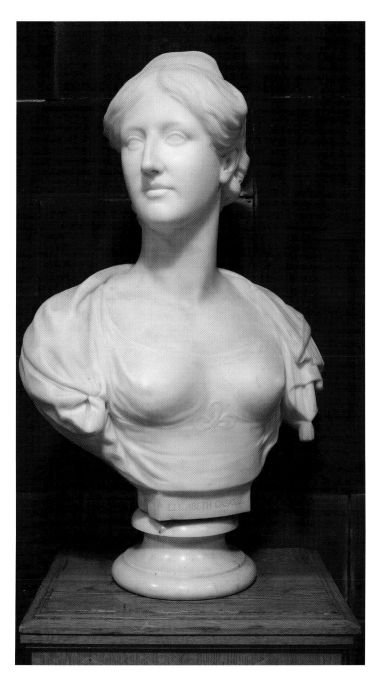

Around 1829 the Scottish artist David Dunbar (1792–1866) was asked to produce a portrait bust of a young woman called Elizabeth Cleghorn Stevenson (1810–65). This was shortly before her marriage to William Gaskell and some time before she became a celebrated author and the biographer of Charlotte Brontë.

What became of the sculpture is unknown, but prior to its loss the eminent sculptor William Hamo Thornycroft (1850–1925) was invited to produce a copy of Dunbar's original, probably by a member of Elizabeth Gaskell's family. The restrained Victorian classicism evident in Thornycroft's copy is likely to be a faithful rendition of Dunbar's portrayal of Gaskell.

At the time of this commission in the 1890s, Thornycroft was recognised as one of Britain's leading sculptors, especially in the genre of Victorian portrait statuary. He was also known as a pioneer of the New Sculpture Movement alongside Albert Gilbert (1854–1934) and George Frampton (1860–1928). Born in 1850 in London to a family of sculptors, Thornycroft spent his childhood on his uncle's farm at Gawsworth, in the rural Cheshire of Elizabeth Gaskell's girlhood. It is perhaps therefore not surprising that Cheshire was not only the setting of some of her stories but also often the inspiration for Thornycroft's art.

After leaving Macclesfield Grammar School, Thornycroft decided to become a sculptor and was trained by both his parents, Thomas and Mary, in the family studio. He enrolled at the Royal Academy in 1869 and was taught by Frederic Leighton. In 1888 he was elected to full membership of the Royal Academy and was knighted in 1917.

In addition to this sculpture, the Library holds an important cache of Thornycroft's letters amongst the papers of M. H. Spielmann (1858–1948). Spielmann was an influential art critic and connoisseur who endorsed and promoted the work of the artists associated with the New Sculpture Movement.

Stella K. Halkyard

1.11 a & b Objects with associational value

Walt Whitman's metal pen nib, 19th century
60 × 13 mm
Object Collection

Flowers given to Walt Whitman previous to his passing away, 1892
94 × 290 mm
Object Collection

The Rylands owns a small assortment of objects including ink-stained pen nibs, a button from a jacket, the crumpled lining of a man's hat and a desiccated bundle of colourless flowers. These once belonged to, and were used by, the great American poet Walt Whitman (1819–92).

Famous in his own time for his compassion as a wound dresser on the battlefields of the American Civil War, Whitman is recognised today as a writer of international importance and distinguished as one of the world's first Modernist poets. His collection of poems *Leaves of Grass*, which was first published in 1855 and refined and augmented through a further nine editions, presents a democratic vision of society. Written in the simple, 'un-dandified' form of free verse, Whitman's poems capture the lives of ordinary American men and women and are notable for their expression and celebration of same-sex love.

As his fame spread, Whitman's ideals made a great impact in Britain. In Bolton, Lancashire, he inspired a group of working-men to establish the Bolton Whitman Fellowship to enjoy and promote his ideas and work. Some members of the group corresponded with him and made pilgrimages to New Jersey to meet him.

After the poet's death, this set of humble everyday things was collected and cherished before being deposited in the Rylands, alongside some of the fragments from his literary remains. These objects have been hallowed by their contact with the poet and, because of their associational value, they continue to play an important role in Whitman's afterlife.

Stella K. Halkyard

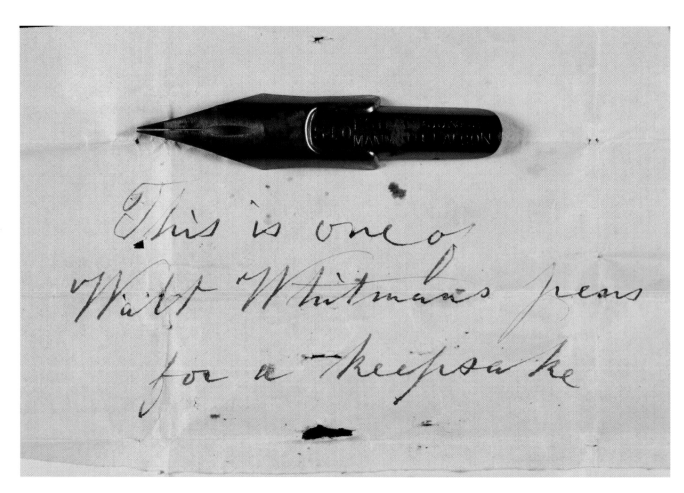

This is one o
Walt Whitmans pens
for a keepsake

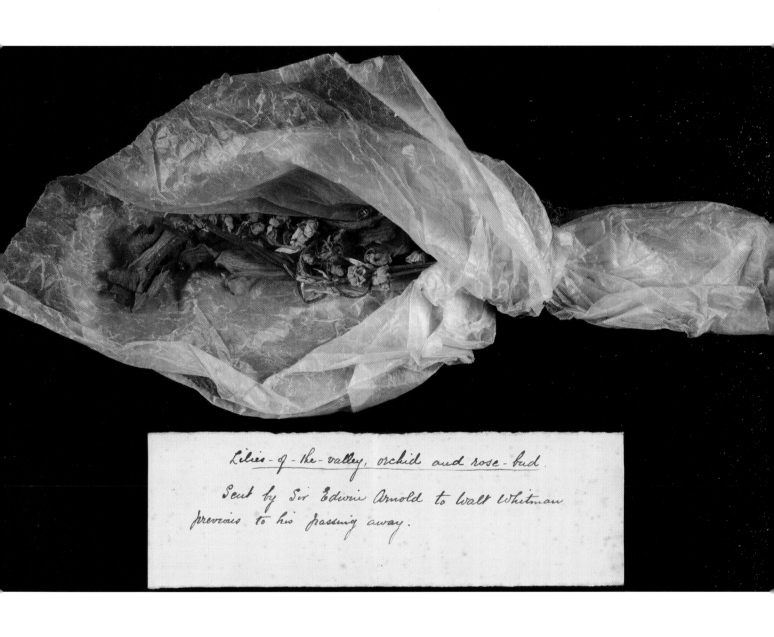

Lilies-of-the-valley, orchid and rose-bud.

Sent by Sir Edwin Arnold to Walt Whitman previous to his passing away.

1.12 a & b Scrapbooks

Buffalo Bill scrapbook compiled by Alfred James Hipkins
and John A. Hipkins, *c.*1887-1903
416 x 315 mm
English MS 1393

James Ernest Hunt William
Portrait of William Frederick Cody ['Buffalo Bill on horse back']
Albumen print, *c.*1909
260 × 230 mm
English MS 1393

Colonel William Frederick Cody (1846–1917), more famously
known as Buffalo Bill, served as a United States army scout,
buffalo hunter and frontiersman. William 'Buffalo Bill'
Cody is best known for his travelling Wild West show which
brought the myth and romance of the American frontier to
audiences around the world.

This photographic print of William Cody on horseback,
in front of a painted landscape scene, is by the London
photographer James Ernest. It is part of a scrapbook of photo-
graphs, letters and newspaper cuttings relating to Buffalo
Bill's Wild West British tours, which took place in 1887, 1892
and 1902–3. Buffalo Bill first brought his Wild West to Earls
Court as part of 'The American Exhibition', in 1887 – the year
of Queen Victoria's Golden Jubilee.

The contents of the scrapbook were lovingly collected
by a family called Hipkins. In the scrapbook's introduction,
Edith J. Hipkins explains why the material was collected:
'This collection of odds and ends is a memento mori of
an exhibition of real life held in London some years ago.
Collected by my brother and carried out by my father for our
mother's amusement.'

The Victorians are renowned for their love of collecting,
and many museums and libraries, including the John Rylands
Library, are indebted to their prolific collecting habits.

Suzanne M. Fagan

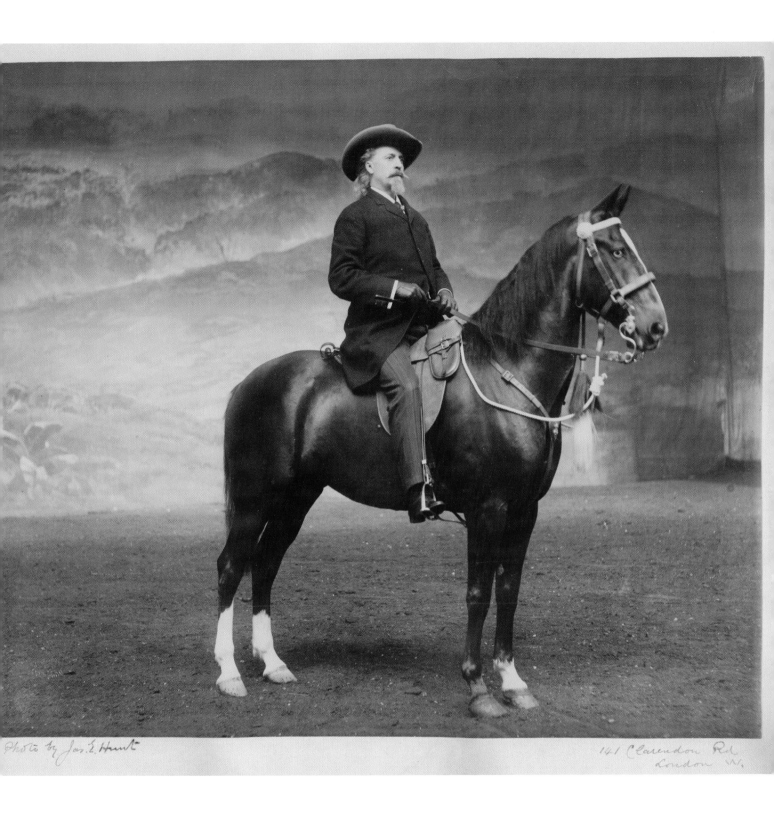

Photo by Jas. E. Hunt

141 Clarendon Rd.
London W.

1.13 Modern art works

dom sylvester houédard
'rock-sand-tide'
Print on paper, c.1972
685 × 920 mm
dom sylvester houédard Collection
Reproduced by kind permission of the Community of Prinknash Abbey

Polymathic, erudite, avant-garde, arcane, dom sylvester houédard (1924–92) became a Benedictine monk at Prinknash Abbey in Gloucestershire in 1949, after his National Service, and he was ordained as a priest in 1959. He was a profoundly serious theologian who engaged in the major religious debates of his time.

Today he is remembered as a translator of the Jerusalem Bible (1961), a pioneer of cross-faith working known as 'wider ecumenism', a prodigious contributor of definitions to the *Oxford English Dictionary* and one of the deftest exponents of Concrete or Visual Poetry.

His large poster-poem 'rock-sand-tide' shown here has been liberated from the confines of the codex. By constructing his poem using only nouns he emancipates his words from the shackles of sentences. Instead he gives them licence to form visual patterns which rely heavily on the involvement of the reader or viewer. This poem needs the reader, through the act of reading, to enter its landscape as an active agent. Scanning the surface of the paper on which the poem is printed, the reader's eyes bring alive the static, elemental seascape 'described' in the poem. This movement transforms the words into an image as the waves crash upon the shoreline.

Stella K. Halkyard

1.14 Email

Email from Sujata Bhatt to Michael Schmidt
20 July 1997
300 × 210 mm
Carcanet Press Archive
Reproduced by kind permission of Sujata Bhatt

One of the biggest challenges for today's archivists is managing 'born-digital' archive material – documents which were created digitally and have no 'analogue' equivalent. This shift to digital is perhaps most obvious in correspondence. Most people today correspond by email or text message rather than by handwritten or typed letter.

For many years, the Library has been acquiring authors' correspondence, manuscripts and proofs from the publishers Carcanet Press. From the late 1990s, Carcanet staff have corresponded with many of their authors by email.

This printed example dates from 1997, and represents the first email sent by the poet Sujata Bhatt to Michael Schmidt – Carcanet's Managing and Editorial Director. Rereading this email in 2012, Bhatt commented on how it reveals the importance of Schmidt as an editor, fellow writer, and friend for many of his authors. At the same time, she also expressed a desire to revise the message, which she felt had been written hurriedly.

This is characteristic of email: its informality encourages people to write more freely and openly, while its speed and immediacy mean that messages are often dashed off quickly, without the kind of thought and planning which would go into a letter. In fact, some linguists have identified in email a new 'contact language' in which the linguistic characteristics of speech and writing are brought together.

In recent years, the Carcanet Archive has been dwindling in size because the publishers' staff prefer to manage their correspondence digitally. To ensure that this digital archive is captured for future researchers, the Library recently made its first digital accession of Carcanet's email totalling 170,000 messages dating from 2001–12.

Preserving this vast body of digital material over time so that it remains both authentic and accessible poses many challenges which the Library will be getting to grips with in the coming years.

Fran Baker

```
Pravin Bhatt, 22:02 20/07/97 -0, No Subject

X-ApparentlyTo: pnr@carcanet.u-net.com
Date:    20 Jul 1997 22:02:37 -0400
From:    "Pravin Bhatt" <pravin.bhatt@yale.edu>
To:      "Michael Schmidt" <pnr@carcanet.u-net.com>
Return-Path: <pravin.bhatt@yale.edu>

                         Subject:
Time:  9:37 PM
  OFFICE MEMO
Date:  07/20/97

Dear Michael,

Hi!  This is my first e-mail letter to you!  My father's
computer is at home so
feel free to reply!  I hope you've sent me the interview with
corrections so I
can start working on it... Although now I'm beginning to
wonder whether I should
change the interview into a memoir style essay...  What do you
think?  In any
case, I'm determined to improve it.

Please make sure that the PNR proofs for "The Hole in the
Wind" reach me in
Connecticut.

Also, could you please send me Shirley Chew's postal and
e-mail addresses as
soon as possible!  (Thanks)

Otherwise, all is well over here.  The weather is perfect--
family and friends
seem well-- and my ideas are boiling over so I need to retreat
and WRITE.  Keep
your fingers crossed for me!

There's a lot more I want to say but I'll do so later!
Be well and warm hellos to everyone in the office--
    love, Sujata

Printed for G Tomlinson <pnr@carcanet.u-net.com>              1
```

1.15 Digital photography

Born-digital positive image made from a glass plate negative, 2011
63.3 MB
Heritage Image Collection

Glass plate negatives (also known as gelatin dry plates) were a method of photography that directly preceded celluloid photographic film. A light-sensitive emulsion was layered on to one side of a glass plate; it was then exposed and processed to produce a negative.

Over time glass plates can deteriorate and suffer risk of damage. As the glass ages it absorbs moisture from the air which can lead to alkali salts appearing on the surface; this is known as weeping. The emulsion is sensitive to light and can also begin to flake and peel away from the glass. The Library holds large collections of photography in the form of glass plate negatives, including some taken by the Langford Brooke family, who lived at Mere Old Hall, near Knutsford in Cheshire, one of which is shown here. As some of the negatives in this collection had deteriorated over the years a process of cleaning, rehousing and digitising the collection was undertaken.

The photographers at the Library's Centre for Heritage Imaging and Collection Care devised a safe methodology to photograph the collection and reduce the risk of any further damage during digitisation.

Once the negatives had been photographed they were processed to produce born-digital positives of the images, as shown here, and these now form part of our Heritage Image Collection. Much information on the provenance of the collection has been gathered using evidence from the born-digital images and this process has allowed researchers to analyse the collection in new ways for the first time.

Gwen Riley Jones

2

Through painted windows: The art of illumination

THE JOHN RYLANDS LIBRARY houses one of the world's great collections of illuminated Western manuscripts. Spanning the continent, from Visigothic Spain to the monasteries strung like pearls along the great rivers of northern Europe, and down through Italy to Naples and beyond, they include the finest examples of art and calligraphy from all the major centres of manuscript production. Created for abbeys and cathedrals, emperors and aristocrats, merchants and financiers, they display in microcosm the changing belief systems, political structures, economies and cultures of Europe across almost one thousand years.

The majority of our illuminated manuscripts derive from the Bibliotheca Lindesiana, that remarkable private library assembled by the 25th and 26th Earls of Crawford and purchased by Enriqueta Rylands in 1901. The 25th Earl, known for most of his life as Lord Lindsay, claimed not to be a collector of manuscripts *per se*. He resisted the dazzling allure of Books of Hours, those prayer books 'shining from shook foil' that survive in large numbers from the fifteenth and early sixteenth centuries. Thus our finest Hours (2.8) is not a former Crawford manuscript, but was purchased by Enriqueta Rylands herself in the 1890s and came to the Library only after her death. Books of Hours were traditionally associated with women, and this volume contains one of the earliest perspective views of Paris, where Enriqueta lived for some years, so it may have held special appeal for her.

Despite his self-denial, Lindsay was able to justify to himself a number of outstanding acquisitions. Although he never realised his ambition to acquire a 'good Anglo-Saxon MS' – nothing of suitable quality came on to the market – he did succeed in obtaining a number of early continental manuscripts from north of the Alps, such as the early ninth-century Lorsch Gospels with its dramatic portrait of St Mark (Latin MS 9), which he bought at the Libri sale of 1859. Ludovic, 26th Earl of Crawford, shared his father's fondness for early manuscripts, and he had no qualms about indulging his passion. He rapidly expanded the collection in a series of extravagant purchases from the mid-1880s onwards; the majority of the items illustrated in this chapter were acquired during that period, as well as the dazzling *Bible Historiée*, or Bible Picture Book, which features in Chapter 7 (7.5). He purchased the magnificent ninth-century

Trier Psalter from the Bollandist Library in Brussels in 1900, less than a year before he decided to sell the collection (2.1). This is the closest we come to an Insular manuscript in Manchester. It combines a number of Irish, Anglo-Saxon and Continental European elements in its script and decoration, and it exemplifies the free flow of cultural influences across Europe during the centuries once dismissed as the 'Dark Ages'.

The Bateman sale of 1893 furnished Ludovic with the remarkable, unfinished Gospel Book from Walbeck Abbey, with its polychrome line-drawing portraits of the Evangelists and other decoration in an early Romanesque style (2.2). One of Ludovic's most spectacular purchases was a monumental copy of Beatus of Liébana's Commentary on the Apocalypse (2.3). Its bold coloration and dramatic representations of the Last Days are unlike any other Rylands manuscript, and contrast with the subtler, almost delicate treatment of the subject in a fourteenth-century French Apocalypse (Latin MS 19).

The glorious Missal of Henry of Chichester, made at Salisbury around 1250 (2.4), and the late thirteenth-century French Psalter and Hours (2.5), epitomise the Gothic style; they are richly coloured with lapis lazuli and other expensive pigments, heavily gilded and decorated with architectural and heraldic motifs. The Psalter and Hours is a pocket Gothic cathedral, its borders alive with jousting knights, courtly ladies, tumblers and grotesques. However, Lindsay did not confine himself to Christian texts: one of his most important purchases was the fourteenth-century Haggadah from Spain, a wonderful amalgam of Christian and Jewish iconography (2.6); while his Armenian manuscripts included a number of vibrantly decorated Gospel Books which similarly fuse Christian and 'Oriental' styles (7.8).

Lindsay had a particular interest in the art and literature of medieval and Renaissance Italy, and he acquired a small selection of manuscripts which exemplify the gradual evolution of manuscripts during the fifteenth century, under humanist influences. Decoration was modelled upon antique motifs, imagery became more naturalistic, and the visual elements were separated from the text and disciplined within framing devices. This transition can be seen in the contrast between a three-volume manuscript of Nicolas de Lyra's Bible Commentary, written at the Franciscan convent at Pesaro in 1402 (Latin MSS 29–31), and the sixteenth-century Missal commissioned by Cardinal Colonna for the Sistine Chapel, a truly remarkable piece of High Renaissance art (2.10).

Of course, the art of illumination did not die out when the first Bible came off Gutenberg's press in 1455. Decorated manuscripts continued to be produced for decades, in parallel with the burgeoning printing industry, as the sumptuous Prolianus manuscript of 1478 (2.9) and the Colonna Missal testify. Early printed books also mimicked the manuscript tradition: deluxe copies were decorated by the same illuminators who embellished manuscripts, and printers left spaces where they intended painted initials and other decorative elements to be added by hand.

The Spencer Collection comprises almost entirely printed material – the manuscript breviary illuminated by Pierre Remiet (2.7) is one of the few exceptions – and includes many richly ornamented books, such as vellum copies of Nicolas Jenson's Bible (1476) and the Aldine editions of Virgil and Petrarch (1501). One of the most magnificent illuminated books in the collection is the *Faits et Dits mémorables* of Valerius Maximus, probably printed and illuminated around 1475–77 (2.11). Over time the economics of mass production and the technical constraints of the printing process limited the scope for such embellishments, while changing tastes and the Protestant Reformation rendered colourful illumination unfashionable. Decoration became confined to title pages, while illustrations (woodcuts or engravings in the main) were demarcated from the text. Nevertheless, illuminated manuscripts remained important in certain specialised contexts, such as gargantuan Catholic choir-books, diplomatic documents and ceremonial addresses.

John R. Hodgson

2.1 The Trier Psalter

The Psalter of St Maximin, Trier
Trier, Rhineland-Palatinate, 9th century
Vellum, 420 × 325 mm, ff. 113
Latin MS 116, f. 16r, Beatus initial

This Psalter, made at the Abbey of St Maximin in Trier (in the Rhineland-Palatinate), during the ninth to tenth centuries, embodies a dynamic fusion of influences from the Carolingian Empire, of which it formed part, and from Insular monks who had helped to revive Christianity in the seventh to eighth centuries. The monastery had been founded by Bishop Maximin (d.346), and Trier – formerly an imperial Roman residence – is the oldest bishopric north of the Alps, attracting pilgrims as the birthplace of St Ambrose and for its relics of St Matthias. During the sixth century the abbey became one of the oldest Benedictine monasteries until it was destroyed by the Vikings of Normandy in 886, subsequently being rebuilt in 942–52.

The manuscript comprises 113 leaves and incorporates a Calendar (list of liturgical feast days) and Psalter (ninth century), a Necrology (roll of the dead) and list of monks (tenth/eleventh century), prayers (tenth century) and a hymnal (from folio 94v), although its only musical notation was added in the eleventh/twelfth century (f. 104v, 'Gregorius presul' on Gothic staves). Bischoff dated the Psalter itself to the early ninth century, before Charlemagne's death in 814. Its script is a fine example of the Caroline minuscule promoted by the emperor and his circle, combined with uncial rubrics and decoration of markedly Insular character. This combines animal ornament of Merovingian and Insular pedigree (ferocious leonine creatures and wide-eyed birds) with pre-Caroline Frankish ribbon-lettering, Insular display capitals with coloured infills (as on f. 16r), Insular interlace and Carolingian Classicising acanthus. The 'three fifties' (Psalms 1, 50 and 100) and the preface are marked by major initials and display script, in Insular fashion, and other liturgically significant psalms by minor initials. The style and palette (which omits gold) are full of verve if a little provincial, in comparison with centres such as Aachen and Tours. The cultural mix of ingredients recalls that of Echternach, an Insular foundation which similarly blended Irish, Anglo-Saxon and Continental influences to produce distinctive works such as the eighth-century Trier Gospels (Trier, Domschatz MS 61).

The Psalter evidently continued in use, with material being added into the twelfth century, assisting in the commemoration of members of the community. A fourteenth-century hand has added some naive doodles in the margins (as on the folio shown). The manuscript was subsequently owned by the Bibliotheca Bollandiana in Brussels and the Bibliotheca Lindesiana. It is contained within an eighteenth/nineteenth-century binding of calfskin, blind-tooled and ruled in gilt.

Michelle P. Brown

2.2 An unusual drawing of the Evangelist Mark

Gospel Book from Walbeck Priory
Manuscript: Paderborn (?), *c*.1000; Illumination: Lower Saxony/Westphalia, third quarter of 11th century (?)
Vellum, 228 × 155 mm, ff. 161
Latin MS 88, f. 59v, St Mark

When Enriqueta Rylands acquired the Crawford Collection in 1901, this Gospel Book numbered among the manuscripts. It had previously belonged to the foundation of canons at Walbeck Priory in Saxony-Anhalt, dissolved in 1810; and it had already passed through many hands, including those of the notorious thief Count Guglielmo Libri.

The codex contains the texts of the four Gospels along with the four general and four specific prefaces. Chapter lists also precede Matthew and Mark; the end of John's Gospel is lost.

This moderately sized Gospel Book must have been highly prized at Walbeck, a foundation established in 941, whose Ottonian church is still visible – in ruins – on a ridge above the River Aller. In the medieval period, canons and dignitaries swore their vows upon the book, as attested by inscriptions of oath formulae within the manuscript.

The Evangelist portraits as well as the initials seem to have been added to the manuscript in a second campaign, although space was left for them in the original design. It is remarkable that the illumination was not completed, even though two artists were apparently involved: no portrait appears before Luke and no framed initial page before Mark, Luke or John. The images are very unusual for the eleventh century. Their execution as polychrome line drawings is almost unique in contemporary German illumination; astounding are the drawings' harmonious proportions, their sense of vivacious presence in the figures, and their pronounced plasticity (albeit with forms reduced to an essential geometry). The incomplete frame of Mark's portrait contains a highly articulated vine scroll populated with lively creatures both naturalistic and fantastic. The use of a single type for all three Evangelist portraits stands in stark contrast to this originality. The two draughtsmen cannot be assigned to a known scriptorium, but they appear to have participated in the decoration of several manuscripts. Most were intended for female monastic foundations in the Ottonian heartland, such as Hilwartshausen (Mainz, Wissenschaftliche Stadtbibliothek, Hs II 6) and Essen (Theophanu Gospels, Münsterschatz, Hs. 3).

Christoph Winterer

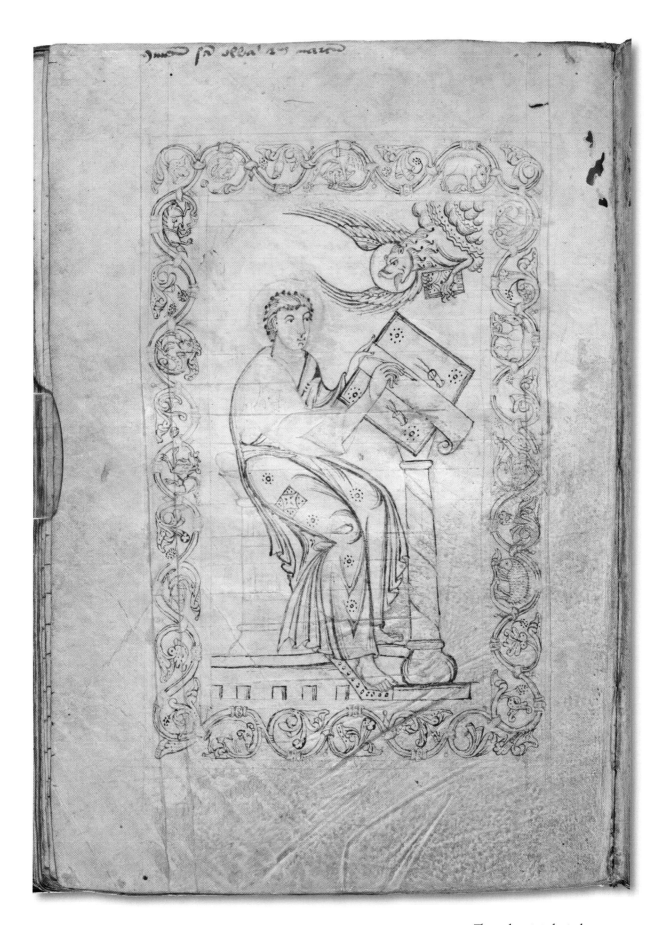

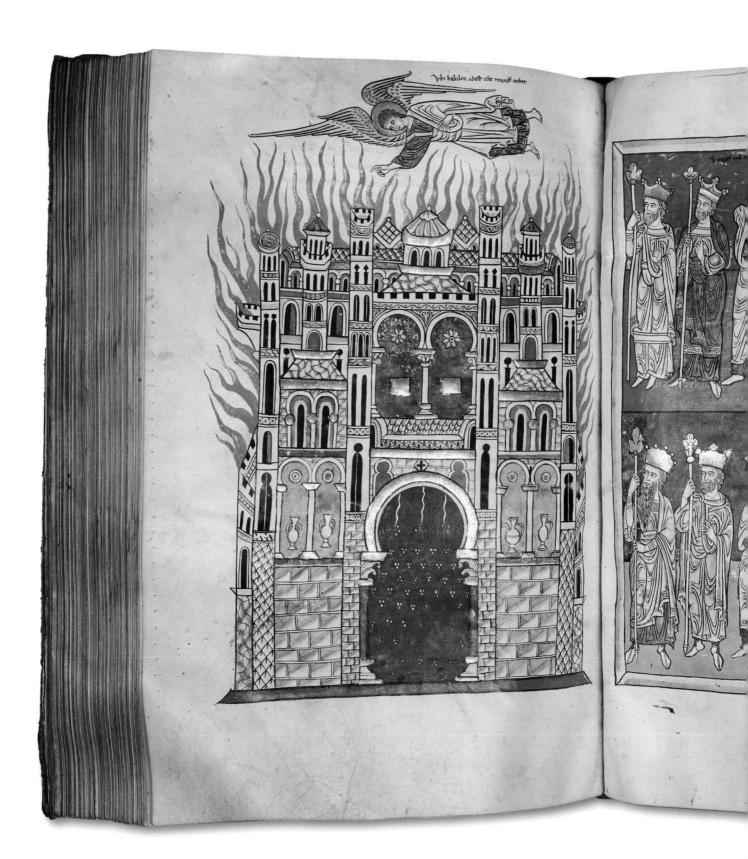

2.3 The faithful witness of an old tradition: The Rylands Beatus

Beatus of Liébana, *Commentary on the Apocalypse*; Jerome, *Commentary on Daniel*
Castile, region of Burgos, *c.*1180–90
Vellum, 454 × 326 mm, ff. 248 + iv
Latin MS 8, ff. 181v–182r. Burning of the City of Babylon

The illustrated Commentary on the Apocalypse, written 776–84 in Asturia by the Spanish monk Beatus of Liébana, was extremely popular on the Iberian Peninsula, though three of the nearly forty extant copies originated outside Spain. Originally, the Beatus Commentary was intended for the private reading of monks. The simple, schematic images of the primitive Beatus tradition, generally concerning only the Biblical text, were probably intended as a visual aid to help memorise the text; they thus formed part of the monastic-spiritual practice of the *lectio divina*, which consisted of reading and memorising, meditation and contemplation. This original function of the Beatus Commentary changed when around 940 a posthumous edition was created, with a marked expansion of both text and illustration; for example, an illustrated version of Jerome's Commentary on Daniel was added. Apparently the Beatus manuscripts were now primarily used for the readings in the monastic liturgy, in particular during the hours of Matins. Therefore, they obtained the imposing size and sumptuous illumination of liturgical manuscripts, including images of the Evangelists and of the *Majestas Domini*, normally found in Gospel Books. The posthumous edition was illustrated in the so-called 'Mozarabic' style, a combination of stylised late Carolingian art and Islamic elements.

The Rylands Beatus is a late Romanesque copy of this posthumous edition; hence, it also contains the illustrated commentary by Jerome. Both in style and iconography it is closely related to the Beatus codex from the Abbey of San Pedro de Cardeña, in the vicinity of Burgos (Madrid, Museo Arqueológico Nacional, Ms. 2), though it probably originated in another Castilian scriptorium. Despite its late date, the Rylands Beatus is an important and virtually intact witness of the older tradition, being mostly an authentic copy of the tenth-century edition. This especially applies to the contributions of the better of the two artists, who did most of the illustrations, like the double-page spread of the 'Burning of the city of Babylon'.

Until 1870 the Rylands Beatus codex was part of the Madrid collection of the Marquis of Astorga, Count of Altamira. It was purchased by the bookseller Bernard Quaritch at the Firmin-Didot sale in 1879, and some years later he sold it to the 26th Earl of Crawford.

Peter K. Klein

2.4 The Missal of Henry of Chichester

Missal of the Use of Sarum
Salisbury, *c.*1250
Vellum, 305 × 200 mm, ff. 256 + iii
Latin MS 24, f. 150v, Betrayal of Christ

This is the earliest extant Missal of the Use of Salisbury (Sarum), which was the liturgical use adopted by most dioceses of England from the late thirteenth century until the end of the Middle Ages. Its owner, Henry of Chichester, named on folio i and depicted in a miniature kneeling before the Virgin and Child, was the precentor of the collegiate church of Crediton, Devon, until 1264, and the book seems to have been made for him *c.*1250 in Salisbury. He was also a canon of Exeter Cathedral, to which the Missal was given in 1277. Salisbury is the likely place of production because the book is illuminated by the same artists as decorated a Bible (London, British Library, Royal MS 1 B.XII), dated 1254, made for Thomas de la Wyle, Master of the Schools at Salisbury, and two Psalters made for the nearby nunneries of Amesbury (Oxford, All Souls College, MS 6) and Wilton (London, Royal College of Physicians, MS 409). The main artist of this group of illuminators has been named the 'Sarum Master', one of the leading illuminators of mid-thirteenth-century England.

The book is exceptional among English medieval Missals in having eight full-page miniatures of the Life of Christ preceding the Canon prayer (Eucharistic prayer), others having only a single picture of the Crucifixion facing this prayer. This feature led to the identification of the Missal in the book inventories of Exeter Cathedral where it is described '*cum multibus imaginibus subtilibus de auro in Canone*' (with many finely worked images of gold in the Canon). These full-page miniatures are by the 'Sarum Master', whose style is characterised by tall, elongated figures and dramatic presentation of narrative through figure pose and facial expression. These features are well shown in the scene of the Betrayal of Christ by Judas. The central figure of Christ is surrounded by the violent men who have come to arrest him, their faces darkly coloured and with strong expressions, contrasting with the pale, calm face of Christ. A speech scroll held by Christ rebukes Peter who, in the bottom-left corner, responds with the violent act of cutting off the ear of the servant of the high priest, Malchus: 'Put your sword into the scabbard' (John 18: 10–11).

Nigel Morgan

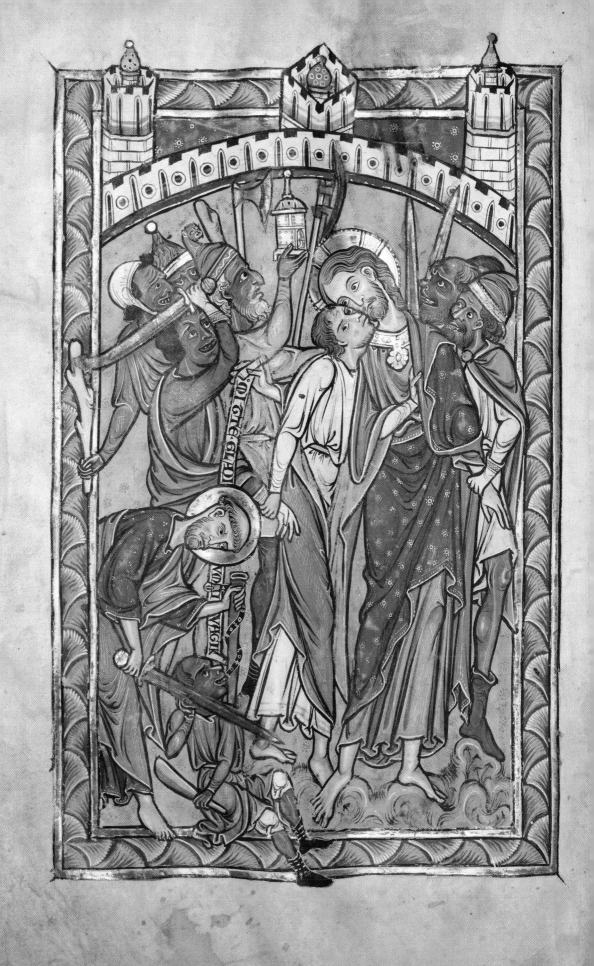

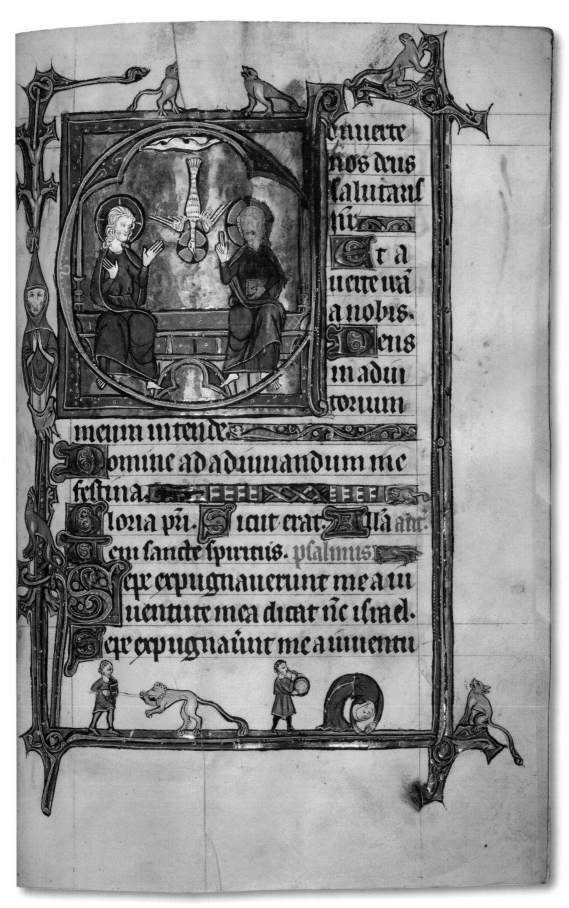

2.5 French Psalter and Hours

Psalter and Hours
North-eastern France, late 1280s or 1290s
Vellum, 192 × 142 mm, ff. iii + 254 + iv
Latin MS 117, f. 236r, opening of Compline

On a background of burnished gold leaf, Father, Son and Holy Spirit confer in heaven. The Trinity inhabits an initial that begins the service of Compline (evening prayer), the last of a series of devotions dedicated to the Holy Spirit in this richly illuminated prayer book that also contains the Psalter and the Hours of the Virgin. In keeping with trends in north-eastern French book illumination of the late thirteenth and early fourteenth centuries, a collection of entertainers, lions, and other marvellous creatures cavort in the margins. In the lower margin, a man carrying a shield attempts to subdue a lion with a spear while another, a musician, provides musical accompaniment to a woman's acrobatic dance. Such motifs evoke idylls of courtly entertainment, frivolities and distractions from the more pious performance of prayer; they provide an engaging test of the reader's devotional concentration.

Most remarkable is the prayer book's wealth of heraldic decoration, exemplified on this folio by the third line beneath the large initial. The heraldry agrees with actual armorials of north-eastern French and Flemish nobility. Prevalent throughout the manuscript are the arms of the powerful barons of Coucy and the Counts of Flanders; judging from the repeated occurrences of these arms, the manuscript probably belonged to Jeanne of Flanders (d.1333), daughter of the famous Count Robert III (d.1322). In 1288 Jeanne was married to the notorious Enguerrand IV of Coucy (d.1311); the prayer book likely acknowledges this union and accordingly may be dated to the late 1280s or 1290s. Many of the manuscript's arms also appear in the fictional tournament described in the *Roman du chatelain de Coucy et de la dame de Fayel*, a late thirteenth-century romance that purports to be the biography of a factual, twelfth-century *trouvère* (poet-composer), the Châtelain of Coucy. The prayer book's illumination thus attests to the inseparability of the sacred and secular in late thirteenth-century French devotional culture.

Richard A. Leson

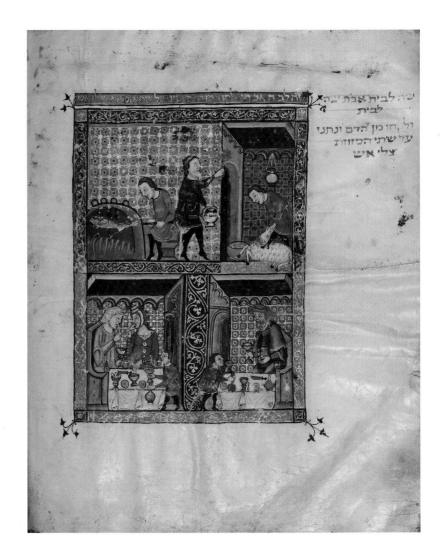

2.6 a & b The Rylands Haggadah

Passover Haggadah of the Sefardi rite, *piyyutim* for
the Passover week and the Sabbath before Passover,
with marginal commentary
Spain, probably Catalonia, mid-14th century
Vellum, 280 × 230 mm, ff. 57
Hebrew MS 6, f. 19b, Passover; f. 29b,
Marginal decoration

The first Jewish work of art to attract wide scholarly attention was an illuminated fourteenth-century manuscript of the Passover liturgy, written and illuminated in Iberia and known as the Sarajevo Haggadah. It soon became apparent that this was one of a group of some fifteen books of which the Rylands Haggadah is an outstanding representative. Most of these manuscripts open with a complete pictorial cycle that not only visualises the historical significance and ritual aspects of the Passover holiday but offers a survey of Biblical history in general.

The Rylands cycle stretches from the beginning of the Book of Exodus, showing Moses at the burning bush, to the slaughtering and roasting of the Passover lamb (f. 19b). Rather than the expected image of the consumption of the sacrificial lamb, the Biblical series is followed by a depiction of a *seder* meal: an elderly man with a Haggadah in his left hand is raising a goblet, while a servant is pouring wine into another cup. A young couple is eating *maror*, the bitter herbs that commemorate the bondage of the children of

Israel in Egypt. The seamless transition from the Biblical slaughtering scene to the contemporaneous homely *seder* ceremony echoes the precept as it is expressed in the text of the Haggadah: 'In every generation a person is obligated to see himself as if he had gone out of Egypt.' Hence, the participants at the *seder* are required to imagine themselves re-enacting the Exodus, and the illustration cycle so to speak helps them to do so.

Folio 29b shows a rich marginal decoration with a hunting scene on the bottom. The hare represents the persecuted people of Israel and the figure of the hunter is an allegory of the gentile oppressor. The black and white dog alludes to the policy of the Dominicans, or *domini canes*, God's watchdogs, as they were occasionally called. This motif has several parallels in portrayals of the Dominican order in the Church of Santa Maria Novella in Florence (Andrea da Firenze, 1365), where white dogs with black spots hunt wolves, usually understood as an allegory for heresy.

Katrin Kogman-Appel

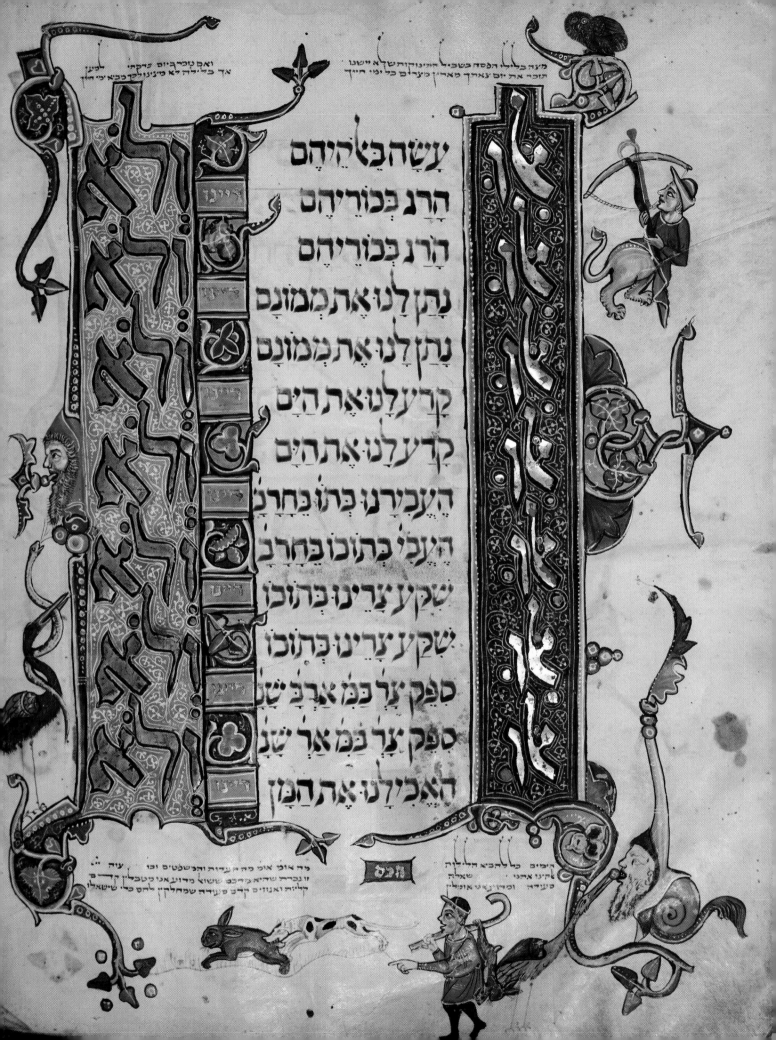

עֲשָׂה בָהֶם שְׁפָטִים

הָרַג בְּכוֹרֵיהֶם

הָרַג בְּכוֹרֵיהֶם

נָתַן לָנוּ אֶת מָמוֹנָם

נָתַן לָנוּ אֶת מָמוֹנָם

קָרַע לָנוּ אֶת הַיָּם

קָרַע לָנוּ אֶת הַיָּם

הֶעֱבִירָנוּ בְּתוֹכוֹ בֶּחָרָבָה

הֶעֱבִי׳ בְּתוֹכוֹ בֶּחָרָב

שִׁקַע צָרֵינוּ בְּתוֹכוֹ

שִׁקַע צָרֵינוּ בְּתוֹכוֹ

סִפֵּק צָרְכֵּנוּ בְּמִ׳ אַרְבָּ׳ שָׁנָ׳

סִפֵּק צָרְכֵּנוּ בְּמִ׳ אַר׳ שָׁנָ׳

הֶאֱכִילָנוּ אֶת הַמָּן

2.7 Breviary illuminated by Pierre Remiet

Breviary, Use of Paris, Notre Dame
Paris, late 14th/early 15th century
Vellum, 185 × 133 mm, ff. ii + 45
Latin MS 136, f. 250v, Invention of the body of St Stephen, detail

The vast majority of medieval scribes and illuminators are shadowy, nameless figures, known to us only by their famous books or by characteristics of their work, such as the Master of the Boucicault Psalter or the Master of the Gold Scrolls. Thanks to the late Michael Camille, however, we know a great deal about the life and work of Pierre Remiet, one of the most distinctive Parisian illuminators.

Remiet was probably born around 1348 and the last reference to him (if it is not to his son) dates from 1428. He lived at the junction of the Rue des Enlumineurs and Rue de la Parcheminerie in Saint Severin, in the heart of Paris; as the street names indicate, this was the centre of manuscript production, close to the University. Remiet's art epitomises the medieval preoccupation with death and decay: the Middle Ages were saturated with death, and many of Remiet's miniatures represent suffering, old age and mortality. This historiated initial is typical of Remiet's earthy style; it depicts the Invention (discovery) of the body of St Stephen in 415.

Remiet enjoyed the patronage of royal and aristocratic collectors. This breviary was commissioned by Louis, Duke of Orléans (1372–1407), brother of the French King Charles VI (variously called Charles the Beloved and Charles the Mad). Louis was also the nephew of Philippe le Hardi, Duke of Burgundy, and Jean, Duke of Berry, owner of the famous Très Riches Heures. Like his uncles, Louis was a great collector of manuscripts.

A breviary contained the prayers, psalms and lessons used in church services throughout the year. Our copy was too long to fit it into a single volume: it was compiled in two, which subsequently became separated. The John Rylands Library houses the summer portion, which runs from Easter to November and contains sixty-nine miniatures by Remiet. The corresponding section for winter, with a further fifty-eight miniatures, now resides in the Bibliothèque nationale in Paris (MS Latin 1024).

John R. Hodgson

2.8 Book of Hours by the Dunois Master

Horae, Use of Paris
Paris, second quarter of the 15th century
Vellum, 220 × 155 mm, ff. 267
Latin MS 164, f. 254r, St Geneviève and view of Paris

The Dunois Master is named after the Book of Hours he illuminated for Jean, comte de Dunois, in Paris in the 1440s (London, British Library, Yates Thompson MS 3). Previously known as the Chief Associate of the Bedford Master, he emerged from that older painter's workshop, which dominated book painting in the 1420s and early 1430s, and assumed the leading role in Parisian illumination from the mid-1430s to the 1460s. He may be a certain Jean Haincelin, if a *Guiron le Coutois* (Paris, Bibliothèque nationale de France, MSS fr. 356–7) and a dismembered *Lancelot del Lac* are indeed those paid for by Prigent de Coëtivy in 1444. Prigent's own Book of Hours (Dublin, Chester Beatty Library, MS W 82) was itself painted by the Dunois Master.

Whatever his identity, the Dunois Master is a gifted painter and an imaginative story teller. His style is a softer, more painterly version of that of the Bedford Master, and, again like his teacher, his miniatures show the artist's keen interest in iconographic richness and lively narrative. These features are certainly evident in the numerous miniatures in this Book of Hours. For example, in the suffrage illustration for St Geneviève, patron of Paris, the artist combines the playful traditional iconography – the saint's miraculous candle continually relit by an angel, to the frustration of the devil who likes to blow it out – with a marvellous cityscape of the French capital. Within the Île de la Cité one can recognise the façade of Ste-Chapelle, the truncated spires of Notre Dame, and some of the towers of the Concièrgerie.

Included among the texts at the beginning of the manuscript are the Lord's Prayer, Hail Mary, Apostles' Creed, Grace before Meals, and the Act of Confession. Hardly ever included in Books of Hours – because they were memorised in childhood – these prayers might indicate that the book played a role in teaching a young child his or her basic catechism.

Roger S. Wieck

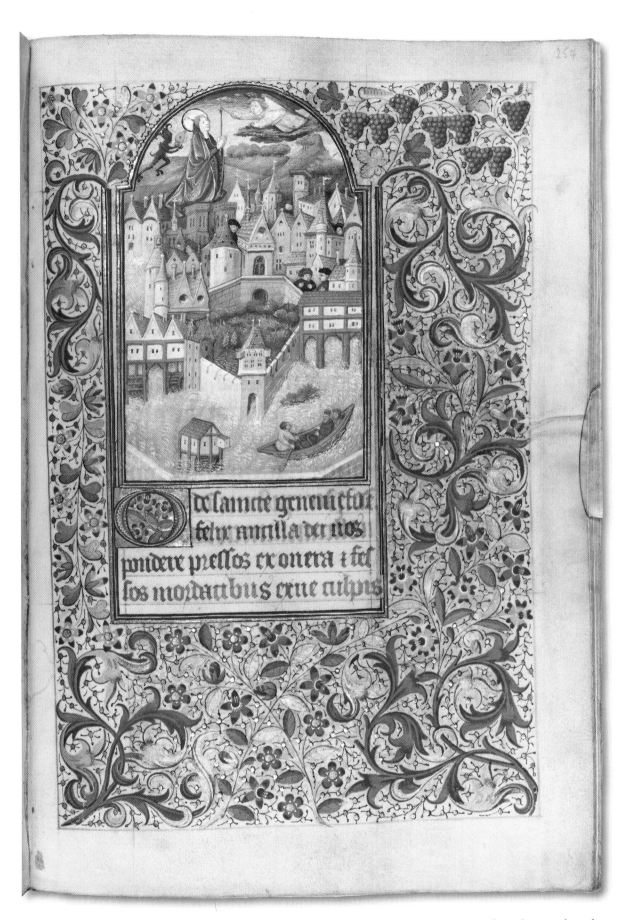

de sainte geneuicson
felix ancilla dei nos
pondere pressos ex onera t fet
sos mordacibus exue culpis

INCIPIT PRIMĀ PARS ET CAP
ITVLVM PRIMVM DE TOTIVS
ORBIS GENERALI DIVISIONE,
OST QVAM
naturalium rerū
omnes causæ aphi
losophantibus ue
re ac subtiliter i
quantum fieri ab
his potuit pēqui
sitæ fuerunt. Vni
uersum orbem ī
duas diuiserunt
partes: In ætheream scilicet & elemētale
et harum quamhbet multas partes prin
cipales habere uoluerunt. Nam elemen
talis cuius qualitates nos cæteraq; genera
bilia magis īmutant: in quatuor partes
maxime diuiditur. Quia tertam aquā
aerem & ignem: & inde cuilibet substā
tialem formam tribuerunt: per quam in
esse reponitur et formaliter differt. Is i
etiam orbis est terminata quantitas atq;
figura. Quia omnium rerum natura con

2.9 A fusion of art and science

Christianus Prolianus, *Astronomia*
Naples, 1478
Vellum, 212 × 140 mm, ff. 77
Latin MS 53, f. 4r, opening of chapter 1

This astrological treatise completed in Naples in 1478 is one of the most beautiful illuminated manuscripts in the Rylands collection. Little is known about the author, other than his position as an astronomer at the Neapolitan court of Ferdinand II of Aragon. This is the only known manuscript copy, but the Rylands collection also holds an early printed edition from 1477. The manuscript is dominated by *bianchi girari*, or 'white vine-stem border', a style typical of fifteenth-century Italian humanist manuscripts. Adorning the border is a selection of creatures, including the parakeets typically associated with Naples, and butterflies which represent Florence. The proximity of these devices is particularly significant, as the two Italian cities were at war for much of the 1470s, and the manuscript's one-time owner and patron, Cardinal Giovanni of Aragon, played a pivotal role in peace-talks between the two cities.

One of the most prominent and interesting illuminations in MS 53 is the coat of arms on the first page. M. R. James speculated that this may have belonged to Ferdinand II of Aragon. Ferdinand's arms, however, are a mirror image of those found in MS 53, which instead belong to Ferdinand's son, Cardinal Giovanni of Aragon. James was, perhaps, misled by the golden crown which tops the Aragonese heraldry. This would usually denote a royal patron and owner. In fact, the arms were probably originally topped by a cardinal's hat, but it is likely that this was painted over when Giovanni predeceased his father, and his library was merged with that of the Aragonese royal household.

My recent research has revealed the previously unknown whereabouts of the manuscript between the fifteenth and nineteenth centuries. The manuscript's path can be traced from its Neapolitan origin to England, through the libraries of the French Royal household, the Duchy of La Vallière and the 'Napoleon of booksellers', Bernard Quaritch, after whom the manuscript was owned by William Morris, an avid bibliophile, who had an obvious professional interest in the aesthetics of illumination. It was sold to Morris with a suggestion that it might be the work of the renowned German/Italian illuminator Gioacchino di Giovanni de Gigantibus. However, further stylistic investigation may question this attribution.

Andrew Phillips

2.10 A Renaissance masterpiece: The Colonna Missal

The Colonna Missal
Rome, early 16th century
Vellum, 370 × 260 mm, ff. 108
Latin MS 32, f. 21r, Mass of St Stephen

The Colonna Missal is a remarkable piece of High Renaissance art and one of the most important liturgical manuscripts of the sixteenth century, both artistically and in terms of its original ecclesiastical context. It was commissioned by Cardinal Pompeo di Girolamo Colonna (1479–1532) for use at some of the most important masses of the year in the Sistine Chapel in Rome, and some of its decoration is contemporary with Michelangelo's fresco of the Last Judgement over the High Altar.

Six volumes of the Missal were purchased by Lord Lindsay (later to become the 25th Earl of Crawford) from the London bookseller Thomas Boone in 1868; since Enriqueta Rylands's acquisition of the Crawford Collection of manuscripts in 1901 they have resided at the John Rylands Library. A seventh volume (actually the second in the series), which had become separated from the others at an unknown date, led a nomadic life in private ownership until July 2011, when the Library was able to acquire it at auction in London. Funding was generously provided by the Art Fund, the V&A Purchase Grant Fund, the Friends of the John Rylands, the B. H. Breslauer Foundation, and the Friends of the National Libraries.

The first volume (Latin MS 32) includes two spectacular illuminated pages, variously attributed to Giulio Clovio (1498–1578) or Vincenzo Raimondi (d.1556) and containing an extraordinary cornucopia of Classical and Egyptian motifs. In fact the Missal was unfinished at the time of Colonna's death, and the entire manuscript was finally completed in 1555. Several artists worked on it at various times, including Apollonio de' Bonfratelli (c.1500–75), who succeeded Raimondi as official miniaturist of the Sistine Chapel. The page illustrated here carries a remarkable *trompe-l'œil* device of a torn page.

The first and seventh volumes are in matching bindings of red morocco stamped with the Colonna family's device of a column. Anthony Hobson identified them as the work of Maestro Luigi, who was binding for the Sistine Chapel and the *capella segreta*, the pope's private chapel, between 1542 and at least 1565.

John R. Hodgson

In festo sancti stepha
m prothomartiris. Sta
tio ad sanctum stepha
nij i celio mote. Introi.

Etenim se
derut prin
cipes et
aduersus
me loque
bantur. z
iniqui p

secuti sunt me adiuua
me domine deus meus
quia seruus tuus exerce
batur in tuis iustificatio

2.11 Valerius Maximus, *Faits et dits mémorables*

Simon de Hesdin, French translation of Valerius Maximus, *Facta et dicta memorabilia*, 2 vols
Place of production and printer of text unknown, but probably illuminated in Ghent or Tournai, *c.*1475–77
Paper, 388 × 270 mm; vol. 1: ff. 262; vol. 2: ff. 250
Spencer 5676, f. 284r, frontispiece to Book VI, On Chastity, the story of Lucretia

The Roman author Valerius Maximus dedicated this work to the Emperor Tiberius (AD 14–37). It gathers together, in nine books, stories from Roman and Greek history illustrating moral and immoral acts of famous people, and was translated into French by Simon de Hesdin, in about 1375, at the request of King Charles V of France. In the late fourteenth and fifteenth centuries this book was much read by courtly society, usually in manuscripts with illuminated pictures in contemporary settings at the beginning of each section. Following the invention of printing, this French translation, *Faits et dits mémorables* (*Memorable Doings and Sayings*), was one of the earliest luxury illustrated books made with spaces left in the printed text to receive illuminated pictures and ornamental borders.

The Rylands copy of *Faits et dits mémorables* is the finest that has come down to us. The date, printer and place of production have yet to be precisely identified, but the illumination was almost certainly done in Ghent or Tournai in about 1475–77. Although there are many heraldic shields in the ornamental borders, these have never been identified and may be fictive and decorative. Book VI is entitled 'On Chastity' and is illustrated with the famous story of Lucretia whose chastity was defiled. She was the wife of Collatinus at the time Rome was ruled by Tarquin the Proud. Collatinus and Tarquin's son, Sextus, on the far left, wager to test the chastity of their wives and, on returning from a siege, find Lucretia innocently accompanied by her women companions. Sextus, however, rapes Lucretia, threatening her in bed with his sword. On the far right Lucretia sends a letter by a messenger to summon her family, and at the top right on their arrival she kills herself with a dagger to expiate the shame of her rape.

Nigel Morgan

loqueti
e ad po-
qā ipſi
etuiatis
ergo ait
o veſtri:
ũm deu
.Domi-
ientes e
ergo iō-
iuit pplo
m. Scri-
volumi-
pergran-

[P]oſt morte
iduerunt f
pñtes. Qu
ante nos c
neum · er er
uixitq; dñs. Iude
Ecce tradidi terrã ĩ
Et ait iudas ſymeo
Aſcende mecũ in ſorte mea
cõtra chananeũ: ut et ego
in ſorte tua. Er abiſt cũ eo
cenditq; iudas · er tradidit
neum ac pherezeum in mã
et pcuſſerunt in bezech dec

3

First impressions:
The early years of European printing

> It is said that this method of making books was discovered ingeniously in 1440 in the city of Mainz on the Rhine. Now it is spread in nearly every part of the world, so that by virtue of it the history of all antiquity may be bought at a small price and read by posterity in an infinite number of volumes … Let thine inventor be extolled in every language, for now under thy guidance – by whom this wonderful art was invented, – anyone may become learned at little expense.

THIS WAS HOW Hartmann Schedel, a Nuremberg physician, described the invention of printing in his new history of the world, the *Liber Chronicarum*, or *Nuremberg Chronicle*, published by Anton Koberger in 1493. The fifteenth century witnessed a radical change in communications technology, every bit as transforming as the digital revolution we are living through today. The invention of movable metal type made possible the mass-production of books, which had previously been laboriously handwritten, and therefore scarce and expensive. The format and appearance of early printed books evolved only gradually. It took several decades for books to adopt the features we are used to, such as title pages, page numbers, tables of contents, etc. Printers based their typefaces on local scripts that were familiar to their readers and easy on the eye. Early books were also decorated in very similar ways to manuscripts.

After the establishment of printing in Mainz by Gutenberg and his successors in the 1450s the innovation spread rapidly and within twenty-five years had reached every country in Western Europe. A print workshop was set up in Bamberg (190 km from Mainz) in about 1460. At around the same time printing began in Strasbourg, followed by other commercial centres such as Cologne (1465) and Basel (1468). German printers journeyed south over the Alps to Subiaco in 1465, Rome in 1467 and Venice in 1469. In 1476 printing reached England, when William Caxton set up his workshop next to Westminster Abbey in London.

By the end of the fifteenth century the book trade had developed into a sophisticated international industry of long-distance commercial networks and specialised businesses of printing, publishing, bookselling and typefounding. Some more successful entrepreneurs encompassed

all aspects of the business while smaller ventures came and went – as with any new technology there was always risk. The number of editions produced in the fifteenth century is estimated at around 28,000, representing more than ten million copies (with an average print run of about four hundred copies per edition). Only a very small proportion of these copies have survived, most now preserved in libraries across the world.

The term often used for books printed in the fifteenth century is 'incunable' or the Latin form 'incunabulum/a'. This was first applied by Bernhard van Mallinckrodt in his book *De ortu et progressu artis typographicae dissertatio historica* (*Historical Dissertation on the Beginning and Progress of the Typographical Art*), published in 1640 to mark the two-hundredth anniversary of Gutenberg's invention. He described the era from Gutenberg until the end of the fifteenth century as 'prima typographiae incunabula' – the time when typography was in its swaddling-clothes. This soon came to be used for the products of this period rather than the era itself. The date of 1500, like so many used in dividing historical eras, is purely arbitrary but remains a useful point of reference.

The John Rylands Library is home to around four thousand incunables. They form one of the largest and most significant collections of early printed books in the world. The majority were part of the collection of George John, 2nd Earl Spencer, purchased by Mrs Rylands in 1892, along with an important collection of books printed by the renowned Venetian printer Aldus Manutius. Spencer's Incunable and Aldine collections were for many years kept separately at Spencer House in London. When they came to the Rylands they (largely) remained as discrete collections – in the Early Printed Books Room off the gallery in the Reading Room, and in the Aldine Room in one of the front towers. The Library has recently undertaken a project to reorganise both collections, adding copies that were previously dispersed elsewhere in other collections. They are now kept in a modern store with strict environmental controls.

There is also a smaller but internationally significant collection of blockbooks, books printed entirely by relief woodblock. These were previously considered to be precursors to printing with movable type, but it is now agreed that the technology developed at about the same time as Gutenberg's invention and continued well into the sixteenth century. The technique was more suited to popular texts dominated by images such as the Apocalypse, *Biblia Pauperum* ('Paupers' Bible') and *Ars Moriendi* ('The Art of Dying'). They were probably printed in much smaller numbers and only about six hundred examples are known to survive today. Partly because of their rarity, but also because of the crude nature of the images, these blockbooks have been relatively little studied over the years.

As well as the Spencer Collection, incunables have come to the Library from other sources. Professor Richard Copley Christie bequeathed his collection to The University of Manchester in 1901. It included an unrivalled set of virtually all the Greek texts published in the fifteenth and sixteenth centuries. Others have appeared from more unlikely sources such as the collection of the Northern Congregational College. Even now the Library seeks to develop its early printed collections by gift and selective purchase. Recent acquisitions include a unique copy of a single-sheet calendar printed in Venice in 1489 and one of only two copies of a 1495 Rouen edition of the *Manipulus Curatorum*, a manual for priests printed in over one hundred editions in the fifteenth century but with only a small number of copies surviving.

Julianne Simpson

3.1 The Buxheim Saint Christopher

Woodcut of Saint Christopher
Southern Germany, *c*.1450
298 × 208 mm
Spencer 17249

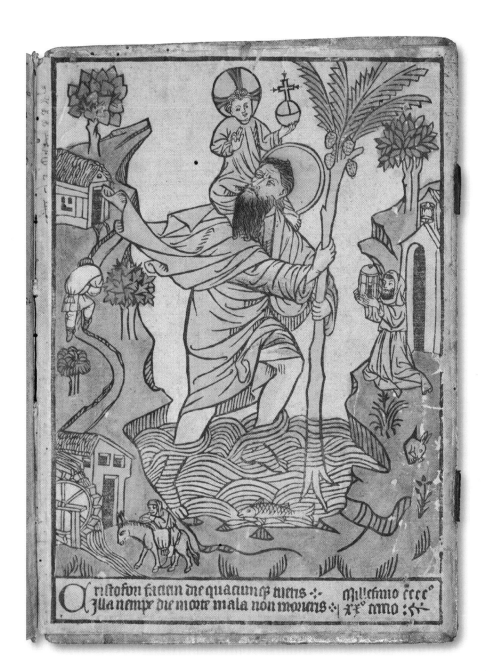

Uncovered by Karl-Heinrich von Heinecken in 1769 in the library of the Carthusian monastery of Buxheim, the St Christopher is one of a handful of early woodcuts to bear a date, 'Millesimo cccc° xx° tertio' (1423). As early as 1837 the validity of this date was under scrutiny and, although scholars are now broadly in agreement that the woodcut must date from *c*.1450, proof remains elusive. Whatever its true date, the St Christopher, and its companion woodcut, the Annunciation, are amongst the most important, best executed and most powerful impressions to survive from the fifteenth century. The overwhelming presence of St Christopher, his expressive and differentiated facial features, and the dynamic, flowing folds of his clothing still have power and resonance. The Annunciation is no less moving, a masterpiece of dynamic drapery and expressive facial features. Both woodcuts originate from the same workshop, and

both originally fulfilled a talismanic role. The translation of the text, 'Whenever you look at the face of Christopher, in truth you will not die a terrible death that day', indicates the protective power ascribed to the saint, a power transferred to the owner of the woodcut by focusing their devotion on Christopher's face. The woodcuts survive pasted to the boards of a manuscript of the *Laus Mariae*, a series of Marian texts to be read throughout the day, completed in 1417, and gifted to Buxheim by a noblewoman, Anna von Gundelfingen. The woodcuts were added later; the St Christopher is pasted over earlier annotations, and is accompanied by a series of notes in a later hand, detailing pseudo-religious formulae to protect against illness, possession and death. These woodcuts easily rank as my favourite items in a collection spectacularly rich in early printed treasures.

Edward Potten

3.2 a, b & c Johann Gutenberg

Biblia Latina
Mainz: Johann Gutenberg and Johann Fust, *c.*1455
400 × 290 mm
Spencer 3069, vol. 1, opening of Judges

Indulgentia (For contributions to the war against the Turks)
Mainz: Johann Gutenberg, 1454–55
205 × 285 mm
Spencer 17250.1

The Gutenberg Bible is the first book printed in movable type, and is a venerated symbol of an invention which is generally recognised as a major step in the development of Western civilisation. The Rylands copy looks as fresh as when it was completed in Mainz in 1455. After some ten years of experimentation, the sharp and regular impression of the type shows that the inventor, Johann Gutenberg, had succeeded in creating a printing type of astonishing perfection. It could be manipulated to produce the regularly spaced columns we see here. It was also fit for purpose, for being read aloud at mealtimes in the refectories of monasteries – 'without one's spectacles', as one early enthusiast commented.

The great technical achievement we see in the Bible was enhanced with the manual finish of the books. Specialised artists painted large initials in many of the copies after they had left the press, reflecting the taste of the first buyers. Thanks to new imaging technology the early owner of the Bible has now been identified as the Augustinian convent in Colmar, easily reached from Mainz along the River Rhine.

The Church was quick to recognise that the medium of print could have many other uses, one of which was to meet the urgent need for hundreds of copies of indulgences. An indulgence is a declaration issued by ecclesiastical authority absolving those who contribute to a stated cause from

paying for their sins in purgatory. Their sale was strictly regulated, and the priests who travelled round and collected the money (known as indulgence pedlars) signed the small sheet which stated the name of the buyer, and place and date of purchase. When the Church announced an indulgence to raise funds for a war against the Turks, following the fall of Constantinople in 1453, the authorities in Mainz found it was economical to have the document copied by printing instead of employing scribes. Spaces were left open for the name of the buyer and the date and place of purchase to be written in by the pedlar. The earliest date in printed indulgences is 1454 – even before the printing of the first Bible was completed.

The John Rylands Library has two of those early indulgences, printed on durable parchment. The main text in both resembles the handwriting of professional scribes for official documents. The indulgence shown here shows the simple shape and very clear impression of this very early type. The few words in large letters are set in the same type as the Gutenberg Bible. The eight surviving copies of this indulgence were all sold in the neighbouring archdiocese of

Cologne. Although they all have the printed date 1454, the earliest sale on record is early in 1455, in the John Rylands copy. It was issued to 'Greorgius de arnsbergh et frederica eius vxor Prima Coloniensis diocesis' (Greorgius of Arnsbergh and his wife Frederica), with the placename and date: 'Colonie' and 'xxvij' [mensis] 'februarij'. The letter 'j' was added in manuscript to the printed date Mccccliiii, thus to be read '1455'.

Lotte Hellinga

3.3 Blockbook Apocalypse

Apocalypsis Sancti Johannis
Southern Netherlands, *c.*1452
290 × 255 mm
Spencer 3103, opening illustrating Revelation 14: 6–13

The Rylands Blockbook Apocalypse, datable on the basis of its paper to just after the middle of the fifteenth century, actually has a strong claim to be the only surviving copy of the earliest European printed book. The status of this claim depends on just what we mean by a 'book'. It was printed not with movable type in a printing press like the Gutenberg Bible, which was first offered for sale in 1455, but from incised woodblocks. Texts and images were engraved on the blocks in reverse, using essentially the same technique as that employed for single-leaf woodcuts, a form of printing of which the Library, with its St Christopher bearing the date 1423 (but printed *c.*1450?), possesses a major historical landmark. But the Apocalypse is not an album of individual plates, but rather a book of 48 leaves which, being printed on only one side of the paper, was bulky enough to be bound as a single item and not simply incorporated into a collection.

This first edition was printed somewhere in the Low Countries; however, the ninety-two illustrations of the Book of Revelation with their texts are derived from a manuscript tradition that originated in thirteenth-century England. The model used by the creator of the blockbook belonged to a continental offshoot of this English tradition, of which the Library also possesses an important example in Latin MS 19. Where the Rylands copy is coloured, like drawings in a manuscript, there are later copies, printed from the same blocks, that have survived without colouring – pointing in the direction of the later practice of monochrome printing, which has dominated book production to the present day.

Nigel F. Palmer

3.4 Nicolas Jenson

Pliny, *Historia naturalis* (Italian)
Venice: Nicolas Jenson, 1476
410 × 280 mm
Spencer 3380, f. 22r, opening of Book Two

Nicolas Jenson had been employed by the Royal Mint in Paris when in early October 1458 he was sent to Mainz at the request of the French king Charles VII to find out what truth there was in the rumours that had reached Paris about printing books with metal types. In Mainz he learnt the art of printing and may have worked with Johann Fust and Peter Schöffer. However he chose not to return to France, rather heading to Venice – a commercial powerhouse and trading link between East and West. Venice soon became a leading centre for the book trade, producing around fifteen per cent of the total books published in the fifteenth century.

Jenson became famous as the designer of elegant Roman typefaces acknowledged to be among the most influential of all type designs, later serving as the model for a typeface of William Morris for his Kelmscott Press. His edition of the Italian translation of Pliny's *Natural History*, printed in 1476, is one of the landmarks of Renaissance printing, displaying in all its splendour Jenson's Roman type. The text itself is a remarkable encyclopaedia of the ancient world which became a source for medieval learning, but the real importance of this book lies in its design and presswork, all of the highest quality. This is a unique copy with a striking illuminated border on the first page of text and fine illuminated initials, evoking those of contemporary manuscripts. Neatly inscribed in the lower margin of the Rylands first text folio is the abbreviation 'Re (?) Fe:'. The abbreviated words may be Re Ferrante which would indicate that the volume was in the library of Ferrante d'Aragona, king of Naples.

Julianne Simpson

LIBRO SECONDO DELLA HISTORIA NATVRALE DI.C.PLI
NIO SECONDO TRADOCTA DI LINGVA LATINA IN
FIORENTINA PER CHRISTOPHORO LANDINO FIOREN
TINO AL SERENISSIMO FERDINANDO RE DI NAPOLI.

SEL MONDO HA TERMINI ET SE E VNO : CAPITOLO PRIMO.

L MONDO ET QVESTO ELQVALE PER
altro nome Anoi piacie chiamare Cielo : elquale
intorno gyrando tutte lechose chuopre : E giusta
chosa credere che sia deita etherna & infinita : Ne
mai generata : Ne mai da douere perire. Ricerchar
lechose extriseche di chostui ne sapptiene alhuo
mo : ne comprendere lepuo la congectura delhūa
na mente. Sacro e & etherno & sāza misura. Tut
to nel tutto : Anzi esso e tutto & e infinito : ma si
mile al finito . Di tutte lechose e certo & simile a
lincerto. Difuori & dentro ogni chosa i se Abbrac
cia. Lui medesimo e opera della natura : & e essa
natura. Furore sāza fallo mosse alchuni A pésare la misura sua : & dipoi Ardire expor
la. Furono etiam mossi da furore quegli equali prendendo occasione di qui innumera
bili mondi essere affermorono : Onde altrettante nature delle chose fussi necessario cre
dere. Et pure se in una natura tutti si posassino : Sarāno constrecti credere che altrettā
ti sieno esoli : Altrettante lelune & laltre immense & innumerabili stelle similmente sie
no multiplicate. Ilperche rimanghono occupati nella medesima inuestigatione : non
hauendo per questo trouato el fine che disiderano. Et se pure uoglamo attribuire alla
natura : laquale e artefice delluniuerso che essa habbi prodocto lechose in infinito : qāto
e piu facile intenderlo in uno mondo solo : maxime essendo quello si grande opera : Fu
rore e per certo : Furore non piccholo Vscire di quello : Et chome se gia lechose dentro
allui poste anchora anoi incerte ci sieno note Inuestigare quelle difuori : Stimando che
chi non sa lamisura dise possi conseguire quella dalchuna altra chosa. O che lamente
humana possi uedere quello che ilmondo inse non cape.

DELLA FORMA DEL MONDO. CAPITOLO. II.
EL nome in prima & dipoi il consenso di tutti glhuomini equali dicono elmōdo
orbe cioe tondo : Dimostrano laforma del mōdo essere ridocta in tondo pfecto.
Ne mācono glargomenti aprouare questo medesimo : perche tale figura da tutte le sue
parti richade in se medesima : & da se medesima puo essere sostentata : & in se si chiude
& contiene : ne dalchuna commissura o cōgiunctura ha dibisogno : ne fine o principio
in alchuna sua parte sente. Preterea al moto elquale ha affare elmondo chome pocho
disotto dimostrerremo : Tale figura e aptissima. Et finalmente glocchi ne danno uero
giudicio : Conciosia che ilconuexo & ilmezo della forma spericha da ogni parte siuede :
Ilche in altra figura non puo addiuenire che nella sperica cioe tonda.

DEL MOTO SVO. CAPITOLO. III.
EL nasciméto & loccaso del sole manifestamente Cidimostrano : che in spatio di
xxiiii. hore Questa sperica machina fa tutta la sua circulare reuolutione. laquale
ethernalmente senza alchuno riposo & con celerita inenarrabile Gyra. Ne si puo facil
méte intédere se elsuono : elquale nascie dellassiduo uoltare ditanta machina e ímeso :
& per questa chagione uincendo elsenso dellaudito non altrimenti si possa udire che

3.5 a & b Anton Koberger

Biblia (German)

Nuremberg: Anton Koberger, 1483

395 × 275 mm

R1763, f. 5r, Creation; f. 224v, Judith and Holofernes

Anton Koberger (*c.*1440/45 – 3 October 1513) originally trained as a goldsmith before taking up printing in about 1471. He quickly became the most successful publisher in Germany, with twenty-four presses in operation, printing numerous works simultaneously and employing at the business's height one hundred workers including printers, typesetters, typefounders and illuminators. He sent out agents and established links with booksellers all over Western Europe, including

Das. XII. Capitel. wye iudith erlaub gawann das sie zu dreyen malen des nachts zu irē gebett mocht auß vnd eingeē Vñ wy sy berüfft ward mit holoferne zeessen.

Ø hieſz er sie eingeen So sein schatz warn behalten. vñ hieß sie da beleiben. vnd schuff das ir würde gegeben von seiner wirtschafte. Judith antwurt vnd sprach. Nu mag ich nit essen von dē dingen die du gebeutest zegeben das die beleidigung nit kum auff mich. Aber ich isse von dē dingen die ich mir hab gebracht. Holofernes sprach zu ir. Ob dir gebresten die ding. die du hast bracht mit dir. was tun wir dir. Vnnd iudith sprach. O mein herze dein sele lebet. wann dein dienn wirt nit verzerē alle dig biß das mir gott tut in meiner hand. Die ding die ich hab gedacht. vnd sein knecht fürte sie ein. in den tabernackel. als er hett gebotten. vñ do sye eingieng. So bat sie daz ir weyl gegebē würde in der nacht auszezeeen vor dē liecht zu dem gebet. vnnd zebitten got. Vnd er gebott seinen kamerern daz sie auffgieng vnd eingieng an zebetten irē got. Durch drey mal als es ir geuiel. Vñ sy gieng auß in dē nechten in das tal bethulie. vñ wusch sich in dē brunn des wassers. vñ als sy auffgieng do betttet sie an den herrē gott israhel. daz er schickket ire weg zu der erlösung seins volcks. Sie gieng ein vnd belyb rein in dē tabernackel. vntz das sie empfieng ir essen an dem abent. Vnnd es ist geschehen an dē vierden tag. Holofernes

macht ein abentessen seinen knechten. vnnd er sprach zu vagao dem keuschen. Gee vnderwey se die hebreerin. das sie williglich veruolge zewonen bey mir. Wañ es ist ein laster bey dē assiriern ze tun. ob das weyb verspottet den man. das sie gee vnschuldig oder frey von im. Do gieng ein vagao zu iudith vnd sprach. Die gut tochter schē sich nit einzegeen zu meim herzen. daz sie werd geert von sein antlytz. vnd esse mit im vnd trinck den weyn in freude. Judith antwurt im. Wer bin ich das ich widerspreche meim herren. Ich thu alles daz da wirt gut vñ das beste vor seinen augen. Vnnd was dings im geuellt. Sitz wirt mir das beste alle die tag meynes lebens. vñ sie stund auff vñ ziert sich mit iren gewanden. sie giengen vñ stund vor seinē antlytz. Wann das hertz holofernis ward geschlagen. Wañ er ward brünnen in irer begirde. Vñ holofernes sprach zu ir. Nu trinck. vnd rue in freuden. wañ du hast funden genad vor mir. Vnnd iudith sprach. O herze ich will trincken. wann heut ist groß gemachet mein sele vor allen tagē meins lebens. Vnd sie nam vnd aß vnd tranck vor ir. Die ding. die ir ir diern het berayttet. Vnd holofernes ward frölich zu ir. vnd tranck gar uil weins. als vil. als er nie het getruncken an ei tag in seym leben.

Das. XIII. Capitel. wye iudith holoferni sein haubt in d nacht abschnyde. cij daz in dy statt bracht. vñ wye daz volck den herren benedeyet.

Venice, Milan, Paris, Lyon, Vienna and Budapest. He was particularly celebrated for producing editions illustrated with fine woodcuts, including the Nuremberg Chronicle published in 1493, and was godfather to the artist Albrecht Dürer.

The first books combining movable type and illustrations printed from woodblocks were produced in the 1460s by Albrecht Pfister in Bamberg. Originally rather crude, the skill of the craftsmen already apparent in single-sheet prints like the St Christopher was soon being harnessed for book illustration. Many illustrative cycles were also influenced by contemporary manuscripts. Woodblocks could be reused over a number of years and the 109 blocks for this Bible had

previously been printed in two German Bibles published in Cologne a few years earlier. Koberger unusually offered three options to the buyer – with the woodcuts uncoloured, with basic colouring of green, ochre, purple and carmine, or a deluxe version with multiple colours and additional gilding as seen on the illustration of Creation here.

This copy was an early acquisition by Mrs Rylands, as shown by the low accession number. It must have been acquired before 1892 as the accession register for the Spencer Collection shows that the Spencer copy was rejected as a duplicate.

Julianne Simpson

3.6 William Caxton

Geoffrey Chaucer, *Canterbury Tales*

Westminster: William Caxton, 1483

240 × 180 mm

Spencer 8694, opening of the Wife of Bath's Prologue

When William Caxton, England's first printer, established a printing house on the premises of the Abbey of Westminster,

his plan was to concentrate on works in English. One of his earliest publications in England was Chaucer's *Canterbury Tales*, which became an enduring success for him. Completed towards the end of 1476, it was a remarkably elegant book, making the text look as new. Several years later Caxton found it necessary to improve the work. A reader of the first edition brought to his attention that different versions of the text existed, others possibly more complete than what he had printed. Caxton had run into the trouble that every

The Wyf of Bathe Prologe

Experience though none auctorite
Were in thys worlde is right ynow for me
To speke of woo that is in mariage
But lordis syn I twelue yere was of age
Thankyd be god that is eternal alyue
Husbondis at the chyrche dore haue I had fyue
If I so often myghte haue weddid be
And alle were worthy men in her degre
But me was told not longe a go ywys
That sith cryst wente neuer but onys
To weddynge in the Cane of galilee
That by the same ensaumpyl taughte he me
That I ne weddid sholde be but onys
Lo he whpehe a sharp worde for the nonys
Besibe a welle Ihesus god and man
Spak in reprees of the samaritan
Thow hast had fyue husbondis sayd he
And that ilke man that now hath the
Is not thy husbond thus he sayd certeyn
What he mente therby I can not sayn
But that I aske why that the fyfth man
Was not husbond to the samaritan
Holw many myght he haue in mariage
Yet herd I neuer tellyn in myn age
Of thys noumbre very dyffynycioun
Men molwe deme and glose vp a doun
But wel I woot expresse wythoutyn lye
That god bad vs weye and multiplye
That gentyl text can I wel vnderstonde
Eke wel I woot he sayd that myn husbonde
Shold leue fader and moder and take to me
But of noumbre no mencion made he
Of bygamye or of Octogamye
Why sholde men speke of it velonye
Lo her the wyse kyng dan Salamon
I trow he hadde wyues mo than on
As wolde to god it leefful were to me
To haue refresshynge half so ofte as he

editor of the *Canterbury Tales* was to face after him: Chaucer had left not one final version of the *Tales* but several different versions which had all been in circulation since his death in 1399. Since the text had remained popular, these were copied in many manuscripts. Caxton, anxious to do justice to a revered author, decided in 1483 to bring out a second edition, correcting the version of the first by comparing it with another manuscript source lent to him by a friend. He also added woodcut illustrations to this new edition, heading each prologue and tale with an image of the fictitious speakers on their pilgrimage from Southwark in London to Canterbury. Shown here is the much-married Wife of Bath, beginning one of the most popular of Chaucer's Tales: 'Experience … is right ynow for me to speke of woo that is in mariage …'. The woodcuts followed the tradition of the very few illustrated manuscripts of the *Canterbury Tales*; Caxton's version became the standard from which the illustrations were copied in many later editions.

Lotte Hellinga

3.7 Nikolaus Laurenz

Dante Alighieri, *La Commedia*
Florence: Nicolaus Laurentii, Alamanus, 1481
420 × 280 mm
Spencer 17280, f. 13r, opening of Inferno

This magnificent edition of Dante's *Divine Comedy*, printed in Florence in 1481, is the only edition to be printed in the poet's native city in the fifteenth century, and is a monumental statement of Florentine cultural supremacy. The book was printed by the German printer Nikolaus Laurenz, and edited by the great Florentine humanist Cristoforo Landino. As a mark of the cultural significance of this edition, it is now commonly known as 'the Landino Dante'.

Lavishly furnished with additional biographical material, a new commentary to the poem by Landino and a sequence of new illustrations printed from engraved copperplates rather than the more usual relief woodblocks, this is by far the largest – and certainly the grandest – of all the editions of Dante's poem to be printed in the fifteenth century.

In the commentary the poet is extolled as the epitome of Florentine culture and his poem historicised as the pinnacle of Tuscan poetic achievement, as seen from the vantage point of Renaissance humanistic culture.

Twenty engravings were made, depicting the first nineteen cantos of the Inferno, but more must have been originally planned, to judge by the spaces left in the text. The Rylands copy is one of the few remaining copies in the world to contain the whole sequence of plates, and these are accompanied by a full-page pasted-in frontispiece engraving of the Inferno fresco in the Campo Santo di Pisa, by Baccio Baldini. In addition, the volume contains hand-decoration in the form of gilded and illuminated initial letters and scribal devices in red and blue ink.

Guyda Armstrong

CANTO PRIMO DELLA PRIMA CANTICA O VERO COMEDIA DEL DIVINO POETA FIORENTINO DANTHE ALEGHIERI : CAPITOLO PRIMO :

DEL
ME
ZO
DEL
CA
MI
NO
DI
NO
ST
RA
VI
TA

Mi ritrouai peruna selua obscura
che la diricta uia era smarrita

Et quanto adire quale era e/ cosa dura
esta selua seluaggia et aspra et forte
che nel pensier rinuoua lapaura

Tanto era amara che pocho e piu morte
ma per tractar del ben chio ui trouai
diro dellaltre cose chio uho scorte

I non so ben ridire chomio uentrai
tantera pien disonno insu quel puncto
che lauerace uia abbandonai

Ma poi chio fui appie dun colle giunto
la oue terminaua quella ualle
che mhauea dipaur el cor compuncto

Guardai inalto et uidi lesue spalle
coperte gia deraggi delpianeta
che mena dricto altrui per ogni calle

Allhor fu lapaura un pocho queta
che nellago del chuor mera durata
lanocte chio passai con tanta pieta

Habbiamo narrato non solamente lauita del poeta et eltitolo dellibro et che cosa sia poeta Ma etiam quanto sia uetusta et anticha quanto nobile et uaria quanto utile et iocconda tal doctrina. Quanto sia efficace a muouere lhumane menti; et quanto dilecti ogni liberale ingegno. Ne giudicammo da tacere quanto in si diuina disciplina sia stata la excellentia dello ingegno del nostro poeta. Inche sisono stato piu brieue che forse non si conuerebbe; consideri chi legge che lanumerosa et quasi infinita copia dellecose delle quali e necessario tractare misforza non uolendo chel uolume cresca sopra modo; a inculcare et inuiluppare piutosto che explicare; et disten dere moltecose et maxime quelle lequali quando ben tacessi non pero ne restera obscura la expositione del testo. Verremo adunque aquella. Ma perche stimo non esser lectore alcuno ne di si basso ingegno; ne di si pocho giudicio; che ha uendo inteso; quanto sia et laprofondita et ua rieta della doctrina; et la excellentia et diuinita dello ingegno delnostro toscano; et fiorentino poeta ; non si persuada che questo principio delprimo canto debba per sublimita et grande za esser pari alla stupenda doctrina dellecose che seguitano; pero con ogni industria in uesti gheremo che allegorico senso arechi seco que sto mezo delcamino; et che cosa sia selua Diche ueggio non piccola differentia essere stata tra glinterpreti et expositori diquesta cantica. Im pero che alchuni dicono; che il mezo della uita hum ana e el sonno mossi; credo dalla sententia daristotele dicendo lui nellethica nessuna diffe rentia essere tra felici; et miseri nella meta della uita per che lenocti che sono lameta del tempo cinducono sonno; et daquello nasce che ne bene nemale sentir possiamo. Ilperche uogliono que sti; che el poeta pongha el mezo della uita per la nocte; et lanocte pelsonno; ad notare che questo poema non sia altro che una uisione che gliap parue dormendo per laquale hebbe cognitone del le cose dallui descripte i queste tre comedie. Di cono adunque che lui imita Ioanni euangelista el

quale dormendo sopra elpecto di christo redemptore hebbe uisione delle chose celeste; oueramente ponghi lanocte dimostrando lui hauere cominciato elsuo poema dinocte nella quale raccoglendosi lanimo insemedesimo et absoluendosi et liberandosi da ogni cura meglio intenda. Ma benche tale sententia quadri al poeta; nientedimeno leparole non la dimostrono senon con tanto obscura ambi guita; che non pare degna della elegantia ditanto poeta Prima perche nonseguita che benche nelle reuolutioni deltempo tanto spatio occupin lenocti quanto el di; perquesto dicendo io scripsi dinoc te sintenda io scripsi nel mezo della mia eta; perche et nel principio et nelfine della eta humana so no lenocti chome nel mezo et similmente el di. Il perche per lamedesima ragione si potrebbe fare tale interpretatione pel di chome per lanocte. Altridicono che uolle pelmezo del camino intende re che nelmezo delleta dette principio alsuo poema. Ma non e unamedsima opinione deltermine della nostra eta; per che diuersi scriptori diuersamente sentono. Aristotile nel suo de republica

3.8 Aldus Manutius

Virgil, *Opera*
Venice: Aldus Manutius, 1501
160 × 100 mm
Spencer 3359, opening of *Bucolica*

Aldus Manutius is the Latinised name of Teobaldo Manucci, born in Bassano near Rome around 1450. Aldus studied Latin and Greek in Rome and Ferrara before becoming tutor to Alberto and Lionello Pio, princes of Carpi. In the 1490s he decided to move to Venice and start a publishing venture, funded by his former students and leading members of Venetian patrician families. His initial aim was to publish correct critical editions of Greek texts and the first publication was a complete edition of Aristotle's works in the original Greek. Published in five folio volumes, it took eight years to complete.

In 1501 Aldus started on a new venture. He explained to a friend: 'We have printed, and are now publishing, the Satires of Juvenal and Persius in a very small format, so that they may more conveniently be held in the hand and learned by heart (not to speak of being read) by everyone'. In fact the first book off the press in this new format was the works of Virgil illustrated here in a fine copy, printed on vellum, with additional decoration and the arms of the Pisani family in the lower margin.

In the poem on the left Aldus praises the skill of the punchcutter Francesco Griffo of Bologna who in fact designed this new 'italic' type. Based on the Italian humanist cursive script first developed in the 1420s by Niccolò de' Niccoli, this Aldine italic became the model for most italic types. The Venetian Senate gave Aldus exclusive right to its use, a patent confirmed by three successive Popes, but it was widely counterfeited. The pocket format was also a great success and Aldus and his sons continued to publish classical and Italian texts in small format throughout the sixteenth century.

Julianne Simpson

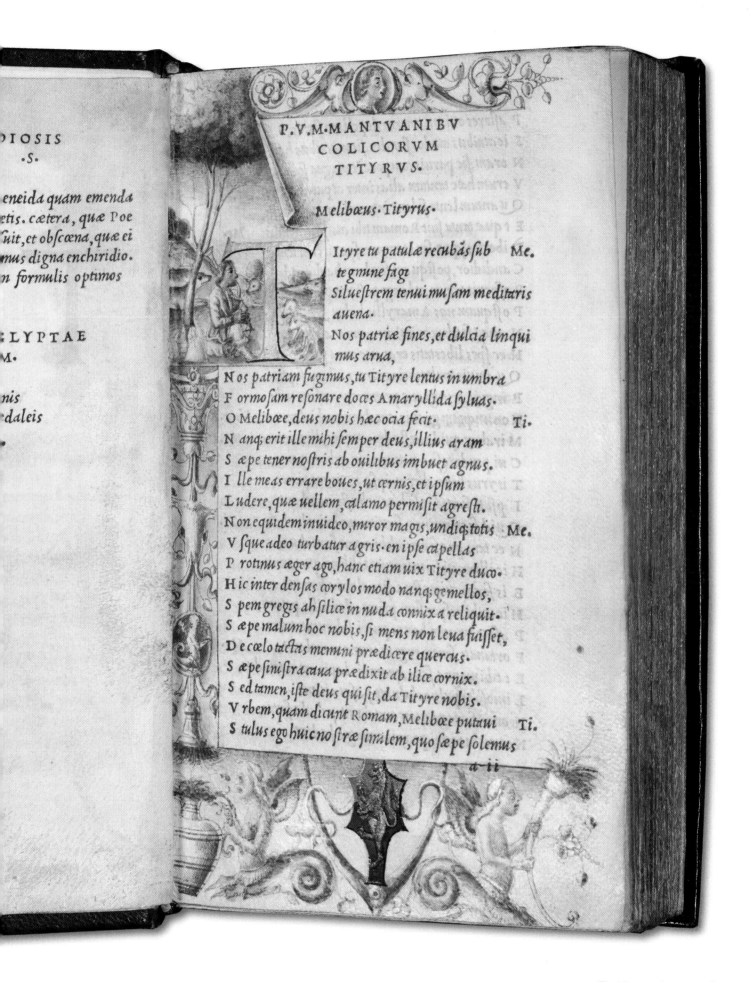

DIOSIS
·S·

eneida quam emenda
etis, cætera, quæ Poe
uit, et obscœna, quæ ei
mus digna enchiridio.
n formulis optimos

GLYPTAE
M.

nis
daleis

P·V·M·MANTVANI BV
COLICORVM
TITYRVS.

Melibœus. Tityrus.

Ityre tu patulæ recubás sub Me.
 tegmine fagi
Siluestrem tenui musam meditaris
 auena.
Nos patriæ fines, et dulcia linqui
 mus arua,
Nos patriam fugimus, tu Tityre lentus in umbra
Formosam resonare doces Amaryllida syluas.
O Melibœe, deus nobis hæc ocia fecit· Ti.
Namq; erit ille mihi semper deus, illius aram
Sæpe tener nostris ab ouilibus imbuet agnus.
Ille meas errare boues, ut cernis, et ipsum
Ludere, quæ uellem, calamo permisit agresti.
Non equidem inuideo, miror magis, undiq; totis Me.
Vsque adeo turbatur agris· en ipse capellas
Protinus æger ago, hanc etiam uix Tityre duco·
Hic inter densas corylos modo nanq; gemellos,
Spem gregis ah silice in nuda connixa reliquit·
Sæpe malum hoc nobis, si mens non leua fuisset,
De cœlo tactas memini prædicere quercus·
Sæpe sinistra caua prædixit ab ilice cornix·
Sed tamen, iste deus qui sit, da Tityre nobis.
Vrbem, quam dicunt Romam, Melibœe putaui Ti.
Stultus ego huic nostræ similem, quo sæpe solemus

a ii

بسم الله الحي الأزلي

نبتدي بعون الله تعالي

وحسن توفيقه نكتب ا

الصلوات الليليه والنهاريه

اول ذلك صلاة نصف الليل

تقول بصلوات جميع ابها

تنا القديسين باربنا يشوع

المسيح الاهنا ارحمنا امين

3.9 Gregorio de Gregorii

Kitāb ṣalāt al-sawā'ī (Precatio horarii)
Fano: Gregorio de Gregorii, 1514
165 × 110 mm
Spencer 13803, title page

Producing type that could capture the flowing Arabic script was a great challenge and very few books in Arabic were printed before the nineteenth century, when lithography and other printing techniques made the task a little easier. This Book of Hours is possibly the first book produced with movable Arabic type. The font is quite clumsy and the text peppered with mistakes suggesting that the (unknown) translator and typesetter had only limited experience of Classical Arabic.

The book was probably produced for distribution among Arabic Christians in the Orient as well as in Venetian territories in the wake of the unions concluded between the Papacy and various Oriental churches during the council of Florence in the 1440s. A multilingual Psalter, including Arabic, was printed in Genoa in 1516. These books were probably also used by orientalist clergymen to learn Arabic.

According to the colophon, it was printed by the Venetian Gregorio de Gregorii in Fano (Marche) in 1514, which would make it Gregorio's only book printed outside of Venice. It is possible that the *Kitāb* was actually printed in Venice, but because another printer held an exclusive privilege for Arabic printing (though no examples survive) this forced Gregorio to print elsewhere or at least to indicate another printing place, outside Venetian territory. One is tempted to connect the *Kitāb* to the later printing of an Arabic Qur'ān by Alessandro Paganini in 1537/38 – not least because there were business links between the Gregorio and Paganini families. However, the types are very different and the connection of the letters reproducing the cursive Arabic *ductus* in the Qur'ān is greatly improved.

Georg Christ

4

Master binders and their craft

THE LIBRARY holds a remarkable array of bookbindings, from ancient codices which preserve the earliest forms of leather casings for books, and medieval jewelled covers, to the finest of contemporary bindings that combine exceptional artistry and technical accomplishment. Bindings made for popes and cardinals, kings and aristocrats, humanist scholars and connoisseurs, as well as for more commonplace readers and owners, are all to be found in our collections. Moreover, our binding collections are by no means confined to the Western tradition. We hold an especially fine corpus of Middle Eastern manuscripts, many of which display the exceptional skills of Islamic bookbinders in embossing, gilding and painting leather (4.4), as well as in creating lacquered panels of exquisite beauty (4.6). These Eastern and Western traditions are not unconnected: Islamic bookbinding had a great influence on the development of European practice, particularly in Renaissance Italy.

George John, 2nd Earl Spencer, like many English collectors in the eighteenth and nineteenth centuries, was in the habit of having his books rebound in the latest style by the leading London binders. The uniform rows of polished morocco, richly gilt, must have looked stunning at Althorp, but the unfortunate result is that few medieval bindings survive in the Spencer Collection (an exception is 4.2). However, Enriqueta Rylands had a particular interest in bookbinding, ancient and modern, and very few styles of binding cannot be found in our collections. The 26th Earl of Crawford coveted jewelled and metal bindings and, when Enriqueta purchased his manuscripts in 1901, she acquired one of the finest collections of such work in Britain (4.1). David Lloyd Roberts, the distinguished Manchester doctor and bibliophile, bequeathed his books to the Library in 1920. He had a passion for bookbinding, and his gift included five hundred fine bindings, ranging from the sixteenth to the nineteenth centuries. Highlights include bindings produced for Giovanni Battista Grimaldi, Jean Grolier, Thomas Mahieu ('Maiolus'), Jacques-Auguste de Thou, Marguerite de Valois, Henri II, Louis XIV and Napoleon I.

By the second half of the nineteenth century, standards of commercial bookbinding had reached their nadir: fierce competition and cost-cutting, the use of inferior materials, shoddy workmanship and an emphasis on surface appearance rather than sound structures meant that

bindings often deteriorated after only a short time. Inspired by the Arts and Crafts revival, a group of men and (notably) women resuscitated the craft of bookbinding at the turn of the century (4.10), and this renaissance continues, with members of Designer Bookbinders and the Society of Bookbinders being dedicated to sustaining the highest standards of bookbinding. Enriqueta Rylands supported the revival, indirectly, in 1894 by purchasing the Tregaskis Collection of seventy-three copies of the Kelmscott Press edition of *The Tale of King Florus and the Fair Jehane*, each in a unique binding, as well as through her many individual purchases of fine bindings. Likewise, the Library has supported modern bookbinding in the last two decades, through the purchase of the Tregaskis Centenary Collection in 1994, the deposit of Anthony Dowd's outstanding collection of modern British bookbindings in 2001 (4.11), and regular purchases of the best of British bookbinding (4.12).

This chapter does not attempt to offer a comprehensive history of bookbinding. Rather, it aims to provide an introduction to the craft, and suggests that you should never 'misjudge' a book by its cover. As Mirjam Foot, who has written extensively on the history of bookbinding, says, when you tell people about your interest in the subject, you are often met with looks of confusion or worse. The 'History of the Book', as it is sometimes called, is a relatively recent phenomenon but there are now many who study the construction of old books in order to uncover secrets of a past that it may not be possible to reveal by other means. The world of science is also interested in our 'dusty tomes', with techniques such as DNA analysis now allowing us to answer questions as to what the books are made of, or indeed to trace who was actually turning the pages through the centuries.

In future, when you look at an old book sitting on a library shelf, you will perhaps do so differently and ponder a few questions: Who was this book made for? Is it still in its original covers? Did its owners care about its long-term preservation, and if so why? Was the book valued by successive owners not only for to its textual content, but because the book itself was a precious artefact, an heirloom or a token of love? In the digital age, when information is available at the touch of a button, old books and their bindings hold an even deeper significance for the secrets they tell about past lives.

Caroline Checkley-Scott and John R. Hodgson

4.1 A real treasure

Trier book covers
Trier, Germany, 10th and 13th centuries
420 × 258 mm
Book Cover 17

The tradition of making treasured bindings, covered with gold, silver, jewels and ivory, was practised for over a thousand years. The book or codex format as we know it began in earnest in the fifth century. Books were sewn together using leather thongs to make them stronger and longer lasting, with wooden boards placed on the top and bottom to keep flat the pages, which at that time were made of animal skin. The bookbinding technique for treasure bindings was similar to other early binding structures and the precious covers were attached to the wooden boards.

Treasure bindings were a rare luxury and were commissioned only by wealthy private collectors, churches, senior clergy and royalty, and were often presented by or to royal or noble persons. Craftsmen worked with sheets of gold, silver or copper to create jewelled and enamelled panels that were nailed or pinned separately into the wooden boards. Ivory panels were also used, although later twelfth-century examples have proved to be carved from either whalebone or walrus. In many cases antique gemstones and ivory panels were recycled, and jewelled bindings tend to be of composite construction, incorporating elements of different dates. So in the case of this binding from a monastery at Trier in Germany, the ivory panels have been assigned to the tenth century, while the gilt metal surround dates from the thirteenth century. The panel shown here depicts the appearance of Christ to the women after his Resurrection, the Ascension and Pentecost.

Owing to the high value of the materials used in their construction, jewelled covers were often removed and, as in this case, are now rarely seen with their original codices. Some were removed by looters, or occasionally when the owners were in need of cash, while some were stored separately in the church treasury. Others survive without their jewels, showing empty hollows, or the whole cover may have been moved to a different book.

Caroline Checkley-Scott

4.2 A pun on a tun

Hieronymus, *Vita et transitus (i.e., Eusebius*
Cremonensis: Epistola de morte Hieronymi; Aurelius
Augustinus: Epistola de magnificentiis Hieronymi;
Cyrillus: De miraculis Hieronymi)
Cologne: Ulrich Zel, *c.*1470
209 × 144 mm
Bound by the Scales Binder, *c.*1470s
Spencer 18179

One of the most important medieval English bindings to survive in the John Rylands Library is on a copy of *Vita et transitus*, printed by Ulrich Zel in Cologne. The binding is by the so-called Scales Binder. This anonymous craftsman used a characteristic square tool representing a set of balance scales, which he used repeatedly on his bindings, in this case no fewer than thirty-four times. Nineteen examples of the Scales Binder's work have been identified by G. D. Hobson and Nicolas Barker, including this one from the Spencer Collection. While Lord Spencer was a notorious 'rebinder', he evidently admired and realised the significance of this binding and ensured its preservation.

The most striking feature of our binding is the large central panel containing an image of a barrel (or 'tun' in medieval parlance), cut into the leather in a technique known as *cuir ciselé*, together with the letters 'lang', the 'l' piercing the barrel. This is a rebus, or visual pun, on the name of the original owner of the book, William Langton. In case we were in any doubt as to its ownership, he has helpfully inscribed the book twice: 'W. Langton' and 'Langton'.

William, who died in November 1496, was Chancellor and later Precentor of York, and was the brother of the more famous Thomas, archbishop-elect of Canterbury, who died in 1501 before his installation. It is quite likely that William purchased the book new, and had it bound while he was a Fellow of Pembroke College, Cambridge, in the 1470s. As an academic and later a senior clergyman, he would no doubt have amassed a substantial library. Another binding made by the Scales Binder for William Langton, which incorporates a similar rebus device, survives at St John's College, Cambridge (St John's MS F.19). That example derives from the library of the clergyman and religious controversialist William Crashaw (d.1625/26).

John R. Hodgson

4.3 On a chain

The Book of Common Prayer, and Administration of the Sacraments
Oxford: printed by John Baskett, printer to the University, 1737
73 × 127 mm
R209008.1

In the film *Harry Potter and the Philosopher's Stone*, based on J. K. Rowling's children's book, the restricted section of Hogwarts library features chained books. A young Harry uses his Invisibility Cloak to visit the restricted section of the library at night, but happily not to steal a book!

In a chained library the books are attached to the book-cases by chains, which are long enough to allow the books to be taken from their shelves and read, but prevent them being removed from the library. This practice was customary for reference libraries (that is, the vast majority of libraries) from the Middle Ages until the eighteenth century. Injunctions of Edward VI to the Church of England in 1547 stated that churches should provide 'one great Bible in english, & one book of the Paraphrases of Erasmus vpon the gospels, both in English', for the congregation to read and hear. As books were extremely valuable during this period, chains were used to provide sufficient security.

The records of Macclesfield (St Michael) in 1723 include an entry: 'Paid for hingis and 2 book chains, 2s.0d.' This prayer book from Bramall Hall Chapel in Cheshire was deposited by Hazel Grove and Bramhall Urban District Council in 1956. A typewritten note by Reginald Dean, June 1956, found with the book states, 'it must be assumed that the chained Prayer Books at Bramall Hall Chapel were retained either out of sentiment or as a memento of former days'.

A chained library can still be found at Chetham's Library in Manchester, the oldest free public reference library in the United Kingdom, which has been in continuous use since 1653. Under the terms of Humphrey Chetham's will, small libraries of books, designed to be 'chained upon desks or to be fixed to the pillars or in other convenient places' were established in several local churches; the one from Gorton was transferred to Chetham's Library in 1984.

Caroline Checkley-Scott

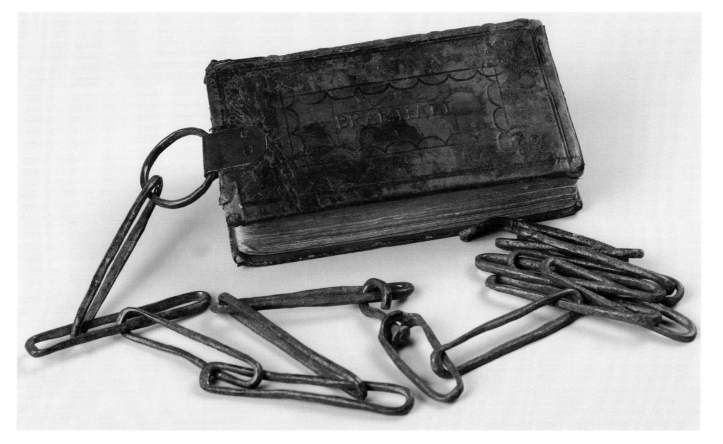

4.4 'Possibly the largest Qur'ān in the world'

Qur'ān
Cairo, late 14th century
876 × 592 mm
Arabic MS 42 (704)

During the Mamluk period (1250–1516), Cairo became the cultural, religious and intellectual centre of the Islamic world and as such fostered a milieu in which the written word was valued and treasured. The Mamluk sultans and amirs sponsored the building of mosques, mausoleums and educational institutions, often grouped together to form a single complex in which a library was included. These religious institutions were endowed with manuscripts for teaching and study purposes including very large Qur'āns, some over a metre in height, beautifully written and illuminated. Given their large sizes, these were used for ceremonial purposes whenever public reading of the Qur'ān was required.

The Rylands Qur'ān, with 470 folios written in *muḥaqqaq* script, was once described as 'possibly the largest Qur'ān in the world' and was associated with the Mamluk Sultan Qānṣūh al-Ghūrī (1501–16) because of the presence of an ownership stamp in his name which has now been obliterated. The Qur'ān (while not now actually the largest in the world) stands as a rare example of a large-volume Mamluk Qur'ān that retains its original covers, as almost all the extant examples have been rebound. The manuscript and binding are most probably datable to the second half of the fourteenth century, in terms of the style of illumination and binding decoration. The calligraphy and the illumination can be compared to two other large-volume Qur'āns in the Dār al-Kutub in Cairo (Rasid 9,755 × 560 mm, and Rasid 10,735 × 508 mm), bequeathed by Sultan Sha'bān (1363–76) to his mother's madrasah in 1369 and his own in 1376 respectively.

The covers are decorated with a repeat pattern of geometrical interlace based on twelve-pointed stars extending into star polygons. The doublures (decorative linings on the inside of the covers) are tooled with central rosettes with pendants, and the borders are decorated with the impressions of small tools that are recorded on other Mamluk bindings of the period. The production and decoration of such large and heavy volumes must have been a very specialised task, standing as unique testimony to the binder's art during the Mamluk period.

Alison Ohta

4.5 Ready to wear

Qur'ān
Glasgow: David Bryce and Sons, *c.*1900
26 × 18 mm
R 47013

The publisher David Bryce and Sons was active around the turn of the nineteenth century and took an active interest in the latest technological advances in photolithography and electroplates, which allowed larger volumes to be photographically reduced to the smallest imaginable size. The result is that his publications are prized for the clarity and legibility of their tiny texts.

One of the more famous of Bryce's publications is the Qur'ān, printed entirely in Arabic and first issued around 1900. Copies were frequently issued to Muslim soldiers fighting with the Allied troops during the First World War. The metal locket allowed it to be easily worn around a soldier's neck. Miniature Qur'āns were published in Delhi in 1892 and in Istanbul around 1899, but the one which seems to have achieved the widest circulation is this Scottish edition. T. E. Lawrence, Lawrence of Arabia, wrote: '[Auda] told me later, in strict confidence, that thirteen years before he had bought an amulet Koran for one hundred and twenty pounds and had not since been wounded … The book was a Glasgow reproduction, costing eighteen pence; but Auda's deadliness did not let people laugh at his superstition' (*Seven Pillars of Wisdom*, Book 4, Ch. 53).

This particular volume is 26 mm in height and bound in red morocco leather. Completely covered in a gilt design, the book is contained inside the original metal locket with a magnifying glass set into the lid and hung by a suspension loop.

Caroline Checkley-Scott

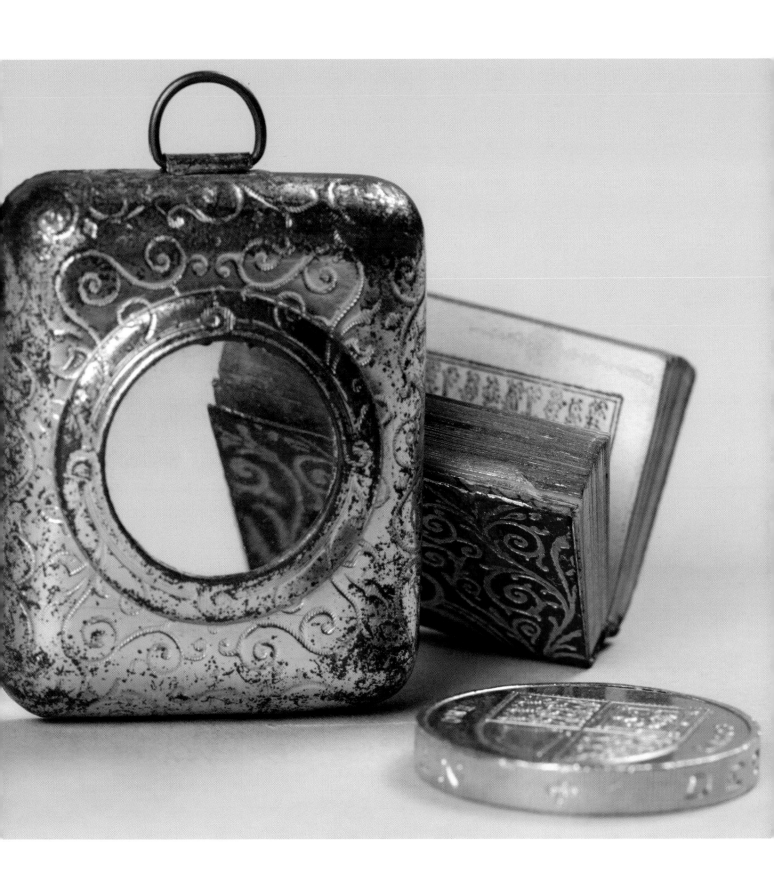

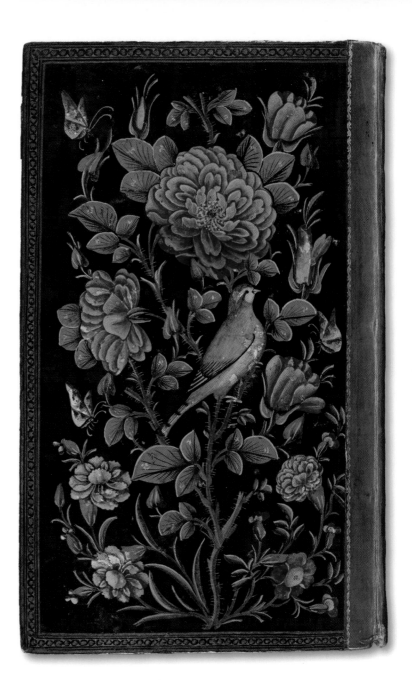

4.6 Fragile beauty

Ẕiyāʾ al-Dīn Nakhshabī, *Ṭūṭī'nāmah*
(*Tales of a Parrot*)
Calcutta, AH 1181/AD 1767
253 × 156 mm
Persian MS 215

Lacquered bindings are actually more the work of the minia-ture painter than the bookbinder and can be found on Persian, Turkish and Indian books. It was a method of deco-rating bookbindings by means of scenes painted and then covered with lacquer or shellac, on either one or both covers of the book. It is thought that lacquer painting was intro-duced from China in the fourteenth century, but the practice flourished between the late fifteenth and the eighteenth cen-turies, when bindings were painted with many colours. The craft is particularly associated with Persia where an early example was found in 1483. It can also be found on pen boxes and mirror cases. As time went on, the bindings became more elaborate, incorporating garden scenes, mythological creatures and human figures.

The production of a lacquered binding is a laborious and time-consuming process. Layers of coloured pigment are applied by brush on to the pasteboard or *papier mâché* substrate, followed by a coating of shellac. Early examples were painted directly on to leather but the paint often flaked off. After the design is laid out, the painting is blocked out in layers of opaque paint consisting of pigments mixed with animal glue. The finer details are painted on to these blocks of colour. Upon completion of the painting, the entire surface is coated with many layers of lacquer or shellac. Any gilding or metallic decoration is laid on to this. The work is finished when a smooth glass-like surface is attained after repeated applications of shellac interspersed with sanding. Many lac-quered bindings, such as this one, are now cracked, owing to the fragile nature of the lacquer or shellac and inappropriate handling and storage conditions.

Caroline Checkley-Scott

4.7 A stitch in time

The term 'embroidered bookbinding' usually describes a book bound in textile, decorated with a design made for the book and worked in coloured and metallic threads on both covers.

The cloth was often embroidered separately before it was glued or stitched to the boards of an already bound book. Embroidered covers generally do not form part of the book construction itself and are purely decorative. Owing to the high quality of the work, it is thought that the majority of embroidered bindings were produced by professional needle-workers, often women. They were never mass-produced but always made for individuals on request, probably because of the time taken to produce them. Embroidered bindings of the sixteenth and seventeenth centuries were usually made of velvet, canvas or silk – the one here being silk.

The most common designs were Old Testament scenes such as Adam and Eve, Moses and Aaron, and Solomon; New Testament scenes; and figures of the saints. Mirjam Foot has noted allegorical figures, such as Peace and Plenty or Faith and Hope, flora and fauna, and heraldic subjects. The use of portraits came into fashion in the seventeenth century. Initials and coats of arms were often added to personalise the work.

The edges of the books were often gilded, gauffered (i.e. decorated with gold and tooling: see 4.9) or painted, and motifs included flowers, birds or coats of arms.

Caroline Checkley-Scott

The Whole Booke of Psalms, Collected into English Meeter, by Thomas Sternehold, Iohn Hopkins, and Others
London: Imprinted for the Company of Stationers, 1639
74 × 50 mm
R9012

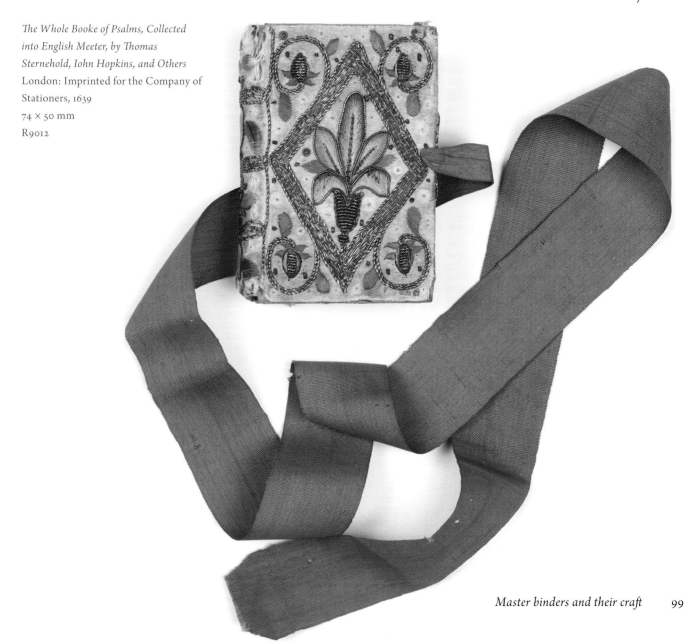

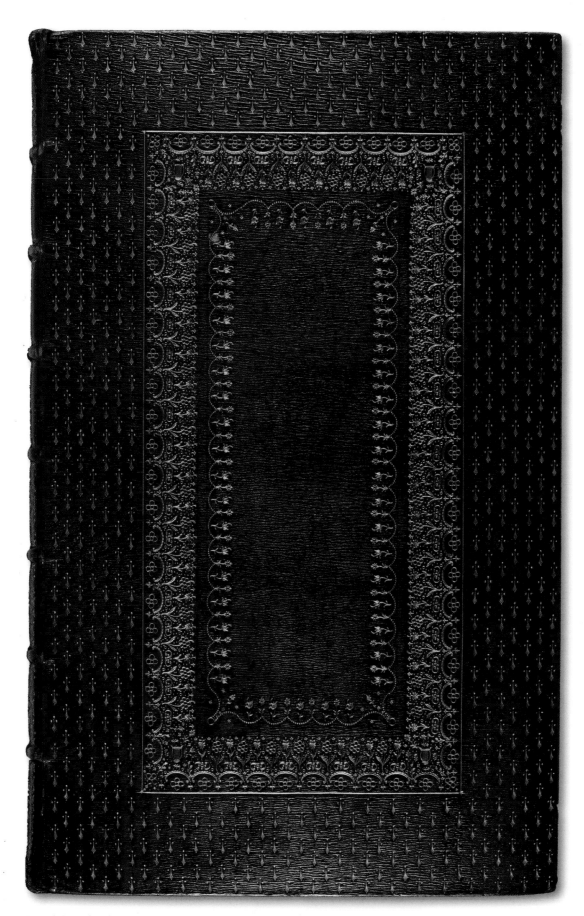

4.8 Classical civility

Aeschylus, [*Hai tou Aischylou tragodiai hepta*]
Glasgow: Andreas Foulis, 1795
492 × 315 mm
Bound by Roger Payne, with the original bill and design notes
Spencer 9334

Roger Payne (1738–97) is regarded as the most accomplished and influential of the eighteenth-century English book-binders. Although often credited with being the 'founder of a purely English style of decoration for the covers of books' (W. L. Andrews), Payne was undoubtedly influenced by the work of Samuel Mearne and other binders of the late seventeenth century. Payne's bindings united elegance with durability; and the ornaments, usually designed by himself, were carefully chosen. He prided himself on using the best materials and paying attention to every aspect of the binding process.

Payne attracted many distinguished patrons including George John, 2nd Earl Spencer, thanks to whom the John Rylands Library holds one of the greatest collections of Payne bindings. Aeschylus's *Tragedies* was a late Payne binding which came to the Library in 1892 when Mrs Rylands purchased the Spencer Collection. It is a large-paper copy of Robert Potter's translation of Aeschylus, printed in Glasgow in 1795, in which are contained John Flaxman's original drawings. Like many of Payne's most beautiful bindings, straight-grained morocco leather is used: the dark blue morocco is decorated (both boards and the spine) with gold tooling, using a variety of ornamental devices, including delicate circlets, fans, leaves and flowers.

Contemporaries, like Thomas Frognall Dibdin, complained of Payne's 'thriftless disposition and most irregular habits of life'. There is, however, nothing 'squalid' or 'wretched' about his mastery of his craft. Each volume he bound was accompanied by a bill describing the work done, and the ornaments used, written in a very detailed and precise manner. In the case of the Aeschylus, Lord Spencer paid fifteen guineas for what most scholars regard as Payne's masterpiece.

Dorothy J. Clayton

4.9 Precious caskets

Torquato Tasso, *La Gerusalemme liberata di Torquato*
London: presso C. Corrall, a spese di G. Pickering, 1822
83 × 45 mm, 2 vols
Spencer 7682

These small but exquisitely bound volumes are printed on vellum and stand only eight centimetres in height. Achieving such a high standard of both binding and gold tooling shows the incredible skill of the binder. This particular book has been chosen also because of its gauffered edges.

Gauffering is the technique of decorating the edges of a book, usually after gilding, using heated finishing tools or rolls to impress patterns into the gold. The decoration could be further enhanced by using two or more layers of leaf, each of a different colour. While this technique was used by a number of European bookbinders, it was especially associated with German bookbinding of the sixteenth century. Plain gauffering was done well into the seventeenth century, usually on embroidered bindings, but it appears to have declined sharply after *c*.1650. It was then revived and exploited from the end of the eighteenth century onwards, and was especially popular in the latter half of the nineteenth century, when it was found on elaborately bound devotional and other books.

This book is printed on vellum, which is derived from the Latin word 'vitulinum' meaning 'made from calf'. However, it is sometimes used more generally to refer to finer parchment made from a variety of animal skins, including sheep and goat. Vellum was made for both writing and printing upon, as well as for bookbinding. The process of preparing vellum included flaying the animal; soaking the skin in rotting vegetable matter, beer, liquor, and in later times lime; stretching and scraping it, to remove the flesh and hair; and finally rubbing it with pumice stone to create a smooth surface.

Caroline Checkley-Scott

4.10 A fairy-tale binding

Indian Fairy Tales, selected and edited
by Joseph Jacobs and illustrated by John
D. Batten
London: David Nutt, 1892
243 × 160 mm
Bound by Alfred de Sauty
R24798

Inspiration for the cover of a well-designed book should be rooted in all its aspects – text, illustration, typography, structure and material. When book artists and fine bookbinders collaborate, each with a passion for presenting the bound text as a unique art object, the results can be outstanding, as in the case of this copy of *Indian Fairy Tales*, printed on Japanese vellum (a smooth, strong paper made with long fibres), illustrated by John D. Batten and bound by Alfred de Sauty (1870–1949). De Sauty worked as a binder in London from around 1898 until 1923, when he moved to Chicago; during his London period he also taught at the Central School of Arts and Crafts. He was renowned for the delicacy and technical virtuosity of his bindings, which show some Art Nouveau influences.

Indian Fairy Tales, full-bound in citron goatskin with depictions of snakes as coloured inlays, is a wonderful example of the skill of the bookbinder in both leatherwork and gold tooling. Tooling leather – that is, making an impression in the leather with individual hand-tools made of engraved brass – can be done with or without gold; in the latter case, it is called 'blind tooling'. In this case the work has been carried out to a very fine standard using real gold. The technique of using gold reached Europe from the Islamic world as early as the fifteenth century. The leather is painted with egg white, gold leaf is then laid on, and the heated tool used to make the impression through the metal and on to the leather. The heads and eyes of the snakes are created by using the technique of inlaying: setting contrasting pieces of coloured leather into the main covering material. The edges of inlays are often gold tooled to give a neater finish and to enhance the effect.

Caroline Checkley-Scott

4.11 A modern masterpiece

Susan Allix, *A Flora*
London: Susan Allix, 1992
No. 25 of 26 copies
340 × 285 mm
Bound by Angela James, 1994
Dowd Collection no. 48

Over a thirty-five-year period, Anthony Dowd amassed a collection of one hundred fine bindings by some fifty leading British practitioners. Pre-war pioneers such as Sybil Pye and George Fisher rub shoulders with leading contemporary binders, including twenty-one fellows and honorary fellows of Designer Bookbinders. Anthony Dowd built up his collection through purchase and by directly commissioning bindings from their makers. In 2001 he transferred the collection to the care of the Library, where it has been regularly exhibited ever since.

A Flora is one of the most spectacular bindings in the Dowd Collection. Susan Allix is a book artist, who produces works in very limited editions, which are printed, illustrated and bound by her. *A Flora* is an anthology of prose and poetry about flowers. Whereas most copies were bound by Allix, Anthony Dowd purchased a set of unbound sheets and commissioned Angela James to bind them for him in 1994. James is a fellow and former president of Designer Bookbinders, noted for the playfulness of her bindings and her bold use of colour.

This complex binding is composed of black, yellow and purple goatskin; white sheepskin sprayed with acrylics in various colours; a chequerboard of black goatskin and white sheepskin; and inset drawings of flowers in pencil and crayon, laminated with transparent vellum. Inside the covers, the doublures are made up of rectangular pieces of variously coloured and speckled leathers.

Angela James explained: 'I wanted to acknowledge the strong use of colour that [Susan Allix] has used throughout without being illustrative and conflicting with her images. The colour and the use of strong, clear lettering are the two things which stand out most strongly in a strong book hence my suggestion of using lettering on the cover in addition to the title.' The result is a *tour de force* of modern binding.

John R. Hodgson

4.12　Prize binding

Enid Marx: *Some Birds and Beasts and Their Feasts: An Alphabet of Wood Engravings Made by Enid Marx*
Oldham: Incline Press, 1997
142 × 100 mm
Bound by Dominic Riley, 2007
R210102

The Library continues to add to its collection of fine bindings and actively promotes the art and craft of bookbinding today, both by having bookbinding specialists in its Collection Care team, and for several years hosting the Designer Bookbinders annual competition and exhibition. One example of these recent acquisitions is by Dominic Riley. Dominic studied at the London College of Printing and has worked in London, New York and San Francisco, where he founded the bindery at the Center for the Book. He teaches in the USA and throughout Britain, believing that 'Teaching is about giving back, but it also keeps the craft alive. If you have a passion, you must pass it on.' In 2007 he won both first prizes and the Mansfield medal in the Designer Bookbinders competition, and he was elected a Fellow in 2008. He is also Vice-President of the Society of Bookbinders. His most recent accolade was winning the prestigious Sir Paul Getty Bodleian Bookbinding Prize in 2013, worth £10,000, for a work made of brown and black goatskin which depicts the story of Pyramus and Thisbe in a landscape of a forest lit by the full moon, with the names of the lovers half hidden in the stars; it is now in the Bodleian Library.

Some Birds and Beasts and Their Feasts, which won the Clothworkers' Company Prize for Open Choice Book in the 2007 Designer Bookbinders competition, has been bound in full blue goatskin over boards that have been cushioned on the edge. The endbands have been woven in silk and the edge of the book has been painted. The intricate pattern on the front cover is composed of a series of inlays with gold tooling around them. Inside the covers are leather doublures in mustard leather with pink leather inlays and suede flyleaves.

Caroline Checkley-Scott

THAT Aprille with his shoures soote
The droghte of March hath perced to the roote,
And bathed every veyne in swich licour,
Of which vertu engendred is the flour;
Whan Zephirus eek with his swete breeth
Inspired hath in every holt and heeth

The tendre croppes, and the yonge sonne
Hath in the Ram his halfe cours yronne,
And smale foweles maken melodye,
That slepen al the nyght with open eye,
So priketh hem nature in hir corages;
Thanne longen folk to goon on pilgrimages,
And palmeres for to seken straunge strondes,
To ferne halwes, kowthe in sondry londes;
And specially, from every shires ende
Of Engelond, to Caunterbury they wende,
The hooly blisful martir for to seke,
That hem hath holpen whan that they were
seeke.

BIFIL that in that seson on a day,
In Southwerk at the Tabard as
I lay,
Redy to wenden on my pilgrym-
age
To Caunterbury with ful devout
corage,
At nyght were come into that hostelrye
Wel nyne and twenty in a compaignye,
Of sondry folk, by aventure yfalle
In felaweshipe, and pilgrimes were they alle,
That toward Caunterbury wolden ryde.

5

'A definite claim to beauty':
The private presses

WHAT IS a private press? There are as many definitions as there are printers and collectors, but the essence of the private presses is printing for pleasure, rather than for profit. Whether inspired by high-minded idealism, such as William Morris and T. J. Cobden-Sanderson, or by a simple love of the book beautiful, private printers choose which books to create, and strive to produce them in a form that satisfies their own aesthetic. They range from large workshops, sometimes even employing a small staff, to weekend printers working on a kitchen table. Some printers verge on the obsessive in their desire to control every aspect of a book's design and production, including making their own paper and casting type, while others are content to leave these specialist crafts to others and prefer to focus on the core functions of designing and printing the book.

Antecedents of the modern private presses can be found in Horace Walpole's Strawberry Hill Press in the eighteenth century, and the press of Henry Daniel in the nineteenth. But the movement proper was inspired by Emery Walker's famous lecture on early typography, delivered to the Arts and Crafts Exhibition Society in 1888. It initiated a golden era in Britain, spanning four decades from the 1890s to the Depression of the 1930s, interrupted by the horrors of the First World War. The Kelmscott, Ashendene, Vale, Doves, Eragny and Essex House presses were all active before the war, and helped to transform the lamentable standards of commercial book production that prevailed in the nineteenth century. The Golden Cockerel, Gregynog, Shakespeare Head and Nonesuch presses took up the baton in the early 1920s. Their books were essays in restrained modernism, less serious than their antebellum forerunners. Nonesuch was in fact arguably a publisher of finely printed books, rather than a private press in a literal sense.

This period coincided with the foundation and early years of the John Rylands Library. It is unsurprising, therefore, that the Library holds a very fine collection of early private press books. Despite her renown as the purchaser of the Spencer and Crawford collections of early printed books and manuscripts, Enriqueta Rylands was a woman of modern, even avant-garde taste in her collecting of contemporary books. It is thanks to her that the Library holds a complete collection of Morris's Kelmscott publications, which she purchased almost before the ink was dry; she kept them at her private residence, Longford Hall, and they transferred to the John Rylands

Library only after her death in 1908. Enriqueta also purchased a collection of seventy-three copies of the *Tale of King Florus and the Fair Jehane* (1893), each in a unique binding. They were commissioned by the booksellers James and Mary Lee Tregaskis from bookbinders around the world and exhibited in London in 1894. No other library is likely to have such a concentration of Kelmscott Press books.

Following its founder's example, the John Rylands Library assiduously collected the first-generation presses, choosing vellum copies of their books wherever possible, but in the 1920s financial retrenchment meant that we collected only representative examples of the great inter-war presses such as the Golden Cockerel and Gregynog. The post-war years were the nadir of the private presses – austerity, paper rationing and an egalitarian, modernist aesthetic did nothing to encourage the production of finely printed limited-edition books – and the John Rylands Library's fortunes were similarly depressed. One of the few presses to remain active in these years was that run by the nuns of Stanbrook Abbey in Worcestershire, whose jobbing work for the Benedictine Order helped to sustain their fine printing.

In the early 1970s commercial printers rushed to jettison their traditional letterpress equipment in favour of giant web-offset machines and phototypesetting (in turn replaced by digital technology). A small band of enthusiasts seized the opportunity to buy up redundant presses and type, began printing books and ephemera, often in their spare time, and thus preserved the art of letterpress printing. Thus sprang a new generation of British private presses: Alembic, Circle, Libanus, Old Stile, Rocket, Tern, to name just half a dozen. Meanwhile, the University of Wales revived the pre-war Gregynog Press as Gwasg Gregynog, and the Rampant Lions Press flourished in Cambridge under Will Carter and his son Sebastian. Some of these latter-day printers have since retired, but other presses continue to thrive and newcomers regularly join the field, often willing to embrace new technologies, such as typesetting on a Mac and printing from polymer plates.

The Library's collection of private press books has grown substantially in the last twenty years, reflecting this renaissance and a renewed commitment to represent the best of modern fine printing, alongside our historic collections. Local loyalties have led us actively to support two northern presses: Simon Lawrence's Fleece Press, located on the 'wrong' side of the Pennines near Huddersfield, and Graham Moss's Incline Press in Oldham. Both are renowned for the quality of their presswork, and for publishing significant works in the field of book history. We also continue to acquire the output of other British and North American presses, especially works on the history of the book, typography and book illustration. So, for example, we have a complete run of *Matrix*, the annual review for printers and bibliophiles, published since 1981 by John Randle at his Whittington Press and widely acknowledged as the most important journal on the book arts in the twentieth century. For as long as printers share Morris's ambition to produce books which 'have a definite claim to beauty', the Library will endeavour to collect them.

John R. Hodgson

5.1 An Idyll by the Thames

Theocritus, *Sixe Idyllia*
Oxford: H. Daniel, 1883
No. 37 of 100 copies
220 × 175 mm
Private Press Collection / R166178,
facsimile title page, detail

SIXE IDILLIA

THAT IS,

SIXE SMALL, OR PETTY

POEMS, OR ÆGLOGVES, CHO-

ſen out of the right famous Sicilian

Poet THEOCRITVS, and tran-

ſlated into Engliſh verſe.

Dum deflvat amnis.

PRINTED

At Oxford, by IOSEPH BARNES.

1588.

Henry Daniel (1836–1919) could fairly claim to have established the press which was the precursor of the modern private press movement. Daniel was an Oxford don (he was elected Provost of Worcester College in 1903), and the output of the Daniel Press reflects his own interests in the Classics, devotional literature and contemporary poetry. It is a genteel world of sun-dappled libraries, reading parties and punting on the Thames.

Daniel began printing at his father's vicarage at Frome in 1851 and he relocated the press to Oxford in 1874. The early productions of the Daniel Press were, in the best sense, home-made affairs: small books printed by Daniel in limited numbers for his friends and family, typographically undistinguished, sometimes decorated and bound by his wife Emily, herself an accomplished artist. The intimacy of Daniel Press books is exemplified in *The Garland of Rachel* (1881), a collection of poetry that Daniel printed to celebrate his daughter's

first birthday; he enlisted literary friends as contributors, including Robert Bridges, Lewis Carroll and Edmund Gosse. Despite its obvious commercial potential, Daniel printed only thirty-six copies for circulation among his family and the contributors. It is very rare and remains on the Library's list of desiderata.

The delicacy was never lost, although over time the Daniel Press grew in reputation and ambition. With Theocritus's *Sixe Idyllia* we move on to a higher plain. This was the first Daniel Press title to carry an illustration, a pretty etching by Alfred Parsons. It was also the first work to be issued in the larger quarto size, the first book to be priced (twelve shillings), and the first for which a prospectus was issued. It was printed in the famous seventeenth-century Bishop Fell type, which Daniel was largely responsible for reviving after a century and a half of neglect.

John R. Hodgson

HERE BEGINNETH THE TALES OF CANTER·
BURY AND FIRST THE PROLOGUE THEREOF

THAT Aprille with his shoures soote
The droghte of March hath perced to the roote,
And bathed every veyne in swich licour,
Of which vertu engendred is the flour;
Whan Zephirus eek with his swete breeth
Inspired hath in every holt and heeth

The tendre croppes, and the yonge sonne
Hath in the Ram his halfe cours yronne,
And smale foweles maken melodye,
That slepen al the nyght with open eye,
So priketh hem nature in hir corages;
Thanne longen folk to goon on pilgrimages,
And palmeres for to seken straunge strondes,
To ferne halwes, kowthe in sondry londes;
And specially, from every shires ende
Of Engelond, to Caunterbury they wende,
The hooly blisful martir for to seke,
That hem hath holpen whan that they were
seeke.

BIFIL that in that seson on a day,
In Southwerk at the Tabard as
I lay,
Redy to wenden on my pilgrym-
age
To Caunterbury with ful devout
corage,
At nyght were come into that hostelrye
Wel nyne and twenty in a compaignye,
Of sondry folk, by aventure yfalle
In felaweshipe, and pilgrimes were they alle,
That toward Caunterbury wolden ryde.

5.2 'Like a pocket cathedral'

Geoffrey Chaucer, *The Works of Geoffrey Chaucer*
Hammersmith: printed by William Morris at the Kelmscott Press, 1896
One of 13 copies printed on vellum, from a total edition of 438 copies
423 × 285 mm
R4833, f. b1r, opening of the Prologue

'Have nothing in your houses that you do not know to be useful, or believe to be beautiful.' So counselled William Morris (1834–96), socialist, poet, designer, book collector and printer. Few would choose to defend the Kelmscott *Chaucer* on the grounds of utility. Yet it is without doubt the greatest achievement of the private press movement, and in beauty it stands comparison with the illuminated manuscripts and early printed books that Morris so avidly collected. It could be said that Morris founded the Kelmscott Press in order to print the *Chaucer*; certainly he was discussing the idea as early as June 1891, and the enterprise dominated his life for the next five years. In 1892 he had a new type cut, several trial pages were printed, and the first announcement was issued. His friend Edward Burne-Jones began designing the engravings in the winter of 1892/3, but printing was fraught with difficulties and was not completed until May 1896. In June the first two bound copies were delivered to Morris and

Burne-Jones, who had likened it to 'a pocket cathedral'. Four months later Morris was dead.

Enriqueta Rylands was a collector of modern taste; and, thanks to her, the Library possesses a complete set of all fifty-three Kelmscott Press publications and an extensive collection of ephemera. Only after her death in 1908 did they pass to the John Rylands Library. She was apparently satisfied with a paper copy of the *Chaucer* – surprisingly – but the Library bought on its own account one of just thirteen copies printed on a beautiful creamy vellum, which sets off the dense Gothic type, borders and engravings to wonderful effect. It is housed in a blind-stamped pigskin binding, designed by Morris in the medieval style. We are thus one of the few libraries in the world where it is possible to compare vellum and paper versions of the Kelmscott *Chaucer* side by side.

John R. Hodgson

5.3 'The qualities of a gentleman'

John Milton, *Three Poems*
Hertford: Ashendene Press, 1896
No. 3 of 50 copies
218 × 160 mm
Private Press Collection / R216319, p. [13], opening of *Il Penseroso*

'My Press has been the most absorbing interest of my life and I never tire of thinking over the many happy hours I spent in that little room at Shelley House. The satisfaction and pleasure to be got out of a handicraft is only known to those who have experienced it. It is a wonderful relaxation, too, from all the cares of life and business worries. I wouldn't have been without it for anything.'

So wrote Charles Harry St John Hornby (1867–1946) shortly before his death. However, his press was far more important than a mere hobby for a stressed businessman. Hornby taught himself the fundamentals of printing after a few hours in the print room of W. H. Smith, where he was a partner and later Managing Director, and over many years he became a true master of the art. During the Ashendene Press's forty-year life, Hornby produced many magnificent books, which reflect his gentlemanly taste for Classical, English and Italian literature. The typography is of matchless beauty, the presswork flawless. The discerning Sir Sydney Cockerell wrote after Hornby's death that 'he is enrolled among the greatest printers of all time'.

These achievements grew from modest beginnings. Hornby produced the first book from the fledgling press in 1895, with help from his sisters, in an outhouse in the family home, called Ashendene, in rural Hertfordshire. The first ten books were all printed there in borrowed type, usually in very low numbers and all using only the help of his family. While the John Rylands Library purchased many of the later books directly from the press (including a vellum copy of *Tutte le opere di Dante*), these early publications were not for sale and so eluded the Library. Recently I have assisted the Library to secure several of these rare early works from the collection of Clarence B. Hanson Jr. They include *Three Poems of John Milton*, the press's fourth book, which is embellished with two borders designed by Hornby's future sister-in-law, Cassandra Barclay, then aged thirteen. It is inscribed to H. C. Hornby, probably the printer's mother Harriet.

Sophie Schneideman

IL PENSEROSO

HENCE, vain deluding Joys,
The brood of Folly
without father bred!
How little you bested,
Or fill the fixed mind
with all your toys!
Dwell in some idle brain,
And fancies fond with gaudy shapes
 possess,
As thick and numberless
As the gay motes that people the
 sun-beams;
Or likest hovering dreams,
The fickle pensioners of Morpheus'
 train.
But hail, thou goddess, sage and holy,
Hail, divinest Melancholy!
Whose saintly visage is too bright
To hit the sense of human sight,

IN THE BEGINNING

GOD CREATED THE HEAVEN AND THE EARTH. ¶ AND THE EARTH WAS WITHOUT FORM, AND VOID; AND DARKNESS WAS UPON THE FACE OF THE DEEP, & THE SPIRIT OF GOD MOVED UPON THE FACE OF THE WATERS. ¶ And God said, Let there be light: & there was light. And God saw the light, that it was good: & God divided the light from the darkness. And God called the light Day, and the darkness he called Night. And the evening and the morning were the first day. ¶ And God said, Let there be a firmament in the midst of the waters, & let it divide the waters from the waters. And God made the firmament, and divided the waters which were under the firmament from the waters which were above the firmament: & it was so. And God called the firmament Heaven. And the evening & the morning were the second day. ¶ And God said, Let the waters under the heaven be gathered together unto one place, and let the dry land appear: and it was so. And God called the dry land Earth; and the gathering together of the waters called he Seas: and God saw that it was good. And God said, Let the earth bring forth grass, the herb yielding seed, and the fruit tree yielding fruit after his kind, whose seed is in itself, upon the earth: & it was so. And the earth brought forth grass, & herb yielding seed after his kind, & the tree yielding fruit, whose seed was in itself, after his kind: and God saw that it was good. And the evening & the morning were the third day. ¶ And God said, Let there be lights in the firmament of the heaven to divide the day from the night; and let them be for signs, and for seasons, and for days, & years: and let them be for lights in the firmament of the heaven to give light upon the earth: & it was so. And God made two great lights; the greater light to rule the day, and the lesser light to rule the night: he made the stars also. And God set them in the firmament of the heaven to give light upon the earth, and to rule over the day and over the night, & to divide the light from the darkness: and God saw that it was good. And the evening and the morning were the fourth day. ¶ And God said, Let the waters bring forth abundantly the moving creature that hath life, and fowl that may fly above the earth in the open firmament of heaven. And God created great whales, & every living creature that moveth, which the waters brought forth abundantly, after their kind, & every winged fowl after his kind: & God saw that it was good. And God blessed them, saying, Be fruitful, & multiply, and fill the waters in the seas, and let fowl multiply in the earth. And the evening & the morning were the fifth day. ¶ And God said, Let the earth bring forth the living creature after his kind, cattle, and creeping thing, and beast of the earth after his kind: and it was so. And God made the beast of the earth after his kind, and cattle after their kind, and every thing that creepeth upon the

27

5.4　High idealism: The Doves Bible

The English Bible: Containing the Old Testament and the New
Hammersmith: Doves Press, 1903–5
One of 500 copies on paper
335 × 235 mm
Private Press Collection / R9629, vol. 1, p. 27, opening of Genesis

Thomas James Cobden-Sanderson (1840–1922) was a man of intense seriousness and high idealism. Disillusioned with life as a barrister, in middle age he took up fine bookbinding at the suggestion of Jane Morris; then, in 1900 he founded the Doves Press in Hammersmith, in partnership with Emery Walker.

Cobden-Sanderson rejected the claustrophobic medievalism of the Kelmscott Press: he tore down William Morris's rich damask curtains and allowed the light to flood into his books. None of the forty works published by the Doves Press was illustrated. The Classical simplicity of the typography, inspired by fifteenth-century Venetian printing, was simply enlivened with elegant initials by Edward Johnston and Graily Hewitt. The press's *magnum opus* was the English Bible, published in five volumes between 1903 and 1905, famous for its monumental opening to the Book of Genesis. Stanley Morison described it as 'the finest achievement of modern English printing'.

Sadly, while the Library holds vellum copies of the Kelmscott *Chaucer* and the Ashendene *Dante*, it is never likely to complete the 'triple crown' of Private Press publications, since only two official copies of the Doves Bible were printed on vellum, which are now housed at the Wormsley Library in Buckinghamshire and at the Bridwell Library, Dallas. We must content ourselves with a paper copy.

Cobden-Sanderson was the guiding spirit of the Doves Press but he was not an easy man to get on with, and his collaboration with Emery Walker ended in bitter acrimony. To prevent the Doves type being used after his death, in 1916 Cobden-Sanderson consigned the punches, matrices and over a ton of type to the bed of the River Thames.

John R. Hodgson

5.5 a & b The Essex House Prayer Book

The Book of Common Prayer and Administration of the Sacraments, & Other Rites and Ceremonies of the Church …
London: printed at the Essex House Press for Eyre and Spottiswoode, 1903
No. 8 of 10 copies printed on vellum

Together with: *Original Drawings and Designs for the Prayer Book of King Edward VII*
353 × 265 mm; 317 × 245 mm
Private Press Collection / R35292, pp. 66–7; R35293

The Essex House Press epitomised the ideals of the Arts and Crafts movement. Inspired by the socialism and revival of traditional crafts espoused by William Morris and John Ruskin, Charles Robert Ashbee (1863–1942) founded the Guild of Handicraft at Essex House in east London in 1888. Workshops run on co-operative lines attracted jewellers, silversmiths, enamellers and blacksmiths, and in 1898 the Guild established the Essex House Press, staffed by former employees of the Kelmscott Press. In 1902 the Guild moved

to Chipping Campden in the Cotswolds, but it was forced into liquidation only five years later.

The Prayer Book of Edward VII was the Essex House Press's masterpiece. It was intended as the modern equivalent of the 1549 Book of Common Prayer, and was illustrated with one hundred and fifty woodcuts and borders designed by Ashbee. Ten copies were printed on vellum, of which the first was presented to the King, while the remainder were sold at £40 each. Four hundred paper copies retailed at £12 12s.

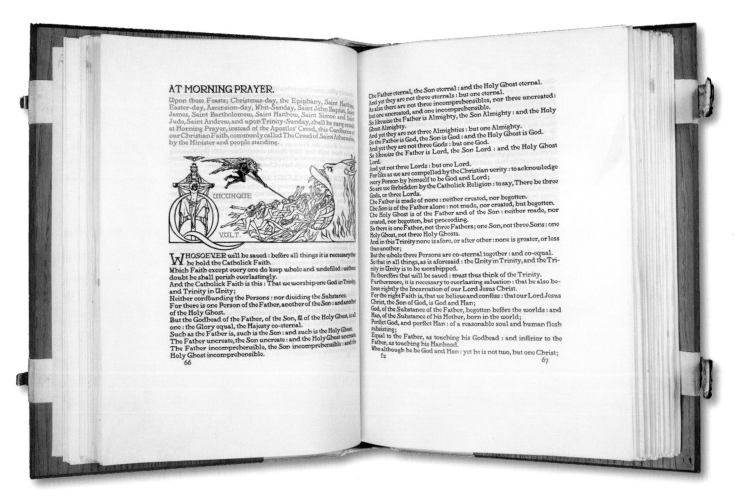

Around 1904 Enriqueta Rylands – a great admirer of the private presses – purchased a volume containing the preliminary pencil drawings and inked designs for the Prayer Book, which uniquely allow us to study how Ashbee's illustrations were translated into woodcuts. Many of the drawings carry Ashbee's comments; for example, after drawing a series of churchmen, he wrote under Bishop Butler: 'I'm so tired of these blessed bishops, please finish him off!' Shown here are the initial Q and accompanying image of the mouth of hell, from the opening of the Athanasian Creed.

John R. Hodgson

THE FABLES OF ESOPE

TRANSLATED OUT OF FRENSSHE IN TO
ENGLYSSHE BY: WILLIAM CAXTON
WITH ENGRAVINGS ON WOOD BY AGNES MILLER PARKER

THE GREGYNOG PRESS: NEWTOWN
MONTGOMERYSHIRE: - MCMXXXI

THE FIERY DRAGON.

THERE WAS ONCE A GREAT HALL, a squire, his wife and his daughter. And a poor man came there to ask for work. The old squire had a talk with him. "I have naught for thee to do," said he, "unless thou lookest after the cows." "Very well, sir." The squire went inside, and told the maids to give him something to eat. He got his bellyful. The old squire showed him where he was to sleep. And the poor fellow was happy. He went to bed. ℂ In the morning he arose and went outside to wash himself. Now the young lady comes out to call him into the house to get his victuals. The

B I

5.6 a & b Restrained Modernism: Agnes Miller Parker at Gregynog

The Fables of Esope, and John Sampson (ed.), *XXI Welsh Gypsy Folk-Tales*

Newtown, Montgomeryshire: Gregynog Press, 1931 and 1933

Nos 70 and 231 respectively of 250 copies each

308 × 215 mm; 278 × 192 mm

Private Press Collection / R94656, title page; R83724, p. 1

The Gregynog Press owed its gestation to Gwendoline and Margaret Davies, two wealthy and philanthropic sisters who are remembered today for the outstanding collection of Impressionist and Post-Impressionist art which they collected and bestowed upon the National Museum of Wales. In 1920 they acquired Gregynog Hall in Montgomeryshire, which, to alleviate unemployment, they envisaged as a centre for rural industries. The creation of a printing house for the purpose of issuing fine editions was the only direct outcome and its first book, *Poems by George Herbert*, was issued in 1923, printed under the direction of Robert Maynard and Horace Bray. Their books, illustrated with wood-engravings, were competent but unexciting.

Following the departure of Maynard and Bray in 1929, the Press entered a new era with the arrival of four artists from London: Blair Hughes-Stanton and his wife Gertrude Hermes, and their Scottish friends, William McCance and his wife Agnes Miller Parker (1895–1980). The years 1930–33 saw the Press at its most creative, producing some of the most exciting limited editions of the century, whose value has increased year upon year.

McCance, as Controller of the Press, had overall responsibility for design, and was anxious to put his own ideas into practice, with the result that *The Fables of Esope* has become one of the most recognisable private press books of the twentieth century. In addition to the thirty-seven wood-engravings created by Agnes, McCance himself cut the exciting initial letters which complemented her work. *The Fables of Esope* was the result of the splendid, if unorthodox, fusing of text and image and the meeting of two minds intent on creating a magnificent showcase for Caxton's translation.

The McCances were able to benefit from the Press's commitment to Welsh culture when Dora Yates, a loyal devotee of the work of Dr John Sampson, Librarian of the University of Liverpool and distinguished Romani scholar who had compiled the majestic *Dialect of the Gypsies of Wales*, offered to edit Sampson's collection and translation of Welsh gypsy folk stories. The Press eagerly agreed, although the severe economic downturn resulted in Agnes being limited to cutting the title-page design for *XXI Welsh Gypsy Folk-Tales* and seven further blocks. Although cubist and vorticist elements are present in *Esope*, they play less part in her second, and last, work for the Gregynog Press.

Ian Rogerson

5.7 'Employing human talents to the glory of God'

Raïssa Maritain, *Arbre Patriarche / Patriarch Tree: Thirty Poems*
Worcester: Stanbrook Abbey Press, 1965
No. XIV of 20 copies bound in full black morocco
253 × 186 mm
Stanbrook Abbey Press Collection / A12(1), pp. 2–3
Reproduced by kind permission of the community of
Stanbrook Abbey

The press founded at Stanbrook Abbey near Worcester in 1876 was unique: run by a religious community, rather than an individual or partnership, it stood at the interface between book design and religious belief. Famously the press was associated in the early twentieth century with one of the great figures of English bibliography, Sir Sydney Cockerell, who introduced the nuns to Emery Walker and C. H. St John Hornby. The press enjoyed a golden age under the direction of Dame Hildelith Cumming, who was printer from 1955 until her death in 1991. With the support of the Dutch typographer Jan van Krimpen and the English designer John

Dreyfus, Dame Hildelith developed a distinctive Stanbrook style: the use of characterful typefaces, expertly printed on fine hand-made papers; the deployment of white space to allow texts to 'breathe'; and a liveliness achieved through coloured inks, calligraphic decoration and fine bindings. David Butcher summed up the Press's achievement: 'The books are an enduring testament to the Benedictine aim of employing human talents to the glory of God.'

In 2007 the Library purchased a major Stanbrook Abbey Press collection, with funding from the Friends of the John Rylands. It contains all but one of the thirty-nine major works published by the Press between 1956 and 1990; thirty-four out of forty-three works printed at Stanbrook on behalf of others; seventeen of the attractive illuminated folders for which the Press was renowned; and scores of minor items and jobbing work. Shown here is one of just twenty special copies of Raïssa Maritain's *Arbre Patriarche / Patriarch Tree*, which was Dame Hildelith's favourite book, printed in van Krimpen's elegant Romanée italic.

John R. Hodgson

5.8 Letterpress lives (in Lancashire)

Gerald Cinamon, *E R Weiss: The Typography of an Artist:*
Emil Rudolf Weiss
Oldham: Incline Press, 2012
No. 131 of 250 copies
350 × 250 mm
Private Press Collection / R221981, pp. [154–5]
Reproduced by kind permission of the Incline Press

Letterpress printing using movable metal type was replaced in the commercial sector by computer typesetting and offset lithography during the 1970s and 1980s. However, a small band of private printers and enthusiasts keep the letterpress tradition alive.

The Incline Press was founded by Graham Moss in the early 1990s. From modest beginnings it has since grown into one of the most active and highly respected private presses in Britain, with over fifty books to its credit and many more in the pipeline. Its home is a former cotton mill in the heart of Oldham, an industrial town nestled in the foothills of the Pennines, east of Manchester. The Library has a complete collection of Incline Press publications, and Graham has given numerous talks and printing demonstrations at the John Rylands Library, bringing to life our collection of historic presses.

Gerry Cinamon's definitive study of the German painter, illustrator, wood-engraver, graphic designer and calligrapher Emil Rudolf Weiss (1875–1942), is one of the largest and most ambitious books the Incline Press has produced to date, running to 178 pages and containing scores of tip-ins specially printed for the book. Research began in 1996, and printing was finally completed in March 2012. This book exemplifies how private printers are adapting to modern technologies. Although the book was letterpress printed on a Victoria platen machine (purchased new by Eric Gill, no less, in the 1930s), the text was designed, typeset and cast by Harry McIntosh of Speedspools in Edinburgh using a state-of-the-art MacTronic 2 computer interface. In addition, many of the reproductions of Weiss's letterpress designs were printed from plastic polymer blocks, instead of the more traditional zinc plates.

John R. Hodgson

6

Envisioning space: Maps and atlases

THE POPULARITY of maps in The University of Manchester Library reveals the fascination that many of us have with these objects. This was demonstrated as far back as 1923, when a loan exhibition of old maps was held in the University's Whitworth Hall. The exhibition, organised by Mr W. H. Barker and featuring the collections of Colonel Dudley Mills and Mr R. Booker, stimulated interest in the teaching of geography. It resulted in the establishment of the University's Department of Geography headed by Mr Barker; and subsequently the Mills and Booker collections were deposited in the University Library. The map collection expanded dramatically throughout the 1950s and 1960s, and in 1970 the Library acquired, on permanent loan, a large number of items from the Manchester Geographical Society. In addition, rare atlases and maps figured prominently in the John Rylands Library since the acquisition of the Spencer Collection in 1892.

The selection of maps and atlases chosen for this chapter, and for Chapters 12 and 13, represents the diversity of cartographic materials found in the collections, from fifteenth-century atlases to modern city maps by contemporary map-makers. It also provides an opportunity to show how maps can tell us stories. By looking at who made them and why, maps can tell us much about the society in which they were produced. They document people's developing knowledge of the world, often serve political and military interests and can help us to imagine and construct our cities.

The first three items selected for this chapter demonstrate people's developing knowledge of the world. These comprise a unique print taken from a metal map, created as an informative work of art (6.1); a world map constructed from the scientific observations of Ptolemy (6.2); and an impressive chart of discovery produced for a wealthy patron (6.3).

For anyone studying cartographic history, the Library's collection of rare books offers many important atlases which both showcase the work of prolific map-makers, and demonstrate a broad spectrum of cartographic techniques and styles. The 1500s saw revolutionary developments in Western cartography, influenced by the rediscovery of Ptolemy's work; the need to document information gathered from voyages of exploration; and the advent of printing.

Examples from this period and the subsequent golden age of cartography can be seen here in the work of Christopher Saxton (6.4); Abraham Ortelius (6.5a); Gerard Mercator (6.5b) and Joan Blaeu (6.6). The Library also holds important works by many other cartographers, including John Speed's highly decorative *Theatre of the Empire of Great Britain* and many more examples of English, Dutch and French atlases from the sixteenth century onwards.

Maps are not, however, simply representations of reality. Every map-maker has to select what to include in a map and what to leave out, and it is these decisions which help us to identify the purpose of the map and whose interests are being served by it. The 'Prussian Octopus' map (12.7) and the German invasion map (12.9) provide examples of propaganda and military intent. In addition to being a pre-war propaganda tool, Mitchell's map of North America (6.7) played a significant role in boundary disputes for over two hundred years. Closer to home, the Soviet map of Manchester (6.11), prepared in the event of possible invasion, offers an unsettling representation of the city; whilst *The Drink Map of Manchester* (6.10) provides an example of a social movement attempting to influence Victorian drinking habits.

Maps also help us to organise, navigate and imagine our cities. City maps and plans are well represented in the Library, from seventeenth-century plans of Paris and London to comprehensive coverage of Manchester's urban development. Included here is the first large-scale map of Manchester, created when the town's landscape was being radically transformed by the Industrial Revolution (6.9). H. W. Brewer offers us a three-dimensional representation of the city, in the form of *A Bird's Eye View of Victorian Manchester*, celebrating the magnificence of the city's architecture.

Maps featured in the *City of Manchester Plan* (13.1) reveal utopian ideals for a future city devastated by Second World War bombing raids. Numerous editions of a contemporary city map by Andrew Taylor (the first edition features in 13.2) record how central Manchester has been reconstructed following the IRA bomb in 1996. In addition, the Library holds many historical and modern maps and plans of Manchester and the surrounding area: these include works from private surveyors; detailed Ordnance Survey plans; and works by contemporary visual artists and designers.

In recent years the Library's map collection has been popular with a growing number of diverse audiences from those studying social history, architecture, politics, geography and the visual arts, to people interested in researching their family history. The Library continues to develop its map and atlas collection and has embarked upon several digitisation projects which have focused upon historical maps of Manchester. In 2009 an exhibition entitled 'Mapping Manchester: Cartographic Stories of the City' featured a number of items from the map collection. It was one of the most popular exhibitions held at the John Rylands Library in recent years, demonstrating that maps continue to fascinate new audiences of all ages and from many different backgrounds.

Donna M. Sherman

6.1 Here are dogs stronger than lions … : A fifteenth century map of the world

According to the distinguished map historian and collector A. E. Nordenskiöld the map shown here 'is in all probability the oldest printed map which is at the present time preserved'.

The map is a unique print taken from a circular metal map which is preserved in Cardinal Stephan Borgia's Museum at Velletri. The map is not a print from a copper-engraving in the traditional sense, but an impression such as goldsmiths take of their art work to assist its progress and to see how it will look upon completion.

The printed map was purchased in Venice by Nordenskiöld, and his research suggests that it dates from around 1410. One of the most intriguing aspects of the map is the anonymity of its maker and the reason for its creation. The map appears to be didactic in its nature, despite its sometimes fanciful observations and decorative appearance.

Observations by Nordenskiöld point to the map being produced by a well-travelled man, rather than simply being based upon commentaries by the map-maker's contemporaries. As well as providing an indication of the geography of different countries, it offers vibrant descriptions of their ethnography, natural conditions, religion and significant events in history.

The map is oriented with Africa at the top, Asia to the east and Europe to the west. This differs from the convention of many medieval maps which were centred on Jerusalem and dissected by a 'T' motif; comprising the River Don to the Nile running west to east and intersected by the Mediterranean sea.

Donna M. Sherman

Unknown artist, copy from a 15th-century
Map of the World engraved on metal,
which is preserved in Cardinal Stephan
Borgia's Museum, Velletri
Engraving on paper, c.1410
635 mm diameter
Map Collection:
JRL B1(224)

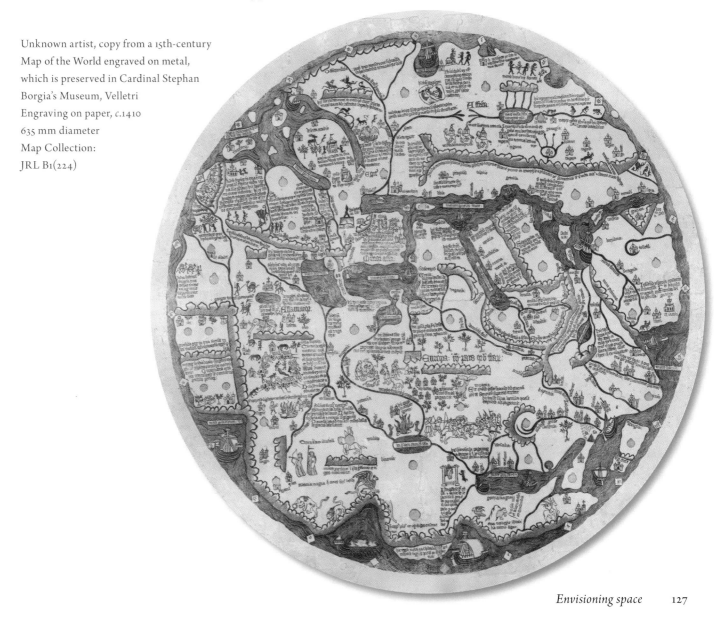

6.2 The origins of scientific map-making

C. Ptolemy, 2nd century, *Cosmographia*, trans. Jacobus Angelus, ed.
Nicolaus Germanus
Ulm: Johann Reger for Justus de Albano, 1486
Hand-coloured engraving on paper
Plate 115/116: World map
420 × 540 mm
Spencer 19038

The foundations of scientific map-making are often attrib-
uted to Greek geographers, the most famous being Claudius
Ptolemy (AD 90–168). Ptolemy's main geographical work,
sometimes cited as *Cosmographia* or *Geographia*, was a
compilation of geographical knowledge about the world in
Roman times. The work included information on map pro-
jections and listed over eight thousand places along with
their estimated co-ordinates. However, there are no existing
manuscript maps based on Ptolemy's findings earlier than
the twelfth century.

Manuscripts of *Geographia* were adopted and translated
by Islamic cartographers in the eighth century AD but were
lost to the Western world until the early years of the fifteenth
century. During the renaissance of classical cartography in
the fifteenth century, many printed editions of Ptolemy's text
and maps, reconstructed from his instructions, appeared in
atlas form. The map of the world shown here is from the Ulm
edition of *Cosmographia* published in 1486. The John Rylands
Library holds several editions of Ptolemy's work including
one of the earliest editions, published in Bologna in 1477.

There were significant errors in Ptolemy's calculations,
such as underestimating the Earth's size, and the area of the
circumference occupied by Asia and Europe. Whilst some of
these inaccuracies persisted until 1700, his work tells us much
about what the Romans knew about the world's geography
at that time.

Donna M. Sherman

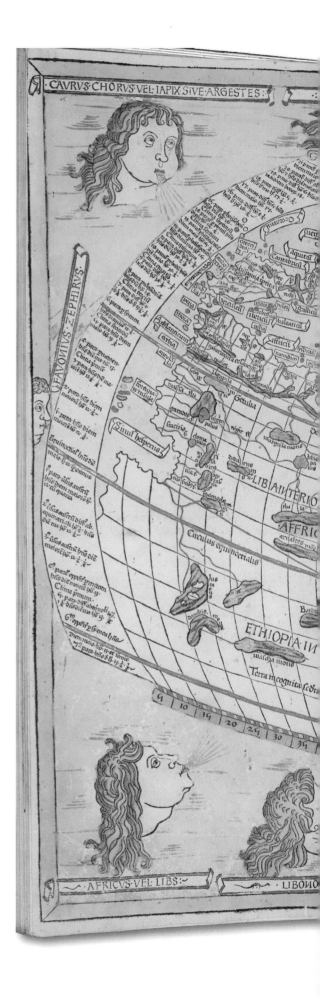

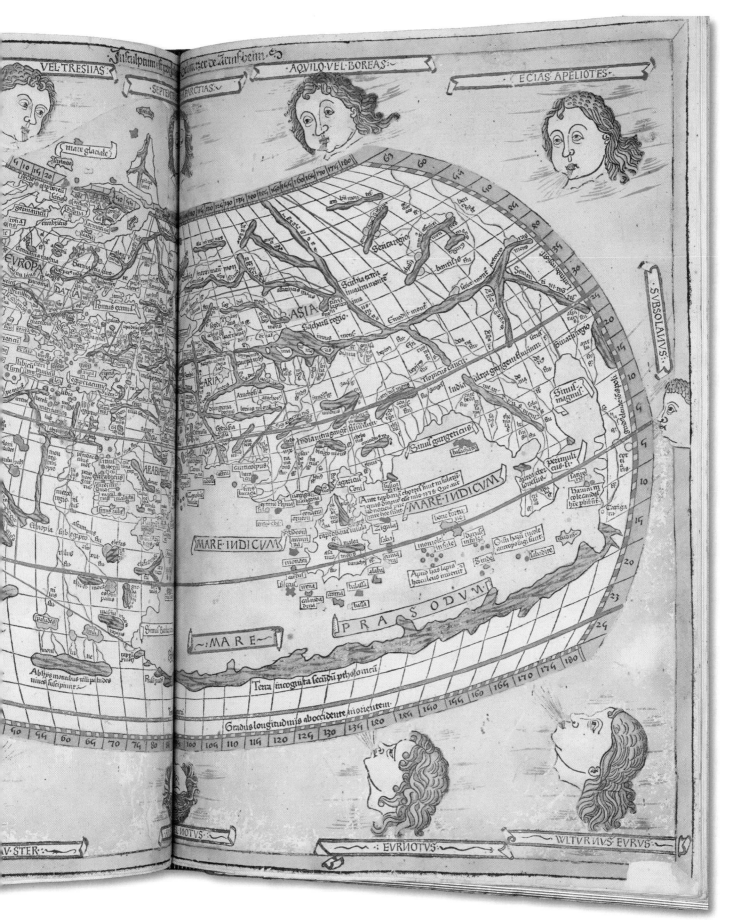

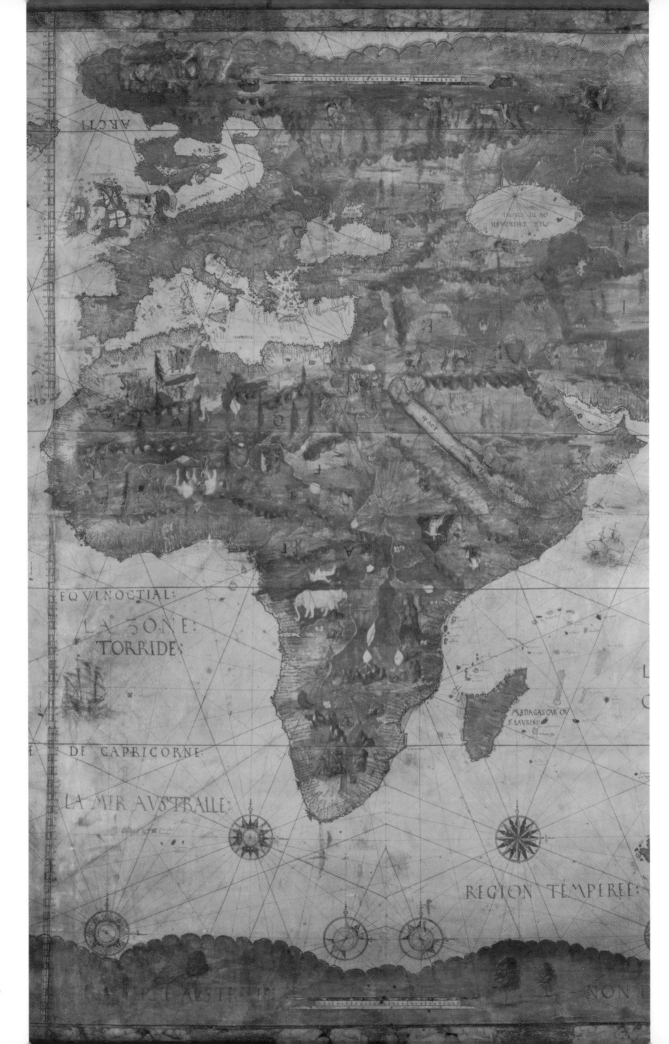

6.3 The Age of Discovery: Detail of British Isles and Africa

P. Desceliers, *Mappemonde*
Painted on vellum, 1546
2,600 × 1,300 mm
French MS 1*, detail

The image shown here is a detail from Pierre Desceliers's *Mappemonde*, or 'World Map'. It is one of three large world maps produced by Desceliers which were made to order for the court of Francis I. Desceliers, a parish priest and chief pilot to the French Navy, was the most distinguished French chart-maker of the Dieppe School of Hydrography. His map is a large hand-made work of art produced for wealthy or royal patrons and is over two and a half metres in height. It has been painted, using minerals, upon the flesh side of six sheets of vellum.

This impressive manuscript map marks a transitional phase from the medieval to the modern era. Whilst the map depicts fantastical creatures and imagined places, it is also remarkably accurate for its time and represents the rapid spread of discovery. For example, Desceliers's depictions of the Americas are surprisingly accurate and there is even a good representation of what is thought to be part of Australia, prior to its official discovery fifty years later.

The map also combines both historic and modern information, including recent discoveries along the Canadian coast and the location of precious spices and minerals. Desceliers's awareness of current events is reflected by his depiction of the war between England and France, represented by galleys flying blue flags sweeping towards this island, carrying French aid to Scotland.

Donna M. Sherman

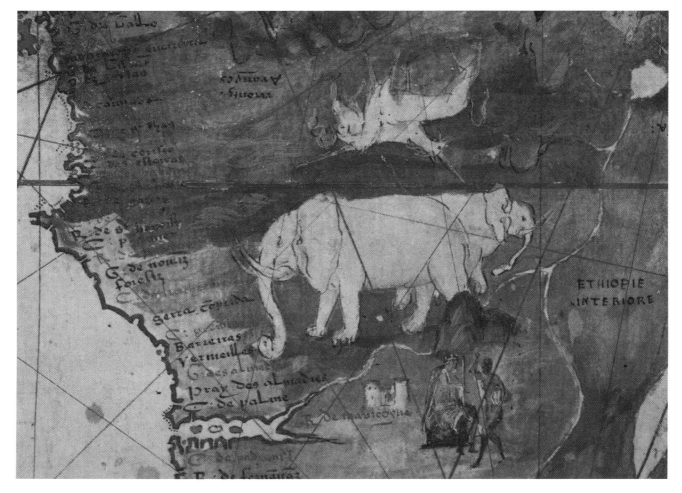

6.4 Mapping England in the sixteenth century

C. Saxton, *Atlas* [containing 34 maps of England and Wales]
London: Christopher Saxton, 1579
Hand-coloured engraving on paper
Plate 27: Lancastria
420 × 510 mm
R1771

This atlas, containing the works of Christopher Saxton and privately commissioned by wealthy barrister Thomas Seckford, is considered to be the first national atlas to be produced in any country. It was published in 1574 and comprises a general map of England and Wales and thirty-four highly decorative and informative county maps.

Cartographic development in Britain during the 1570s was influenced by skilled Flemish map-makers introducing the art of copper-engraving into England, accompanied by improvements in surveying techniques and equipment. Furthermore, following the dissolution of the monasteries and the redistribution of monastic land, wealthy landowners began to commission maps of their property. It was not long before mapping the areas owned by the Crown also became an urgent issue; and, from the Elizabethan period up until the beginning of the nineteenth century, the county map and the private county surveyor characterised regional mapping in Britain.

Christopher Saxton was amongst the greatest of British cartographers to emerge from this period, and was granted his own coat of arms by Queen Elizabeth I. It was support from the Queen which granted Saxton access to any tower, castle or hill in order to view and survey the surrounding landscape.

Saxton's exuberant maps reflect the commercial prosperity of Elizabethan society and the new wealth of landed gentry. He used conventional symbols effectively to represent settlements and features of the landscape such as hills, rivers, towns and villages, but, surprisingly, he omitted roads and a key or a legend. However, the accurate position of settlements appears to have been Saxton's priority, indicated by the pinpointing of the centre of each settlement with a dot within a circle.

The map shown here is of the county of Lancashire. The sea monsters such as those depicted in the Irish Sea, gave engravers the opportunity to flaunt their artistic flair.

Donna M. Sherman

6.5 a & b
The first atlas

A. Ortelius, *Theatrum orbis terrarum*
Antwerp: [Coppens de Diest], 1573
Engraving on paper
Frontispiece
380 × 240 mm
Spencer 3905

G. Mercator, [*Mercator's Atlas*]
Amsterdam: *c.*1625
Engraving on paper
Plate 41/42: Polar map
460 × 560 mm
Northern Congregational College
Printed Collection / R214774

The first atlas of the world, *Theatrum orbis terrarum* (Theatre of the World), has been attributed to Abraham Ortelius. This work was the first bound collection of maps showing parts of the known world which were engraved in a uniform size and style and were based upon the most reliable sources available. The publication was an immediate success and was translated into several languages and issued in over forty editions. However, it was Gerard Mercator, a distinguished geographer and map-maker, who later coined the word 'atlas' named after a legendary Moroccan king, renowned for his skills in geography, mathematics and astronomy.

Ortelius and Mercator were both born in or around Antwerp and represent a period of map-making during which the Low Countries were unsurpassed in their cartographic supremacy, producing maps which were remarkably accurate for the period and demonstrating great beauty and craftsmanship. Far from being rivals, Ortelius and Mercator

enjoyed a fruitful friendship, *Theatrum* possibly being a product of Ortelius's enterprise and Mercator's exceptional cartographic skills. Mercator, famous for developing the map projection which bears his name, also produced a magnificent atlas, which was reissued many times by various distinguished map publishers such as Jodocus Hondius, Jan Jansonn and Willem Janszoon Blaeu.

The frontispiece to Ortelius's work is shown here, the four female figures representing different continents:

Europe at the top; Asia to the left; Africa to the right; and America at the bottom. A map from Mercator's *Atlas* depicts the North Pole, along with insets of the Shetland and Faroe islands. The inset at the top left of the map shows an imaginary island, Frisland, which appeared on a copy of a fake medieval map in 1558, an oversight which persisted for several decades!

Donna M. Sherman

6.6 The golden age of cartography

J. Blaeu, *Atlas maior (The Grand Atlas)*
Amsterdam: Blaeu, 1662
Hand-coloured engraving on paper
Plate j/ij: Terrarum orbis tabula
410 × 550 mm
Spencer 8069

During the seventeenth century Amsterdam took Antwerp's place as the leading map-making city in Europe. The rival publishing houses of Blaeu and Jansson were producing maps and atlases unrivalled in their beauty and elegance. Joan Blaeu continued the business after the death of his father (Willem Janszoon Blaeu) in 1638. Between 1662 and 1672 Blaeu published one of the finest atlases ever produced, the *Atlas maior* or *Grand Atlas*. It was the largest and most expensive printed book in the seventeenth century and was published in Latin, French, Dutch, German and Spanish. It comprised approximately six hundred maps and three thousand pages of text. Wealthy clients could commission a binder to bind their volumes in red velvet, embellished with their crests. It is likely that this copy was bound by the distinguished binder Albert Magnus. There are eleven volumes in the Latin edition, and all volumes comprise hand-coloured maps with gold highlighting.

The image shown here was designed as an eye-catching ornament to serve as the frontspiece to the *Great Atlas*. Representations of the four seasons appear along the bottom. From left to right are Spring, Summer, Autumn and Winter. Portraits of the astronomers Galileo and Tycho Brahe (Joan Blaeu's father's teacher) adorn the corners, with several Classical deities appearing on clouds in between. California is shown as an island off the west coast of North America but the outline for the western portion of Australia is remarkably accurate.

Donna M. Sherman

6.7 The power of maps

J. Mitchell, *A Map of the British and French Dominions in North America. With the Roads, Distances, Limits, and Extent of the Settlements. Humbly Inscribed to the Right Honourable the Earl of Halifax, and other Right Honourable The Lords Commissioners for the Trade & Plantations ...*
London: Andrew Millar, 1755
Hand-coloured engraving on paper
1,370 × 1,960 mm
Map Collection: Mills and Booker F6, detail

John Mitchell's map of the British and French Dominions in North America, published in 1755, has been regarded as the most important map in American history. It served both geographical and political purposes, containing detailed and current information and defining territorial boundaries. The large-format map, measuring almost two metres wide, was initially produced for the British public, to emphasise the French threat to British colonies in North America. As such, the map demonstrates a strong English bias, evident in its interpretation of various boundaries and its questionable claims to some territories such as land inhabited by the native Iroquois people.

Mitchell produced an initial draft of the map in 1750, but the result had been dependent upon sources which were publicly available. Impressed by the first draft, the 2nd Earl of Halifax, President of the Board of Trade and Plantations, commissioned Mitchell to make a new and improved map, giving him access to official archives and instructing colonial governors to supply him with detailed maps and boundary information. The result was a map which displayed the most detailed and current information of the region, including descriptions of natural resources, potential settlement regions and Indian tribes and trails.

The third edition of the map was used at the 1783 Treaty of Paris to dispute French claims in North America and to establish the boundaries of the new United States. The map has played a significant role in many legal boundary disputes since, and was used as recently as the 1980s in a US–Canadian dispute over the Gulf of Maine fisheries.

Donna M. Sherman

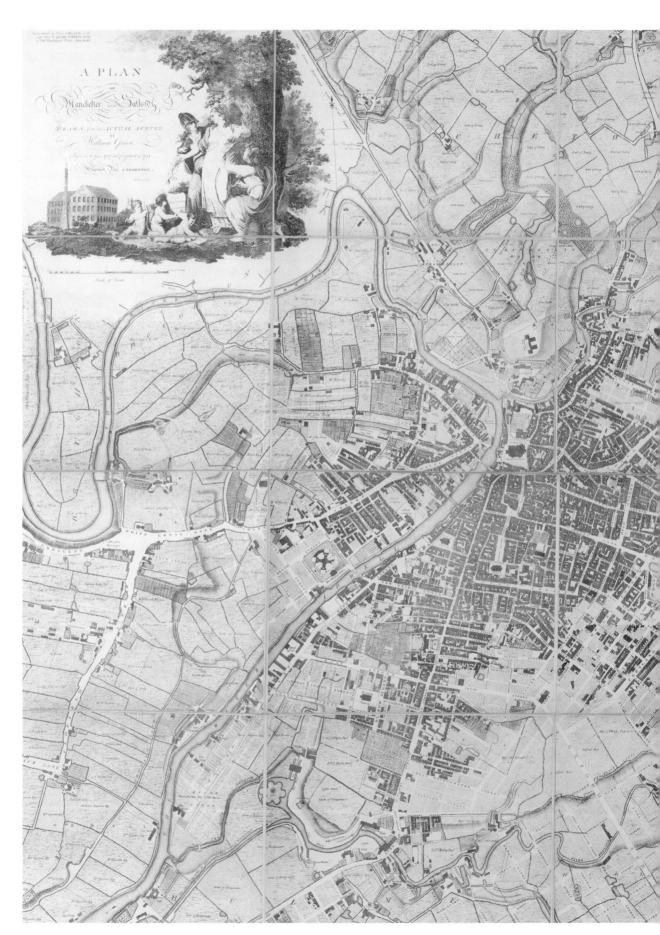

6.8 Planning for change in the industrial city

W. Green, A Plan of Manchester and Salford, drawn from an actual survey by William Green, begun in the year 1787 and completed in 1794
Manchester: Deansgate Press, 1902
Print on paper
1,170 × 1,440 mm
Map Collection: C17:70 Manchester (12), detail

In 1794 William Green, a Manchester surveyor and artist, produced the first large-scale map of Manchester. The original map measured over eleven feet by nine feet and it was the most detailed and authoritative map of Manchester available during the eighteenth century. It was engraved by the Manchester-based John Thornton.

The plan is a powerful visual representation of how the Industrial Revolution was transforming Manchester's landscape. Green intentionally extended the map beyond the boundaries of the township, recognising that Manchester's rapid expansion would soon lay claim to undeveloped land. Rows of streets are named but not yet built upon, and surrounding pastures provide details of land ownership and field boundaries

The cartouche, drawn by William Craig, heralded this new Manchester, personified as a female. She is accompanied by Britannia representing trade, and a kneeling female representing industry. The factory represents the new cotton industry that was driving Manchester's economic growth, whilst the bobbin, shuttle and beehive symbolise industrial progress.

Green clearly saw the commercial potential of the map to his subscribers but the survey progressed slowly and failed to make much profit. This in part was due to a French geographer, Charles Laurent, publishing his cheaper and smaller map of Manchester just four months prior to Green's. However, it is widely believed that Laurent plagiarised Green's survey, clearly alluded to in the title of Green's map, '... drawn from an actual survey by William Green'.

The detail shown here is from a facsimile of the original map, produced by G. Falkner and Sons of the Deansgate Press, Manchester in 1902. The map is printed on sixteen sheets bound into a single volume; it was donated to the Library by the Manchester Geographical Society.

Donna M. Sherman

6.9 Bird's-eye view of Victorian Manchester

H. W. Brewer, 'Bird's-Eye View of Manchester', *The Graphic:
An Illustrated Weekly Newspaper*, 4:2 (November 1889), f. 576
London: s.n., 1889
Print on paper
585 × 1,260 mm
R198665

H. W. Brewer was a Victorian illustrator and architectural draughtsman known for his depictions of cities drawn from an elevated viewpoint. His bird's-eye views were produced for architects' magazines such as *The Builder* and weekly newspapers such as *Harper's Weekly* and, in this example, *The Graphic* magazine. Brewer produced his aerial panoramic

DRAWN BY H. W. BREWER

A BIRD'S-EYE VIEW OF

views of cities such as Manchester, Birmingham, Edinburgh, Dublin and Portsmouth, as well as producing imagined views of historical London.

Most maps depict the built environment in two dimensions, but there has been a long history of trying to map out the city in a third dimension to evoke a more realistic impression of the urban landscape, whilst using artistic licence to emphasise its most important assets. In this example, Brewer exaggerated the size of the Town Hall and other buildings of 'architectural magnificence'. Brewer's viewpoint at the top of Exchange Station allowed him to capture details of the Cathedral, the Exchange, the Town Hall, and the Victoria University in the distance. Brewer prepared his drawing on a public holiday capturing the hustle and bustle of the city; however, the mills and slums belching out black smoke across the river and in the distance also depict a darker side of the city and its environs.

Copies of this map are now rare and often fragile because they were produced on poor-quality paper as supplements in widely circulated magazines. However, the Library has captured a digital image of the map, so that it can be preserved and enjoyed for many years to come.

Donna M. Sherman

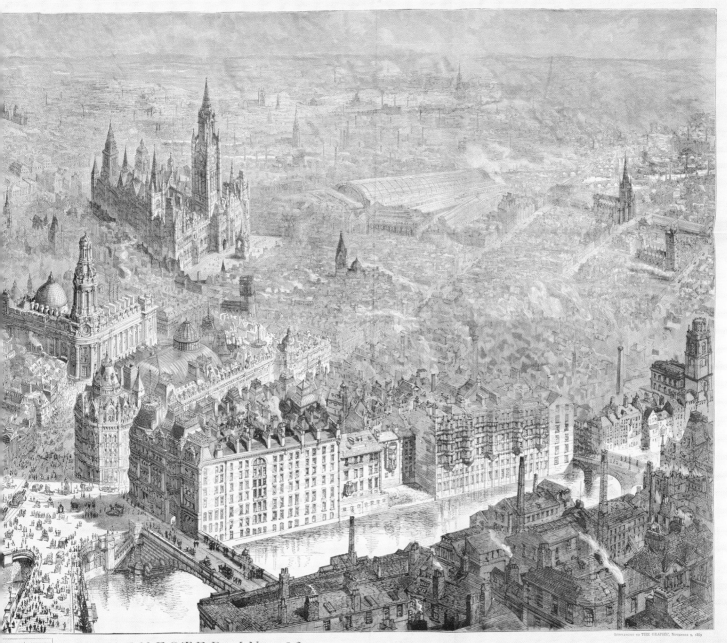

MANCHESTER IN 1889

6.10 Mapping the 'Demon Drink'

United Kingdom Alliance, *The Drink Map of Manchester*
Manchester: United Kingdom Alliance, 1889
Print on paper
725 × 595 mm
Map Collection: C17:70 Manchester (2), detail

The Drink Map of Manchester appeared in the *Manchester Guardian* in 1889 and was prepared for the information and use of city magistrates. It was published by the United Kingdom Alliance, a temperance movement which argued that the distribution and consumption of alcohol was directly related to poverty and crime.

The map shows the extent of liquor outlets like a rash all over the face of the city, with clusters in the poorer districts. Money wasted on intoxicants was also seen to rob trades which contributed to the comfort and prosperity of Manchester's people.

The United Kingdom Alliance called for a system of direct veto, whereby members of the public could object to liquor licences being granted in their own community. By giving citizens the power to protect their community, it was hoped that the 'evil of drink' prevalent in the City of Manchester would be removed:

> The foul blotches of drink that now disfigure the map will be removed, and increased health, order, and comfort will show how much opposed to the interests of the public are the trade interests of the publican. The removal of the most active agent of poverty, disorder, disease and crime, would give a boundless prosperity to the City of Manchester.

Donna M. Sherman

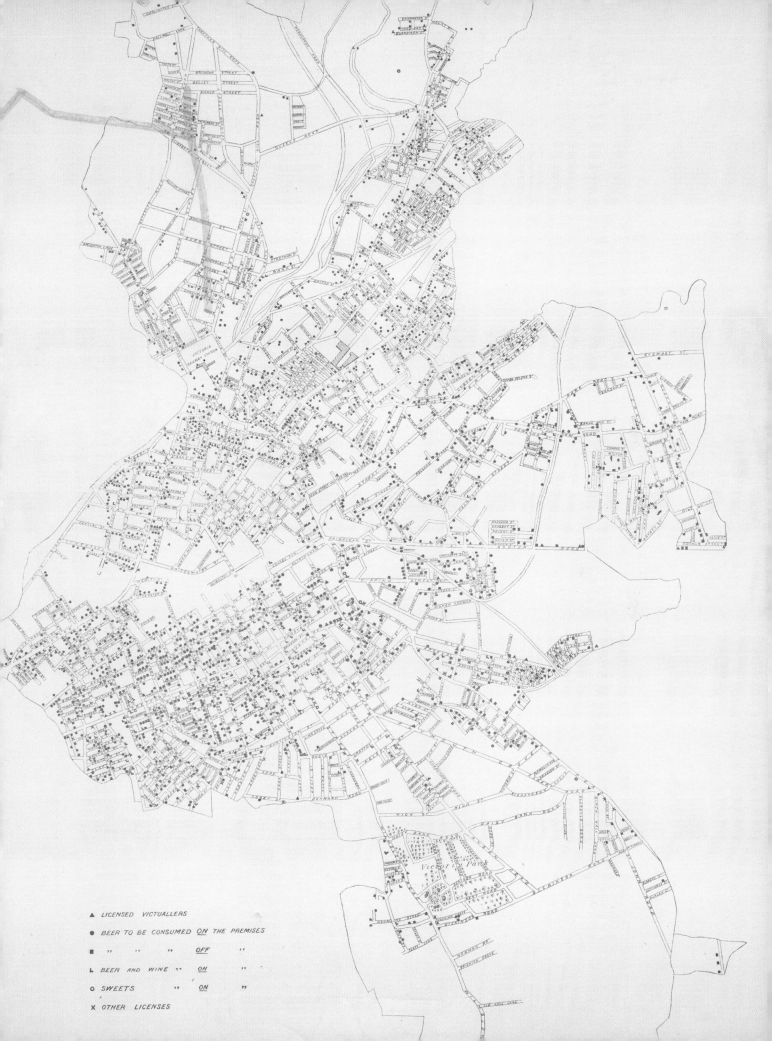

▲ LICENSED VICTUALLERS

● BEER TO BE CONSUMED <u>ON</u> THE PREMISES

■ " " " <u>OFF</u> "

L BEER AND WINE " <u>ON</u> "

O SWEETS " <u>ON</u> "

X OTHER LICENSES

6.11 Espionage and invasion: Detail of central Manchester and Trafford Park industrial estate

Military Topographic Directorate of the Soviet Union (VTU)
Soviet Military Map of Manchester and Surrounding Areas
[Sheet 3: Manchester, Stockport, Bolton and Oldham]
Soviet Union: VTU, 1975
Print on paper
825 × 925 mm
Map Collection: C17:41(3), detail

During the Cold War the Soviet Military secretly mapped foreign towns and cities in a staggering amount of detail. More than eighty UK towns and cities were mapped, including London, Edinburgh, Southampton and Manchester.

The maps often recorded information such as the width and gradient of roads, the carrying capacity and construction materials of bridges and the width and depth of rivers. Significant buildings were identified, numbered and classified according to three criteria: government and communications (purple); military (green); and military industrial (black). The maps also include descriptive accounts of the physical landscape, urban settlements, local industry and communication networks.

The level of detail depicted on the Soviet maps indicates that agents on the ground gathered intelligence to supplement satellite imagery and captured mapping of foreign cities. The amount of information gathered and the identification of strategically important targets point rather chillingly to invasion.

In this extract Manchester's city centre, Stretford and Salford have had their names transliterated into Russian and Trafford Park industrial estate can be clearly identified by black shading. Some roads have been marked in bold orange, possibly indicating assault routes wide enough to carry tanks along the Mancunian Way and Princess Road.

After the fall of Communism in the 1990s the maps became available on the Western market for the first time. Managers of individual print factories, local map dealers and eventually the Russian government all saw the opportunity to capitalise on the previously top-secret maps.

Donna M. Sherman

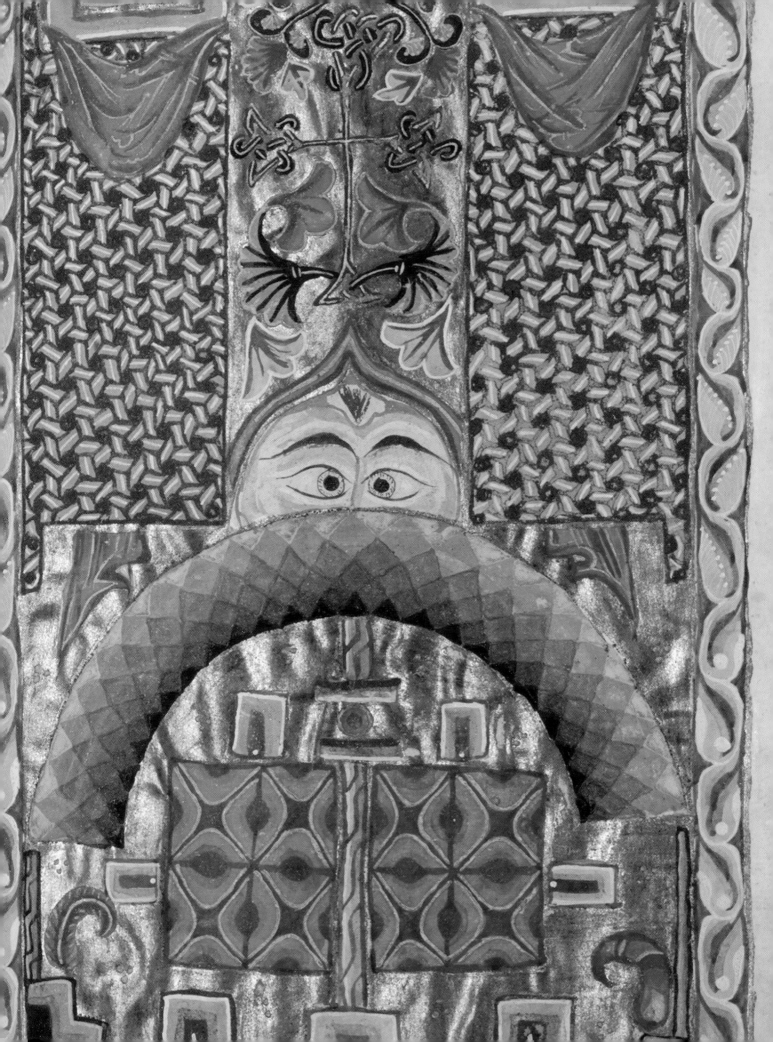

7

'Lively oracles of God': The Bible from antiquity to modernity

THE JOHN RYLANDS LIBRARY holds one of the world's greatest Bible collections, from early papyrus fragments to key printed editions. This chapter seeks to convey the richness and diversity of this extensive collection. The study of the Bible was central to the mission of the Library from its inception. Enriqueta Rylands shared with her husband John a strong belief in the importance of Bible study, reflecting their faith as Congregationalists. John Rylands had sponsored the printing of a Bible arranged by paragraphs to aid interpretation and also of an Italian translation along similar lines, to be distributed in the recently unified Italy. So it comes as little surprise that, after a year of acquiring modern theological works to form the core of the Library, Enriqueta began to buy rare and valuable Biblical texts. In 1891 her purchases included a copy of Caxton's *Golden Legend* and a Coverdale first edition, of which Enriqueta wrote: 'it will in itself stamp our library'.

By July 1892 the Library had a good collection of Bibles printed in English, but progress towards a complete series was slow. The purchase of the Spencer library enabled Enriqueta to fulfil this ambition and elevated the collections to international importance. Lord Spencer had sought to collect all the major landmarks of European printing and in doing so acquired hundreds of Bibles. The earliest woodcuts demonstrate the reception of the Bible in a predominantly oral culture (see 3.1 and 3.3), while the Gutenberg Bible spearheaded the printing revolution (3.2). The development of the printing press played a key role in the Protestant Reformation; the Bible could now be widely distributed and read, not only in Latin but also in vernacular languages (3.5). Inspired by humanist scholars who sought out the least corrupt manuscripts of Classical texts, theologians began looking back to the Greek and Hebrew versions of the Bible. This development was accompanied by increasing technological confidence, demonstrated in the great polyglot Bible (see 7.7). The printing presses thus catered both to the needs of popular devotion and to theological scholarship.

Before the opening of the Library, the holdings were almost exclusively printed. The mid-1890s saw a search for Wycliffite manuscripts from the fourteenth century in an attempt to fill the gap – at least for English translations of the Bible. However, the administration of the material that had already been obtained took precedence over new acquisitions. In January 1896, Enriqueta's agent J. Arnold Green wrote to her: 'As to early printed books and manuscripts I am

declining all offered to me in [*sic*] your behalf ... I even declined a Wycliffe manuscript the other day – an Old Testament, price £500, so you see I am learning my lesson.' The following year, however, Enriqueta demonstrated her commitment to Biblical scholarship through the purchase of fourteen Wycliffite manuscripts from the 'Ashburnham Appendix' (7.6).

A broader range of Biblical manuscripts was acquired by the Library in 1901 when Enriqueta purchased the Crawford Collection. The manuscript culture of medieval Europe was well represented, including important and beautiful Bibles (7.5) alongside commentaries, Books of Hours and service books (see Chapter 2). The collection also included important manuscripts from the Eastern Orthodox traditions and the Christian communities of the Coptic, Syriac, Ethiopic and Armenian churches (7.8). Furthermore, Christianity was by no means the only faith represented (see Chapter 8). Hebrew and Samaritan scriptures (7.3) sit alongside such Jewish treasures as the Esther scroll (1.3) and Haggadah (2.6). These manuscripts are a key resource for the understanding of the creation of the Bible and of how it has been read and interpreted through time.

Enriqueta Rylands was determined that the Library should be used to advance understanding and scholarship, particularly of the Bible. Her recognition of modern theological approaches can be seen in the Library's great north window, where Friedrich Schleiermacher (1768–1834), the father of modern liberal theology, stands alongside figures such as Moses, Paul and Jerome. In 1904 Enriqueta demonstrated her commitment to theological scholarship by endowing a Chair of Biblical Criticism and Exegesis at The University of Manchester, a post which has been held since 1997 by George Brooke, who introduces the first item in this chapter, eight fragments of Deuteronomy (7.1). These ancient Biblical scraps were part of a batch of papyri which also contained the fragment of the Gospel of Mary (7.2). They were purchased from James Rendel Harris in 1917 but arrived in the Library only in 1919. When Harris attempted to return from Egypt, his ship was torpedoed and sank; his close friend, the Biblical scholar James Hope Moulton, died from exhaustion. These fragments were identified by Colin Roberts in the 1930s and published alongside the fragment of the Gospel of John (see Introduction, p. 12) which had been purchased from Bernard P. Grenfell in 1920. With these discoveries, the John Rylands Library became known as the custodian of some of the most famous Biblical manuscripts in the world.

The John Rylands Library continued to collect Biblical texts after the death of its founder, albeit with a reduced budget. Of particular significance to the understanding of the Jewish traditions was the acquisition in the mid-twentieth century of the collections of Moses Gaster, which included the early Hebrew fragment of Jeremiah (7.3, see also Chapter 8). Later purchases include Bibles annotated by writers as varied as Hester Thrale Piozzi and Elizabeth Fry. Outstanding among these is a set annotated by John Nelson Darby, whose apocalyptic vision gripped the Protestant Evangelical movement (7.9). This literal interpretation of the Bible is a key aspect of Christian fundamentalism, which stands in contrast to the historical view of the Bible as a living text, changing to meet the needs of worshippers in different times and places.

Elizabeth Gow

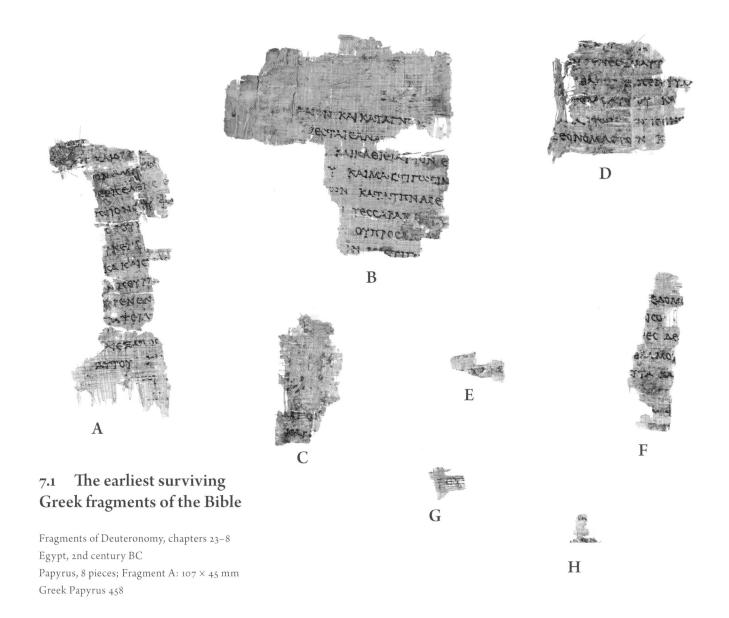

A

B

C

D

E

F

G

H

7.1 The earliest surviving Greek fragments of the Bible

Fragments of Deuteronomy, chapters 23–8
Egypt, 2nd century BC
Papyrus, 8 pieces; Fragment A: 107 × 45 mm
Greek Papyrus 458

The Jewish community in Alexandria, Egypt, translated Deuteronomy, the fifth book of the Torah, from Hebrew into Greek early in the third century BC. These eight fragments come from a papyrus roll penned in a very neat hand a century or more later, perhaps for synagogue use. They are the earliest extant Greek fragments of any book of the Bible. The fragments were recovered from two pieces of mummy cartonnage purchased in 1917.

The back of this discarded copy of Deuteronomy was used to write some kind of account in the second century BC, before being reused again as mummy cartonnage. The cartonnage also contained pieces of other literary works in Greek as well as Demotic documents. The name Setwoti, which is partially extant in these Demotic documents, was common in the Fayum region of Egypt. There were Jewish communities in the Ptolemaic Fayum, and these fragmentary remains of a discarded copy of Deuteronomy reveal the character of Jewish life there. Fragment A preserves the unique Jewish scriptural use of a technical term for 'trespassing' in Ptolemaic Greek. This possibly shows the minor assimilation of this Jewish law to local non-Jewish counterparts; although Jews had an autonomous legal system, they expressed themselves in a hybrid mixture of scriptural and Greek terms.

The Greek text of Deuteronomy in these fragments displays various distinctive features, several of which are found in the later Greek version of Codex Alexandrinus (fifth century AD). However, in a few places the text seems to be closer to the known Hebrew form of the text than the likely translation of the previous century. That probably indicates some genuine, if grudging, acknowledgement of the ongoing authority of what was coming from Jerusalem.

George Brooke

7.2 The Gospel of Mary

Fragment of the Gospel of Mary
Egypt, early 3rd century AD
Papyrus, 89 × 99 mm
Greek Papyrus 463

This fragment of papyrus preserves the final part of the Gospel of Mary. This apocryphal gospel tells the story of a disciple named Mary who played a central role in the inner circle of Jesus's first disciples. Scholars have debated whether the woman in question is Mary Magdalene, Mary of Bethany (the sister of Martha) or Jesus's mother, but the debate remains unresolved.

The Rylands fragment shows the male disciples Peter, Andrew and Levi arguing about whether or not to accept the teachings which Jesus revealed to Mary in private. It is a question of trust: Peter argues that Jesus would not have given important teachings to a woman. Levi accuses Peter of trying to sideline Mary in order to enhance his own importance.

To a modern eye, this is a surprising episode, but in early third-century Egypt, when the book that included this fragment was made, a wide variety of gospels and other narratives remembering Jesus and the apostles were in circulation, and many recorded debates over who could represent Jesus after his death. Beginning in the second century, a group of texts began to be referred to as the 'Canon' (literally,

'measuring-stick'), the standard against which the authenticity of other ideas and teachings could be judged. (The New Testament did not exist as a single bound collection until the fourth century.) Texts that were not chosen for the Canon were sometimes accepted as secondary witnesses to the faith of the early church, and sometimes dismissed as heretical. The Gospel of Mary, by contrast, simply seems to have been forgotten – its existence was not recorded in antiquity and it was rediscovered only at the turn of the twentieth century.

No complete copy of the Gospel of Mary survives, and Rylands 463 is one of three fragmentary manuscripts from which it can be reconstructed. P.Oxy.3525 preserves a second, briefer fragment of the Greek text dated to the early third century, while a longer but incomplete Coptic text dating to the fifth century is preserved in Berlin. Like P.Oxy.3525, the Rylands fragment is dated to the early third century on palaeographical grounds (i.e. analysing features of the handwriting and comparing it with that of firmly dated papyri). Its particular importance is that it preserves the only exemplar of the original Greek text of the debate among the male disciples about whether to recognise Mary's spiritual authority.

Kate Cooper

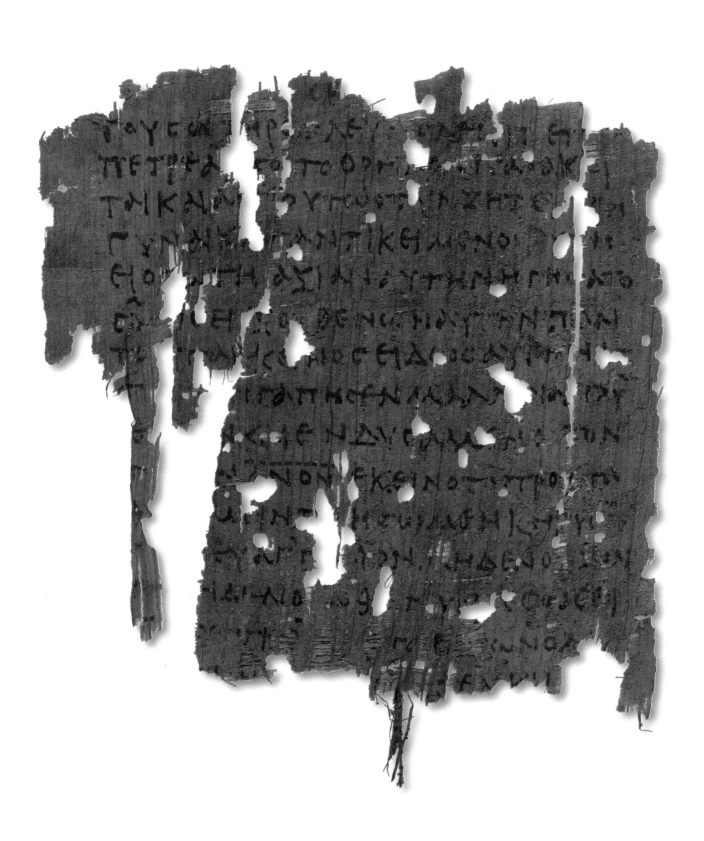

7.3 a & b An early vocalised fragment of the Book of Jeremiah in Hebrew

Fragment of Jeremiah, 1:1–12

Egypt, dated the year 886 from the destruction of the Jerusalem Temple (AD 954)

Parchment, 158 × 142 mm

Rylands Genizah 2, recto and verso

Before the discovery of the Dead Sea Scrolls, this nondescript little fragment was one of the earliest known manuscripts of the Hebrew Bible. It is part of a codex (rather than a scroll) and contains the opening chapter of the Book of Jeremiah (verses 1–12), arranged in two columns to the page. On the back is a colophon (placed at the beginning rather than the end of the text) which shows it belonged to a copy of the first four books of the Latter Prophets written in the year 886 from the destruction of the Jerusalem Temple (AD 954). It was copied in Gaifa, a small town to the north-east of Cairo

(at the time a great centre of Jewish life and learning), by a scribe called Sahalan. The Latter Prophets is the section of the Hebrew Bible containing the prophetic writings (Isaiah, Jeremiah, Ezekiel and the so-called Minor Prophets, Hosea to Malachi). Unusually Sahalan begins the Latter Prophets with Jeremiah, rather than Isaiah.

The text is fully vocalised – in fact it has two systems of vocalisation, Babylonian and Tiberian. The former is a set of small vowel-symbols written above the consonants, the latter vowel-symbols written mainly below. The Tiberian system, which replaced the Babylonian, is now standard in Hebrew Bibles. The appearance of both systems here, side-by-side, shows we are in a transitional period when one was taking over from the other. One of a number of medieval Hebrew Bible codices, this was a scholarly copy of the Biblical text, which recorded meticulously how the Hebrew is to be pronounced and punctuated. The Bible is actually read in synagogue from unvocalised scrolls: the reader needs a volume such as this to teach him how to read it correctly aloud. The parchment fragment comes from the Cairo Genizah, a cache of medieval Jewish manuscripts found in a storeroom in the Ben Ezra synagogue in Fostat, Old Cairo.

Philip Alexander

7.4 a & b Samaritan Pentateuch

Samaritan Pentateuch
AH 607 (AD 1211/12)
Parchment, 290 × 260 mm, ff. ii + 302 + ii
Samaritan MS 1, pp. 508 (Colophon) and 500 (Numbers 34)

The Samaritans are a religious and ethnic group which preserves a distinct version of the Pentateuch (the first five books of the Old Testament). This version is written in the ancient Hebrew script and is read by them in their own distinct Hebrew dialect. The Samaritans emerged during the second century BC in the course of disagreements with the Jews over the place of the sanctuary, which for the Samaritans is not Jerusalem but Mount Gerizim, an impressive mountain just south of Nablus.

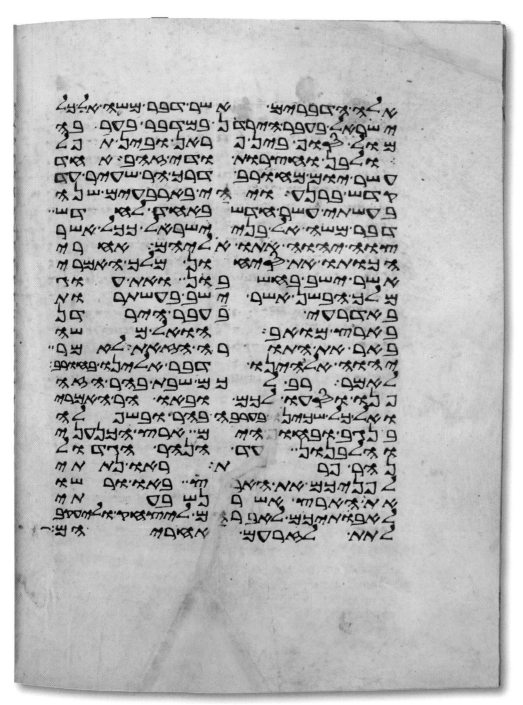

The present manuscript of the Samaritan Pentateuch is one of the oldest and finest to have been preserved. An embedded colophon, created through letters moved into an otherwise empty vertical band, stretches through the middle of several pages (see image on p. 156). This *tashqil* provides details of the creation of the manuscript: 'I, Abi Berakata, son of Sason [...] from Zarephath, have written this holy Torah for the two brothers Tabiah and Joseph, sons of Saada, [...] in the year 608 of the dominion of Ishmael. And it is the 27th Torah I have written. Great is God, who is witness for this.'

A key characteristic of Samaritan manuscripts is the geometrical arrangement of the written words in order to create an accompanying text, such as a colophon. This technique can also be used to create a type of illustration. Here, the page describing the borders of the Promised Land (Numbers 34) is shaped according to the Samaritan concept of the Holy Land: Mount Gerizim at the centre, surrounded by four parts according to the four points of the compass (see image below).

Stefan Schorch

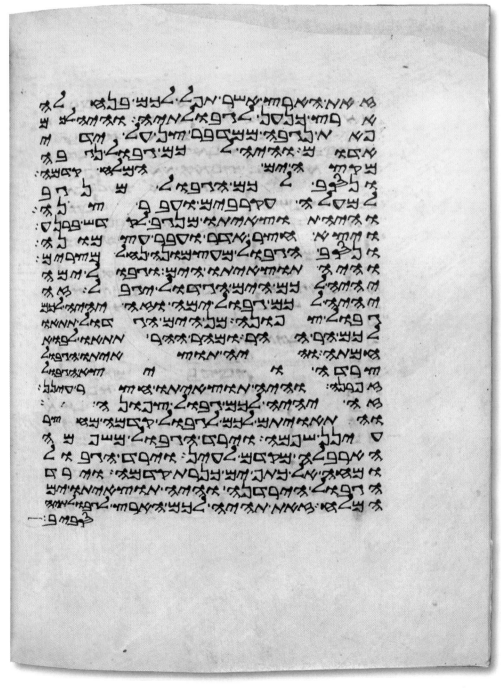

Jei font la tor babel cont la uolente deu · e il mua lor langues

q lun ne faueit q laut diseit · e deuant nesteir q langaige ·

7.5 Medieval Bible picture book

Bible historiée toute figures
North-eastern France or Flanders, early 13th century
Parchment, 185 × 150 mm, ff. ii + 48 + ii
French MS 5, f. 16r, Tower of Babel

This small volume contains a series of miniatures depicting scenes from Genesis and Exodus. It was illuminated in north-eastern France or Flanders early in the thirteenth century. The illustrations are accompanied by brief, essentially descriptive, inscriptions added in one of two hands, each of which postdates the illuminations by at least twenty or thirty years. The Rylands manuscript may originally have opened a prefatory cycle of miniatures for a Psalter, but it is more likely that it is an example of a rare type of illustrated scriptural compilation known as a 'Bible picture book'.

Bible picture books are typically lavishly decorated, exhibiting copious illumination, the finest pigments and a characteristic subordination of text to imagery that is exceptional in medieval codices of any genre. The full-page, single-subject miniatures in this example move slowly through the opening books of the Bible and exhibit the extensive use of gold. This page illustrates the construction of the Tower of Babel described in the Book of Genesis. The textual inscriptions did not form the basis of the overall composition; indeed it is likely that the cycle of illuminations was originally intended to function without any textual passages to identify or clarify the events depicted.

This reliance on images instead of text to convey sacred scripture is remarkable on several levels. The process by which this manuscript was created represents an inversion of the typical method of book construction. Traditionally scribes oversaw the design and layout of a medieval codex; countless examples show that the textblocks were entered on to the page prior to any pictorial decoration. The development of this practice stems in part from practicality, but also in large measure from medieval notions of the Word of God deserving precedence over everything else, including images meant to illustrate the scriptural texts. That inscriptions in Bible picture books were frequently added at a later date forces questions as to how they were meant to be 'read'. Was French MS 5 created merely as an extravagant display of the taste and wealth of its original patron? Certainly the added inscriptions indicate that its pictorial cycle, fine as it may be, failed to function without at least some verbal framework.

Caroline Hull

payede ſbiy preſent yingis ſoyely
le ſeyde / j ſhal not leeue yee neyer
forſake ſo yat ſbe triſtely ſeye /
ye lozde is an helper to me · j ſhal
not drede · ſbhat a man ſhal do
to me · haue zee mynde of zoure
ſouereynis · yat haue ſpoken to
zou ye ſbozde of god · of ſbhom
zee biholdynge ye goinge oute
of lyuynge · ſue ye feiy · jhu
criſt ziſtindaya to day he · t into
ſbozldis ¶ Nyl zee be ledde aſbey
ſbiy dyuerſe techyngis t pilgriy
oz ſtraunge · forſoye it is beſto
forto ſtable ye herte ſbiy grace
not ſbiy metis · ye ſbhiche profi
tiden not to men ſbandrynge
in hem / ſbe haue an auter of
ye ſbhiche yei yat ſeruen to ye
tabernacle of ye body · haue not
poſber forto ete · forſoye of ſbhi
che beeſtis ye blood is bozne in
foz ſynne into holy yingis bi ye
biſſhop · ye bodies of hem ben
brente ſbiy oute ye caſtels · foz
ſbhiche ying t jhu yat he ſhul
de haloſbe ye puyple bi his blood ·
ſuffride ſbiy outen ye zate · perfoze
go ſbe oute to hym ſbiy oute
caſtels · berynge his reproue oz
ſheuſſhip · ſoyely ſbe haue not
here adſbellynge cytee · but ſbe
ſeeken aytee to comynge / yerfo
re by hym offir ſbe an ooſte of
herynge euermoze to god · yat
is to ſeye ye fruyte of lippis kno
ſbeledynge to his name · forſoye
nyl zee forzete of ſbel doinge oz
zeuynge t of comunynge · foz
ſoye by ſuche ooſtis · god is deſer
uyde ¶ Obeye zee to zoure pzouoſ
tis oz pzelatis · t vndirleye zee
to heu / yer parfitely ſbaken ·
as to zildynge reſoune foz zoure
ſoules · yat yei do yis ying ſbiy
ioye t not ſorolbynge · forſoye
yis ying ſpediy not to zou · preye
zee foz vs · ſoyely ſbe triſten foz

ſbe haue gode conſcience in alle
yingis ſbillynge t to hyue ſbel
moze ouer to ſoye t biſeche zou
to ſbo do · yat j ſinner be reſtozde
to zou · ſoyely god of pees yat led
oute tiv deade men ye grete ſheperd
of ſheep · in ye blode of euerlaſtyng
teſtament oure lozde jhu criſt ·
ſhape oz make zou able in al
gode ying · yat zee do ye ſbille of
hym · doinge in zou yat ying yat
ſhal pleſe bifoze hym by jhu criſt ·
to ſbhom is gloze into honoure
ſbozldis of ſbozldis amen ¶ ſforſo
ye breyeren j preye zou yat zee
ſuffre a ſbozde of ſolace · forſoye by
ful felbe yingis j haue ſbriten
to zou · knoſbe zee zoure bzoyer
tymoythe lefte · ſbiy ſbhom zif he
ſhal come moze haſtely · j ſhal
ſe zou · Grete ſbel alle zoure ſoue
reynes t alle holy men · ye breyen
of ytalie · greten zou ſbel · ye grace
of god ſbiy zou alle zinuen

here biginnes ye apocalips

Pocalips oz reue
lacion of jhu criſt ·
ye ſbhiche god zaue
to hym forto make
oppn to his ſeruau
tis · ſbhiche yingis
it bihoney forto
be made ſoone / and he ſignyfiede
ſendynge bi his aungel to his ſer
uaunt joon · ye ſbhiche bare ſbit
neſſynge to ye ſbozde of god · t ſbit
neſſynge of jhu criſt in yes yingis
ſbhat euer yingis he ſize / Bleſſide
he yat rediy a he yat heriy ye ſbozdis
of yis pzophecie · and kepiy yo
yingis yat ben ſbriten in it · forſoye
ye tyme is niz / joon to ſeuene
chirchis yat ben in aſie · grace to
zou t pees of hym yat is t yat
ſbas t yat is to comynge · and
of ye ſeuene ſpiritis yat ben in
ye ſizt of his trone · t of jhu criſt
yat is a feiyful ſbitneſſe · ye firſte

7.6 Middle English New Testament

Wycliffite New Testament, Earlier Version
England, late 14th or early 15th century
Parchment, 270 × 192mm, ff. vii + 153 + xi
English MS 81, f. 143v, beginning of the Apocalypse

The first translation into English of the complete Bible was undertaken in the late fourteenth century by followers of the Oxford theologian John Wyclif (c.1330–84). Fourteen of the about 250 surviving manuscripts of this translation are now in the Rylands. Most of these are of the idiomatic Later Version, probably completed between 1395 and 1397, but this example is in the rather clumsy and literal Earlier Version translated c.1380–85 by Nicholas of Hereford and others. This version kept much of the word order of the specially collated Latin Vulgate text from which it was made and included alternative ways of rendering certain significant words or phrases, but left the final choice of expression to a later stage. In English MS 81 alternative translations are indicated by red underlining. Despite the intermediate state of the translation the book is formally written with rubrics and decorated initials.

John Wyclif's preaching against the wealth and sinfulness of the church hierarchy led to him losing his post at Oxford University in 1381. The association of the English Bible with Wyclif, and its use by the Lollards, caused it to be banned by Archbishop Thomas Arundel in 1407–9. Many manuscripts were burned. Later in the fifteenth century, however, ownership by devout Christians was permitted under supervision or episcopal licence, but only to allow a better understanding of the official Vulgate Latin text.

This manuscript was given in 1517 to her confessor and his brethren at Syon Abbey (Middlesex) by Dame Anne Danvers, widow of Sir William Danvers, in return for prayers for her family and others. She probably wished to surrender the manuscript into ecclesiastical hands rather than cause trouble for her heirs through their possession of it. Later owners included Edward Reynolds, bishop of Norwich, 1661–76; the Wycliffite scholar Lea Wilson (whose transcript of this manuscript is now English MS 902); and the 4th Earl of Ashburnham.

Alexander R. Rumble

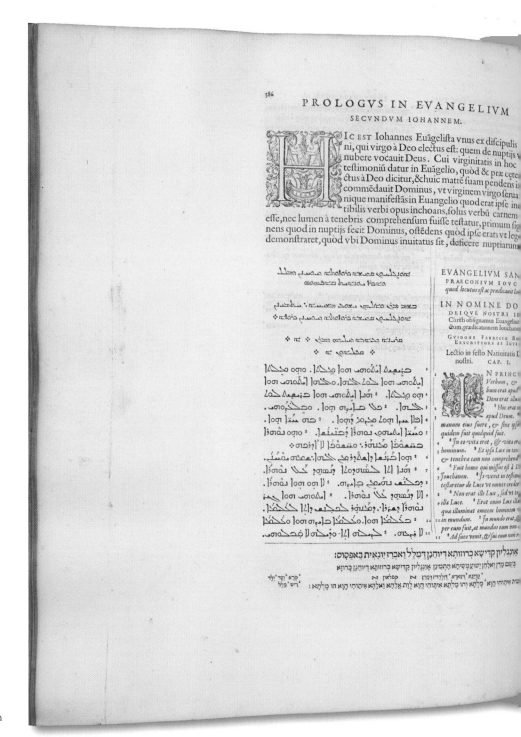

7.7 The Word of God laid out on the printed page

Biblia Sacra Hebraice, Chaldaice, Græce, & Latine
Antwerp: Christopher Plantin, 1569–73
Extra large imperial paper, 455 × 365 mm, 8 volumes
Spencer 8034, pp. 386–7, Prologue to John

The development of printing not only encouraged the publication of vernacular translations of the Bible but was also an impetus to produce scholarly editions of the earliest forms of the text. This era saw three magnificent 'polyglot' Bibles that printed versions of the text in Hebrew, Greek, Latin, Syriac and Aramaic: the Complutensian Bible produced under the auspices of Cardinal Ximenes in Spain from 1514 to 1517, the Antwerp Polyglot or 'Biblia Regia' published by Christopher Plantin, and the Walton Bible published by Brian Walton in

the seventeenth century. All three were exceptional collaborations of scholars, publishers, typefounders, compositors and engravers.

The Antwerp Polyglot Bible was printed in eight large folio volumes with the first four volumes covering the Old Testament, the fifth for the New Testament and three volumes of additional dictionaries and commentaries. After two years of planning, the printing of volume one began on 17 July 1568 and was completed with volume eight in April 1573. The

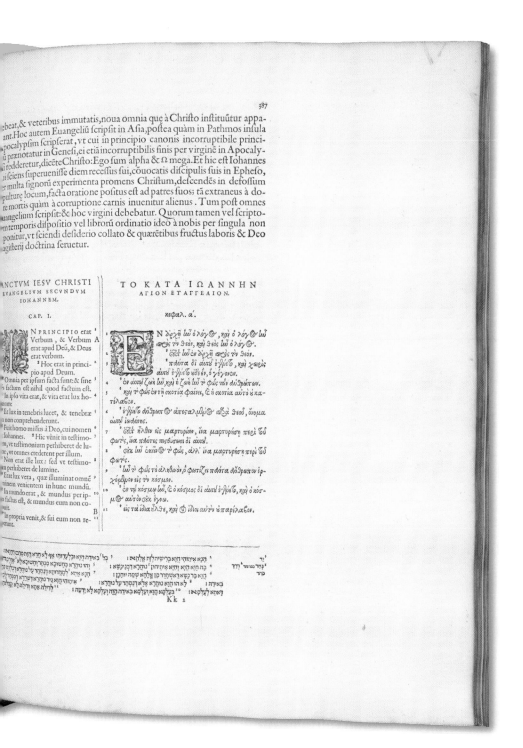

enormous expense was subsidised by Philip II of Spain who sent his own chaplain, Benito Arias Montano, to supervise the work. The opening illustrated here is the beginning of the Gospel of John. From left to right are the Syriac version, then a new translation into Latin, next the earliest Latin translation by Jerome (generally known as the 'Vulgate' version) and the original Greek text on the right. At the top of the opening is Jerome's prologue and along the bottom is the Syriac text printed again using the Hebrew alphabet.

We know a great deal about the planning, production and sale of this Bible from the archive of Christopher Plantin which has survived in Antwerp. A total of 1,212 copies were printed, including twelve special copies on vellum for Philip II. This copy is one of ten printed on extra large imperial paper especially imported from Italy which is why it has such wide margins. Its first owner was Jacques Auguste de Thou, a French politician and book collector.

Julianne Simpson

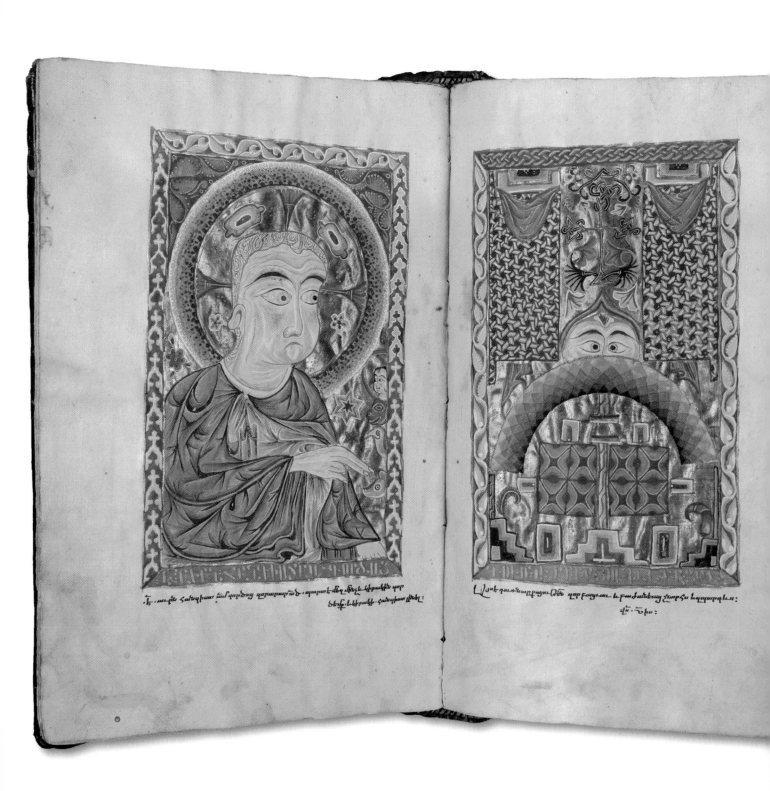

7.8 Armenian Gospel Book

The Four Gospels

Iran, 1587

Oriental paper, 273 × 170mm, ff. i + 339 + i

Armenian MS 20, ff. 7v–8r, God resting on the seventh day, and
Paradise

The illuminated pages depicted here belong to an Armenian
manuscript of the Four Gospels copied and illuminated in
1587 in New Julfa (in Isfahan, Iran), by the deacon Hakob
Jughayetsi, on the request of Khwaja Atibek. The artist
Hakob was the pupil of the famous scribe and artist Zakaria,
Bishop of Gnunik' (c.1500–76), at the scriptorium of the
Monastery of Lim, located on an island in Lake Van, in
modern-day Turkey. Nine manuscripts, dating from 1576 to
1610, have survived from his pen, the most outstanding of
which is this manuscript.

The most distinguishing feature of the manuscripts illu-
minated by Hakob is the inclusion of a cycle of miniatures
illustrating the Creation story in Genesis, chapters 1–11. Six
full-page miniatures are devoted to the Creation story. The
last two, shown here, depict God resting on the seventh day
and Paradise. Nothing could be farther from the traditional
iconographic type than to see God represented in a strange
but powerful figure which defies any customary representa-
tion, whether Armenian, Christian East, or Western art. God
the creator with a face of a Buddha is pointing at the heads of
the Evangelists' symbols with the legend below: 'This is the
seventh day, resting from all works which God performed.
It is our duty to work until Sunday and to rest on Sunday.'
The composition on the facing page is explained: 'This is the
gate of the kingdom that He opened, and bestowed grace
and blessings to the world.' The half-face peeping above the
arch which encloses the gates of Paradise represents God the
Creator.

In the context of Armenian art of the Middle Ages,
Hakob Jughayetsi's artistic style, which is a fusion of both the
Western and the Eastern, not witnessed before or repeated
since, is the trademark of an artist of genuine talent, ability
and individuality, who makes a conscious effort to emphasise
the link between the Old and New Testaments.

Vrej N. Nersessian

7.9　John Nelson Darby's Bible

Novum Testamentum Graece, annotated by John Nelson Darby
Published: London, 1818; Annotations: mid-19th century
Paper, 415 × 252 mm, 4 volumes
Papers of John Nelson Darby, JND/3/2, p. 143, opening of Mark

John Nelson Darby (1800–82) is one of the most important influences on contemporary evangelical Protestantism. As an Anglican priest in Ireland, working among the Catholic peasantry of county Wicklow, he grew increasingly concerned by the links between church and state, and moved into a loosely connected but socially privileged community of dissenting Protestants. His impressive manner and intellectual abilities brought him to the forefront of the new movement, identified by its detractors as the 'Plymouth Brethren', and enabled him to popularise a radically new way of thinking about the end of the world.

This emerging system – later dubbed 'dispensationalism' – developed elements of Darby's thinking. It argued that Christians should be waiting for the 'rapture' – the imminent translation of all true believers to meet Jesus Christ 'in the air' and their removal into heaven – which would be

followed by the rise of the Antichrist and a seven-year period in which God's wrath against this rebellious world would be unleashed. This 'tribulation' would be followed by the second coming, the final judgement and the beginning of a one-thousand-year period of spiritual plenitude known as the 'millennium'. At the end of this period, a final rebellion by Satan and his followers would be crushed, hell would be eternally populated with the human and angelic impenitent, and true believers and elect angels would live for ever in the new heavens and earth.

Darby's new way of thinking about the end of the world has come to dominate modern-day evangelical thinking on the subject. It has extraordinary political power, particularly in the USA, where most presidents since the 1980s have found it politically expedient to invoke its central themes in discussions about the Cold War, European Union and conflict in the Middle East.

Darby developed his thinking on this subject in his Greek New Testament, which he had bound in four interleaved volumes. The illustration shows the beginning of the Gospel of Mark and the copious notes made by Darby. This treasure is a crucial source document for one of the most important cultural modes influencing the course of the modern world.

Crawford Gribben

8

'So many paths': Religious traditions across the world

THE WEALTH and diversity of religious traditions and spiritual belief systems around the world reach far beyond the collections of any library. The illustrations in this chapter reveal something of this richness through a selection of the manuscripts and images which have found their way into the John Rylands Library. The Library was founded as a centre for theological scholarship, and its religious holdings consequently demonstrate an emphasis on Christian traditions. Outstanding examples of these can be found in the previous chapter concerning the Bible (Chapter 7), and in the chapters on illumination (Chapter 2) and early printing (Chapter 3). However, the Library's collections encompass a range of religious and spiritual traditions, from ancient ceremonial inscriptions (1.1) to the books of Batak medicine men (1.7). This chapter focuses on the written traditions of the major world religions, drawing particularly on the world-class collection of manuscripts and archives. This small sample, ranging from Chinese Buddhism to Unitarianism in America, illuminates the influence of particular communities on the transmission of sacred texts.

The wide scope of the Library's holdings of sacred texts is due in large part to the acquisition in 1901 of the manuscript portion of the Bibliotheca Lindesiana. Lord Lindsay, intending to create a universal library containing the world's best books, amassed a collection of manuscripts in more than fifty languages including sacred texts from all the major world religions. The Islamic manuscript tradition is particularly well represented, reflecting perhaps the central importance of manuscripts in Islamic culture. This chapter includes an early Qur'ānic manuscript (8.1) which demonstrates the beauty of Islamic calligraphy but also the problematic relationship between oral performance and written word. The Library's famously giant fourteenth-century Qur'ān is illustrated in the Bindings chapter (4.4) alongside a modern miniature printed edition (4.5).

In addition to sacred texts, the Library's collections document religious life and thought more broadly. Dr Moses Gaster (1856–1939) gathered together a fascinating array of manuscripts which reflect his diverse interests in Jewish culture – encompassing folklore, mysticism and Samaritan scribal culture. The portion of Gaster's collection acquired by the Library in the 1950s includes nearly fifteen thousand Genizah manuscript fragments from the Ben Ezra synagogue in

Old Cairo. These provide fascinating insights into Jewish life in Egypt from the tenth to the nineteenth centuries, and include a number of fragments in the hand of the great medieval thinker Moses Maimonides (1135–1204), one of which can be seen in this chapter (8.2). The Library's collection of Hebrew manuscripts includes such treasures as an illustrated scroll of Esther (1.3) and the famous Rylands Haggadah (2.6); Jewish Biblical manuscripts in Greek, Hebrew and Samaritan can be found in the Bible chapter (7.1, 7.3, 7.4). The Maimonides fragment is followed by Codex Harris (8.3), a manuscript of the Odes and Psalms of Solomon which demonstrates the cultural intersection between Judaism and Christianity.

The relationship between local culture and religious tradition is clearly evident in the Library's collections. The Library has a wealth of materials relating to China, including important Taoist and Confucianist woodblock books and an unusual collection of Naxhi manuscripts of the Dongba shamen of Northern China and Tibet, acquired in the early twentieth century. Illustrated in this chapter is a set of Buddhist paintings on bodhi leaves (8.4), which shows a particularly Chinese expression of Buddhism, a faith that was established in India and evolved as it spread across Asia. The arrangement of these paintings alongside apparently unrelated passages from Buddhist sutras gives us some clues as to the manner in which manuscripts have been used in religious and spiritual practice, in particular the relationship between the written text and the oral and performative elements of religious tradition. In some cases the manuscript does not seek to reproduce the spoken word but acts as a mnemonic for the enaction of a religious or spiritual performance.

The variety of religious traditions practised in South Asia is illustrated by the breadth of manuscript cultures represented in our collections, which include important texts of Buddhism, Sikhism, Hinduism and Zoroastrianism. These manuscripts encompass many different languages and scripts, physical formats and decorative styles. India is famous for its oral traditions, particularly the Vedic hymns, but there is also a long Indic manuscript tradition. More recently established religions, such as Sikhism, are rooted within earlier cultural traditions. This chapter illustrates our holdings of Sikh, Hindu and Zoroastrian texts with three Indian manuscripts from the eighteenth and nineteenth centuries (8.5–8.7). The histories of these objects also reveal how the British colonisation of India brought such manuscripts to England, and how these collections played a role in the development of Western understanding of world religions.

Finally, this chapter documents the development of Protestant Nonconformity, and especially the efforts of Nonconformist missionaries to spread the Christian Gospels and the practice of their own religious communities across the world (8.8–8.10). The examples of the Christian Brethren missionaries in India and the early Unitarian movement in America reveal something of the diversity within Protestant Nonconformity. The John Rylands Library is home to one of the world's finest collections of books, archives and manuscripts relating to Protestant Nonconformity. The largest collection relates to the Methodist Church of Great Britain and its predecessor institutions dating from the 1730s to the present, from autograph manuscripts of the denominational founders, John and Charles Wesley, to industrial mission and ministerial training. In the twenty-first century, Protestant Nonconformity is one of the Library's most active areas of collecting.

Elizabeth Gow

8.1　Early Qur'ānic manuscript

Fragments of Qur'ānic text in early Abbasid script
9th–10th century AD
Parchment, 230 × 320 mm, ff. 27
Arabic MS 11 (688), ff. 15b–16a

Among the Qur'ānic manuscripts at the John Rylands Library there are fragments from the ninth and tenth centuries AD. They are written in early Abbasid script, named after the caliphate which ruled from AD 750; it is commonly called Kufic script. This composite manuscript has been formed by bringing together twenty-seven parchment leaves written by four scribes. Each scribe uses a different calligraphic style, devices to mark each individual verse or groups of verses, number of lines and writing system. The manuscript bears fragmentary sequences of the Qur'ānic text, from *sūra al-A'rāf* to *sūra al-Zuḥrūf* for a meagre total of about ninety verses.

A closer look at folios 5 to 27 reveals a number of stages in writing, though it is not clear whether these stages are the work of the same scribe. The scribe(s) probably first traced the *rasm* (consonantal skeleton) in brown ink with a complete mastery; secondly he added red dots to mark vowels, *hamza* (glottal stop), *waṣla* (sign of silent *alif*) and connections between words and thirdly he provided the letters with diacritical strokes in brown ink. Finally coexisting readings were superimposed on the script in green ink.

Within this system the colours green and red are used to distinguish standard from alternative readings, for example by providing a letter both with a red dot-vowel in the standard position and a green dot-vowel in an alternative position. Moreover the scribe has deleted characters of the consonantal skeleton by tracing a green line over them or added small green *alifs* to mark different readings. The scribe sometimes placed two differently coloured diacritics on a basic letter form. Thus for example the diacritics in red ink above the second line mark the reading *ta'murunā* (you order us) in verse 60 of *sūra al-Furqān* (the Criterion), whereas the two diacritics in green ink below mark the coexistent reading *ya'murunā* (he orders us), handed down by the Islamic tradition.

Alba Fedeli

8.2 Autograph of Moses Maimonides

Mishneh Torah, in the hand of Moses Maimonides

Egypt, 12th century AD

Paper, 162 × 166 mm

Genizah A 281–1 & B 5756–1, Hilkhot Malveh ve-Loveh and Hilkhot To'en ve-Nit'an

Peering at this humble butterfly-shaped piece, consisting of two conjoined Hebrew fragments from the Rylands Genizah collection (A 281 and B 5756), we suddenly find ourselves in the presence of the great medieval Jewish mind Moses Maimonides (1135–1204). In this particular case we see him at work on his fundamental code of Jewish law, the *Mishneh Torah* (*Repetition of the Torah*), carefully deducing the 'laws pertaining to lenders and borrowers' from the vast Talmudic literature. A furtive look over his shoulder reinforces our impression that he is still at drafting stage, in view of the odd deleted word and the relatively copious notes in the margin.

Like other autographs by Maimonides, these treasured fragments offer a fascinating, momentary glance into the development of his thought. News of the man's profound erudition reached far and wide in the world of Judaism, Christianity and Islam. His lasting fame as a philosopher rests on the *Guide for the Perplexed*, which he originally composed in Judaeo-Arabic as the *Dalālat al-Ḥā'irīn*. The Cairo Genizah is a rich source for autograph fragments by well-known scholarly figures, such as Judah Halevi (1075–1141) and Joseph Caro (1488–1575), to name a few, but also for the personal letters, business contracts and day-to-day documents of many ordinary people who would otherwise have vanished from history.

Renate Smithuis

8.3 Codex Harris: *The Odes and Psalms of Solomon*

The Odes and Psalms of Solomon
Syria, 13th–17th century AD
Paper, 155 × 105 mm, ff. 56
Syriac MS 9, ff. 29b–30a, Ode 41 'Let us promise the Lord, all his children'

Codex Harris is named in honour of James Rendel Harris who, on 4 January 1909, discovered the lost *Odes of Solomon* together with part of the *Psalms of Solomon* among 'a heap of torn and stained paper leaves'. This was the first of two manuscripts discovered in the modern era containing the *Odes* in Syriac.

The *Odes* and the *Psalms of Solomon* are two quite different texts although attributed to the same ancient Jewish king and found together in early lists of apocryphal works. The *Psalms* were known to Harris from earlier manuscripts and are dated from about the first century BC. The *Odes* were also known to him, but only from snippets of text in other early writings. The later discovery of a Greek version of the eleventh *Ode*, dating from the late second or early third century AD, provides us with the earliest record of a Greek version of the *Odes*. A precise dating for Codex Harris

has proved difficult, with scholars proposing greatly varying dates between the thirteenth and seventeenth centuries AD.

The *Psalms* are of Jewish origin and resemble very closely the kind of writing we find in the psalms of the Hebrew scriptures (Old Testament). On the other hand the *Odes* make no clear reference to other writings, and scholars have discussed for many years what their origin might be (e.g. Christian, Jewish, or Gnostic). They are poetic, personal, inspirational, even ecstatic, and we could readily understand that the person who wrote them had perhaps little interest in describing such experience by using 'dogmatic' terminology that would clearly identify the author as Jewish or Christian or something else. As Harris wrote of them: 'Their radiance is no reflection from the illumination of other days: their inspiration is first-hand and immediate …'.

Majella Franzmann

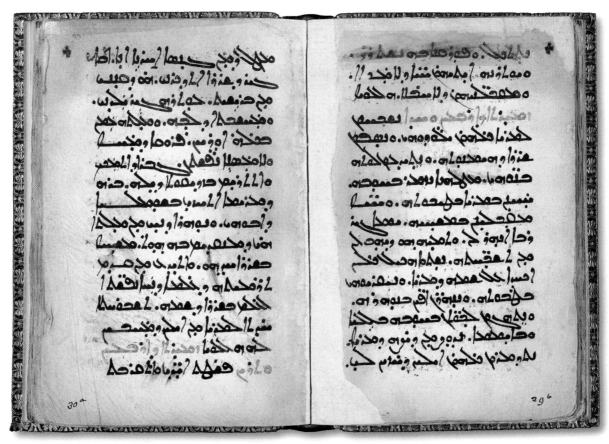

8.4 Buddhist painting on bodhi leaf

Painting of Guanyin and Wei Tuo with passage from the *Diamond Sutra*
China, probably 18th century
Bodhi leaf, paper and silk, 195 × 290 mm, 26 pieces
Chinese Drawings 28 no. 2, Guanyin with Wei Tuo

After six years of meditative experience the prince Siddhartha Gautama became a 'Buddha' (meaning 'Enlightened') and started preaching what we now know as Buddhism. From that time (sixth to fifth century BC) Buddhism spread through the rest of India and beyond. It eventually became a popular tradition across Asia, blending with local religions and cultural traditions as it moved into various regions.

This painting shows Guanyin, who is the Chinese female representation of Avalokitesvara the Bodhisattva of Compassion, together with Wei Tuo, who is the Chinese version of Skanda the Bodhisattva protector of Buddhism. One of the Chinese legends that justify the female gender of Guanyin regards the female Princess Miao Shan, whose lover was the General Wei Tuo. Wei Tuo became a Bodhisattva when Miao Shan ascended as Guanyin. The two infants in the painting are also found very often in the iconography of Guanyin.

The paintings are made on leaves of the bodhi tree, the tree under which Buddha reached Enlightenment, which thus embodies a special sacredness. In India it was not uncommon to use leaves of the bodhi tree as material support for the writing of scriptures and the painting of eminent Buddhist figures or events. Such a practice was then transmitted to the rest of Asia along with the spread of Buddhism.

This image is from a set of twenty-six that was acquired by Nathaniel Bland in the first half of the nineteenth century. Each painting is paired with a passage from either the *Heart Sutra* or the *Diamond Sutra* written in golden ink – in this case the beginning of the *Diamond Sutra*. The subjects of the paintings are not connected with the meaning of the passages, which suggests they were joined at a later date.

Stefania Travagnin

金剛般若波羅蜜經

如是我聞一時佛在舍衛國祇樹給孤獨園與大比丘眾千二百五十人俱爾時世尊食時著衣持鉢入舍衛大城乞食於其城中次第乞已還至本處飯食訖收衣鉢洗足已敷座而坐時長老須菩提在大眾中即從座起偏袒右肩右膝著地合掌恭敬而白佛言希有世尊如來善護念諸菩薩善付囑諸菩薩世尊善男子善女人發阿耨多羅三藐三菩提心云何應住云何降伏其心佛言善哉善哉須菩提如汝所說如

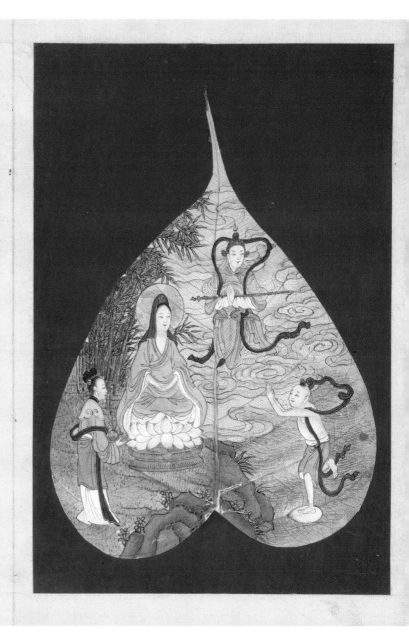

8.5 Life stories of Guru Nānak

Janamsākhī
India, early 19th century
Paper, 140 × 195 mm, ff. vii + 264 + viii
Punjabi MS 4, ff. 224b–225a

This manuscript is a copy of the *Life of Nānak*, known in Punjabi as *janamsākhī* (life stories). *Janamsākhīs* recount the life of Guru Nānak (1469–1539), the founder of Sikhism and the first of the Sikh Gurus. They were first transmitted orally as individual anecdotes, many of which were borrowed from Hindu and Muslim sources, and only later set down on paper. The earliest dated *janamsākhī* was recorded in 1658,

although their origins probably go back as far as Nānak's own lifetime. The Rylands manuscript is written in Gurmukhī, commonly translated as 'from the mouth of the Guru', the Punjabi script used for Sikh holy texts.

Pasted in the front of the manuscript is the bookplate of Sir Henry Miers Elliot (1808–53). A senior figure in the East India Company, Elliot played a key role in the annexation

of the Punjab in 1849, negotiating the treaty with the Sikh chiefs which ended the period of Sikh control over the North Western Provinces. From 1840 onwards, Elliot amassed a large collection of manuscripts relating to the history of India. He undertook extensive research into the history of India under Muslim rule, particularly as represented in Indo-Persian manuscript histories. This scholarly endeavour was inextricably linked to his official position; his official objectives leading his research, and the results of his research influencing his official activities. Although the bulk of Elliot's manuscripts were sold to the British Museum by his son Reverend H. L. Elliot in 1878, a small number found their way into the Bibliotheca Lindesiana, and thence to the John Rylands Library.

Elizabeth Gow

8.6 a & b *Bhāgavata-Purāṇa*

Illuminated scroll of the *Bhāgavata-Purāṇa*
India, 18th century
Box: mahogany and glass, 325 × 170 mm; manuscript: paper, 13,900 × 115 mm
Sanskrit MS 7, Śuka and King Parīkṣit; three incarnations of Viṣṇu

Purāṇas are collections of ancient myths or legends, containing tales of Hindu gods, demons, kings, sages and heroes. The *Bhāgavata-Purāṇa*, or 'Tales of the Supreme Lord', is one of the most sacred texts for followers of Kṛṣṇa (Krishna). It describes the *līlā* (pastimes) of twenty-five incarnations of the god Viṣṇu (Vishnu).

This manuscript roll begins with a series of exquisite miniatures, painted in vivid colours. The last of these shows Śuka, son of Vyāsa, giving knowledge of the *Bhāgavata-Purāṇa* to King Parīkṣit. According to Hindu tradition, the *Bhāgavata-Purāṇa* was written by the ancient sage Vyāsa, but scholars now consider that it was composed in southern India around the tenth century AD. Book ten of the *Bhāgavata-Purāṇa*, illustrated here, tells the story of the childhood of Kṛṣṇa, Viṣṇu's eighth *avatāra* (incarnation), and the attempts by his wicked uncle Kaṃsa to kill him.

The *Bhāgavata-Purāṇa* is written in Sanskrit, the sacred language of Hinduism. The script is a minute Devanāgarī – too small for most people to read without the aid of a magnifying glass. The scroll was probably created in Rajasthan in northern India in the late eighteenth century and is housed in a mahogany box with ivory handles to make it easier to view. The roll has had a series of interesting owners. The first we know of is Rebekah Bliss (1749–1819), one of the earliest female manuscript collectors. After her death it was purchased by Nathaniel Bland (1803–65), a scholar of Persian, whose gambling habit forced him to sell the manuscript along with his library in 1856. Three years later, it appeared at a sale of the Italian count Guglielmo Libri (1803–69), now known as a prolific book thief. It was bought by Lord Crawford, who later acquired the rest of Bland's collection of Oriental manuscripts.

Elizabeth Gow

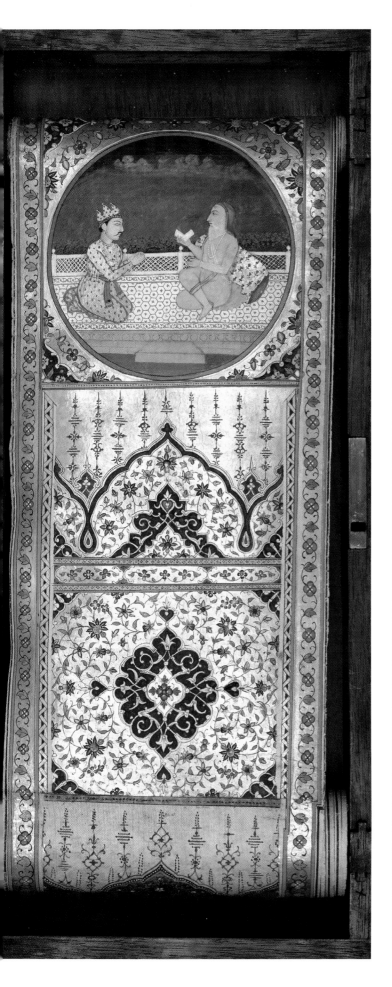

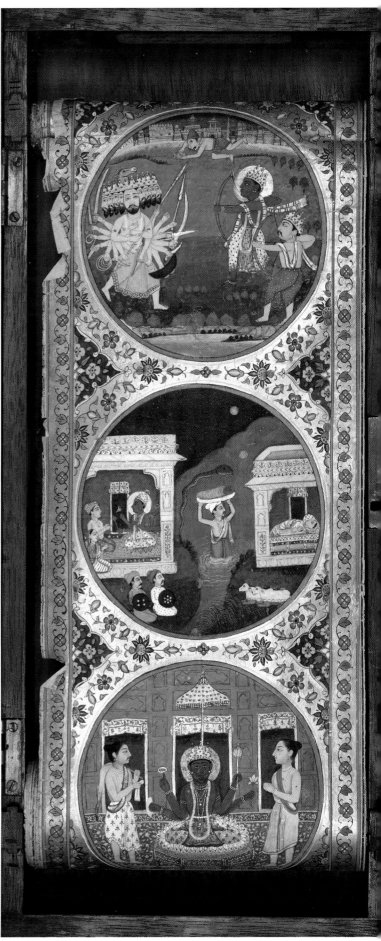

بدین فی شبک بدی دور مهربدی دور

زاهجروزنسا بهربیز کردی

بهرکرفه کشتن بودت توانا

نیفکندی لبغردلکار کرفه

ازان پاکیزه کشتم من بدنشان

سروش آنجا کرفته دست علیک

بدیدم مهرایزدرا درانجای

بداری ده یکی سالد دستور

بسیج روز رستا خبر کردی

شناب و جهد کردی مروانرا

نجست شست اندرکار کرفه

که حق جست زبد بودی هراسان

وزانجا برزسوی جشنود دل

تترز و را مدست رش هربای

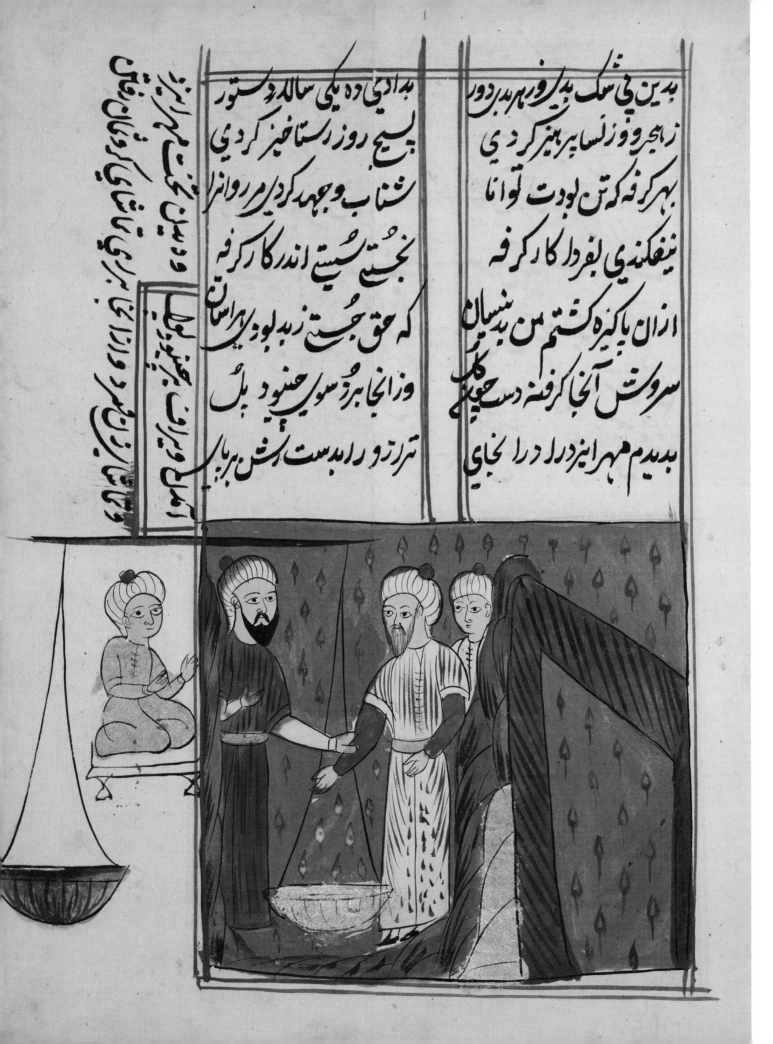

8.7 *The Revelations of Arda Viraz*

Ardā Virāf Nāma
Gujarat, India, AD 1789
Paper, 227 × 174 mm, ff. 73
Persian MS 41, f. 12r, Arda Viraz at the Cinvad bridge

The revelations of Arda Viraz ('Viraz the just') or Viraf, as he is called in Persian, were originally written in Pahlavi (a precursor to Persian) during the early Islamic period. The story describes how the Zoroastrian community selected the righteous Arda Viraz to visit the world of the dead, returning with an account of the rewards and punishments in store. The text assumed its definitive form in the ninth to tenth centuries AD, and was translated several times into Persian prose and verse and also into Gujarati. Many copies of this popular story survive, some of them including vivid illustrations, reinforcing its underlying importance as a Zoroastrian didactic text.

This manuscript was copied in July 1789 in Navsari, Gujarat, by a Zoroastrian, Peshotan Jiv Hirji Homji. It was brought to England by Samuel Guise, a surgeon working for the East India Company. After Guise's death in 1811, his collection was sold and this manuscript was acquired by the Persian scholar and former Chetham's Librarian John Haddon Hindley (1765–1827). It was later part of the manuscript collection of the Persian scholar Nathaniel Bland which was sold *en bloc* to Alexander Lindsay, 25th Earl of Crawford, in 1866.

This illustration shows Arda Viraz with the divinities Srosh, Mihr and Rashn, at the Cinvad bridge, which the souls of the dead must cross. If a soul's good deeds outweigh the bad it is met by a beautiful woman (an embodiment of his virtuous past life), the bridge is broad and easy to cross on the way to Paradise; but if the scales are weighed down by bad deeds, the bridge becomes narrow, and the soul encounters a foul hag and falls down into hell.

Ursula Sims-Williams

UCC/2/19/220

Dear Sir, Cheltenham. Aug. 1.
 1794

Having received a letter since we came to this place, from my friend and old correspondent, Mr Freeman of Boston, N.E. and as you used to like his communications, I thought some account of this would be agreeable, and therefore promised to send it.

After mentioning much at large the benefit which had been received by the dispersion of the different tracts, which I make a point of sending him two or three times a year, whenever I have opportunity. "They have sown the seeds of truth, says he, particularly in the minds of our younger clergymen. At this season of the year, (June.5) when our ministers from all parts of the State assemble at Boston, I have an opportunity of distributing them, particularly your Examn. of Robinson, Vindiciæ Priestleianæ, Conventicles on ye idolatry, and Wayne, which are read with great avidity. In former letters I have given you an account of the progress of unitarianism and liberal

sentiments along with it, in the eastern part of the State. At present it seems to be making rapid strides in the southern part. "The counties of Plymouth, Barnstable, and Bristol, were the first part of New England settled by the English, and till the year 1692, when they were annexed to Massachusetts, constituted a distinct province. These first settlers were a religious and industrious people, of more candid minds, and less disposed to persecution than the settlers of Massachusetts. Though the country is barren, yet it has become one of the most populous districts of the United States. The inhabitants are enlightened and virtuous. Crimes are unknown, and there has not been a capital **execution** for upwards of sixty years. Such characters are valuable acquisitions to the cause of truth. It must give you pleasure therefore to learn, that two ministers, one in the county of Plymouth, and the other in the county of Barnstable, have lately come forwards, and openly opposed the doctrine of the Trinity. Their preaching has made a deep impression, and converts have been multiplied. In Barnstable county in particular, there is a very large body of unitarians. Several ministers of that county have prevailed upon their people to use ~~Enfield~~ forms of prayer in their families. A very numerous edition has been printed, with additions from Dr Priestley and Bp Hoadly, to be read in churches, when

the ministers are occasionally absent." (N.B. I like this idea hugely, and so will you) "I forward a copy for your acceptance, and, [at the request of General Freeman of Sandwich, one of the editors of the book,] another for Enfield, which you will have the goodness to convey to him. The same persons, who have adopted Enfield's prayers, intend soon to reprint Christie's Discourses, to which no doubt there will be large subscriptions. He then goes on to speak of Mr H. Tulmin, from whom he had frequently heard; he had not seen him, and of what a blessing such an enlightened achievement would be in that new country where so would be so much wanted.

Of the new settlement upon the branches of the Susquehanna by our friends from England, I am pleased to hear him speak so very favourably, from his own knowledge; that they will there find a pleasant climates, and a fertile soil; as they will lay the foundations of a purer christianity, which may in time lead the Pennsylvanians to reject the doctrines of Athanasius and Calvin.

My wife sends her kindest respects, and hopes will me, that their fine summer weather will contribute to invigorate you. Dear Tucker is here at the spaw in his 82 years, complaining, his very vigorous. I wish you was as stout in body. He is civil and we met together as in former days. But on church and state matters no one touches. On monday we depart to visit a widow lady for a week or ten days, a friend of my wife's, near Ross. after that we are to pass a few days at Mr Martin's, by invitation; and if Mr Rowe will be so good as to send under his cover two letters I say, you have received those two epistles, and that you are hearty well, and also his self, lady, and family. I shall thank him for that and his former favour when we get back to London. I remain always, Dear Sir, your most truly, obliged and faithful affecte servt
 T. Lindsey.

P.S. I am sorry Dr Tulmin is not continued but rather from the violent spirit against him & dissenters in this town; they are now threatening him for publishing, by the mothers desire, a young man from enlisting in the army. they will not rest, till they have forced him to America.

8.8 a & b Unitarians in America

Letter from Theophilus Lindsey to William Tayleur
Cheltenham, 1 August 1794
Paper, 250 × 390 mm (unfolded)
Unitarian College Collection, Lindsey Letters, UCC/2/19/220

The letters of Theophilus Lindsey (1723–1808) are among the most fascinating of the manuscript collections of the Library. A Cambridge-educated clergyman of the Church of England, Lindsey resigned his church living in 1773 and became in effect the founder of the British Unitarian movement. From his Unitarian chapel in London, he was at the centre of an international Unitarian network, and received news of the progress of Unitarianism in many parts of the world. One letter to him, from James Freeman of Boston, Massachusetts, described in detail the development of Unitarianism in America, and Lindsey quoted extensively from it when writing to his Shropshire friend, William Tayleur, on 1 August 1794:

> The counties of Plymouth, Barnstable, and Bristol, were the first part of New England settled by the English, and till the year 1692, when they were annexed to Massachusetts, constituted a distinct province. These first settlers were a religious and industrious people, of more candid minds, and less disposed to persecution than the settlers of Massachusetts. Though the country is barren, yet it has become one of the most populous districts of the United States. The inhabitants are enlightened and virtuous. Crimes are unknown, and there has not been a capital execution for upwards of sixty years. Such characters are valuable acquisitions to the cause of truth.

On a less cheerful note, and as a sign of the hostility towards Protestant Dissenters in Britain during the French Revolution, Lindsey added in the same letter that the political opinions of his friend Joshua Toulmin, Unitarian minister at Taunton, had led him into 'continual hot water from the violent spirit against him & Dissenters in that town'.

Grayson Ditchfield

8.9 Missionary lantern slide: 'India's Need'

India waiting – for Christ – for you!
19th century
Glass lantern slide, 80 × 80 mm
Brethren Lantern Slides, BLS/27

During the late nineteenth and early twentieth centuries, magic lantern slides were widely used to encourage British Protestants to support overseas missionary work. This example comes from the collection of a Brethren missionary agency, Echoes of Service, which forms part of the Christian Brethren Archive.

The Brethren began in the late 1820s, as a movement seeking to cut free of tradition and compromise with the unbelieving world, and to return to the teaching of the Bible. They were Evangelical, but gave that distinctive expression in the form of plural lay ministry and opening participation at communion to all committed Christians. Rapidly they also came to believe in the imminence of the Second Coming, and the urgency of mission at home and overseas. It is reckoned that Brethren sent a higher proportion of their membership abroad as missionaries than any other denomination except the Moravians.

This slide was used to argue India's need for the Christian gospel as taken by Western missionaries. At the top right is a recurrent motif – 'before' and 'after' pictures, illustrating the change wrought by conversion to Christ. The impact is reminiscent of military recruiting posters featuring Lord Kitchener.

In the picture can be seen Anthony Norris Groves (1795–1853), one of the first Brethren missionaries (bottom left). Groves worked in the Middle East and Iran, but moved to India in 1833 at the suggestion of a military engineer, Arthur Cotton (top left), anticipating that this would prove a more responsive field. Groves's influence on later generations of missionaries was seminal, through his personal example, through writings such as *Christian Devotedness* (1825) and through his advocacy of 'living by faith'; this was the practice of devoting oneself to Christian work without any guaranteed income, trusting that God would provide. Such an approach was long regarded as normative by English-speaking Brethren.

Tim Grass

8.10 Mary Bosanquet-Fletcher: Early female Methodist preacher

Portrait of Mary Bosanquet-Fletcher, *c.*1810
Miniature painting on ivory, 92 × 74 mm (painting), 242 × 226 (frame)
Methodist Archives, Sidney Lawson Collection of Wesleyana

One of the most significant collections of personal papers in the Library is the Fletcher–Tooth Archive. This contains thousands of letters, diaries, notebooks, scripture notes and associated papers relating to the joint ministry of the ordained Anglican evangelical John Fletcher (1729–85) and his wife, the former Miss Mary Bosanquet (1739–1815).

Mary Bosanquet-Fletcher was one of the earliest female preachers of Methodism and for over fifty years was regarded as a model of spiritual leadership. Through her papers and those of her husband, one can see the transition of Methodism from Anglican revival movement to independent denomination and the effects this had on the women who formed the majority of the membership. The archive includes several hundred manuscript sermons preached by Bosanquet-Fletcher and these constitute the only surviving sermons preached by a woman from the eighteenth-century Revival.

The Fletcher–Tooth Archive spans almost one hundred years from 1760 to 1843 and charts in detail the effects of the great Evangelical Revival, particularly but not exclusively on the parish of Madeley in Shropshire. The papers illustrate a wide range of themes from the often uncomfortable relationship between the Church of England and the Methodist movement to the central role played by dreams and visions in Evangelical spirituality – a feature that was largely ignored by Victorian Church historians and is only recently being uncovered. Furthermore, the Archive places these religious developments into the social and economic context of a town that was an important centre of the Industrial Revolution and is now part of the Ironbridge Gorge World Heritage Site.

Gareth Lloyd

B E a b a E B r q p F V

Structure of the Human Eye

... is here supposed to be cut exactly ...

... to be represented by the above Figure.

... non Eye.

... is transparent, like Horn. Rays of

... is not transparent. ...2R pa...

... the Eye called Iris. Humou...

... Axis of the Eye. back P...

9

'On the shoulders of giants': Science, technology and medicine

THE LIBRARY'S scientific and medical collections provide very broad-ranging coverage of the history of human invention and discovery. They are particularly illuminating for Manchester's contributions to scientific and medical endeavour since the Enlightenment. The collections encompass manuscripts, archives and printed books dating from the early medieval period to the twenty-first century. Some of the earliest materials are medical and astronomical texts in the Greek, Latin, Persian, Turkish and Hebrew manuscript collections.

The many facets of Enlightenment science are well captured in the Wedgwood Collection, which includes copies of the correspondence of the ceramicist Josiah Wedgwood (1730–95) with, among others, Joseph Priestley, Matthew Boulton and James Watt. Also dating from this period are notes of lectures delivered by Joseph Black (1728–99), the discoverer of carbon dioxide, the Scottish chemist William Cullen (1710–90) and the great anatomist William Hunter (1718–83). These notes were made by students, such as the chemist William Henry (1774–1836) and the physician John Hull (1764–1843), who later made their careers in Manchester.

Perhaps the greatest Manchester scientist of this period was John Dalton (1766–1844). In 1979 the Library acquired a collection of his surviving manuscripts (many others were destroyed in the Second World War). The manuscripts confirm Dalton's reputation as a polymath, expert in the fields of meteorology and optics as well as chemistry (9.6).

The papers of another Manchester scientist, James Prescott Joule (1818–89), include his laboratory notes of experiments which led to his demonstration of the mechanical equivalent of heat, a key discovery for the science of thermodynamics. In a more unusual vein, the papers of the economist William Stanley Jevons (1835–82) include his theories on how sun-spot activity was an ultimate cause of some earthly economic phenomena.

The later nineteenth century saw an academic scientific culture develop in Britain. This process is well documented in The University of Manchester's own archives, and in the personal papers of University-related scientists. Sir Edward Frankland (1825–99) left a major archive, detailing not only his contributions to chemistry but also his activities as an influential scientific statesman in the Royal Society and the prestigious X Club.

For the twentieth century, the archives of the Jodrell Bank radio-telescope and the optical astronomer Zdeněk Kopal provide differing but complementary perspectives on astronomy during the 'Space Race' (9.11). Kopal's papers include his work on mapping the Moon, an essential prerequisite of the Apollo lunar landings.

The National Archive for the History of Computing provides wide-ranging coverage of academic and commercial computing in Britain in the middle decades of the twentieth century (9.10), and includes papers of leading practitioners such as Douglas Hartree (1897–1958), F. C. Williams (1911–77) and Alan Turing (1912–54).

Medical archives range from papers of nineteenth-century Manchester doctors such as Charles Clay (1801–93) and Thomas Radford (1793–1881), both important innovators in the field of obstetrics. The papers of the neurosurgeon Sir Geoffrey Jefferson (1886–1961) and Sir John Charnley (1911–82), inventor of the artificial hip operation, describe two twentieth-century surgical innovators. One collecting focus has been the history of X-rays and medical imaging, as represented by the papers of Ian Isherwood and Derek Guttery (9.8).

There are many significant individual printed items in the Rylands collections such as the first edition of Andreas Vesalius's *De humani corporis fabrica* (Basel, 1543) and Isaac Newton's *Philosophiæ naturalis principia mathematica* (London, 1687), as well as magnificent nineteenth-century illustrated books such as John James Audubon's *Birds of America* (1827–39), John Gould's many bird books and Henry Dresser's *History of the Birds of Europe* (9.7). However, it is from the University collections that the real strength lies, with many important items from the University's general Special Collections including a heavily annotated copy of Nicolas Copernicus's *De revolutionibus orbium coelestium* (Basel, 1543) and a copy of Robert Hooke's *Micrographia* (London, 1665). There are also a number of important discrete collections such as James Partington's books on the history of chemistry and the library of James P. Joule.

The core of Manchester's medical printed collections is the library formed by the Manchester Medical Society from its foundation in 1834. A number of notable clinicians either purchased books on behalf of the Society or donated their own considerable private collections. Thomas Windsor (1831–1910) served as honorary librarian for around twenty-five years from 1858 and later collected on behalf of the Surgeon-General of the USA. The gynaecologist Charles Clay donated one thousand volumes in 1860. Books bear the marks of ownership of these individuals as well as other local leaders of the profession, including the obstetrician Thomas Radford and the bacteriologist Auguste Sheridan Delépine (1855–1921). In 1875 Owens College (forerunner of The University of Manchester) became a trustee of the Manchester Medical Library. Over the next seventy-five years it acted as a central repository for outlying medical collections, incorporating the collections of the Manchester Royal Infirmary and St Mary's Hospital (founded on the private library of Thomas Radford). The growth of the collection mirrored the growth of the Medical School. The collection was finally transferred to the University in 1930.

The library associated with the Manchester Medical Society offers a unique insight into the development of medicine in Manchester, reflecting new developments in both medical practice and professional organisation in the century prior to the foundation of the National Health Service in 1948, and the coalescing influence of the early medical associations both regionally and nationally. The majority of items in the collection date from the nineteenth century with strong holdings of pre-1850 hand-press books and of unusual foreign imprints from the first decade of the nineteenth century.

James N. Peters and Julianne Simpson

9.1 Avicenna's *Canon of Medicine*

Ibn Sīnā, *Avicennae Arabum medicorum principis canon
medicinae. Quo universa medendi scientia pulcherrima, & brevi
methodo planissime explicatur*
Venice: Giunta family, 1608
350 × 250 mm
Medical (pre-1701) Printed Collection 108, frontispiece

Avicenna, or Ibn Sīnā (980–1037), is probably the most influential physician of the medieval period. This frontispiece of the 1608 edition of his *Canon of Medicine, On the Faculties of the Heart, On how to avoid harm during a medical regimen, On acid syrup*, and *The Poem of Medicine* illustrates both visually and textually the importance of the Arabic tradition for the development of Western medicine. The frontispiece shows the three facets of therapeutics: diet on the top, surgery on the left and pharmacology on the right. In the area of pharmacy, we find a mixture of Greek and Arabic medical luminaries: not only Hippocrates, the 'father of medicine', and Dioscorides, the author of the famous work *On Medical Substances*, but also al-Rāzī ('Rasis', d. *c.*925), Mesue, the author of a number of pharmacological works translated from Arabic, and Avicenna. Moreover, at the bottom, Avicenna appears as one of the four main medical authorities, the others being Hippocrates, Galen and Aëtius of Amida, famous for his medical encyclopaedia. The first two carry a banner with the Greek motto 'we flourish, because *he* does', whereas the latter two carry a Latin translation of this motto.

Galen, Avicenna and Aëtius all look towards Hippocrates, and it is therefore clear to whom the '*he*' in the quotation refers. In other words, the message is that medicine in Greek, Arabic and Latin draws on the same tradition, namely that of Hippocrates. The *Canon of Medicine* was first translated into Latin by Gerard of Cremona (d.1187). Here, however, we have the new Renaissance translation prepared by Andrea Alpago of Belluno (d.1522). He was also the first to translate into Latin the other minor works contained in this edition. This demonstrates the importance of Avicenna for Renaissance medicine. For instance, during the fifteenth and early sixteenth centuries, Avicenna's *Canon* in Gerard's Latin translation figured prominently in the medical curricula of the nascent European universities. But there was also an interest in improving and correcting it through a fresh translation. Throughout the seventeenth century, Avicenna continued to be used frequently in medical teaching and practice. This underscores, again, the importance of the Arabic medical tradition for the development of 'Western' medicine.

Peter E. Pormann

9.2 'Experiment leads to knowledge': Francesco Redi's insect drawing

Francesco Redi, *Esperienze intorno alla generazione degl'insetti*

Florence: All' Insegna della Stella, 1668

290 × 220 mm

Spencer 9798, p. 157

Francesco Redi (1626–97) was a physician, poet and courtier to Archduke Ferdinando of Tuscany. In his remarkable book *Esperienze intorno alla generazione degl'insetti* (*Experiments on the Generation of Insects*)– written in Italian, not Latin – Redi attempted to understand where insects come from, using experimental methods. Previously, most people thought that insects generated spontaneously from rotting matter. Redi took such widely held views about insects and their origins and subjected them to the pitiless glare of experiment. For example, he tested the suggestion that ox dung gave rise to caterpillars which in turn became bees, or that you could generate scorpions from rotting scorpions ('I always got flies', he said), or even the claim by the Arab philosopher Avicenna that 'a scorpion will fall dead if confronted with a crab to which a piece of sweet basil has been tied' ('it is likewise false' wrote Redi, laconically).

Above all, however, Redi carried out a series of experiments to test his idea that insects come from eggs laid by a female of the same species. By studying dozens of different kinds of rotting meat and vegetable matter,

Redi showed that insects would appear in the matter only if flies had been able to lay eggs on the decaying material. He carried out these experiments with amazing rigour and determination, and left no doubt in the reader's mind that his theory was true.

In this picture, Redi – or, more likely, an artist employed by him – shows a maggot (on the right) that lives in a cherry, which pupates (centre) and turns into a fly (on the left). This drawing was probably made with the aid of a strong magnifying glass, rather than a microscope. Below the enlarged images of the fly at its different stages, there are tiny life-size images.

Redi's book showed that the power of experiment could challenge widely held beliefs and enable new knowledge to be gained. The first page carries an Arab proverb: 'Experiment leads to knowledge, credulity leads to error.' This is the essence of how most forms of science try to understand the natural world. Redi was one of the key founders of this new way of looking at the world.

Matthew Cobb

9.3 'To the Midwives of England': Jane Sharp's *Midwives Book*

Jane Sharp, *The midwives book, or, The whole art of midwifry discovered*

London: Printed for Simon Miller, 1671

150 × 100 mm

Medical (pre-1701) Printed Collection 2302, plate 1, facing p. 155

The midwives book, or, The whole art of midwifry discovered, which extended to four further editions as *The compleat midwife's companion*, was written by the midwife Jane Sharp in 1671. The book is celebrated as the first midwifery text written in English by a traditional midwife. Sharp's accomplishment was quite remarkable for the time and demonstrated not only how well read she was but also how insightful and witty. Her main concern was a fear that men midwives were going to usurp traditional midwives and undermine their value to society, unless midwives acted quickly and familiarised themselves with the more impressive medical theory and anatomical terms, which for various reasons had so far been generally inaccessible to them. Sharp acknowledged that midwives' clinical competence was a major strength, although this was variable, hence her desire to share her own book learning and experience, gained from over thirty years' practice, with less experienced midwives.

While some of the description of the image would be considered inaccurate by today's standards, the inclusion of images in Sharp's text makes it all the more impressive.

Anatomy lent itself particularly well to visual representation and anatomical diagrams were increasingly used in instructional texts on childbirth during the seventeenth and eighteenth centuries.

This image with its key (not shown here) is one of two found in the book. It portrays a pregnant woman, casually displaying the 'secrets' of her womb, while adopting a lifelike ultra-realistic pose – typical of the genre. Sharp describes the amniotic and chorionic membranes which are shown neatly divided and folded back, exposing the foetus and placenta (cake) and the attachments of the navel string (umbilical cord) to placenta and baby. Interestingly, the placenta appears below the foetus, which implies that the image was either drawn by someone with limited knowledge of the pregnant body, as the placenta normally embeds at the top or on the side walls of the uterus, or was produced to optimise the view of the placenta. Elaine Hobby has produced an edited version of *The midwives book*, making this rare book accessible to a wider audience.

Janette C. Allotey

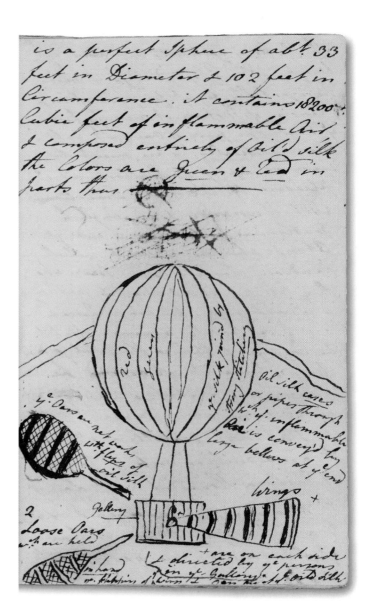

9.4 Full of hot air: A bluestocking describes Lunardi's balloon ascent

Account of Lunardi's Balloon Ascent,
Mary Hamilton's Diary, 1784
165 × 103 mm
Mary Hamilton Papers, HAM/2/13

Mary Hamilton was an eighteenth-century bluestocking, courtier and diarist. Within one of her diaries is an image she had sketched of Vincenzo Lunardi's balloon – one of the first ever hot-air balloons to take off in London. On 13 August 1784 Hamilton went to see the balloon at the Lyceum and she writes in detail on its construction, noting that it 'is a perfect sphere of about 33 feet in Diameter & 102 feet in Circumference, ... [the] Gallery contains one pair of wings which are raised high, & move horizontally for the purposes of increasing the motion it receives from the Wind, [it] also [had] one pair of oars, which will move vertically, & are meant to raise or depress the Balloon at the pleasure of aerial travelers'. Hamilton records that Lunardi and an Englishman were to ascend in it and that the King and Queen were to observe the spectacle. She later notes that when the balloon was launched a dog and a cat ascended with Lunardi, rather than the Englishman,

and that the dog and cat were subsequently exhibited at the Pantheon and Pall Mall.

There are further references to hot-air balloons in the diaries which reveal the excitement they created in society at that time. One of Hamilton's friends spent five hours in a coach going to see the balloon at Chelsea and all she managed to see was the top of it. The 'mob' was so enraged that the balloon was not allowed to ascend because it was raining 'that they set fire to it & destroy[e]d what cost some hundred[s] of pounds ... besides the labour & anxiety of the poor man'. Another friend went to see a Chinese balloon and doubted that it would succeed in getting off the ground as 'it was an old one that had failed in France'. She told Hamilton that the owner of the balloon had collected £2,000 worth of subscriptions and that it was a 'miracle that he escaped the fury of the mob'.

Lisa M. Crawley

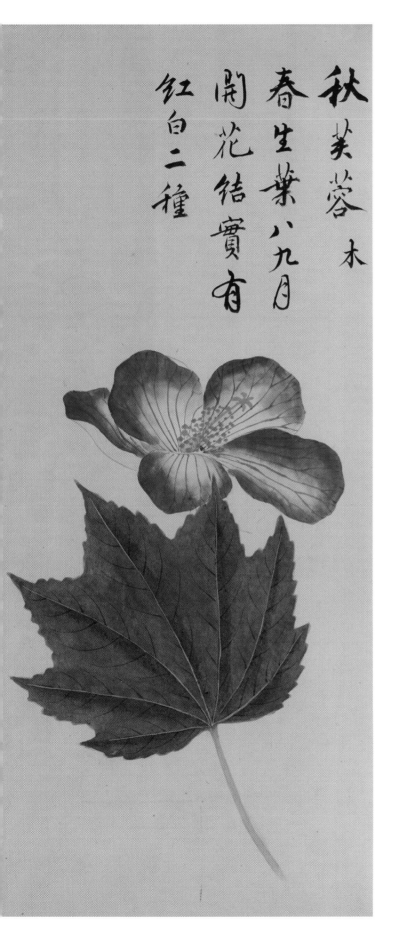

9.5 Inside the Chrysanthemum Kingdom: A Japanese botanical album

Taishūen sōmokufu (botanical album), *c.*1785–92

390 × 232 mm

Japanese Collection 228, 24v, Akifuyō or *Hibiscus mutabilis*, detail

In East Asia the study of plants has a history of more than two thousand years. It was in China that botany first developed and the main focus was the identification of the medicinal properties of plants. This knowledge was in due course transmitted to Japan, Korea and Vietnam, but of course they did not necessarily have the same plants at their disposal. In Japan, in the course of the Edo period (1603–1868), botanical knowledge grew rapidly as the use of woodblock printing made it possible to include illustrations in printed books and therefore put a premium on accuracy in botanical illustration. Shown here, however, is an image taken from a manuscript produced in 1786, apparently by the wife of the emperor's physician. It is titled *Taishūen sōmokufu*, or 'Taishūen's botanical album'; 'Taishūen' was a pen-name used by Ogino Gengai (1737–1806), a famous doctor and medical scholar who served the imperial court. This beautiful volume was acquired by Isaac Titsingh (1745–1812) while he was in Japan in charge of the Dutch East India Company's trading post at Dejima in the bay of Nagasaki. The page shown here depicts Akifuyō, or *Hibiscus mutabilis*, a plant native to southern Japan. The text in Chinese characters gives its Japanese name and explains that its leaves appear in spring and the flowers in late summer. On other pages Titsingh, who had a remarkably good knowledge of Japanese acquired during more than three years' residence in Japan, added the Latin names in his own hand. The album later passed to Alexander Lindsay, 25th Earl of Crawford, who was one of the first collectors of Japanese books in England.

Peter F. Kornicki

9.6 More than meets the eye

Diagram of the human eye by John Dalton, *c*.1805
155 × 195 mm
John Dalton Papers, DAL/84

This drawing appears in a set of John Dalton's notes for lectures on Optics, used in 1805, 1806, 1808 and 1811, at least. The notes survived the bombing of Manchester at Christmas 1940, during which the bulk of his papers was destroyed.

John Dalton (1766–1844) was born near Cockermouth, on the edge of the Lake District, to a family of Quakers. Though poor, he attracted support from notable teachers and naturalists in the Quaker community. After years as a young teacher or labourer, he moved to Manchester in 1793 to teach in Manchester Academy, newly begun by local Unitarians (exponents of rational religion). The town was then the heart of the Industrial Revolution; it was more exciting than salubrious, but Dalton remained here to his death. A bachelor with simple tastes, he taught private pupils (including James Prescott Joule), gave lectures, helped run the Manchester Literary and Philosophical Society, and worked in its laboratory.

Dalton became internationally famous after suggesting in 1803 that the behaviour of gases and the combinations of chemical elements could be explained by supposing that elements were composed of atoms and that the atoms of each element all had a characteristic relative weight. A gifted teacher, he devised wooden balls to represent the elements, with holes and sticks to connect them. After his death, his body lay in state in the Manchester Town Hall, and forty thousand of his fellow citizens filed by.

Optics was particularly interesting to Dalton because he was colour-blind – the subject of his first presentation to the Lit and Phil. This presentation became the first published paper on colour blindness, soon to be known as Daltonism – a term which has persisted to the present in some languages, though not commonly in English. He explained his inability to see red by suggesting that the aqueous humour in the front of his eye (see the diagram) was uncommonly blue, thus absorbing red light before it could reach the retina. But there were other theories, and Dalton's did not last. He donated his eyes to be dissected at his death and the aqueous humour proved normal. Recent DNA tests on the remains of his eyes have shown that, in our terms, Dalton was a deuteranope: his retina lacked the receptors for red–green light, the middle range of the visual spectrum.

† John V. Pickstone

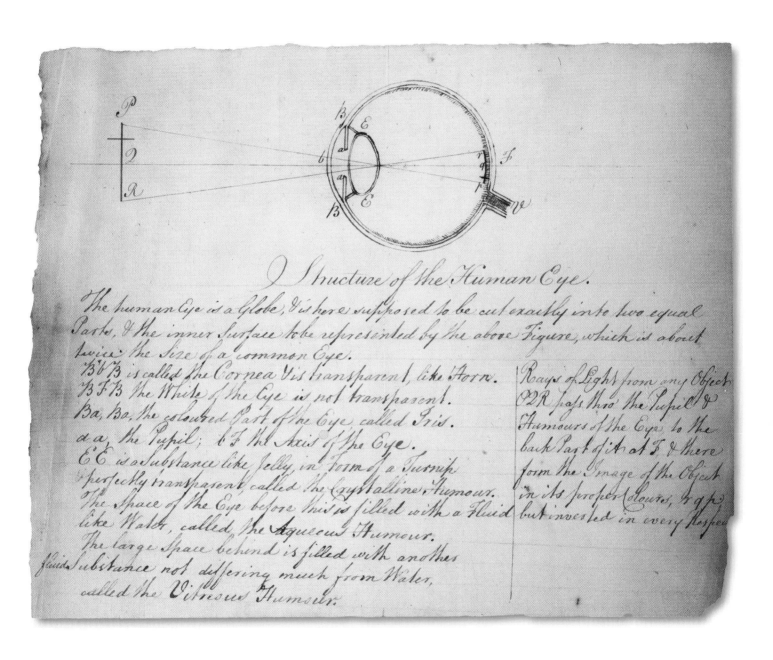

Structure of the Human Eye.

The human Eye is a Globe, & is here supposed to be cut exactly into two equal Parts, & the inner Surface to be represented by the above Figure, which is about twice the Size of a common Eye.

B & B is called the Cornea & is transparent, like Horn.
B F B the White of the Eye is not transparent.
B a, B a, the coloured Part of the Eye called Iris.
a a, the Pupil; b F the Axis of the Eye.
E E is a Substance like Jelly, in Form of a Turnip & perfectly transparent, called the Crystalline Humour.
The Space of the Eye before this is filled with a Fluid like Water, called the Aqueous Humour.
The large Space behind is filled with another fluid Substance not differing much from Water, called the Vitreous Humour.

Rays of Light from any Object P Q R pass thro' the Pupil & Humours of the Eye to the back Part of it at F & there form the Image of the Object in its proper Colours, r q p, but inverted in every Respect

9.7 'His bill an augur is': Two woodpeckers from *Birds of Europe*

H. E. Dresser, *A History of the Birds of Europe*
London: Printed for the Author, 1871–82
315 × 255 mm
R2490, vol. 5, plate 274

A History of the Birds of Europe was one of the most ambitious bird books of the late nineteenth century. It was begun in 1871 by Richard Bowdler Sharpe (1847–1909) and Henry Eeles Dresser (1838–1915), both of whom became leading figures in ornithology. Sharpe withdrew from the project in 1872 as he had gained a position at the British Museum (Natural History) and did not have enough time to work on the book. After this, Dresser worked on the project alone, writing in the evenings as he worked full-time during the day as an iron merchant in the City of London. The book was based on Dresser's collection of around seven thousand preserved bird specimens (now in the Manchester Museum) and those of other private collectors and museums. It involved the collection and examination of bird specimens, and reviewing published literature, to produce articles that described the appearance and variation of each species, and worked out their distributional range. Articles also covered the birds' behaviour and habits, and first-hand encounters from naturalists, travellers, colonialists and explorers. The book knitted together the individual experiences of hundreds of people to produce an encyclopaedia of Europe's birds. Dresser's collection of preserved bird skins was also the basis for lifelike illustrations which accompanied the articles. These were produced by the leading bird illustrators of the day, including John Gerrard Keulemans and Joseph Wolf. The book was a monumental undertaking: 624 species were described and illustrated, many for the first time. Around three hundred copies were issued, meaning that over two hundred thousand lithographic plates required hand-colouring. The work was issued in eighty-four parts between 1871 and 1882, which were rebound into eight enormous volumes. A supplement was issued in 1895–96. *A History of the Birds of Europe* is a fine example of the combination of artistic skill and attention to detail that characterised many of the great encyclopaedic book projects of the late nineteenth century. Today, copies are mostly to be found in private collections and in special collections libraries. The accompanying illustration shows two Black Woodpeckers from Dresser's collection. This species is found from mainland Europe to Japan and had been widely reported as having occurred in Britain at various times. Sharpe and Dresser, with the help of John Henry Gurney Jr, showed that none of these occurrences was reliable and that it is not a British bird.

Henry A. McGhie

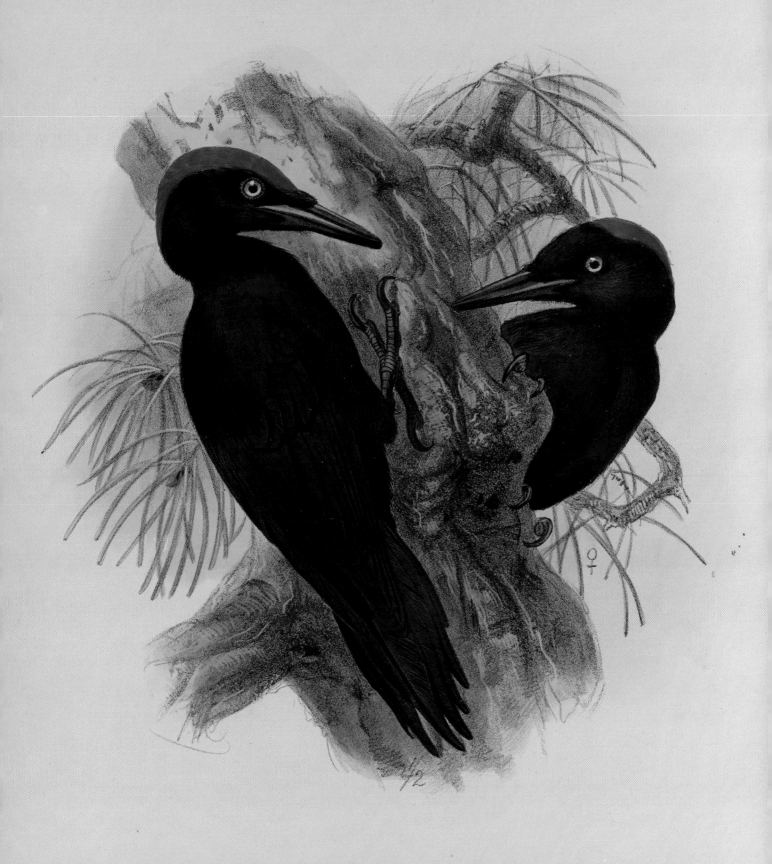

DRYOCOPUS MARTIUS.

XVIII

Needle in Foot.

Photographed at the Physical Lab: Owens College.

9.8 'A new kind of rays': An early X-ray image by Arthur Schuster

Early X-ray: Pantomime dancer's foot with needle embedded in it, 1896
150 × 210 mm (photograph), 190 × 250 mm (frame)
Papers of Ian Isherwood, ISH/4/1/1

When Wilhelm Conrad Röntgen discovered X-rays in November 1895, Arthur Schuster had been Professor of Physics in Manchester since 1888. He was carrying out similar research, amongst many other studies, into the effect of electricity in gases. Professor Schuster and Lord Kelvin were the only two scientists in the United Kingdom to receive the remarkable news from Röntgen himself in December 1895. Professor Schuster received his information as a form of apology for a perceived breach of Victorian etiquette by Röntgen in not having responded to Schuster's calling card left earlier at Röntgen's holiday home in Pontresina. Schuster recognised immediately the importance of the discovery and as Past President of the Manchester Literary and Philosophical Society addressed the Society on the subject on 7 January 1896 and wrote a letter to the *Manchester Guardian* on the following day.

Earlier in January 1896 Schuster had used the new X-rays to investigate the painful foot of a pantomime dancer who was appearing at the Palace Music Hall. They revealed a needle embedded in the foot, which had previously gone undetected. This dramatic demonstration resulted in a flood of patients being referred to his laboratory, work which significantly impeded his research programme. Schuster appealed to the Manchester Medical Society in a lecture on 2 March 1896 to set up an alternative, and more appropriate, medical facility. During the lecture he demonstrated the medical value of X-rays, using his six-year-old son as a 'patient'. The boy remembered the rather frightening experience, with its long five-minute exposures, into his nineties!

An X-ray facility was subsequently established in the then Piccadilly Infirmary with processing of the glass plates at Mottershead's chemist shop in St Ann's Square.

Ian Isherwood

9.9 Dorothy Davison's drawing of neurofibromatosis

'The pathology of neurofibromatosis' watercolour by Dorothy
Davison (1890–1984), 1943
381 × 270 mm
University of Manchester Museum of Medicine and Health, Dorothy
Davison Collection, 2004.027

Miss Davison was a medical artist in The University of Manchester's departments of anatomy and surgery from around 1910 until she retired in 1954. She helped to put 'medical illustration' on a professional footing and founded the Medical Artists' Association of Great Britain in 1948. She first worked with the anatomist Grafton Elliot Smith (1871–1937) who inspired her with an interest in anthropology and later she wrote and illustrated four books on prehistoric man. Her anatomical illustrations were used in many medical text-books and scientific papers. However, perhaps she is best remembered for her work with the neurosurgeon Geoffrey Jefferson (1886–1961) and orthopaedic surgeon Harry Platt (1886–1986), which resulted in a collection of hundreds of operative and pathological drawings. Most are pencil sketches or more detailed drawings using the 'Ross Board' technique, only a few are in watercolour, done especially for publication or presentation at scientific meetings.

Neurofibromatosis is a rare genetic disorder. The painting shows multiple nodules or benign tumours growing on nerves in the foot and thigh. The tumours can grow on nerves in any part of the body and cause discomfort and deformity by pressing on adjacent structures. Other manifestations can include pigmented skin patches and deafness. Joseph Merrick (1862–90), celebrated in Sir Frederick Treves's book *The Elephant Man*, is thought to have suffered from a form of this condition.

Peter D. Mohr

D.DAVISON

Notebook kept by G. C. Tootill whilst working on the SSEM, 4 June – 28 November 1948
240 × 180 mm
University of Manchester Department of Computer Science Collection, NAHC/MUC/2/C3

Photograph of the enhanced SSEM, known as the Manchester Mark I, photographer unknown, June 1949
University of Manchester Department of Computer Science Collection, NAHC/MUC

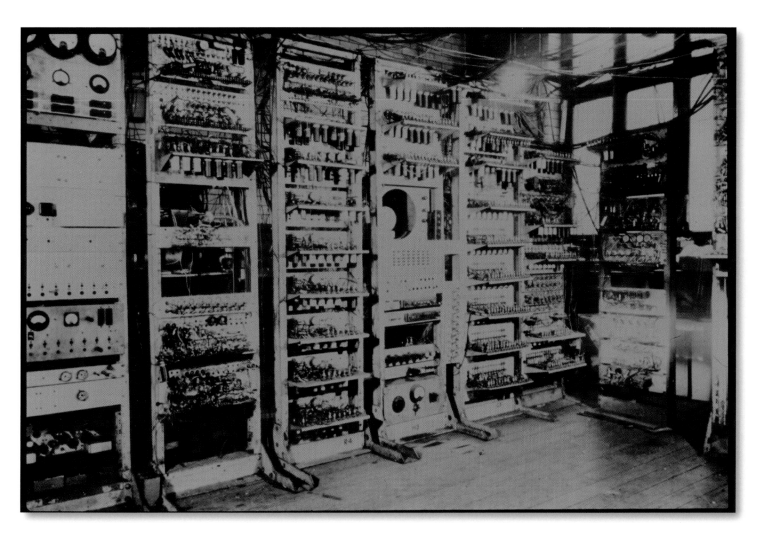

After wartime research at the Telecommunications Research Establishment (TRE), Geoff Tootill was seconded to The University of Manchester in September 1947. He joined F. C. Williams and Tom Kilburn, also ex-TRE, to work on a novel type of computer memory. Devising suitable storage mechanisms was by far the most demanding problem facing the designers of early electronic computers.

In 1948 Kilburn and Tootill designed a simple computer, the *Small-Scale Experimental Machine* (SSEM), to see how well the Manchester storage system could perform under realistic computational conditions. The SSEM was completed in June 1948 and, after struggling with faulty wiring for some days, the first program finally ran successfully on the morning of Monday 21 June 1948.

The SSEM was the first general-purpose, electronic, stored-program computer to have worked. Though small in size and affectionately known as *The Baby*, this Manchester computer was ahead of contemporary pioneering developments in America and the UK. Over the next twelve months, the team expanded and enhanced the SSEM's facilities to produce the Manchester University Mark I computer. The local firm of Ferranti Ltd was given a government contract to build a production version. The Ferranti Mark I was delivered to the University on 12 February 1951, thereby becoming the world's first commercially available computer.

In the late 1960s, when an interest in computer history was embryonic and documents had already been discarded, neither Kilburn nor Tootill could remember the date on which the SSEM first worked. The breakthrough came in 1974, when Tootill's notebook was rediscovered amongst unrelated papers in the University. The importance of the notebook in revealing the day-to-day details of an early computer project cannot be overemphasised. Spurred by the notebook's discovery and related historical research, a faithful working replica of *The Baby* was constructed in 1998, to mark the fiftieth anniversary of its birth.

Simon H. Lavington

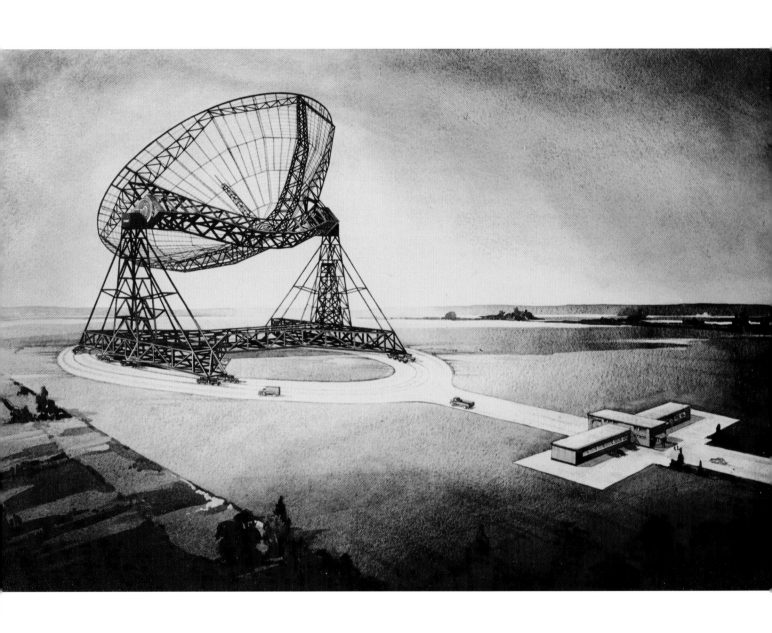

9.11 Listening to the stars: Drawing of Jodrell Bank Observatory under construction

Memorandum on a 250ft aperture Steerable Radio Telescope ('The Blue Book'), 1951
240 × 160 mm
Jodrell Bank Observatory Archive, JBA/JBM/5/1

The Lovell Telescope at The University of Manchester's Jodrell Bank Observatory in Cheshire was first used in 1957 to track the launch rocket of Sputnik 1 at the dawn of the space age. This architect's concept drawing shows the telescope and its control building just before construction work started in 1952.

Astronomy research at Jodrell Bank began in 1945 when Bernard Lovell returned to the University from his wartime work on radar. Radio interference from trams forced Lovell to move his experiments from Manchester to the botanical grounds at Jodrell Bank. There he and his team pioneered the new science of radio astronomy and created the world-famous Observatory which now exists at the site.

The Library houses the Jodrell Bank Observatory Archive containing papers deposited by Sir Bernard Lovell (1913–2012). These include extensive files of correspondence, papers relating to the construction of the telescope, logbooks, research notebooks and even Lovell's school reports.

The archive is a significant source for the history of radio astronomy and science in general.

A Grade I listed structure, the Lovell Telescope is internationally regarded as an icon of science and engineering. It is still the world's third largest steerable telescope and more capable than ever, playing an essential role in pulsar research and as part of the UK's e-MERLIN network. Looking to the future, the Observatory hosts the international headquarters of the world's largest telescope, the Square Kilometre Array. To be built in Africa and Australia, it will play a leading role in radio astronomy for the next fifty years.

Jodrell Bank combines outstanding scientific heritage, world-leading research and accessibility to the general public. Its new Discovery Centre attracts almost 150,000 visitors each year, building on Lovell's tradition of engaging with the public and inspiring the next generation of scientists and engineers.

Tim J. O'Brien

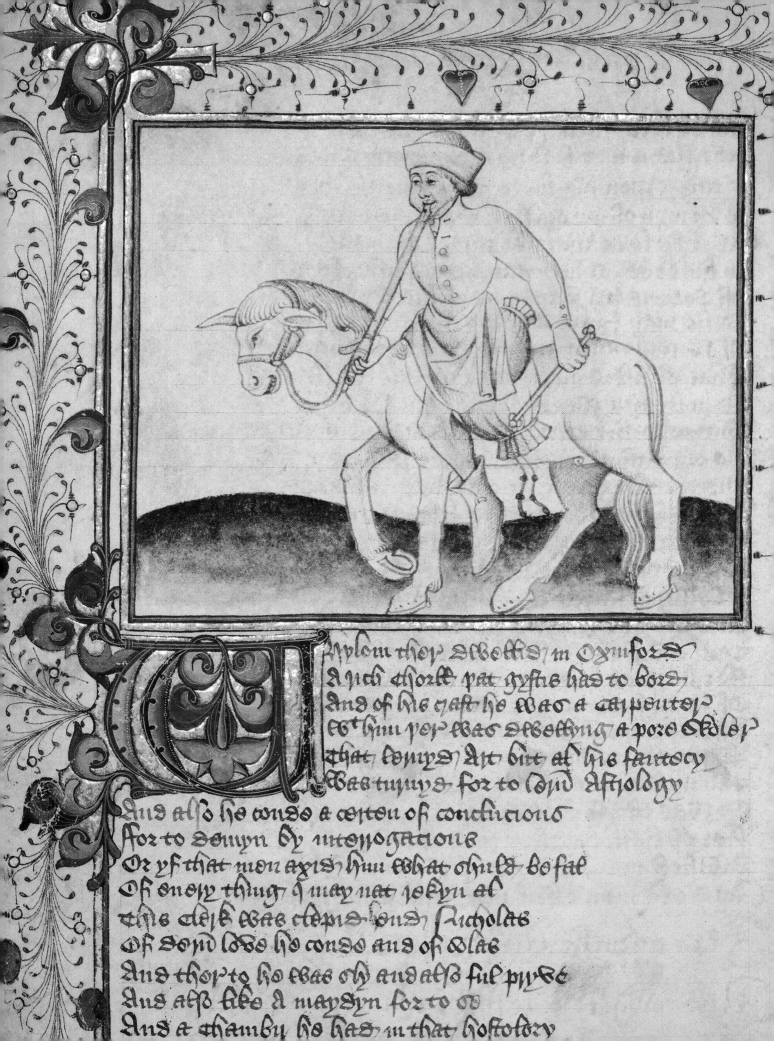

Whylom ther dwellyd in Oxnford
A riche chorle þat gystis has to bord
And of his craft he was a carpenter
Wt hym þer was dwellyng a pore skoler
that conynd art but at his fantecy
Was tournyd for to lern Astrology

And also he conde a certen off conclucions
for to demyn by interrogacions
Or yf that men axid hym what shuld befall
Off enoy thyng I may nat rekyn al
this clerk was clepid hend Nicholas
Off dern love he conde and of solas
And therto he was sly and also ful pryve
And also lyke a maydyn for to se
And a chamby he has in that hostolry

10

'Between the covers': A literary miscellany

THE JOHN RYLANDS LIBRARY's literary holdings embrace the globe and span five millennia – from poetry inscribed on clay tablets in ancient Mesopotamia to word-processed essays preserved as email attachments. Every literary genre is represented, as well as every type and stage of literary endeavour – drafting and composing, revising, editing, translating, copying, printing, publishing, reviewing, and more. This chapter can only provide a taster of such diverse riches.

Epic poetry – the earliest literary form – was often committed to writing only after having circulated orally for many centuries. Many epic narratives are central to specific cultures, possessing the status of national poems. Epic poems included in the Library's collections range from the ancient Sumerian story of Gilgamesh and Aga (preserved in cuneiform script on a clay tablet) to John Milton's Christian epic, *Paradise Lost*, first published in 1667 and subsequently in many other important editions. In this chapter, the epic is represented by a sumptuous manuscript copy of the Persian *Shahnama*, which is still considered the national poem of Iran (10.1).

The genres of epic and romance overlapped, and in the medieval period often combined to produce some of the most memorable literary works of all time, preserved in beautiful and often lavishly illustrated manuscripts, as well as some of the earliest printed books. In Western Europe, King Arthur and his knights often formed the focus of medieval chivalric romances, and the Library holds copies of some major Arthurian narratives. However, here we feature not an Arthurian romance but a fourteenth-century manuscript of the famous French allegorical poem of chivalric love, the *Roman de la Rose* (10.4), alongside a romance from another culture in the form of a rare sixteenth-century manuscript of the Indian *Laur-Chand* (10.3).

One of the greatest Middle English literary texts is Chaucer's *Canterbury Tales*, which ranges in content from idealised chivalric romance to bawdy farce. The Rylands holds a complete manuscript of *The Canterbury Tales* as well as the beautifully illustrated manuscript fragment of the Miller's Tale featured in this chapter (10.2); Caxton's early editions of the *Canterbury Tales* are discussed in Chapter 3.

Chaucer drew on the work of the Italian poet Petrarch, and the Library's holdings of medieval and early modern Italian literature are outstanding, including works by Dante, Boccaccio,

Ariosto, Tasso and others. It was Petrarch too who laid the foundations of the sonnet form, which was widely imitated and adapted by other writers; in sixteenth-century England these included Philip Sidney, Thomas Wyatt, Henry Howard and Edmund Spenser, all of whom are represented in the collections. However, it is Shakespeare's sonnets that are best-loved by many readers, and the Library holds one of only thirteen copies of their first rather humble appearance in print (10.5).

Shakespeare and his legacy are exceptionally well documented in the collections. There is a copy of the magnificent posthumous First Folio of 1623 (1.5), as well as the three subsequent seventeenth-century Folios. All other major editions of Shakespeare are included, alongside deluxe and illustrated editions. One of the most important early editors of Shakespeare was Samuel Johnson – a towering figure in the world of eighteenth-century letters who also figures strongly in our collections. Featured here are proof sheets from the influential Preface to his Shakespeare edition, annotated in his own hand (10.6). These come from the papers of Johnson's friend Hester Lynch Thrale-Piozzi, who presided over a glittering literary salon, moving among the intellectual elite of her day. Her archive is a testament to the golden age of letter-writing, containing thousands of letters alongside diaries, journals and manuscripts of her work. It is complemented by the papers of Mary Hamilton, courtier and diarist, who moved in late eighteenth-century literary, artistic, and aristocratic circles (9.4).

As so eloquently conveyed in Edwin Morgan's poem 'Archives' (see 10.10), the quantity of surviving manuscripts, letters and books increases as we come closer to the present, and our nineteenth-century collections form a veritable *Who's Who* of major and minor British literary figures, from Lord Byron to George Gissing, plus many from overseas. One of the most important literary archives is that of Elizabeth Gaskell, whose wide and varied social network means that her correspondence is particularly rich, featuring letters from Charlotte Brontë, Charles Dickens, Elizabeth Barrett Browning, John Ruskin and many others. The Rylands also holds the world's most important collection of Gaskell's literary manuscripts, but in this chapter we choose to highlight a rather poignant personal letter she received from her brother when she was just seventeen, which owes its survival to the endeavours of the great Gaskell enthusiast and collector J. G. Sharps (10.7).

One of the Library's most vibrant areas of collecting focuses on modern literary archives – dating from 1900 to the present. These provide a truly unique treasure trove of primary source material, representing most major literary movements from the period. At their core is the vast archive of Carcanet Press. Manchester-based, yet with an international reputation, the Press is committed to publishing contemporary poetry in English from across the world, poetry and some fiction in translation, as well as selections of work by writers from earlier periods. The correspondence, manuscripts and proofs of literally thousands of writers are represented in the Press's archive. It lives alongside the archives of literary magazines (such as *Critical Quarterly*), individual writers (such as Katharine Tynan and Elizabeth Jennings), as well as editors, translators, collectors and academics.

The Library is fortunate to have ongoing relationships with many of its archive creators, and this chapter features contributions from three of them: the poet and scholar Grevel Lindop writes on the work of Norman Nicholson (10.9); the writer Elaine Feinstein examines her own practice of literary translation (10.11); and Michael Schmidt (writer, academic and Managing Director of Carcanet Press) focuses on four Nobel Laureates published by the Press (10.12).

Fran Baker

10.1 A Persian epic: The *Shahnama*

Abu'l-Qasim Hasan Firdausi (Ferdowsi), *Shahnama*
AD 1650 (AH 1060)
Paper, 400 × 230 mm, ff. iii + 493 + ii
Persian MS 909, f. 47a

Over one thousand years old, the *Shahnama* (*Book of Kings*) is the longest poem written by a single author, the Persian poet Abu'l-Qasim Hasan Firdausi, or Ferdowsi. It relates the story of the ancient Persian Empire (modern-day Iran) from the creation of the world through to the Arab invasion in the seventh century AD, weaving together tales of kings, queens and princes; heroes and villains; good and evil; fabulous creatures; war, love and tragedy.

Completed in AD 1010/AH 400, the *Shahnama* is still considered the national poem of Iran. It was sourced from existing histories and oral traditions, and evokes a glorious, albeit bygone, era. Recounting the histories of forty-seven kings and three queens, it is divided into three distinct sections: the Mythological; the Legendary; and the Historical. Although the narrative is similar in structure to the medieval, prose chronicles of Europe, the *Shahnama* is written entirely in couplets. It contains over fifty thousand lines; each line consists of twenty-two syllables.

Ferdowsi wrote in Persian; the ruling Samanids were sympathetic to Persian culture, and had chosen Persian, rather than Arabic, as the language at court. The Persian language has remained largely unchanged since. This continuity is due in no small part to the literary and cultural legacy of the *Shahnama*.

The Library holds several manuscript copies of the *Shahnama*, some boasting magnificent calligraphy and beautifully vivid illustrations. The miniature shown here depicts the birth of Rustam, the hero of the *Shahnama*. Above, the Simurgh, a mythical, winged creature, instructs Rustam's father Zal on how to deliver the baby by Caesarean section.

Carol Burrows

10.2 Chaucer's Miller

Geoffrey Chaucer, fragment of the *Canterbury Tales*
England, 15th century
Vellum, 290 × 200 mm, ff. iv + 2 + iv
English MS 63, f. 1v

The Canterbury Tales by Geoffrey Chaucer (*c*.1340–1400) is probably the best-known work of English literature from the Middle Ages.

While many of his contemporaries paid tribute to Chaucer and his work, there are no extant manuscripts of *The Canterbury Tales* dating from his own lifetime, and there is no indication that he intended to 'publish' the text (which was left unfinished at his death) in any formal way. However, the fact that there are so many surviving copies from the early fifteenth century suggests that the text had already reached a wide circulation by that time.

The manner in which the *Tales* were left by Chaucer, and the processes involved in manuscript circulation, mean that there is no 'authoritative' version of the text, which is inherently unstable. Variations between copies can arise from various sources – ranging from scribal error to deliberate editorial intervention. Manuscripts were not always bound; they could circulate in gatherings or booklets, and their content might be rearranged. Subsequently they might be rebound, bought and sold by collectors.

Of just over eighty surviving manuscripts of *The Canterbury Tales*, only around fifty-five are complete or nearly complete. The Rylands fragment contains the final twenty-nine lines of the Miller's Prologue, and two different sections of the Miller's Tale. It forms part of what is known as the 'Oxford Manuscript' of *The Canterbury Tales* dating from the second quarter of the fifteenth century. Eleven further leaves of the same manuscript are held in the Rosenbach Museum and Library in Philadelphia, USA.

The manuscript, which is on vellum, is likely to have been written by a professional scribe; some care was taken with the layout of the text, and ruling in red ink is just visible. The tinted drawing of the Miller on horseback, framed in gold, is thought to have been added at a later date – possibly the early part of the sixteenth century. It has been suggested that the illustrations were added in gaps that were never filled during the initial production of the manuscript.

Amongst over forty Middle English manuscripts, the Library also holds a complete copy of *The Canterbury Tales* dating from the later fifteenth century.

Fran Baker

10.3 An Indian Sufi romance: The *Laur-Chand*

Maulana Daud, a Sufi poet from Dalmau (modern Uttar Pradesh, India), composed his narrative of the hero Laurak, and his beloved, Chanda, around AD 1377/8. Drawing on a popular north Indian regional folktale, which still circulates in vibrant performative traditions today, Daud used the language of Avadhi (or Hindavi) to compose the first surviving Indian Sufi romance, a model for later poets. Avadhi was both a courtly literary language and a vernacular; Daud used Persian *masnavi* conventions, such as opening verses in praise of Allah, the Prophet Muhammad and his four Companions, Daud's patron and his own *pīr* (Sufi teacher), alongside Indian images and settings, to create an Indo-Islamic story with wide appeal.

The story tells of the mutual love of Laur (Lorik/Laurak), already married to Maina, and the beautiful Chand (or Chanda), separated from an unsuccessful childhood marriage. Brought together through the mediation of Chanda's nanny, they run away together and face many trials, including Chanda's near-fatal snakebites, the result of a curse. Eventually they return to Maina, but the end of the story is unknown, none of the five surviving manuscripts being complete. Chanda's beauty draws Laurak, the Sufi seeker, to God's beauty; his 'death' to *nafs*, the ego-self, as she 'dies' at the second bite, hints at *fanā'*, the annihilation of the seeker in God's Being alone.

The Manchester *Chandayan* is the most extensive extant manuscript, despite lacking beginning, end and some middle pages. A clever use of picture series draws readers into the story, immersing them in an experience which hints at emotions and unfolding action, creates suspense and engages them with the pace of the narrated tale. While previously the Manchester manuscript was seen as an inferior version of a common lost original better reproduced by the Mumbai *Chandayan* (Losty), Adamjee has now convincingly argued for its subtle independent narrative strategies intertwining paint and word.

In this picture, Laurak has just scaled the wall to Chanda's bedchamber, before they have actually met. He gazes on her beauty as she sleeps, her female companions failing to wake and guard her as they should. The verses opposite (on f. 159b) describe the gorgeous wall-hangings depicting scenes from the epic of Rama and Sita, and the story of the Pandavas, from the *Mahabharata*; all are delicately etched on the walls 'the colour of aloewood', gold-leafed in the painting. In a moment, Laurak will wake Chanda, and the passion of their romance will begin … .

Jacqueline Suthren Hirst

Moulana Daud, *Laur-Chand* (or *Chandayan*)
India, *c.*1570
Paper, 230 × 140mm, ff. 318
Hindustani MS 1, f. 160a

amoures Ql ma si loiaument serui

Ql a bien vers moy deserui

Ql ie saille ⁊ que ie ma tour

De rompre les murs ⁊ la tour

Et du fort chastel assocur

Il tout qcique iai de pooir

Et plus encor me doit seruir

Car pour ma grace deseruir

Guillaume Soit il comencer le vouuant

Ii seruoit mis tait mi comaut

Et iusq̃ la le fera uia

Ou il a bel acueil dira

Ql languist or en la prison

Par douleur ⁊ par mesprison

Coment guillaume de loris fine laptie

Ie suy durement esmaiez du romãs

Quentroublie ne maiez de la rose

Si en ai duel ⁊ desconfort

Pert iamais riens qui me cfort

Se ie pert vre bien vueillance

Car ie nay mais ailleurs fiance

Coment guillaumez gist mort

Ci se reposera Guillaumes

Li quels tombeaus soit plein de basme

Dencens de myrrez daloe

Tant ma serui tat ma loe

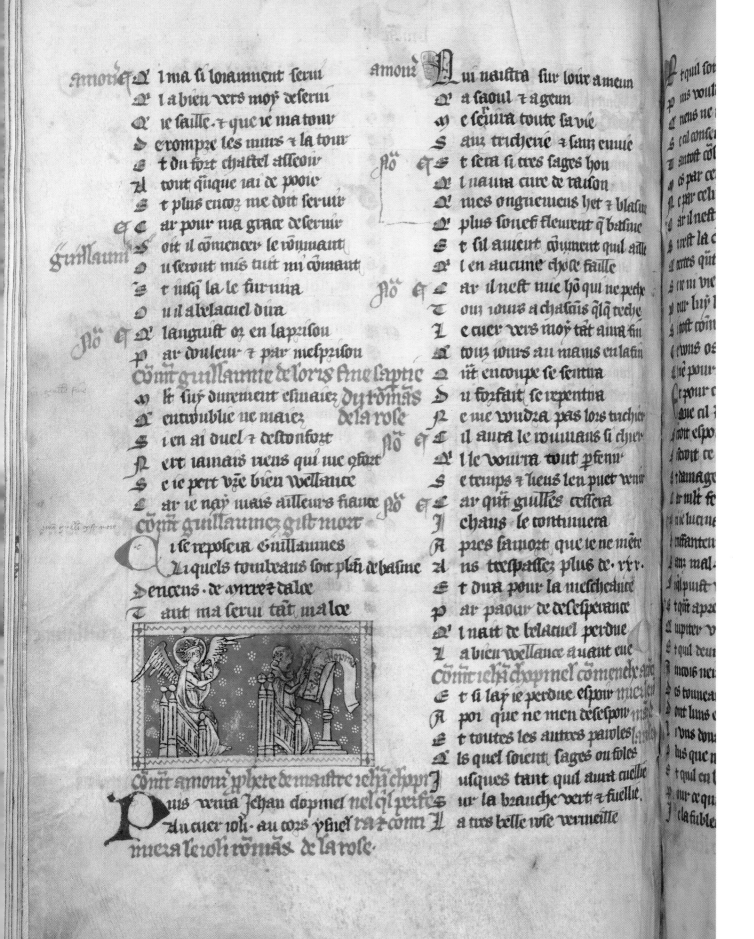

Coment amour prophete de maistre iehã clopin

Puis uenra iehan clopinel nel cil prises

Au cuer ioli au cors ysnel rat coint

Mura le ioli romãs de la rose.

amour Qui naistra sur loire amein

Qa saoul ⁊ a gein

Me seruira toute sa vie

Saus tricherie ⁊ saus euuie

Ro Et Et sera si tres sages hou

Ql nauira cure de raison

Mes ongnemens het ⁊ blasme

Ql plus sonef fleurent q̃ basme

Et sil auuent coment quil aille

Ro Ql en aucune chose faille

Car il nest nue hõ qui ne peche

Ou iours a chascuis qlq̃ teche

Le cuer vers moy tat aura fin

Tour iours au mains en la fin

Quit encoupe se sentira

Du forfait se repentira

Ce me uuldra pas lors trichier

Il aura le roummaus si chier

Ql le vouura tout psenir

Et teups ⁊ lieus len puet venir

Ro Et Car quit guilles cessera

Jchaus le continuera

Apres sa mort que ie ne mete

Ius trespassez plus de xl.

Et dira pour la mescheauce

Par paour de desesperance

Ql nait de bel acueil perdue

La bien vueillance a uant eue

Coment iehã chopinel comence apres

Et si lay ie perdue espoir mieleu

A poi que ne men desespoir meffi

Et toutes les autres parolles grôlx

Els quel soient sages ou foles

usques tant quil aura cueilli

ur la branche vert ⁊ fueille

A tres belle rose vermeille

Et quil soit

Mes uoulr

Ql neus ne

Cal conseil

Si antost cõ

Es par ce

E par celi

Sil il nest

Sinest la c

Mes qu il

Sen uie

Pour luy

Si tost coue

Es uous os

Se ie pour

Et pour c

Que cil

Soit espoi

Souit ce

Es damag

Or uilt fe

Me lueine

Ssanten

Cnu mal

Sil puit

T quil apa

Juppter v

Et quil deu

Ii mois ue

Es touuea

Ont luus

Ii ous dou

Plus que re

Et quil en

Our ce qui

Jtela fueble

10.4　A medieval romance: The *Roman de la Rose*

Guillaume de Lorris and Jean de Meun, *Roman de la Rose*
France, first half 14th century
Vellum, 284 × 195 mm, ff. ii + 163 + ii
French MS 66, f. 87v

The *Roman de la Rose* is one of the most important and influential works of medieval French literature. It was begun by Guillaume de Lorris around 1230 and completed some forty years after his death by Jean de Meun, whom we see depicted at work in the accompanying reproduction, identified by a scroll bearing another of his names, *Jehan Chopinel*. The text is an allegorical love poem of over twenty thousand lines of octosyllabic couplets. The poem's narrator recounts a dream in which, struck by the arrows of the God of Love, he strives to woo the eponymous flower. While Guillaume's opening section, barely a fifth of the whole poem, is in essence a guide to the correct courtly conduct for a lover, Jean's continuation varies widely in tone and topic, offering an encyclopaedic treatment of thirteenth-century thought and knowledge. It was one of the most prolifically disseminated of all vernacular secular texts of the Middle Ages, and survives in well over three hundred manuscripts copied during the thirteenth to the sixteenth centuries.

The Rylands manuscript dates from the fourteenth century, and contains a copy of the *Rose* (ff. 7–163v) which is complete save for a missing gathering which would presumably have contained the final seven hundred lines. While this copy, with four miniatures of mediocre quality, may not boast the artistic excellence of some of the more lavishly decorated extant manuscripts, it is of particular interest for the profusion of rubrics and marginalia added in red ink in order to facilitate navigation around the extensive text. The copy is preceded by a rubric briefly describing part of the content of the *Rose* and its authorship, an anonymous prose treatise on love that some scholars have tried to attribute to Richard de Fournival, and a list of 133 chapters of the *Rose*. An annotation by a seventeenth-century hand at the top of folio 2 reveals that the manuscript was owned by the Friars Minim convent at Mons; precisely how it reached the London bookseller from whom Mrs Rylands acquired it in the late nineteenth century is unclear.

Daron L. Burrows

10.5 Shakespeare's sonnets in print

William Shakespeare, *Shake-speares Sonnets: Neuer before Imprinted*
London: G. Eld for T[homas] T[horpe], 1609
185 × 133 mm
Spencer 10739

Although humble-looking in comparison with the magnificent posthumous First Folio, this copy of Shakespeare's *Sonnets* is in some ways more precious: it was published during Shakespeare's lifetime, and it is one of only thirteen surviving copies.

It is not known when most of the sonnets were composed, but many of them are likely to have been written during the 1590s, and their manuscripts circulated amongst a coterie of friends.

Shakespeare was largely unconcerned with seeing his plays in print, and it is still disputed as to whether he authorised this edition of his *Sonnets*. However, one theory suggests that the prominence of his name on the title page of this volume indicates that he may have had a hand in preparing it for the press.

This title page is followed by an enigmatic dedication to 'the onlie begetter of these ensuing sonnets Mr W. H.'. Centuries of speculation have never reached a firm conclusion about the identity of the mysterious Mr W. H., although popular candidates are William Herbert, 3rd Earl of Pembroke, and Henry Wriothesley, 3rd Earl of Southampton, who was Shakespeare's patron in the early 1590s. More speculation surrounds the identities of the beautiful youth, 'dark lady' and rival poet who feature in the 154 sonnets.

The sonnet form originated in Italy during the fourteenth century, with Petrarch's famous series of sonnets to his idealised lover, Laura. Sonneteering became hugely popular in Britain during the sixteenth century, and Shakespeare's name has become synonymous with the English sonnet, adapted from its Italian origins to a form more suited to the English language.

Fran Baker

SHAKE-SPEARES

SONNETS.

Neuer before Imprinted.

<hr />

<hr />

AT LONDON
By *G. Eld* for *T. T.* and are
to be folde by *Iohn Wright*, dwelling
at Chrift Church gate.
1609.

ward, he shortned the labour, to snatch the profit. He therefore remits his efforts where he should most vigorously exert them, and his catastrophe is often improbably produced or imperfectly represented.

He had no regard to distinction of time or place, but gives to one age or nation, without scruple, the customs, institutions, and opinions of another, at the expence not only of likelihood, but of possibility. These faults *Pope* has endeavoured, with more zeal than judgment, to transfer to his imagined interpolators. We need not wonder to find *Hector* quoting *Aristotle*, when we see the lives of *Theseus* and *Hippolyta* are combined with the *Gothick* mythology of fairies. *Shakespeare*, indeed, was not the only violator of chronology, for in the same age *Sidney*, who wanted not the advantages of learning, has, in his *Arcadia*, confounded the pastoral with the feudal times, the days of innocence, quiet and security, with those of turbulence, violence and adventure.

In his comick scenes he is seldom very successful, when he engages his characters in reciprocations of smartness and contests of sarcasm; their jests are commonly gross, and their merriment licentious; neither his gentlemen nor his ladies have much delicacy, nor are sufficiently distinguished from his clowns by any appearance of refined manners. Whether he represented the real conversation of his time is not easy to deter-

determine; the reign of *Elizabeth* is commonly supposed to have been a time of stateliness, formality and reserve, yet perhaps the relaxations of severity were not very elegant. There must, however, have been some modes of gayety preferable to others, and a writer ought to chuse the best.

In tragedy his performance seems always to be worse, as his labour is more. The effusions of passion which exigence forces out are for the most part striking and energetick, but whenever he solicits his invention, or strains his faculties, the offspring of his throes is tumour, meanness, tediousness, and obscurity.

In narration he often affects a disproportionate pomp of diction and a wearisome train of circumlocution, and tells the incident imperfectly in many words, which might have been more plainly delivered in few. Narration in dramatick poetry is naturally tedious, as it is unanimated and inactive, and obstructs the progress of the fable; it should therefore always be rapid, and enlivened by frequent interruption. *Shakespeare* found it ungraceful, and instead of lightening it by brevity, endeavoured to recommend it by dignity and splendour.

His declamations or set speeches are commonly cold and weak, for his power was the power of nature, when he endeavoured, like other tragick writers,

a 2

10.6 Johnson and Shakespeare

Samuel Johnson, Page proofs of Preface to *The Plays of William Shakespeare* [*c*.1765]
Paper, 220 × 270 mm, ff. 16
Thrale-Piozzi Manuscripts, English MS 653

These page proofs constitute rather less than half of Samuel Johnson's preface to his edition of *The Plays of William Shakespeare* (1765), but they contain many corrections in Johnson's hand.

In his detailed study of these proof pages, Arthur Sherbo noted that the published preface incorporates some changes not made here. Conversely, some marked corrections did not find their way into print. An example of the latter occurs in the first line of the recto illustrated. Johnson changes the semicolon after 'determine' to a period, but the original punctuation survives in the published version. There may, therefore, have been a further set or sets of proofs.

Many of Johnson's changes remove verbal repetition or otherwise sharpen expression. An example of the latter can be seen in the third line of the verso shown, where Johnson deletes 'often' to intensify his criticism. Other changes improve the text by opting for a more precise word. In line 24 of the verso, Johnson alters 'merriment' to 'pleasantry', which he defines in his *Dictionary* both as a general synonym for 'merriment' and as 'sprightly saying; lively talk'. The latter sense is relevant for the present context, where verbal

humour is his topic. In line 20 of the recto, 'progress of the action' replaces 'progress of the fable' where the argument is that narrative speeches are non-dramatic. Johnson thus chooses a more exact phrase at the expense of introducing verbal repetition ('inactive'/'action').

Proposals for Johnson's *Shakespeare* appeared in June 1756, the year after the publication of his famous *Dictionary*. After much delay, the eight volumes of the edition were published in 1765. The preface was probably the final part to be written. It crowns a work that changed the shape of editions of Shakespeare as surely as the *Dictionary* had established the form of modern dictionaries. It was the first 'variorum' edition, one that includes not only Johnson's own commentary but significant notes by earlier editors, so allowing readers to judge the history of scholarly criticism. The preface matches the editorial method by locating the test of literary value in readers' or audiences' responses over time. Johnson's careful correction of his proofs indicates the importance he attached to his most substantial, influential and radical critical essay.

William Hutchings

10.7 a & b A letter from sea: Elizabeth Gaskell and her brother

John Stevenson, letter to his sister Elizabeth (later
Gaskell), 16 July and 11 August [1827]
Paper, 310 × 195 mm
Papers of J. G. Sharps, Box 30/2
Reproduced by kind permission of Sarah Prince

W. J. Thomson, portrait miniature of Elizabeth Gaskell
[June 1832?]
Watercolour on ivory, 110 × 85 mm
Gaskell Collection, University MSS

John Stevenson (1798–1828?) was the older brother
of the novelist Elizabeth Gaskell (1810–65). Their
mother died in 1811, after which John began a career
in the merchant marine and Elizabeth was sent to
live with her aunt, Hannah Lumb, at Knutsford. The
Library holds a sequence of nineteen letters from John
to his sister, dating from ?1819–28. Two of the letters are
in manuscript; the remainder in an unidentified typescript
copy of the lost originals. Some, like this one, are incomplete.
The letter is written from the *Recovery*, a merchant vessel on
which John Stevenson served as second officer. The precise
location is given: 'At sea lat.38–30N / Long, 15–10W' (in the
Atlantic off the coast of Portugal). By 1828 John Stevenson
had established himself as a figure in the India trade: other
letters give interesting details of his experiences in Calcutta
and Rangoon. This example uses the crossed letter form,
common before the mid-nineteenth-century postal reforms,
in the interests of saving the costs of both paper and weight.
At first reading it can seem difficult to decipher but in fact
the system demanded regularity and clarity of script for it to
be decipherable. How a letter written on shipboard would be
carried is not clear.

Much of the letter is given over to an account of the cer-
emony of crossing the line, whereby those on board crossing
the equator for the first time were subjected to various comic
humiliations. There is also an incident involving the ship's
newspaper, a publication for which Stevenson, who was
not without his own literary ambitions, had made himself
responsible.

Beyond this sequence of letters we know little of John
Stevenson. It is generally assumed that he died in 1828, lost
either at sea, or on the subcontinent. It is clear from these
letters that there was reciprocal affection between him and
Elizabeth, albeit that he often addresses her paternalistically.
In *Cranford*, Elizabeth Gaskell describes the career of the
long-lost 'Cousin Peter' who disappeared in the subconti-
nent, but who miraculously returns at the conclusion of the
novel. This, if only implicitly, may be an echo of his impor-
tance in his sister's early life.

The miniature of Elizabeth Stevenson was painted by
W. J. Thomson of Edinburgh, and inscribed on the back
'Painted by W. Thomson June 1832 Edin –'. This is mislead-
ing however, since Elizabeth Stevenson's known visits to
Edinburgh took place in 1830 and/or 1831. She was married to
William Gaskell at Knutsford on 30 August 1832.

Alan Shelston

10.8 a & b Two war poets: Wilfred Owen and Edmund Blunden

John Gunston, Photograph of Wilfred Owen, *c.*1916
161 × 114 mm
Papers of Dennis and Joan Welland, DSW/1/1/4/5/2

Edmund Blunden, Notebook [1920s]
Paper with vellum binding, 200 × 152 mm
Papers of Dennis and Joan Welland, DSW/1/1/4/2
Reproduced by kind permission of the Trustees of the Owen Estate

The unassuming volume in which this poem appears is one of the most important items among the papers of the Manchester University academic Dennis Welland (1919–2002).

Welland's PhD and earliest academic work focused on the poetry of Wilfred Owen (1893–1918). This was in the late 1940s, a time when doctoral research in modern literature was rare, and Welland became an early and highly respected pioneer in the field of Wilfred Owen studies.

Although Owen's poems and life-story are now so well known, at the time Welland embarked on his research very little secondary material had been published on the poet or his work. Not even all of his poems had made it into print: only five of Owen's poems were published during his lifetime, and by the late 1940s there had been only two selected editions of his work.

Welland therefore set about some literary detective work, tracing the surviving manuscripts of Owen's work and tracking down those who had known him – all of his activities being documented in the Welland archive. One of those who offered ongoing assistance and advice was the poet and university teacher Edmund Blunden (1896–1974).

Blunden had published a selection of Owen's work in 1931. In preparing his edition he transcribed many of the poems from manuscript sources into this vellum-bound notebook. The book itself dates from the early nineteenth century and was originally used as an account book: the first few pages record the financial transactions of a company run by Messrs H., G. and J. Campbells. Blunden acquired and re-purposed the volume during the course of his research, noting on the first page that he bought it in 1924.

The poem 'Inspection', transcribed here in Blunden's meticulous hand, was drafted by Owen in August and September 1917, when he was at Craiglockhart Military Hospital recovering from shellshock. It was only when he met the older and more established poet Siegfried Sassoon at Craiglockhart that he began directly addressing the war in his work, producing some of the most powerful war poetry of all time.

Sassoon outlived the younger poet by almost fifty years: Wilfred Owen returned to the front in 1918, being awarded the Military Cross in October. He was killed on 4 November and his parents received the telegram notifying them of his death on 11 November, just hours after hostilities ceased.

Fran Baker

Inspection.

"You! What d'you mean by this?" I rapped,
"You dare come on parade like this?"
"Please, sir, it's —" "'Old yer mouth," the sergeant snapped.
"I takes 'is name sir?"— "Please, and then dismiss."

Some days "confined to camp" he got
For being "dirty on parade."
He told me afterwards, the damnéd spot
Was blood, his own. "Well, blood is dirt," I said.

"Blood's dirt," he laughed, looking away
Far off to where his wound had bled
And almost merged for ever into clay.
"The world is washing out its stains", he said.
"It doesn't like our cheeks so red.
Young blood's its great objection.
But when we're duly whitewashed, being dead,
The race will bear Field-Marshal God's inspection."

10.9 a & b Millom and the universe: Norman Nicholson's 'The Pot Geranium'

Photograph of Norman Nicholson, photographer unknown [c.late 1970s / early 1980s]
200 × 152 mm
Papers of Norman Nicholson, NCN16/2/20

Norman Nicholson, draft of 'The Pot Geranium' [1940s–50s]
Paper, 360 × 220 mm
Papers of Norman Nicholson, NCN3/1/4/16
Reproduced by kind permission of the Norman Nicholson Trustees

Norman Nicholson (1914–87) was a leading mid-twentieth-century English poet, and the most prominent Cumbrian poet of his time. 'The Pot Geranium' is the quintessential Nicholson poem, and gave its title to his third poetry collection, published in 1954. It finds the poet in his attic bedroom at 40 St George's Terrace (the house where he spent nearly his whole life), surveying the 'green slated gables' of Millom, the declining industrial town about which he often wrote. He watches a red box kite 'ride the air', then lies on his bed, contemplating the potted plant on his windowsill, its flower red like the kite and, like the poet, rooted in one place (its 'crock of soil, six inch deep by four across'); yet, through the elements that nourish it, participating in the whole universe.

The poem not only celebrates – and is slightly defensive about – Nicholson's provincial rootedness. It contains hidden autobiography. As 'the ceiling slopes over like a tent' and walls leave 'a flap for the light to blow through', Nicholson recalls, and brings into the present, his teenage years spent in a Hampshire TB sanatorium where patients slept in open-sided marquees where the wind blew through unobstructed. Nicholson recovered, but the 'looping springs [which] Twine round my chest and hold me' hint at the occasional difficulties in breathing which he suffered lifelong.

The poem is one of some thirty drafts, many unpublished, in a cardboard folder from John Summers and Sons Ltd, property agents. The folder is marked, in Nicholson's hand, on the outside: 'POEM IN PROGRESS' and within: 'SHOP LETTING' – a reminder that the ground floor retail premises were rented out long after the death of Nicholson's father, a 'gentleman's outfitter'.

Nicholson had perhaps the least legible hand of any modern British poet. The manuscript displays his characteristic scrawl with its private shorthand: the elongated 'c' which serves for 'the'; the 'v' which does duty for 'and'. The word deleted in pencil before 'cornice' in line 8 (hollowed? furrowed? ballooned?) has resisted all attempts at decipherment. But its deletion saves the line from being, like its predecessors, a pentameter, thus producing Nicholson's typical flowing irregularity of rhythm.

Characterful yet inscrutable, the manuscript is redolent of the man. Its conclusion – 'I eat the equator, breathe the sky, and carry / The great white sun in the dirt of my fingernails' – is both cosmic and grubbily – disconcertingly – down-to-earth.

Grevel Lindop

generation upon
generation upon
generation upon
generation upon
generation upon
generation upon
generation upon
generation upon
generation upon
generation upon
generation upon
generation upon
generation upon
generation upon
generation upon
generation upon
generation upon
g neration upon
g neration up n
g nerat on up n
g nerat n up n
g nerat n p n
g erat n p n
g era n p n
g era n n
g er n n
g r n n
g n n
g n

140

10.10 An archival poem by Edwin Morgan

Edwin Morgan, 'Archives', from the collated proofs of *Collected
Poems* (1990)
Paper, 210 × 297 mm
Archive of Carcanet Press, Accession 3, Box 357/3
Reproduced by kind permission of Carcanet Press

Edwin Morgan (1920–2010) was the Scots Makar or poet
laureate of Scotland from 2004, and was deeply attached to
his native land and especially to his home city of Glasgow. He
lived there all his life except for a brief period of war service
in the Middle East. Nevertheless, he was absolutely interna-
tionalist in his outlook, and a brilliant translator from Latin,
Russian, Hungarian and Italian. He was drawn into the con-
crete poetry movement in the late 1960s, corresponding with
its Brazilian and Swiss proponents, and 'Archives' comes
from that period. He loved playfulness in poetry, patterns
and verbal games, but not just for their own sake. So here,
after nineteen solid lines (if you read from the top down),
bits of the words go missing, just as in archives: the further
you go back, the more patchy the written record becomes.
And when the first letters go, you can still make some sense
of the words, but gradually they lose their identifying letters
– a bit like personal memory, too. A stray Latin word emerges
out of 'generation': 'erat' – 'he/she/it was'. Stripped of its 't',
'era' then stands out, a unit of time. Then the 'er' that sug-
gests hesitation or even confusion, and down to 'r' – added
to 'er' gives us 'err', to wander in the wrong direction. We've
come quite a long way from that apparently stable begin-
ning, which looks rather like serried bricks on the page. Of
course this poem could be read from bottom to top, and then
the message would be different as the spaces fill with bricks
after the frail beginning (in the '*garden*'?), and a solid family
history is amassed.

When his *Collected Poems* were published in 1990, books
were still being typeset from scratch; the setter would not
have been working from an electronic file but a big file of
photocopied poems from Morgan's various volumes. Concrete
poetry always poses a challenge in alignment and spacing.
No doubt the typesetter would have been concentrating on
that and did not notice that the final 'g' was absent. This cor-
rection may be in Morgan's hand but is probably in that of the
proof-reader. He was a meticulous proof-reader himself, and
the Carcanet archive contains much evidence of his care with
his texts. Despite his famous poem 'The Computer's First
Christmas Card', and his general curiosity about science
and technology, Morgan never used a computer, only a type-
writer and his distinctive, elegant handwriting.

Robyn Marsack

10.11 a & b Translation in practice: Elaine Feinstein and Marina Tsvetaeva

Elaine Feinstein, translation of Marina Tsvetaeva's *Desk* [c.1970s], detail; Simon Franklin, literal translation of *Desk*
Both items paper, 295 × 210 mm
Papers of Elaine Feinstein, Box 126
Reproduced by kind permission of Elaine Feinstein (a) and Simon Franklin (b)

Marina Ivanovna Tsvetaeva (1892–1941) was one of the greatest European poets of the twentieth century. The lyric shown here is part of *Desk*, a sequence of poems written in Paris in the mid-1930s: the literal version (p. 227) was made by Simon Franklin for an expanded second edition of her *Selected Poems* (1982). Elaine Feinstein's draft faces it. Feinstein has used Franklin's annotated literal translation to read Tsvetaeva's Russian text accurately, while working as a poet to preserve the strong rhythms and lyrical shapeliness of the original.

In 1922, after the Bolshevik victory in the Civil War, Tsvetaeva left Russia with her daughter to join her husband, Sergei Efron, in Prague. He had fought in the White army. She found him living on a small Czech student grant, and suffering from TB. Thereafter, she was the main financial support of her family, which was increased by a son in 1925.

After Tsvetaeva's tumultuous love affair in Prague (and an epistolary romance with Boris Pasternak), the family moved to Paris. By 1932, Efron was a convinced Socialist, and longed for a return to Russia – a prospect which filled Tsvetaeva with dismay. She was relieved when he was refused a Soviet passport. By now, the two of them bickered constantly. Their daughter Alya, to whom Tsvetaeva had been very close in the Moscow famine, now sympathised wholeheartedly with her father. Tsvetaeva's spoiled young son, Georgy, began to mock his mother very rudely. These were some of the people Tsvetaeva describes in her first line as 'eating her up', but the rest of the poem has the rich émigré community in its sights.

Writing was now Tsvetaeva's strongest passion. *Desk* celebrates her dedication to it. The last, triumphant verse on the next page declares that Judgement Day will show *gourmands* as 'stuffed capons' while she will lie 'naked / with only two wings for cover' (see *Bride of Ice* pp. 143–4. The omission of 'h' in 'thick-legged' is also corrected there).

Tsvetaeva's colloquial vigour points up her own contempt for material comfort. This she had learned in her Moscow childhood from a gifted, frustrated mother, who forced her to learn the piano, and died when Marina was only fourteen. In an essay written at the same time as *Desk*, Tsvetaeva reflected: 'After a mother like that, I had no choice but to become a poet!'

Elaine Feinstein

(3) – 6 ? Or do you want to give the impression that the poem is continuous and complete?

The rest of you can eat me up
 I just record your behaviour!
For you they'll find dining tables
 to lay you out. This desk for me!

Because I've been happy with little
 there are foods I've never tasted.
The rest of you dine slowly
 you've eaten too much and too often.

Places are already chosen
 long before birth for everyone.
The place of adventure is settled,
 and the places of gratification.

Truffles for you not pencils.
 Pickles instead of dactyls
And you express your pleasure
 in belches and not in verses.

At your head funeral candles
 Must be tick-legged asparagus;
Surely your road from this world
 Will cross a dessert table!

Let's puff Havana tobacco
 on either side of you then;
and let your shrouds be made
 from the finest of Dutch linen.

And so as not to waste such
 fine cloth let them shake you
With left-overs and crumbs
 into the grave that waits for you

6

1] "жратомнами" a not a dictionary word; a frequent pseudo-neologism

Quits: by-you I am-eaten-out-of-house-and-home,
By-me - [you are] depicted.[1]
You they-will-lay - on a-dinner [table],
But me - on a-writing [table/desk].

2] Not quite accurate word-split in transl for the negative "не бедал"

3] The verb at the end of the last line must be understood in the 3rd: The order is perfectly natural in Russian

Because with-an-iota I-am-happy,
Some/viands I-have-not known.[2]
Because you [have dined] too often,
Too-long you have-dined.[3]

4] lines 1&3 with similar 'delayed' predicate to that in 3] above

Each in [the place] chosen in-advance -
Much before birth! -
The-place of-his exploit,[4]
Of-his gratification:[5]

5] 'deяnie', 'radenie'- both archaic words, closer perhaps, to 'deed' & 'zeal'.

6] Each line has strong internal rhyme that seems almost more important than the actual choice of noun: отрыжками-книжками, трюфелен-грифелен, оливками-рифмами, пикулям-дактилям.

7] lit. 'mortal' or 'pertaining to death'.

You - with eructations, I - with note-books,
[You] with truffles, I with slate-pencils,
You - with olives, I - with rhymes,
[You] with pickles, I - with dactyls.[6][7]

7] all the nouns in ll.2+4 are grammatically singular, but semantically collective. Thus they are a rhythmic contrast to the plurals in ll.1,3, without altering meaning.

At [your] head - as-funeral[8] candles -
Thick-legged asparagus.
A-striped dessert
Table-cloth [is] for-you - as-a-road!

Let-us-puff / Havana tobacco
On-the-left for-you - and on-the-right for-you.
A-Dutch / linen
Table-cloth for-you - be-it as-your-shroud!

But so-as not to-waste / the-table-cloth -
Into a-pit, a-low place,
They-will-shake you all out-of the-table-cloth:[9]
With the-crumbs, with the-left-overs.[10]

9] The 'out' is part of the verb, "вытрясут" not of the preposition "из".

10] 'огрызки' = "things that have been gnawed down & left" - thus, in other contexts, 'apple-core', & even 'stub of a pencil'

10.12 a, b, c & d Carcanet's Nobel Laureates and the work of Stephen Raw

Orhan Pamuk, *The White Castle*, translated from the Turkish by
Victoria Holbrook
Manchester: Carcanet Press, 1990
225 × 145 mm
SC13881B

José Saramago, *Manual of Painting and Calligraphy: A Novel*,
translated from the Portuguese by Giovanni Pontiero
Manchester: Carcanet Press, 1994
222 × 145 mm
Carcanet Press Printed Collection / R161214

Czeslaw Milosz, *Facing the River: New Poems*, translated from the
Polish by the author and Robert Hass
Manchester: Carcanet Press, 1995
215 × 135 mm
Carcanet Press Printed Collection / R161733

Octavio Paz, *Collected Poems, 1957–1987*, translated from the Spanish
by Eliot Weinberger et. al.
Manchester: Carcanet Press, 1988, 2001
215 × 135 mm
Carcanet Press Printed Collection / R197030

All items reproduced by kind permission of Stephen Raw and Carcanet Press

Carcanet Press has a long commitment to publishing trans-
lations. Formerly, fiction was the chief focus for translation
work, and first novels of Nobel Prize laureates Orhan Pamuk
(2006) and José Saramago (1998) were commissioned and
published by Carcanet in 1990 and 1994 respectively; by the
time the Saramago appeared, several of his great later novels
had been published by Harvill Press.

Carcanet published Czeslaw Milosz's poems in the year

he received the Nobel Prize (1980), having bought in the American translations and published them a month before the Prize was announced. The collection illustrated here is a later book, from 1995. Octavio Paz's work has featured on the Carcanet list from 1985. He was something of an editorial presence, encouraging and advising the editor and contributing to Carcanet's associated magazine *PN Review*, for which many of his essays were translated. His *Collected Poems* appeared two years before he received the Nobel in 1990.

The four covers featured here illustrate the evolving style of Carcanet's presentation, and changes in cover fashion can be traced. Because Carcanet worked with the accomplished and inventive lettering artist Stephen Raw, the main feature of the first two covers was bespoke lettering devised in relation to the rudimentary image by John Booth in the case of Pamuk and in relation to the title (*Manual of Painting and Calligraphy*) in the case of Saramago. The movement

away from bespoke lettering began with the Milosz when Raw experimented with planes and the image by Mary McQuillan was foregrounded. Carcanet was restricting itself to two-colour covers still, and with screens and half-toning Raw achieved real depth. Finally, with the paperback edition of Paz's *Collected Poems*, the 'image' was in fact a letterform rendering, in a style appropriate to Joan Miro. The poem calligraphically illustrated is entitled 'A Fable of Joan Miro' and is about repetition, erasure and renewal. This was an early example of Stephen Raw's bespoke letterform rendition of poems which he has developed into a genre of its own over the last two decades. By the time of the paperback of the Paz *Collected* in 2001, the image reproduced here, Carcanet had begun to use four-colour printing on all its covers and adopted the cover 'grid' it has used ever since for its poetry publications.

Michael Schmidt

11

Illustrated imaginative children's literature

THE INTELLIGENT COLLECTING of books equates with the acquisition of knowledge, and is equally applicable to the collecting of juvenile literature, and in particular to the genre of folk and fairy. Towards the end of the nineteenth century scholars argued vehemently on the origin of such stories. Andrew Lang and Joseph Jacobs were deeply involved in the controversy: Jacobs's theory held that such stories came from one central source, India, and gradually dispersed over the Earth's surface; while Lang denied the theory of migration. Lang used his introduction to Marian Roalfe Cox's important study *Cinderella, Three-hundred and Forty-five Variants* (London: David Nutt, 1893), to disagree with Jacobs's theory. Both men, however, were united in their belief that such stories were more than mere entertainment and held deeper meaning.

In the early nineteenth century, books for children by leading writers such as Sarah Trimmer and Mary Sherwood were imbued with depressing religious and moral overtones. However, an English translation of *Kinder- und Haus-Märchen*, the folk and fairy stories collected by Jakob and Wilhelm Grimm, appeared in two volumes as *German Popular Stories* in 1823, with etchings by George Cruikshank (11.1). This marked a new direction in juvenile literature, with folk and fairy stories becoming an important element. Entertaining reading was replacing admonition.

John Leech, an illustrator of the satirical magazine *Punch*, created spirited drawings for Gilbert À Beckett's version of *Jack the Giant Killer*, published in 1843. Another *Punch* luminary, Richard Doyle, produced atmospheric drawings for John Ruskin's fairy story *The King of the Golden River* (London: Smith Elder, 1851). Two years later, George Cruikshank published his own illustrated *Fairy Library*, for which he rewrote *Jack and the Beanstalk*, *Hop o' My Thumb*, *Cinderella*, and *Puss in Boots*.

Apart from such notable exceptions as Cruikshank's fairy illustrations and Leech's hand-coloured illustrations to Dickens's *A Christmas Carol* (1843), etching was rarely used in children's book illustration. Wood-engraving was the preferred medium for illustration, as text and image could be printed simultaneously. The Industrial Revolution had created a growth in literacy which, by the 1830s, was satisfied by such popular reading matter as *The Penny Magazine* and *The*

Saturday Magazine. These magazines relied heavily on illustration, resulting in a rapid increase in the number of reprographic wood-engraving studios.

From 1865 Walter Crane, who had been trained to draw on the woodblock, copying artist's drawings for reproduction, together with Edmund Evans and publisher George Routledge, issued fairy stories in a *Toy Books* Series. From 1870 their books became increasingly attractive as Crane's boldly drawn artwork became more adventurous.

Evans's printing of William Allingham's verse *In Fairyland* (1870), with Richard Doyle's delightful fairies set in a magic garden, resulted in one of the finest nineteenth-century colour books, the brilliant reproductions from woodblock far outshining the unremarkable verse (11.2).

Household Stories from the Collection of the Bros Grimm, translated by Lucy Crane with pictures by her brother, Walter Crane (1882), was aimed at older children, with the artist providing 119 pen drawings in black and white, reproduced from woodblock. Walter's design for the cover cleverly invites the reader to open the door and enter into the text, a device copied and developed by Alfred Nutt for use on the cover of Joseph Jacobs's *English Fairy Tales.* Although Edmund Evans continued to print the *Toy Books* from woodblock, the first use of the line-block photo-mechanical process from 1885 in the *English Illustrated Magazine* meant that reprographic wood-engraving was largely doomed, although it enjoyed a minor revival as a creative art.

The fairy story came of age with Andrew Lang's collection *The Blue Fairy Book* (London: Longmans, 1889). Its success encouraged Lang to put together a total of twelve fairy books, mainly illustrated by H. J. Ford (11.5). His friend and competitor Joseph Jacobs compiled five fairy books for the publisher David Nutt, the first of which, *English Fairy Tales,* appeared in 1890. These volumes offer a rare glimpse of the art of John D. Batten, whose assured black-line drawings created an astonishing variety of spirited animals and mythological creatures that captured the readers' interest.

The collections of Lang and Jacobs led to a stream of imitators. In a differing vein, Arthur Gaskin's illustrations to Hans Andersen's *Fairy Tales* (1893), and Sabine Baring-Gould's *Book of Fairy Tales* (1894), were in the Arts and Crafts tradition, while Laurence Housman's sinuous Art-Nouveau-influenced illustrations to Christina Rossetti's *Goblin Market* (1893; see 11.4), introduced a new level of emotional intensity. These were notable examples, with a stream of lesser publications in their wake, giving work to a new generation of illustrators drawing for reproduction by the line-block process. However, *The Golden Fairy Book* (London: Hutchinson, 1894), *The Silver Fairy Book* (London: Berhardt, 1895), *The Diamond Fairy Book* (London: Hutchinson, 1897), and *The Ruby Fairy Book* (London: Hutchinson, 1897), illustrated by H. R. Millar, were firmly set in the 1890s 'black and white' school. These titles indicate the strength of Lang's *Colour Fairy Books* and the desire of other publishers to take advantage, with Millar labouring to produce hundreds of pen drawings to fill the pages.

From 1900 the newly perfected colour half-tone process resulted in a flow of impressive volumes of fairy stories, lavishly illustrated by Arthur Rackham, Edmund Dulac, the brothers Robinson – Charles, William Heath and Thomas Heath – among others who worked in watercolour and body-colour with a necessary understanding of the technology. These books were cleverly marketed through the simultaneous issuing of boxed, limited issues, bound in vellum with silk ties, alongside the normal trade cloth bindings. The popularity of these expensive books continued until the outbreak of war in 1914.

Ian Rogerson

11.1 a & b The Brothers Grimm

Jacob Grimm and Wilhelm Grimm, *German Popular Stories, Translated from
the Kinder- und Haus-Märchen, Collected by M. M. Grimm, from Oral Tradition*
London: C. Baldwyn, 1823; James Robins, 1826
2 vols
183 × 115 mm
R20575, Vol. I, Title page; Vol. I, facing p. 217, Rumpel-stiltskin (see p. 230)

Jacob Ludwig Karl Grimm (1785–1863) was the founder
of scientific German philology. Together with his brother
Wilhelm Karl (1786–1859), as 'The Brothers Grimm', they
published the first volume of *Kinder- und Haus-Märchen* in
1812, followed by further volumes in 1815 and 1818. Their
collection was based on stories of purely German origin,
contributed mainly by female family members and friends.

The first English translation, *German Popular Stories*,
illustrated with twenty-two etchings by George Cruikshank
(1792–1878) became a landmark, indicating the direction in
which children's literature and its illustration would develop
in the future. It stimulated authors to produce an increas-
ingly imaginative literature for children, a departure from
the dull moralising tales which had dominated the market
up to that time. Through numerous editions, the Brothers
constantly modified the text.

By 1820 Cruikshank had become recognised as England's
leading caricaturist, and the spiky, incisive style which he had
employed in his caricatures was carried through into *German
Popular Stories*. That Cruikshank chose to use etchings for
his illustrations added to the atmosphere of his pictures, with
very fine line giving more detail than the more commonly
used wood-engraving.

Marina Warner, in her narrative *From the Beast to the
Blonde*, points out the symbolic nature of Cruikshank's
laughing storyteller and his audience on the title page of
volume one, 'laugh that you may not weep', while drawing our
attention to a portrait by Ludwig Emil Grimm of Dorothea
Viehmann, the principal oral storyteller used by the broth-
ers, which was redrawn and engraved by Cruikshank for the
title-page of the second volume.

In 1853 Cruikshank published his own *Fairy Library*.
By that time, he had developed strong views on temper-
ance which affected his illustrations, and those for the *Fairy
Library* were described in *George Cruikshank* (London: Arts
Council of Great Britain, 1974) as 'an uneasy mixture of
avuncular charms and stern warnings'. By this time, his
career was on the wane.

Ian Rogerson

11.2 a, b & c *In Fairyland*

Richard Doyle, *In Fairyland: A Series of Pictures from the Elf-World.*
With a poem, by William Allingham
London: Longmans, Green, Reader and Dyer, 1870

388 × 282 mm

Children's Printed Collection / R198978, p. 7, Triumphal March of
the Elf King; p. 9, The Tournament; p. 12, Teasing a Butterfly

Triumphal March of the Elf-King.

This important personage, nearly related to the Goblin family, is conspicuous for the length of his hair, which on state occasions it requires four pages to support. Fairies in waiting strew flowers in his path,
and in his train are many of the most distinguished Trolls, Kobolds, Nixies, Pixies, Wood-sprites, birds, butterflies, and other inhabitants of the kingdom.

The Tournament.

Teasing a Butterfly.

Richard Doyle (1824–83) became well known for his comic, inventive drawings for *Punch*. With his drawings for *The Fairy Ring* (London: Murray, 1846), he rivalled George Cruikshank, who had brought a new dimension to illustration with his etchings for the fairy stories collected by Jacob and Wilhelm Grimm, published as *German Popular Stories* (1823, 1826). Rodney Engen, in his monograph on Doyle, found that Thackeray, who had championed Cruikshank as 'the only designer fairyland has had', now acknowledged the supremacy of Doyle.

Doyle's powerful drawings for *Jack and the Giants*, wood-engraved by the Dalziel Brothers for publication in London in 1850 by Cundall and Addey, were swiftly followed by his outstanding illustration of John Ruskin's fairy story *The King of the Golden River* (London: Smith, Elder, 1851). Doyle's obsession with the world of fairy resulted in a series of sensitive watercolours, culminating in his illustration for *In Fairyland*, a folio volume printed by Edmund Evans, who had established himself as the greatest colour printer from

woodblock. The first edition was dated 1870, with a second edition in 1875.

Thirty-six outline key woodblocks were cut in Evans's establishment in Racquet Court, Fleet Street, and hand-coloured by Doyle to provide guidance for the wood-engravers who were responsible for the colour separation blocks and for the technicians who prepared the colours. In his introduction to *The Reminiscences of Edmund Evans*, Ruari McLean tells that the sixteen full-page plates were the biggest colour wood-engraved illustrations made by Evans and each was printed from eight to twelve colour blocks.

Doyle's fantastic imagination and delicate colouring placed *In Fairyland* in the front rank of colour picture books of the nineteenth century, although it was hardly a children's book. Years later, Andrew Lang was allowed use of the blocks and wrote his own fairy story *The Princess Nobody* to fit around Doyle's illustrations. Some of the large blocks were cut down for this purpose, an act of vandalism to which Lang was supremely indifferent.

Ian Rogerson

11.3 King Luckieboy's Party

Walter Crane, *King Luckieboy's Picture Book*
London: George Routledge and Sons, [1870]
245 × 186 mm
Children's Printed Collection / R221875, p. 1, King Luckieboy in his 'lofty state chair'

Walter Crane (1845–1915) was the son of a Liverpool portrait painter. In 1859 he was apprenticed at the studio of W. J. Linton, where he learned how to draw for wood-engraved reproduction. In the *Reminiscences of Edmund Evans*, Evans claimed that, on meeting him, he 'availed himself of Walter Crane's talent at once – he did all sorts of things for me – he was a genius'.

Initially designing the covers for 'Yellowback' books (cheap reprints of novels), Crane commenced designing and illustrating the *Toy Books* in 1865. *King Luckieboy's Picture Book* was one of the *Aunt Mavor Series of Toy Books*, later known as the *Sixpenny Toy Series*, published in London by George Routledge. Some titles were laid on linen and sold at one shilling.

Their success resulted in other publishers following suit, involving several London printers, but Ruari McLean, in his Introduction to Evans's *Reminiscences*, believed that all Crane's designs for his *Toy Books* were printed by Evans. *Bluebeard* (1875) and *Beauty and the Beast* (1874) are but two of the most arresting and exuberant examples of nineteenth-century colour printing.

For the *Toy Books*, Crane drew the black line of the designs in reverse on to the surface of the block. When the proofs were hand-coloured, the artist's intention was achieved, printing with solid surface or gradation of engraving. By crossing the colours, only three printings were needed to produce the desired effect. Most text was written by Crane, or possibly by his sister, Lucy.

Crane was active in the Arts and Crafts movement, but many of his toy books show the influence of the Aesthetic movement and, in particular, the newly imported art of Japan. Crane extended his activities into wallpaper, fabrics and pottery. He was an indefatigable educator, creating monographs based upon his lectures, *The Bases of Design* (London: Bell, 1898), *Line and Form* (London: Bell, 1900) and *Ideals in Art* (London: Bell, 1905). He was Director of Design at the Manchester School of Art from 1893 to 1896. From this association, Isobel Spencer, in her monograph on Walter Crane, shows that he was commissioned to design a mace for the city of Manchester.

Ian Rogerson

KING LUCKIEBOY sat in his lofty state
 His Chancellor by him, [chair,
 Attendants, too, nigh him,
For he was expecting some company there.
And Tempus, the footman, to usher them in,
 At the drawing-room floor;
 And a knock at the door [begin.
Came just at the hour they'd announced to

'T was General Janus, the first to arrive,
 In snow-shoes and gaiters,
 Escorted by skaters, [drive.
And looking quite blue with the cold of his
See him come in, with his footman Aquarius,
 Who presents his Ah-kishes,
 That's to say, his best wishes,
A choice of fresh colds, and compliments various

1

11.4 a & b *Goblin Market*

Christina Rossetti, *Goblin Market*
illustrated by Laurence Housman
London: Macmillan, 1893
190 × 111 mm
R183390, front cover; pp. 8, 9

Christina Rossetti (1830–94) wrote simply for young people in *Sing Song: A Nursery Rhyme Book for Children* (London: Routledge, 1872). Her haunting verse *In the Bleak Midwinter* is well known to schoolchildren. *Goblin Market,* however, is a

very different creation. A fairy story with a moral dimension, it is an exciting, scary experience for the young. Grown-ups, however, find a compelling narrative laced with sensuality and, perhaps, evidence of repressed sexuality and other curious overtones.

Laurence Housman (1865–1959) was a prolific writer, and a gifted illustrator. During the 1890s he produced three books of fairy stories with his black and white drawings printed from wood-engravings by his sister Clemence. Both had attended the City and Guilds Art School in Lambeth. From the artist Charles Ricketts, also a product of the Lambeth School, Laurence became devoted to the idea of total book design, the outcome of which was *Goblin Market.*

Although Laurence became skilled in black and white pen-drawn illustration, the master wood-engraver Bernard Sleigh, in his unpublished *Memoirs of a Human Peter Pan*, felt that, if Laurence had tried to cut the blocks himself, he would not have produced drawings so totally unsuitable for wood-engraving, and he would have avoided 'cruelty to Clemence'. In addition to a half-title vignette and decorative title page, Clemence engraved thirty-two other illustrations and decorations in the text. Especially significant are the four pages of facing illustrations by Laurence, who had paid close attention to the text, showing for example, rat-faced and cat-faced anthropomorphic goblins illustrating the line, 'cat-face purred and rat-face spoke a word'.

Rodney Engen, in *Laurence Housman*, has shown that this 1893 edition of *Goblin Market* was entirely Laurence's conception, submitted for Christina Rossetti's approval, and made entirely according to Laurence's concept. *Goblin Market*, a narrow, saddle-back book in green cloth bearing sinuous medieval strapwork blocked in gold, is now recognised as a supreme example of Art Nouveau book design, while Rossetti's text continues to be a focus of gender studies.

Ian Rogerson

11.5 a, b & c *The Grey Fairy Book*

Andrew Lang, *The Grey Fairy Book*, illustrated by H. J. Ford
London: Longmans Green, 1900
190 × 130 mm
Children's Printed Collection / R140448, p. 3, The King's Pet
Donkey; p. 20, The King sees Princess Mutinosa out hunting; cover

The fairy story came of age in 1889 with the appearance of Andrew Lang's collection, *The Blue Fairy Book*, with 130 black and white pen drawings by Henry Justice Ford and G. P. Jacomb Hood. There was an initial, standard issue of five thousand copies and a 'large paper edition' of 113 copies, with a special introduction by Lang.

Its success prompted a second collection, *The Red Fairy Book* published in 1890 with illustrations by Ford and Lancelot Speed. Ford alone illustrated *The Green Fairy Book* and all ten subsequent 'Fairy' titles. Lang took care of the selection, compilation and editing, while the stories were translated and written by his wife and a team of helpers. By 1903, combined sales of *The Blue Fairy Book* and *The Red Fairy Book* alone exceeded ninety thousand copies. Unlike many imitators, Longmans's *Colour Fairy Books* were constantly reprinted until the London Blitz of December 1940 to January 1941, when the publisher's stock, blocks and originals of the illustrations were lost.

The front cover of *The Grey Fairy Book* is representative of the care bestowed upon the outward appearance of the series although the typography was ill-suited. The black and white pen drawings were reproduced by the 'line block' process, which had largely replaced representational wood-engraving, and colour plates in the later volumes were undistinguished examples of the three-colour half-tone process.

Humbert Wolfe, in *A Winter Miscellany*, was one of many who remembered the series with pleasure:

Always a new coloured fairy book – yellow, red, blue, green – oh the whole palette of immortal Andrew Lang. Christmas Day – I might crouch in a deep chair behind the tree – if there was none to prevent me, I would strike a match and set fire to a few needles. I have never forgotten that sweet resinous smell. I have come to believe that it was implicit in the text, and that Andrew, by virtue of his long association with magic, had been endowed with some wizardry that could affect the printed page.

Ian Rogerson

DONKEY SKIN 3

called him) came to see her, she told him that she could give him no answer until he had presented her with a

The King's Pet Donkey

dress the colour of the sky. The king, overjoyed at this answer, sent for all the choicest weavers and dressmakers in the kingdom, and commanded them to make a robe
B 2

11.6 *Rip Van Winkle*

Washington Irving, *Rip Van Winkle*
London: W. Heinemann, 1905 (second impression)
257 × 195 mm
Children's Printed Collection / R135973, 'He preferred making Friends among the Rising Generation'

Washington Irving (1783–1859) was born in New York and moved to England in 1815. He achieved literary fame in 1819 with *The Sketchbook of Geoffrey Crayon*, which contained his short stories 'The Legend of Sleepy Hollow' and 'Rip Van Winkle'. In 1860 Joseph Cundall, the London publisher, produced an illustrated edition of *Rip Van Winkle*, but it was not until 1905, when Heinemann chose Arthur Rackham (1867–1939) to illustrate the story for one of the early twentieth-century 'colour-plate' books, that the tale achieved prominence and Rackham was established as a unique illustrator of the fairy world.

By 1900 the colour half-tone process had been perfected, which resulted in an upsurge in the use of colour in illustration. However, the medium demanded a thorough understanding of its advantages and limitations and only a few contemporary illustrators could achieve good results. For Heinemann's edition of Irving's classic, Rackham completed fifty-one illustrations, forty-eight of which were in colour. In the trade edition held in the Library, the card-mounted colour plates were gathered together following the text, a 'penny-pinching' device which would have been anathema to the illustrator.

Rackham's use of colour, and his unique interpretation of the fairy world, gained him worldwide popularity. Enchanting pictures for J. M. Barrie's *Peter Pan in Kensington Gardens* (1906) and Shakespeare's *A Midsummer Night's Dream* (1908) immediately followed. In contrast, Rackham managed to convey a distinct transatlantic tone to his pictures for *Rip Van Winkle*, and, in a similar way, he imbued his illustrations to Richard Wagner's *Siegfried and the Twilight of the Gods* (1911) with Teutonic overtones. *Rip Van Winkle* was a pioneering venture, with a signed, deluxe issue of 250 copies accompanying the trade edition.

William Heath Robinson, whose colour-plate books included a very different conception of *A Midsummer Night's Dream* (1914), expressed his dislike of the colour half-tone process in his autobiography, *My Line of Life* (London: Blackie, 1938), because 'this method could only be used on a certain type of paper that was impossible for the rest of the book. Consequently the colour pictures had to be stuck in making the book a scrapbook. This was not true bookmaking.'

Ian Rogerson

11.7 a & b Hans Andersen

Hans Christian Andersen, *Stories from Hans Andersen*
with illustrations by Edmund Dulac
London: Hodder and Stoughton, 1911 (Edition de Luxe)
320 × 270 mm
Alison Uttley Book Collection / R141606, Frontispiece,
Princess and the Pea; p. 215, The Emperor's New Clothes
Reproduced by kind permission of Headline Publishing

English translations of the fairy tales of Hans Christian
Andersen (1805–75) began with Mary Howitt's *Wonderful
Stories for Children* (London: Bohn, 1846). By the 1890s, when
Arthur Gaskin's black and white illustrations for *Stories and
Fairy Tales* (London: George Allen, 1893), were published,
redolent of the Arts and Crafts movement, Andersen's tales
were commonly known.

Edmund Dulac (1882–1953), after studying art and
working in Paris as an illustrator and designer for the stage,
came to London in 1906. His first major illustrations were in

colour for the publisher J. M. Dent's set of the Brontë sisters' novels. Colin White, in his monograph on Dulac, states that these images had a muted reception.

However, on his showing his portfolio at the Leicester Galleries, the owners immediately commissioned fifty evocative watercolours for *Stories from the Arabian Nights, retold by Laurence Housman* (London: Hodder and Stoughton, 1907). Ann Conolly Hughey, in her comprehensive analysis, *Edmund Dulac, His Book Illustration: A Bibliography*, reported that its publication proved an overnight sensation, with further printings and translations which gave Dulac worldwide popularity.

Hodder issued the book in both trade and luxurious, limited issues, and this pattern was followed with other titles, including *Stories from Hans Andersen*. Here, the artist was working in a North European context and most of his fifty watercolours bear a lighter touch, and there is less evidence of the heavy blue overtones prominent in his earlier work, such as in *The Rubaiyat of Omar Khayyam* (London: Hodder and Stoughton, 1909). While the plates in both the limited and trade editions are mounted on card and protected by tissue guards, the plates in the trade edition, with the exception of the frontispiece, follow the text.

Although enjoying a long career as a graphic designer, Dulac's best work was in the gift books which demonstrated his understanding of, and mastery in the use of colour half-tone printing. A century after the publication of these magnificent illustrated editions, his imaginative images for the *Arabian Nights* and *Stories from Hans Andersen*, richly decorated, dreamy and romantic, come to mind whenever these works are discussed.

Ian Rogerson

12

Power, politics and propaganda: The story of Britain from 1215

MORE THAN seven hundred years of royal, political, military, social and economic history are spanned by the nine items considered in this chapter. The subject matter, although diverse, is linked by a coherent theme, namely the exercise of power by monarchs and political leaders; the opposition to it, in the form of military conflict; and the quest, often pursued with violence, for political, economic and social reform. The Library houses many thousands of books, manuscripts and artefacts directly relevant to this theme from all over the world, and from ancient times to the present day. However, this chapter focuses on a consideration of these themes in relation to the British Isles, and the seminal events in its history between 1215 and the Second World War. Some of the items are already well known, but several have received little attention in previous surveys. Most are fine examples of the work of illuminators, scribes, printers and artists; and all are important and significant in helping to understand the evolution of Western governments and political systems.

Magna Carta has been described as 'a landmark in the transition from an oral to a written society'. The Library has a magnificent and unique edition of *Magna Carta*, produced in 1823 for a member of the Spencer family (12.1). The original document, signed in 1215, was, in essence, a treaty between King John and his rebellious barons. It followed a tumultuous period during which the King failed to defend his possessions in Normandy and attempted to make extortionate demands upon his powerful subjects. Here, in this extravagantly illuminated volume, we can see the workings of power, propaganda, conflict and rebellion; as well as patronage, in relation to the book's content, production and ownership.

The relationship between English and French monarchs, particularly with regard to the possession of Normandy, is a recurrent theme throughout the Middle Ages. John Lydgate's *Troy Book* (12.2) has been described as 'the Library's most visually impressive English manuscript'. The work was commissioned by the future Henry V and was presented by Lydgate to his royal patron on the King's return to England, following successful siege-warfare campaigns in Normandy. A French approach to these events is given in Rylands French MS 99 (12.3). Here the unnamed French chronicler wrote with a political purpose and bias and was an effective

propagandist, managing to ignore completely the English triumphs over the French which began at Agincourt in 1415.

Robertus Valturius's *De re militari* (1472) is included here, primarily for its subject matter, although it is certainly a fine incunable which has received comparatively little attention from scholars (12.4). It is the earliest European printed technical manual with illustrations, and was acquired by rulers in Western Europe and beyond. The heavily armed fighting vessel, revolving gun turrets, pontoons and bridges are all uncannily similar to images in Lydgate's *Troy Book*. Like Lydgate, Valturius draws extensively on his wide knowledge and understanding of the Classical world.

Over four hundred years after her death, Elizabeth I's reputation as 'Gloriana' remains strong. Her long reign (1558–1603) is often depicted as a golden age of political, military and cultural achievement. Much of Elizabeth's reputation reflects her own skilful use of power and patronage to promote her image. Among the devices she employed were elaborate tournaments; 'progresses' through the country during which she enjoyed the hospitality of rich nobles and upwardly mobile gentry families; reverential royal portraits; and celebrations of her accession and other significant anniversaries, like the New Year's gift exchanges. The gift roll shown here is one of the most interesting and significant official documents held by the Library (12.5).

From the late eighteenth century the quest for political, economic and social reform gathered apace throughout Europe. In Britain, this was the era of popular British radicalism, and the movement was strongly rooted in north-west England. Indeed, the 'Peterloo Massacre' of 1819 might be considered the single most significant event in Manchester's history. The Peterloo Relief Fund Account Book is one of the Library's best-known items (12.6).

The most important events in Britain during the twentieth century were the two World Wars. Nobody who lived through those years was unaffected by the horrors and untold misery unleashed by war and the political, social and economic turmoil which characterised the period. The Library houses much significant material relating to the First and Second World Wars, including books, manuscripts, archives and newspaper collections. Here some little-known items from those years are considered. The Prussian 'Octopus' map, printed in Britain in 1916, for distribution in Italy, illustrates how maps can be used as powerful political propaganda (12.7). Also from the period of the First World War are two examples of the highly evocative watercolour paintings produced by Wilfrid Phythian during his service on the Western Front (12.8). During the early 1940s, the German military produced 'invasion maps' for all the major British towns and cities, including Manchester (12.9). As the Nazis were defeated in the Battle of Britain of 1940, these maps are now seen as chilling reminders of what might have happened. Had the Nazis been victorious, the same maps might have been used to illustrate the benefits of careful advance planning. Information can be interpreted to suit the motives of the interpreter; and several of the items described in this chapter demonstrate clearly how information can be used to the advantage of the powerful.

Dorothy J. Clayton

12.1 *Magna Carta*: Illuminated edition, printed for George John, 2nd Earl Spencer

Magna Carta Regis Johannis
Westminster: printed by John Whittaker, illuminated by Richard Thomson, 1823
Bound in leather, 620 × 470 mm, 18 vellum leaves with text printed in gold and lavish illumination
Spencer 20671, leaf 2, 'The Garter Page'

The signing of *Magna Carta* by King John in 1215 established for the first time a constitutional principle of great significance, namely that the power of the English king over his subjects could be limited by a written treaty. Indeed, the fact that copies of *Magna Carta* were still being produced more than six hundred years after the event indicates the perceived importance of the document as the 'practical' starting point of England's history.

Between 1816 and 1823, John Whittaker, an innovative Westminster bookbinder and printer, published a few copies of *Magna Carta* for the Prince of Wales (George IV from 1820) and some prominent book collectors, including George John, 2nd Earl Spencer (1758–1834). The book was produced in various formats: non-illuminated copies on paper or thick card; and richly illuminated copies on satin or vellum. No two copies were identical. However, all were printed using Whittaker's newly invented process of printing in burnished gold letters.

Earl Spencer's copy is undoubtedly one of the finest. It is lavishly illuminated by Richard Thomson (1794–1865) who signed and dated each vellum leaf. Thomson wrote an account of the work he did on the Spencer volume (Rylands English MS 1179). The page shown here (second leaf) is described by the illuminator as 'The Garter Page'. The splendid interior of St George's Chapel, Windsor, where the Garter ceremonies take place, is depicted. There is a fulsome dedication to Earl Spencer, printed in gold leaf, which celebrates the fact that he was a Knight of the Garter (installed 1799). Along the bottom of the page, a procession to an installation during the reign of Henry VIII is shown. First, the aristocratic Garter knights process, followed by royal knights, including Francis I of France, Emperor Charles V and James V of Scotland. Finally, there is the tall imposing figure of Henry VIII, resplendent in his robes of office and wearing the crown. Interestingly, this preliminary page to *Magna Carta* makes no reference to King John.

Dorothy J. Clayton

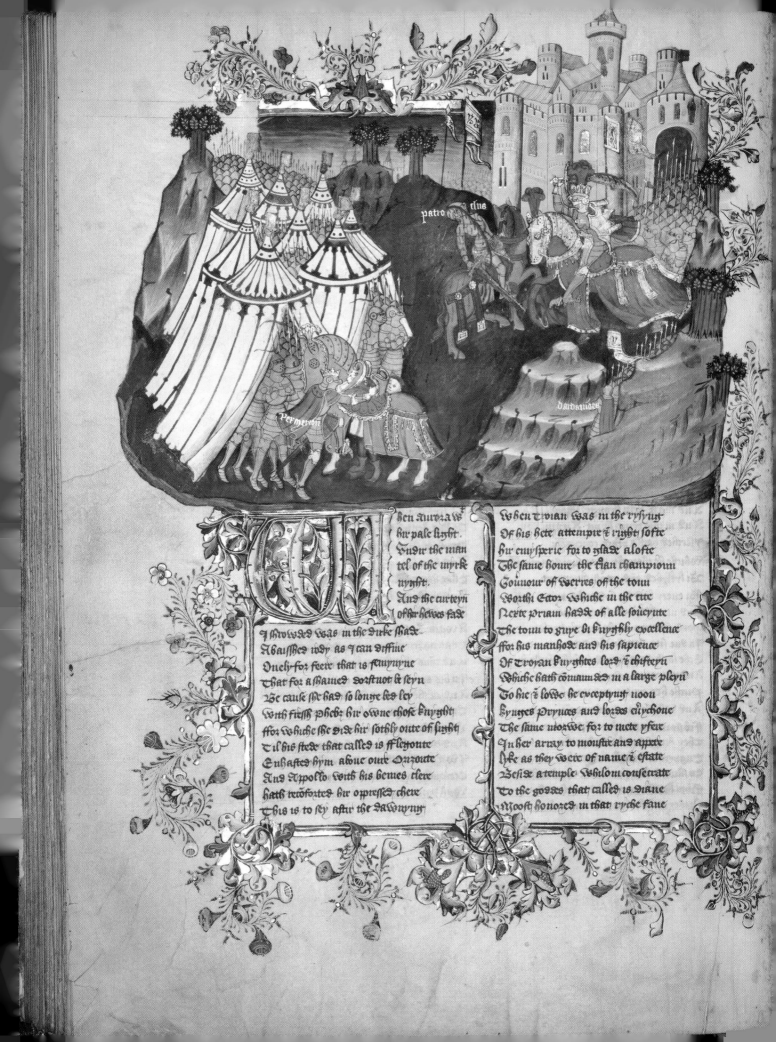

hen Aurora wt / hir pale lyght. / Vndir the man / tel of the myrke / nyght. / And the curteyn / of hir heires fare	when Troian was in the rysyng / Of his hete attempre & right softe / hir enysperie for to made alofte / The same houre the Troian champioun / Gouuour of werres of the toun / worthi Ector whiche in the tite / Nexte priam hadd of alle soueryute

Left column:

I shrowded was in the derke shade
Abaisshed why as I can diffine
Onely for feere that is femynyne
That for a shamed dorst not be seyn
Be cause she had so longe bee ley
wt fiersh phebus hir owne chose knyght
ffor whiche she hid hir sothly oute of syght
Til his stede that called is fflegoute
Enhasted hym aboue oure Orizonte
And Appollo with his bemes clere
hath recomforted hir oppressed chere
this is to sey aftir the dawenyng



The toun to gye by knyghtly excellence
ffor his manhode and his sapience
Of Troian knyghtes lord & chiefteyn
whiche hath commaunded in a large pleyn
To hie & lowe he exceptyng noon
kynges Prynces and lordis euerichone
The same morwe for to mete yfere
In her army to moustir and appere
lyke as they were of name & estate
Beside a temple whilom consecrate
To the goddes that called is Diane
Moost honoured in that ryche fame

12.2 a & b Henry V, warrior king and patron: John Lydgate's *Troy Book*

John Lydgate, *Troy Book*
Mid-15th century
Vellum, 450 × 325 mm, ff. ii + 174 + iii
English MS 1, f. 78v, Hector slaying
Patroclus; f. 1r, Lydgate and Henry V

John Lydgate (*c*.1370–*c*.1451), a Benedictine monk of Bury St Edmunds, was a prolific writer of poems, allegories, fables and romances. An admirer of Geoffrey Chaucer, he was heralded by his contemporaries as a worthy successor. Nineteenth- and twentieth-century critics, however, spoke more about his role as a 'prince-pleaser' laureate of the Lancastrian dynasty than about his literary output; certainly Lydgate's many patrons included the future Henry V, Henry's youngest brother, Humphrey, duke of Gloucester, and Henry VI. Today there is something of a Lydgate revival, with scholars describing the subtleties of Lydgate's 'politics', along with the complexity of his 'poetics'.

English MS 1 is one of twenty-three manuscripts and fragments of Lydgate's *Troy Book* to survive. It is richly decorated with floriated borders, a half-page miniature at the beginning of each of the five books, and sixty-four other large paintings. J. J. G. Alexander (Columbia University) has identified the illuminator as William Abell, an important fifteenth-century London artist. Lydgate was commissioned by Prince Henry (later Henry V) to recount the story of the Trojan War in the vernacular. Composed between 1412 and 1420, the poem is a translation and expansion of Guido delle Colonne's *Historia destructionis Troiae* (1287), a Latin prose account based, without acknowledgement, on Benoît de Sainte-Maure's Old French *Roman de Troie* (*c*.1160).

In five of the surviving manuscripts, including ours, a portrait is found of Lydgate presenting his work to Henry V on the latter's triumphant return from his campaign in France begun in August 1417. Henry V, Lydgate proclaims, is 'a worthy king of wisdom and renown'. With justification, the poet is able to say that, from henceforth, 'England and France may all be one'. A lengthy campaign of siege warfare culminated in the Treaty of Troyes in May 1420. Henry's campaigns in 1415 and 1417–21 were in pursuit of his claim to the French throne. The Treaty assured Henry of marriage to Katharine, daughter of the French king, Charles VI, and gave him the title of heir to the French kingdom and the commitment that, on Charles VI's death, the French crown would pass to Henry and his heirs for ever. Marriage to Katharine soon followed and, after a triumphal entry into Paris in December 1420, Henry returned to England in January 1421 for the coronation and enthronement of his French bride. Readers of the poem would appreciate the intentional comparison between the besiegers of Troy, with their medieval armour and weaponry, and the series of successful sieges which Henry had conducted in Normandy from 1417. The illustration showing Hector slaying Patroclus, with Troy in the background and the Greek camp in the foreground (f. 78v), might almost be mistaken for Henry's successful siege of Rouen in 1418–19.

Dorothy J. Clayton

12.3 a & b Divine providence in history: French Chronicle Roll, 1450s

French Chronicle Roll
Mid-15th century
Vellum, 17,000 × 686 mm
French MS 99, St Louis of France and his descendants; William
of Normandy's victory over Harold II at the Battle of Hastings,
14 October 1066, and its dynastic implications

This fifteenth-century vellum roll is remarkable, not least, at 17 m long and 686 mm wide, for its sheer size. Written in French in up to five columns, with connections sometimes made across columns and between sections by bold red lines, the text is vividly illustrated by sixty-five medallions. While figures are generally represented simply, even crudely, buildings and battles are finely drawn. The roll begins with the Creation and then, in explaining the general descent from the

sons of Noah, introduces its key theme of legitimising authority in both state and church by demonstrating succession with events depicted as following an ordered pattern. The central column is dominated by major events in French history.

The chronology across the columns is often confused: Pontius Pilate appears after the Crucifixion; Charlemagne is juxtaposed with the battle of Hastings. Myth and legend are interposed with historical events – the Tower of Babel, the siege of Troy, King Arthur. Cities, always well-fortified, are important: the foundation of both Rome and London is illustrated, while Jerusalem is shown with its various gates. Powerful figures – Judas Maccabeus and Alexander, for instance – are prominent. The medallion illustrating Hastings (Harold II, the last king of the English, here dies by the sword) is followed by a table showing descent from the Conqueror and the dynastic impact of William's victory in 1066. St Louis of France, Louis IX (1226–70), renowned as crusader, wise ruler and patron of the arts, is portrayed in a large medallion with lines of descent and succession emphasised.

Although there is a reference to the capture at Poitiers in 1356 of John II of France by Edward III, the loss of the French crown to England under Henry V is not mentioned in the account of Charles VI. Tellingly, the roll concludes with a medallion of Charles VII having two pennants, one labelled 'Guienne', the other 'Normandy'. This suggests the roll's political purpose as a celebration of the expulsion of the English from France by 1453, implying that divinely endorsed legitimacy had triumphed.

John D. Milner

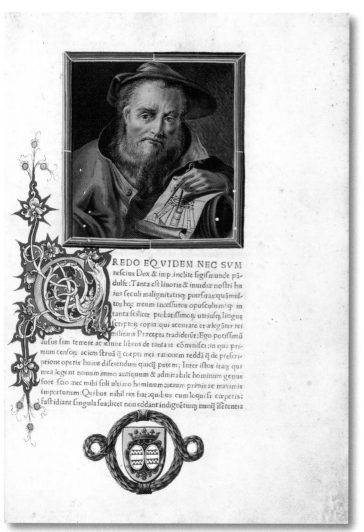

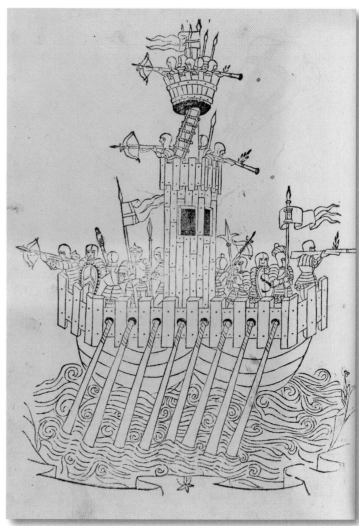

12.4 a, b, c & d Siege-warfare manual, 1472

Robertus Valturius, *De re militari*

Verona: Johannes Nicolai de Verona, 1472

Paper, 330 × 220 mm, ff. 152, including 82 woodcuts

Spencer 9924, f. 1r, Portrait of Robertus Valturius illustrating his work; f. 185v, Warship with elaborate fortified central tower and crow's nest showing soldiers with both crossbows and guns; f. 186v, Armour-clad turtle with extended head and immense inverted horse-drawn cone used as battering rams; f. 187v, Soldiers in armour attacking city walls using battering rams with animals' heads, one also illustrating a pulley for use in sieges

The printer Johannes Nicolai of Verona regarded his edition of *De re militari*, the military manual of Robertus Valturius, as 'the most elegant book', comprising both substantial text and eighty-two woodcuts. It is indeed a remarkable work, exploiting the new techniques of printing and including vivid illustrations, doubtless designed to make the complex text accessible to a wide audience. Published in Latin, consisting of 152 folios, unnumbered after folio 100, it is the woodcuts which are outstanding, setting new standards for illustrated books in the earliest years of printing.

Born in Rimini in 1405, Robertus Valturius joined the papal administrative staff in Rome from 1438 as an abbreviator, drafting papal bulls and other formal documents.

Returning to Rimini, Valturius wrote *De re militari* about 1450, dedicating it to his new master Sigismund Malatasta. Manuscripts were widely distributed to some of the most significant contemporary rulers in Europe, including Louis XI of France and Lorenzo de' Medici, a signal of Malatasta's pride in the achievement of his court. That a copy was also given to Sultan Mehmed II in 1463 might seem curious, at a time when the Italian states were regularly at war with the Turks, but perhaps suggests the confidence Malatasta had in the devices so graphically illustrated in the book.

In the beautiful miniature on the first folio, Valturius is portrayed as intensely thoughtful, half-smiling into the distance. The mathematical instrument he holds, and the scroll

showing one of his complex siege machines, give the clue to his astonishing imagination, realised in the woodcuts by the artist he engaged (possibly Matteo de' Pasti (1420–67)). Towers, pulleys, siege engines, cranes and cannon are all designed with great skill and attention to mathematical and geometric detail. Many of these devices were mere ingenious fantasies. Even by the early sixteenth century, works on war were demonstrating a more practical approach. Valturius's ideas – elaborate, ingenious, technically skilled but impracticable – were soon to be superseded by a more scientific approach as demonstrated by the guns and batteries used by Charles VIII of France in 1494 to devastating effect in his attacks on Italian cities previously regarded as almost invincible.

Drawing substantially on the Classical military writers with whom he was thoroughly acquainted, Valturius's work can be seen as an encyclopaedia of ancient military and naval science, yet recognising changes in weaponry. So there are cannon on wheeled trolleys and soldiers occasionally armed with an arquebus. Valturius died in 1475, before he could know that the *De re militari* would become one of the most reprinted works on military strategy. An Italian translation (with ninety-six woodcuts) was published in Verona in 1483, with the first French edition in 1484 and French translations published in 1532, 1535 and 1555.

While steeped in Classical knowledge, and the writings of authors such as Vegetius, Valturius was also an exponent of the new humanism. Writing at a time of transition, his imagination outreached the possible, and new weaponry and techniques would soon overtake his approach. Like many of the writers on military strategy, Valturius was a scholar so familiar with the history of the Greeks and Romans that he had a much deeper understanding of strategy and discipline than many professional soldiers.

John D. Milner

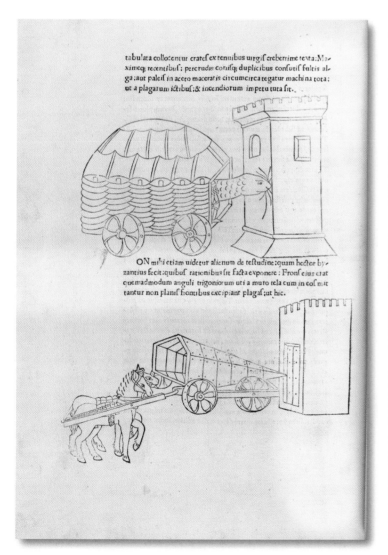

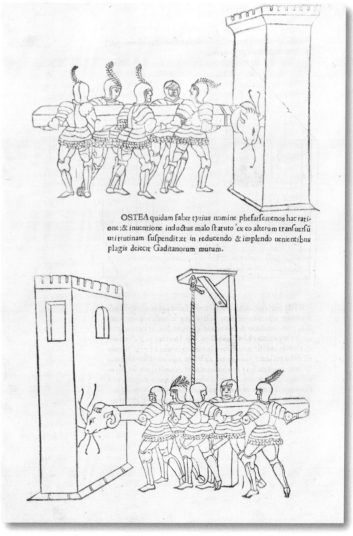

12.5 Elizabeth I's New Year's Gift Roll, 1559

Neweyeres Guiftes Geuon to the Quenis Maiestie ... [and] ... by the Quene ...
The First of January ... Anno Regni Regine Elizabeth Primo [1559]
Vellum, 3,470 × 428 mm
English MS 117

The offering of gifts to the sovereign at the English court's ceremonies to mark the New Year is documented from the mid-thirteenth century. By the fourteenth century, the ceremony had become one of exchanging gifts. The custom reached its apogee under the Tudor monarchs, and especially under Elizabeth I when donors vied with each other to find favour with the Queen.

This vellum roll, with wooden rollers attached to its head and foot, records the Queen's first New Year's Day Gift Ceremony in January 1559. On one side is a brief description of gifts presented to the Queen by 221 donors; and on the reverse (shown here) are listed the gifts the Queen gave to 237 people. Elizabeth's characteristically bold and imposing signature appears at the head and foot of both sides of the roll. 'Special' donors are listed first – paternal blood relatives and the highest-ranking officers of state. Thereafter, donors are introduced by headings based on eleven categories of social rank or title, from 'Earls' and 'Busshoppes' to 'Gentlemen'. The listing of the recipients follows a similar pattern, although there are additional categories, including 'Freguiftes' for the Queen's personal 'Maides' and for Jewel House staff.

The bishops and most of the higher-ranking nobility gave gifts of purses filled with coins. The debased state of English coinage is reflected in the mixture of coins given: Flemish angels, French crowns, Spanish pistolets, as well as

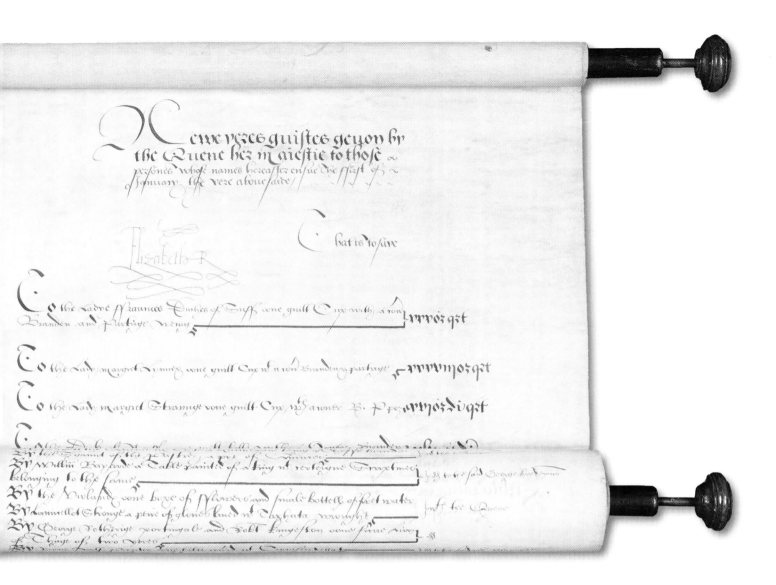

English sovereigns. The gifts offered by other donors were exceedingly diverse. Items associated with personal adornment featured prominently: jewellery, including precious stones; a pair of gold and silk sleeves; sweet (perfumed) gloves and bags; ruffs; cowls, collars and handkerchiefs, embroidered and edged with gold thread; fans, mirrors and combs. Some donors sought to reflect the Queen's leisure interests with gifts of riding equipment and musical instruments. Mr Jugge, her printer, gave 'oone Mappe and Ptholomeis Tables in Italion'. The Queen's kitchen suppliers gave foodstuffs: Mr Harres, the Queen's fruiterer, offered 'oone Basket of Apples, Wardons [pears], and oone glas of Cheries preserued'.

The Queen's gifts, by contrast, displayed little originality: plate, vessels or utensils made from silver or gilt. By the side of each gift, the weight of the metal is noted. Elizabeth I's jewels were 'the pride and glory of this kingdom', according to Sir John Eliot in 1626, yet few of these precious items survive today. Many were dispersed years later – during the Civil War and under Cromwell. However, a comparison of the gift rolls which survive from Elizabeth's reign shows that the Queen herself frequently 'recycled' gifts, especially jewellery and expensive plate. This was probably due to changing fashions and personal financial needs. 'Neweyeres Guiftes' were undoubtedly a useful form of currency to Elizabeth I.

Dorothy J. Clayton

Ellen Croft
Back Mill St Bradley /

Crushed & bruised very infirm
thrown into a Cellar & a
good deal bruised

 20/ final

M b 20/

John Black
10 Union Street Stockport

Beat by Constables on
the Head & trod on by
the Cavalry an Old Man

 20/ final

Ann Barlow
Coldhurst Lodge Oldham

This poor Woman who is a
Widow with 7 Children was
beat by some of the Constables
thrown down & trampled on
her Breast Bone broke she
was in the Infirmary 3
Weeks & is still very Ill

 80/
 4£

M b 20/

Ann Roberts
Late of Atherton St Now of Rusholme

Crushed by the People thinks a horses
foot cut her Eye was twice cut at
by a Soldier & much bruised

 30/ final

Ann Bardsley
Bamford Street Stock t

Sabre Cut on her right
Arm & beat about the
Head by Swords

 20/ final

James Berry
Carrington Fields Stockport

A Sabre Cut on the left
side of his ~~head~~ face &
2 Cuts on his head bruised
inwardly 3 Weeks totally
disabled

 31/ final

12.6 Peterloo Relief Fund Account Book, c.1820

Peterloo Relief Fund Account Book, c.1820
Paper notebook bound in leather, 179 × 112 mm, 118 ff
English MS 172, f. 4

On 16 August 1819, sixty to eighty thousand people, largely drawn from the poor and working classes of Manchester and the surrounding towns, assembled at St Peter's Fields, Manchester, to hear the radical politician, Henry 'Orator' Hunt. The rally was organised by the Manchester Patriotic Union, a body campaigning for parliamentary reform and the abolition of the Corn Laws of 1815. Despite Manchester's population having increased sevenfold between 1750 and 1820, it was not represented in Parliament, and local government was still in the hands of manorial and parish officers. Although the meeting was clearly peaceful, the local magistrates, probably alarmed at the large numbers involved, panicked and ordered the special constables and the Manchester and Salford Yeomanry, a body of volunteer cavalry, to disperse the crowd. In the ensuing chaos, eleven people were killed (a figure which later rose to seventeen) and over 650 wounded.

A week after the event, John Edward Taylor (1791–1844), a local businessman and political reformer, who in 1821 would establish the *Manchester Guardian*, published the first of fourteen weekly tracts, entitled 'The Peterloo Massacre'; this dubbing of the event was an ironic comparison to the recent Battle of Waterloo. A Relief Fund was quickly established, supported by voluntary subscriptions which soon reached £3,000, to provide financial assistance to those wounded and the families of those who had died.

This remarkable small notebook, described on the spine as *Peterloo Relief Fund Account Book*, records the names and addresses of 347 people who received payments from the fund, along with graphic descriptions of their injuries, the circumstances in which they occurred, and the amounts of compensation paid to them. Interestingly, ninety-three of the 347 people who received relief were women. Richard Carlile (1790–1843), a reformist agitator present at Peterloo, believed that women were especially targeted. Certainly the large number of women who suffered from wounds caused by weapons would appear to support this view. Ellen Croft, Ann Barlow, Ann Roberts and Ann Bardsley were four female recipients of the Peterloo Relief Fund; their personal circumstances are described in this opening.

Dorothy J. Clayton

12.7 *The Prussian Octopus*

Unknown artist, *The Prussian Octopus*
London: H. and C. Graham, 1916
Lithograph and letterpress on paper
382 × 534 mm
World War I Pamphlet Collection, 1976

The 'Prussian Octopus' poster provides a visually striking example of how maps can be used effectively as political propaganda. The first 'Octopus' map of Europe was created by Fred W. Rose in 1877 and since then many propaganda maps have used similar imagery to convey their message powerfully. This map dates from 1916. It was printed in Britain for distribution in Italy, possibly to boost morale on the Italian home front. The English version is shown here.

Here a map of Europe sits behind two octopuses, the larger one representing Prussia and the other Austria–Hungary. The poster is a commentary on the declaration made by the German Chancellor Bethmann-Hollweg on 10 December 1915: 'We do not threaten small nations … we do not wage the war which has been forced upon us in order to subjugate foreign peoples, but for the protection of our life and freedom.'

The poster, however, tells a different story. The relatively small territories included in the original kingdom of Prussia are identified by hatched lines, whilst the diagonally shaded areas mark territories which it had acquired 'by negotiation, force or fraud'. The implication is that Prussian aggrandisement had been constant and steadily increasing in scope since the seizure of Silesia from Austria in 1740. So there are references to Prussian acquisitions in the three partitions of Poland in the late eighteenth century and the incorporation of Schleswig-Holstein in 1864, culminating in the invasion and occupation of Belgium in 1914.

The smaller octopus, Austria–Hungary, is shown holding Bosnia-Herzegovina and Serbia between two of its tentacles. Meanwhile, the baleful eyes of this octopus stare down a tentacle which curls round north-eastern Italy. This perhaps supports the view that the map was produced to boost morale in Italy where there was fierce fighting with the Austrians.

The map contains an apparently curious contradiction. A significant amount of Prussia's expansion is shown to have been at the expense of Austria and Austria–Hungary. Perhaps this is why one large tentacle of the Prussian octopus is resting menacingly close to the head of the Austro-Hungarian octopus. In the end, it seems to suggest, Prussia will show no mercy, even to its friends.

Donna M. Sherman

THE PRUSSIAN OCTOPUS.

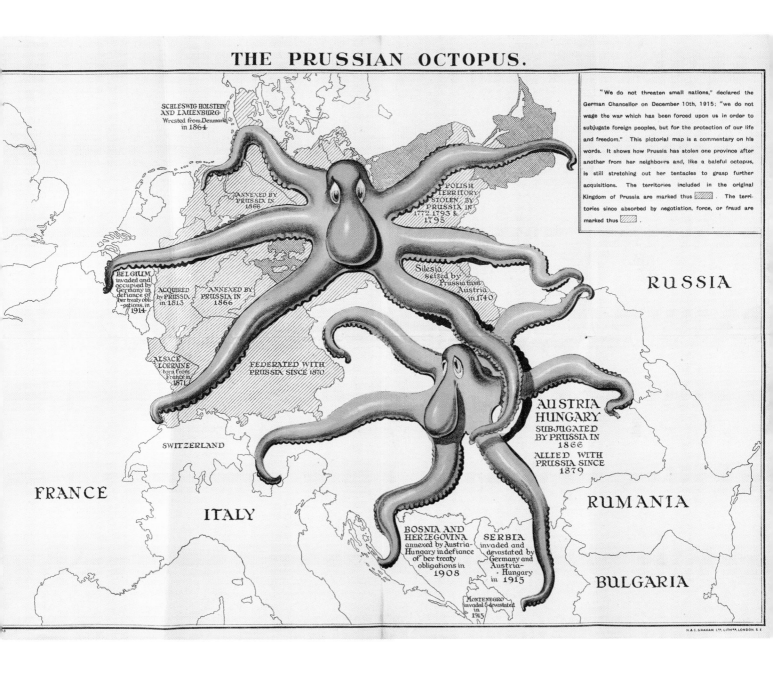

SCHLESWIG HOLSTEIN
AND LAUENBURG
Wrested from Denmark
in 1864

ANNEXED BY
PRUSSIA IN
1866

POLISH
TERRITORY
STOLEN BY
PRUSSIA IN
1772,1793 &
1795

Silesia
seized by
Prussia from
Austria
in 1740

RUSSIA

BELGIUM
invaded and
occupied by
Germany in
defiance of
her treaty obli-
gations in
1914

ACQUIRED
by PRUSSIA
in 1813

ANNEXED BY
PRUSSIA IN
1866

"We do not threaten small nations," declared the
German Chancellor on December 10th, 1915; "we do not
wage the war which has been forced upon us in order to
subjugate foreign peoples, but for the protection of our life
and freedom." This pictorial map is a commentary on his
words. It shows how Prussia has stolen one province after
another from her neighbours and, like a baleful octopus,
is still stretching out her tentacles to grasp further
acquisitions. The territories included in the original
Kingdom of Prussia are marked thus [hatched]. The terri-
tories since absorbed by negotiation, force, or fraud are
marked thus [hatched].

ALSACE
LORRAINE
torn from
France in
1871

FEDERATED WITH
PRUSSIA SINCE 1870

AUSTRIA
HUNGARY
SUBJUGATED
BY PRUSSIA
IN 1866

ALLIED WITH
PRUSSIA SINCE
1879

SWITZERLAND

FRANCE

ITALY

RUMANIA

BOSNIA AND
HERZEGOVINA
annexed by Austria-
Hungary in defiance
of her treaty
obligations in
1908

SERBIA
invaded and
devastated by
Germany and
Austria-
Hungary
in 1915

BULGARIA

MONTENEGRO
invaded & devastated
in
1915

H.&C.GRAHAM LTD. LITHᴿᴿ.LONDON S.E.

Power, politics and propaganda 261

12.8 a & b The Great War, July 1917: Watercolours by Wilfrid Phythian

Wilfrid Phythian, 'Ypres, July 1917'; and 'Paris Plage, July 1917'
Watercolour paintings on paper, 130 × 205 mm
Dame Mabel Tylecote Papers, TYL2/2/2/12, 35

Wilfrid Phythian (1895–1954) served as an officer in both World Wars. The son of John Ernest Phythian, a Manchester solicitor, local politician, art historian and lay preacher, Wilfrid attended Manchester Municipal College of Art and initially joined the University and Public Schools Brigade in 1914. His sister, Dame Mabel Tylecote (1896–1987), became well known as a pioneer of adult education in Manchester and as a Labour Party politician. Among her personal papers held in the Library is a collection of drawings and watercolours executed by her brother. Most date from the First World War when 2nd Lieutenant Wilfrid Phythian served on the Western Front with the 18th Manchesters. Phythian used poor-quality paper, torn from an album. On the reverse he often made pencil annotations. The pictures themselves were usually drawn *in situ*, and coloured later.

Phythian's annotations on the first watercolour describe the scene perfectly: 'Working party leaving the trenches in the early morning caught in a gas shell bombardment. The black stuff bursting over a tower is shrapnel. We had a lively time that morning. Ypres, July 1917.'

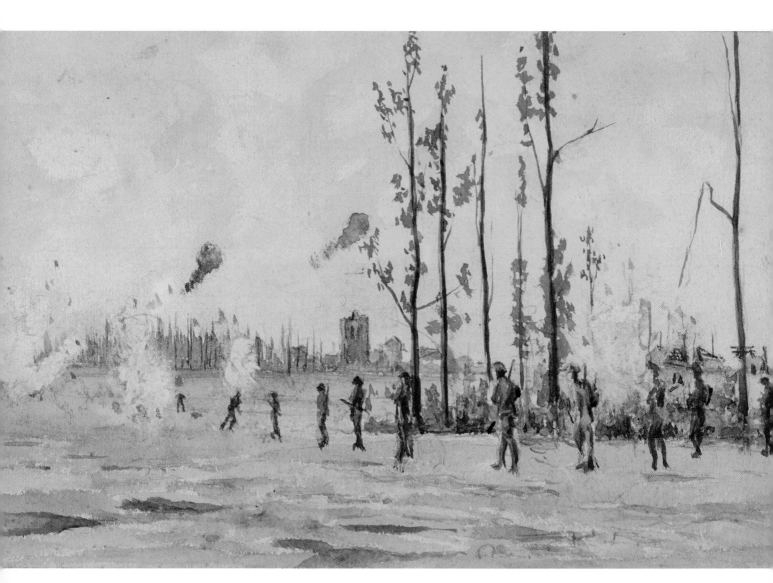

The second watercolour shows 'Paris Plage, July 1917'. Le Touquet Paris-Plage is a French coastal resort town, near Étaples. Between October 1914 and July 1918 the British Red Cross operated a large 'Base Hospital' there in a former seaside hotel. Also in the town were several convalescent homes. Perhaps Phythian was himself injured in the Ypres bombardment and was sent to Le Touquet. Phythian has captured the scene in great detail and the accuracy with which he portrays military uniforms and civilian dress is particularly striking. On the left a British army officer is talking to what appears to be a Red Cross nurse and an officer of the newly formed Women's Army Auxiliary Corps. In the centre foreground a French army officer strolls along the coastal promenade with his fashionably dressed wife and young daughter. In the right of the painting, two British army officers, relaxing against the promenade railings, survey the beach huts and swimmers below; whilst a third looks out to the open sea in the distance. The entire scene is a far cry from life in Messines and Ypres, and the trenches to which the soldiers would soon return.

Dorothy J. Clayton

12.9 German invasion map of Manchester, 1940: Detail of Salford Docks

Stadtplan von Manchester mit Militärgeographischen Eintragungen
Berlin: Generalstab des Heeres
Print on paper
500 × 720 mm
Map Collection: C17(17) GB4 BB12, detail

Maps produced by official agencies such as the Ordnance Survey contain information which, if captured by enemy forces, could provide valuable intelligence. Although official map-makers have been known to suppress features which could pose a threat to national security, it is also likely that spies on the ground have supplemented information found in existing maps.

This map of Manchester was produced by the German military in 1940 and is based upon a standard Ordnance Survey map. In this German edition, industrial and communication sites such as gas works, warehouses, bridges and railways have been identified, along with important sites such as the Town Hall, Central Library and the large hospitals. The key includes additional useful information, for example, the width and depth measurements of the Docks area; and the names of individual companies occupying industrial sites.

The German military produced similar maps of towns and cities throughout Britain during the early 1940s; clearly they would have been most useful, both in planning an invasion, and in the event of a successful invasion.

Donna M. Sherman

England 1:10000

Militärgeogr. Angaben nach den bis zum
15. III. 1942 vorhandenen Unterlagen

119546 LON 2° 18' W Greiferkante LMSR 47 2° 17'

Ship Canal Tar Works

School

Weaste Recreation Ground

New Barns Works

Vere Street Works

Disinfecting Station

WEASTE CEMETERY

Mort. Chaps.

Engineering Works

Lodge

Public Baths

Thurlow St Saw Mills

NEW ROAD

Warehouse

Warehouses

Club

Timber Yard 10

SALFORD

Timber Yard

Allotment Gardens

Warehouse

Warehouse

239

New Barns Junction

Hydraulic Capstans

209

F.B.

Model Lodge

Hydraulic Capstans

No. 9 DOCK

Engine Shed

Warehouse

204

Stages

MANCHESTER SHIP CANAL

Landing Stage

SALFORD QUAY

210

208

DRY DOCK

Trafford Oil Mill
B.M. 73·89

Warehouse Warehouse

No. 8 DOCK 79·93

240

238
Grain Elevator

Warehouse

202 B.M. 78·21

MANCHESTER DOCKS

No. 7 DOCK B.M. 80·19

Trafford Wharf

Hope Mills

242

Mills

Timber Yard

Elevator Ship Mills

241

Goods Shed

Engineering Works

No. 6 DOCK

Warehouse

Engineering Works

Tank

208

Electric Engineering Works

Dynamo Works

Swing Bridge

Warehouse

211

205

Ford Motor Works

Lead Works

Sufos

Recreation Ground

Electric Cable Wks.

Saw Mills

207

243

206

200

Swing Bridge

Boat Ho.

101

Coaling Shed

Elec Cable Wks.

Engine Shed

212

Football Ground Stand

Trafford Park Junction

Coaling Shed

Royal Deaf Schs.

Greyhound Racing Track

TRAFFORD WHARF

Co. & Parly. Boro. By.
Manl. Boro. By.
Travelling Elevator

13

Manchester: Local connections

WIDELY ACKNOWLEDGED as the first industrial city, Manchester expanded rapidly during the Industrial Revolution of the nineteenth century, building its wealth and population on the manufacture of textiles. The original 'Cottonopolis', Manchester achieved city status in 1853, reflecting its growing importance as a commercial and cultural centre. The John Rylands Library, built as a memorial to Manchester's first cotton millionaire, provides an appropriate setting for collections which document multiple strands of the city's history, providing an insight into Manchester life across the centuries.

Although booksellers are recorded in Manchester from the early seventeenth century, the earliest extant book printed in the town dates from 1719. The Library holds twenty out of forty-eight known surviving Manchester imprints (excluding periodicals) up to 1750. Thereafter, printing, like the population, increased steadily. The Library's extensive collection of Manchester imprints from the eighteenth century onwards is complemented by significant material which relates to Manchester but was published elsewhere. The earliest known surviving catalogue for a book auction in Manchester, for example, was printed in Leeds in 1745; and the first Manchester trade directory (1772) was printed in London.

The Manchester imprints are wide-ranging in subject matter, but many reflect local concerns including sermons, lectures and meetings, and the rules and proceedings of various institutions. Manchester's intellectual and philanthropic pursuits are further documented in papers relating to societies and charities, such as the Manchester Literary and Philosophical Society, the Manchester Reform Club and the Wood Street Mission. The archives of The University of Manchester and its predecessor institution, Owens College, recall the important link between education and Nonconformity in the city, and local theological colleges are well represented.

Ephemera, including leaflets, notices and playbills, are particularly evocative of town life. Early dramatic performances in Manchester took place at the first Exchange (built 1729) and at the Marsden Street Theatre from 1753 to 1775. A patent for Manchester's first Theatre Royal was granted in 1775, and the new theatre opened in Spring Gardens with a Whit Week performance of *Othello*. The venue survived a fire, and numerous changes of management, before the patent

was transferred to larger premises in Fountain Street in 1807. This second Theatre Royal burned down in 1844 and was replaced by a splendid building in Peter Street which operated between 1845 and 1921. The Library holds playbills relating to performances at all three Theatre Royals.

Manchester's later theatrical history is captured in several archive collections. These include the papers of Annie Elizabeth Fredericka Horniman (1860–1937), the repertory theatre movement pioneer, who took over the Gaiety Theatre in Manchester in 1908; and the archive of the theatre producer Basil Dean (1888–1978) who performed at the Gaiety between 1908 and 1911. The Library also holds the archive of Robert Donat (1905–58), the Manchester-born actor and film star, best known for his Oscar-winning performance in *Goodbye, Mr Chips*.

Authors with Manchester connections are well represented. Women writers include Elizabeth Gaskell (1810–65), whose first novel *Mary Barton: A Story of Manchester Life* (1848) captured the poverty of industrial Manchester; Isabella Varley, commonly known by her married name, Mrs G. Linnaeus Banks (1821–97), whose most successful novel, *The Manchester Man*, went through five editions in her lifetime, and remains popular today; and the children's author Alison Uttley (1884–1976), who read physics at Manchester and, in 1906, became only the second woman honours graduate of the university. Her personal diaries (1932–71) reveal a hatred of the 'dusty and dirty' city (20 June 1932), but a love of the Library, which she describes as 'a gem in dark Manchester' (17 September 1932). Male writers associated with Manchester include George Gissing (1857–1903), who attended (and was expelled from) Owens College; William Harrison Ainsworth (1805–82), who was born in King Street; Harold Blundell (1902–85), a Manchester banker, who wrote over forty detective stories under the pseudonym 'George Bellairs'; and Howard Spring (1889–1965), a journalist for the *Manchester Guardian*, whose first novel *Shabby Tiger* (1934) was set in Manchester.

The Library holds the papers of several staff members of the *Manchester Guardian*, plus the archive of the newspaper itself. The *Manchester Guardian* was founded in 1821 by John Edward Taylor in the wake of the 1819 Peterloo Massacre. Manchester's radical tradition is reflected in a wealth of material relating to Peterloo, including the Peterloo Relief Fund Account Book (see 12.6), original placards and notices, and contemporary reports. The city's political history is revealed further through its roles in the abolition of slavery, the women's suffrage movement and trade unionism, while sources for economic and industrial history centre on the textile trade. These include the archives of McConnel and Kennedy, cotton-spinners, and the cotton manufacturers, Rylands and Sons. Pharmaceuticals, engineering and the computer industry are also represented, and Manchester's important transport links are documented in material relating to the Liverpool and Manchester Railway (1830) and the Manchester Ship Canal (1894). The development of the town is captured visually in extensive cartographic collections. These range from William Green's large-scale map of 1794 to twentieth-century representations of both the actual and the imagined (6.8–6.11, 12.9, 13.1 and 13.2).

The Library is well placed to record the changing faces of Manchester and its inhabitants, and its relationship with the city has impacted on the shaping of its collections. Deposits and donations by Manchester academics span the fields of science, art and the humanities, while notable acquisitions, such as the Brockbank Cricket Collection, have been gifted by local residents. The Library's collections relating to Manchester, like the city itself, will continue to grow and evolve.

Julie Ramwell

KEY TO COLOURS

HISTORICAL BUILDINGS
EXISTING BUILDINGS
PROPOSED BUILDINGS
OTHER BUILDING AREAS
RAILWAYS
VEHICULAR ACCESS NOT PERMITTED

REFERENCE

1. TOWN HALL	4. ALBERT SQUARE	7. MASONIC TEMPLE	10. TRINITY STATION ANNEXE	13. CATHEDRAL	16. ART GALLERY	19. RETAIL MARKET
2. PROPOSED EXTENSION	5. POLICE HEADQUARTERS	8. COURTS OF LAW	11. SAINT ANN'S CHURCH	14. CHETHAM'S HOSPITAL	17. AMUSEMENT CENTRE	20. BUS STATION
3. EXISTING EXTENSION	6. RYLANDS LIBRARY	9. EXHIBITION HALL	12. ROYAL EXCHANGE	15. COMMERCIAL CENTRE	18. PICCADILLY GARDENS	

13.1 Mapping the reconstruction of a city: 1. *City of Manchester Plan*, 1945

R. Nicholas, *City of Manchester Plan*, abridged edition

Norwich: printed and published for the Manchester Corporation by Jarrold and Sons, 1945

300 × 380 mm

R91041, plate 78

The destruction of areas of Manchester has given planners the opportunity to imagine and develop a very different city. The Manchester Blitz in December 1940 resulted in the loss of over six hundred lives and left much of the city in ruins. In August 1941 it was proposed to the Manchester and District Regional Planning Committee that a provisional plan for the redevelopment of the city should be prepared.

In 1945 the City Surveyor Rowland Nicholas presented his monumental *City of Manchester Plan* to the City Council. The object of the plan was to ensure that the redevelopment of Manchester conformed to a master pattern which was built upon utopian ideals that enabled every inhabitant to 'enjoy real health of body and health of mind' (p. 3). The central area of the city of Manchester shows plans to extend Piccadilly Gardens and the suggested building of an amusement centre which 'might incorporate a cinema, a theatre, dance halls, a skating rink, a boxing stadium … and a variety of other types of entertainment' (p. 50). The changes that actually evolved were often piecemeal and occurred slowly over the next sixty-five years. However, the plan maps out a utopian dream of a future city and represents the bold vision of planners to create an opportunity out of destruction.

Donna M. Sherman

13.2 Mapping the reconstruction of a city: 2. *Manchester City Centre*, 1996

A. Taylor, *Manchester City Centre*, 1:3,500

[Manchester]: Andrew Taylor, 1996

625 × 640 mm

Map Collection: C17:70 Manchester (11), detail

Reproduced by kind permission of Andrew Taylor

On Saturday 15 June 1996, Manchester city centre was subjected to the largest bomb attack in Britain since the Second World War. The Irish Republican Army claimed responsibility for the attack which was centred on the corner of Corporation Street near to Marks and Spencer's and the Arndale Centre. Over two hundred people were injured in the blast but remarkably there were no fatalities, owing to the effective evacuation of up to eighty thousand shoppers and workers present in the city that morning. The damage to buildings and businesses in the city was extensive; some buildings had to be demolished completely, while others were closed for months. Hundreds of millions of pounds in insurance claims and rebuilding work has been reported. However, the city responded to the attack by treating it as an opportunity, and embarked upon an unprecedented reconstruction of Manchester's central area.

By the time Andrew Taylor's first edition of his *Manchester City Centre* map was published in July 1996, it was significantly out of date. The events of 15 June meant that Taylor's map now showed buildings which had been demolished and businesses which were no longer operating. As such, this first edition map is a remarkable record of the central area of Manchester before the effects of the bombing. Subsequent editions of the map (his latest edition being the eighth), have recorded changing land use and the reconstruction of the central area of Manchester city centre throughout the last fifteen years.

Taylor's map focuses on the commercial core of the city, providing a greater amount of detail than commercial rivals such as *Geographers' A–Z*. Large-scale Ordnance Survey plans provide the base map but this is supplemented by rigorous ground survey. The result is a striking map, which uses colour coding to distinguish land use and which records business names both on the map and in its comprehensive index on the reverse.

Donna M. Sherman

13.3 The first book printed in Manchester

Manchester is known to have played a small part in the clandestine printing of the 'Martin Marprelate Tracts', a series of Puritan pamphlets, when a press was established briefly in Newton Lane, now Oldham Road, in August 1589. However, the men involved were arrested and the press destroyed before the work in hand had been completed. The first extant book printed in Manchester did not appear until 1719, the same year that Manchester's first newspaper, the *Manchester News-letter*, later renamed the *Manchester Weekly Journal*, was issued. Both of these publications were the work of Roger Adams (1681?–1741), a freeman of the city of Chester, who returned there in around 1726–28.

Mathematical Lectures, a forty-two-page octavo, committed to paper two lectures by 'the late Ingenious Mathematician John Jackson', which had been delivered to the recently formed Mathematical Society. The price, printed at the foot of the title page, was 'Six Pence'. The Society, the first of its kind in Lancashire, was established for 'the Improvement of Young Gentlemen and Others in Mathematical-Learning' and appears to have met weekly, these first two lectures being read on Friday 12 and 19 August 1718 respectively. Following Jackson's death, the revisers of the text expressed a wish to prevent such 'worthy Performances' from expiring with him. They dedicated the book to Lady Ann Bland (1664–1734) 'the Lady of the Manor of Manchester', and 'Patroness and first Subscriber to these Mathematical Lectures'. Today, only four copies of the book are known to have survived.

This copy of Jackson's work was accessioned into the library of Owens College (now The University of Manchester) in February 1870, as part of the library bequeathed by James Prince Lee (1804–69), the first bishop of Manchester. Previous owners of the volume include Manchester-born Charles White (1728–1813), a surgeon and man-midwife, whose armorial bookplate ('Chas: White F.R.S.') appears on the rear pastedown. White played a prominent role in the town, and was instrumental in founding the Manchester Infirmary. He became a Fellow of the Royal Society in 1762. An inscription indicating that the volume was once bound with Edward Strother's (1675–1737) *Dissertations upon the Ingraftment of the Small-pox* (London, 1722) may relate to White's ownership. The earliest-known owner of the book is a 'John Sidebotham', whose handwritten book label is dated 1725.

Julie Ramwell

John Jackson of Manchester, *Mathematical Lectures, Being the First and Second, that were Read to the Mathematical Society at Manchester* Manchester: printed by Roger Adams, in the Parsonage, and sold by William Clayton bookseller, at the Conduit, 1719
166 × 100 mm
SC12710A

13.4　Manchester's earliest surviving book auction catalogue?

S. Newton, *A Catalogue of the Library of the Late Richard Mydleton Massey, M.D. ... Sold ... under the Old Coffee-House in Manchester*
Leeds: printed by James Lister, 1745
237 × 152 mm
Library Auction Catalogues / R213584

Selling books by auction was first introduced to England from the Netherlands in 1676. The innovation proved popular and soon spread from London to the provinces. By the mid-eighteenth century auctions were an established part of the book trade in Manchester. Despite this increasing popularity, the survival rate of the accompanying sales catalogues is low. Many, including those issued by the Manchester bookseller Robert Whitworth (1707–72) in the 1730s–40s, are known only from advertisements in the press.

This catalogue of the sale of the library of the Cheshire-born physician Richard Middleton Massey (1678–1743) is believed to be the earliest surviving printed catalogue of a book auction held in Manchester. The sale, which began at 10am on Monday 11 February 1744/5, to 'continue daily till all are sold', was held by 'S. Newton, Bookseller, Under the Old Coffee-House in Manchester'. Catalogues were available 'Gratis' from booksellers across the north of England and in London, and the books were available for viewing a week before the sale began. A starting price for each lot was published in the catalogue. 'Thurloe's State Papers, 7 vol. neatly bound new' had the highest reserve at £7 7s, but some books were advertised for as little as a shilling.

The catalogue lists nearly three thousand books, divided into sizes and subjects which reflect both the professional and personal interests of their former owner. There are strong sections on medicine, natural history and science, while other topics include theology, history and English literature. The books range in date from 1489 to 1742, the year before Massey's death. Of particular significance is possibly the earliest English public sale record for a copy of the first edition of Copernicus (1543). Interestingly, at least two of the books listed in the catalogue are now held in the Library's medical collections, and can be identified by Massey's armorial bookplate.

Julie Ramwell

✗ In 1800 was sent to Lancaster as a
Debtor — Jan 1801 Released by the Insolvent
Act. settled in Ireland — Family left him
and 1811, & now live at ardwick. He returned to his
family , had a paralytic stroke — died at Altringham

Kershaw Joseph 1. Portland Place)
Removed to Urmston May 1799, failed
in 1800 & both he & his brother James left
the kingdom ✗ ✗. In 1801 Jos.ᵖʰ returned &
was concerned with his brother in law Mr Jos.
Hanson — lived at Urmston. his wife's fortune
was in part settled on her & in 1803 an uncle
left her a handsome legacy.

Keymer R. removed to Heaton Hall near Congleton
April 1799

Keymer Robert Moseley S.ᵗ & Lilibeth Hall
having purchased Mr Barker's Small-wares
manufactory L.ᵗ Col. Command of ye Newton &
Failesworth Local Militia — failed 1812
✗ Kershaw Thos his affairs being deranged
he gave up business in 1801 — In 1804 he
married a young woman who lived with him as
servant and companion by whom he had a son. He died
March 2ᵗʰ 18 at ...
J Kinaston was a man of reading and had a retentive
memory and flow of words; often spoke at
public meetings; but was disgraced and died a
pauper.

✗ Mr Reyner Alderson went to near Congleton
and lived there many years and then went to Bakewell. He
acted as Steward for Sir Edward Antrobus

[77]

Kenyon Samuel, butcher, Chapel-street, Salford
✗ Kenyon Robert, and Co. fustian, and check manufac-
 turers, 13, Back George-street Failed 1794.
Kenyon Charles, butcher, 127, Great Ancoats-street
Kenyon James, fustian-manufacturer, Blue Boar-court,
 house, 4, Hanover-street
Kenyon Lawrence, weaver, Howard-street
Kershaw John, fustian-manufacturer, Kershaw's-court,
 Alport-street
Kershaw John, flour-dealer, 51, Alport-street
Kershaw Joseph, shop-man, 8, Camp-street
Kershaw James, jun. merchant and cotton-manufactu-
 rer, 53, Market-place a disolute character died a pauper
Kershaw Samuel, shoe-maker, 3, Hanging-bridge
✗ Kershaw Thomas, calico-printer, house, Marsden-square, failed
Kershaw Charles, dealer in cotton goods, Gravel-lane,
 Salford
Kershaw Thomas, book-keeper, 13, China-lane
Kershaw John, weaver, 148, Great Newton-street
Kershaw Edward, weaver, 129, Great Newton-street
Kew Bartholomew, weaver, Green-street
4 Keymer Richard, and Sons, smallware-manufacturers,
 6, New-market-lane
Kiddal Benjamin, victualling-house, 16, Deansgate
✗ Kidson William, perfumer & hair-dresser, 39, Cannon-st
Killer Robert Wagstaff, surgeon, 19, Lever's-row declined
Kilner George, butcher, 10, Croft-street, Bank-top October 1822
✓ Kinaston Thomas, deputy constable for Salford, New-
 Bayley-street, Salford. removed from his office
Kinaston John, distiller, Chapel-street, Salford
Kinder John, bricklayer, 102, Great Ancoat's-street
Kinder Hugh, cotton-spinner, 89, Great Ancoats-street
Kinder John, bricklayer, Port-street
Kinder Joseph and Samuel, woollen-clothiers, 13, Bra-
 zennose-street, warehouse, 6, Hulme-street
King Samuel, school-master, 69, Oldham-street
King Alice, undertaker, 54, Market-place
King William, weaver, Ashley-street
Kinsey Ralph Gleave, attorney, King-street, Salford
Kinsey Thomas, tailor, King-street, Salford

(right margin, vertical) practice 1822 went to Islington near London on account of his wife's ill health. corresponded with one for Hall for a time

13.5 Early Manchester trade directories

John Scholes, *Scholes's Manchester and Salford Directory*
Manchester: printed by Sowler and Russell, MDCCXCIV [1794]
Annotated by Robert Wagstaffe Killer (1763–1841)
174 × 117 mm
R197872, p. 77 and facing interleaf

Trade and commercial directories became popular in the eighteenth and nineteenth centuries in response to the growing size and importance of provincial towns. Listing the names, addresses and occupations of leading residents, together with details of transport and postal services, they provided a helpful resource for commercial users, travellers and visitors. Manchester's first directory, which also incorporated the neighbouring town of Salford, was issued by the cookery writer Elizabeth Raffald (1733–81) in 1772. Further editions followed in 1773, and in 1781, the year of her death. Edmond Holme compiled a directory for 1788, while John Scholes, junior, son of a Manchester tea-dealer, entered the market in 1794, publishing a second edition three years later. In 1800 the printer and bookseller Gerard Bancks (d.1804) issued his first directory. This included over 6,500 entries, four times the number found in Raffald's original publication.

The Library holds six out of seven of these early Manchester directories, wanting only Raffald's 1781 edition. Of particular significance is a copy of *Scholes's Manchester and Salford Directory* (1794) which is interleaved with extensive manuscript annotations, written predominantly in the hand of Robert Wagstaffe Killer (1763–1841). Killer, who entered Manchester Grammar School in 1774, went on to become an eminent surgeon who worked both at the Manchester Royal Infirmary and, later, as surgeon to the Manchester and Salford Volunteers. He often attended the poor without charging for his services.

The scope of the annotations is wide-ranging, including: details of marriages and offspring; changes of address and occupation; dissolutions of partnerships; and removals from the town. Many of the comments reflect Killer's professional interests. These include references to medical conditions such as rheumatism and gout; and to procedures such as tapping (draining off fluid) and amputation. Causes of death cited range from the natural ('phthisis', 'hydrothorax', 'consumption', 'grief') to suicide ('cut his own throat', 'drowned himself in his own fish pond'); and the accidental ('thrown from the top of a coach', 'killed by a fall from his horse'). Observations are also included on the medical practitioners of the day: 'a skilful physician'; 'a neat & skilful operator particularly on the eyes'.

Throughout the directory, factual comments are enriched by personal remarks, allowing an insight into Killer's opinion of his townsmen. While some are praised for their worthiness, respectability and integrity, the death of one contemporary is described as 'No great loss'; and more than one Manchester resident is found to be 'too fond of the bottle'. Early trade directories provide a valuable resource for family, local and economic historians. The addition of Killer's copious annotations offers a unique insight into the lives – and deaths – of Manchester's 'principal inhabitants'.

Julie Ramwell

13.6 The Liverpool and Manchester Railway

Thomas Talbot Bury, *Coloured Views on the Liverpool and Manchester Railway, with Plates of the Coaches, Machines, &c. from Drawings Made on the Spot, by Mr. T. T. Bury. With Descriptive Particulars, Serving as a Guide to Travellers on the Railway*
London: published by R. Ackermann, 96, Strand, and sold by R. Ackermann, Jun., 191, Regent Street, 1831
R108488: 348 × 294 mm; R108488.1 (first bound-in item): 340 × 274 mm
Kenneth Brown Railway Collection / R108488.1

Railways are a relatively recent speciality of the Library, developed around the collection of E. Kenneth Brown, which was bequeathed to the Library in 1958. The collection comprises over 1,200 printed volumes, and many prints and photographs. Books printed in the early days of railways are particularly well represented. Since 1958 the collection has been enhanced by purchases and bequests.

A short walk from the Library, on Liverpool Road, is the Manchester terminus of the world's first passenger railway, the Liverpool and Manchester, which opened in 1830. In 1844 its passenger trains transferred to the new Victoria station, but Liverpool Road station continued to handle goods until closure by British Rail in 1975. The site, still with its original buildings, was saved and is now home to the Museum of Science and Industry.

The coloured aquatint, engraved by Henry Pyall after a painting by Thomas Bury, 'Entrance into Manchester across Water Street', is one of a series published in 1831 for sale as souvenirs. It portrays the line on its approach to Liverpool Road station. To the left is the stone bridge over the River Irwell, which still stands. On the right is the bridge over Water Street. An early example of an iron girder bridge, notable for its rows of Classical columns, it was replaced by a stronger and wider steel bridge in 1905. Between them stands the (now long-vanished) 'cistern house' which stored water, pumped from the river below, for the locomotives, and a ramp by which arriving passengers descended to the street. The station agent's house, glimpsed at the right-hand edge, was an existing residence purchased by the Railway. It survives, but the viewpoint chosen by Bury now lies under the viaduct carrying the Castlefield to Ordsall Lane railway line, built in the 1840s.

Charles Hulme

13.7 a & b Manchester theatricals

Theatre Royal (Manchester: Spring Gardens) [A collection of 108 playbills for performances at the Theatre Royal, Spring Gardens, Manchester, from the period December 1803–December 1804]
Manchester: J. Harrop, printer [1803–4]
Bound in one volume with the bookplate of James Watson (1775–1820)
265 × 207 mm
R183838

Hand-coloured aquatint of the Theatre Royal, Manchester
Originally published in James Winston, *The Theatric Tourist*
London: T. Woodfall, 1805
210 × 260 mm
R214259

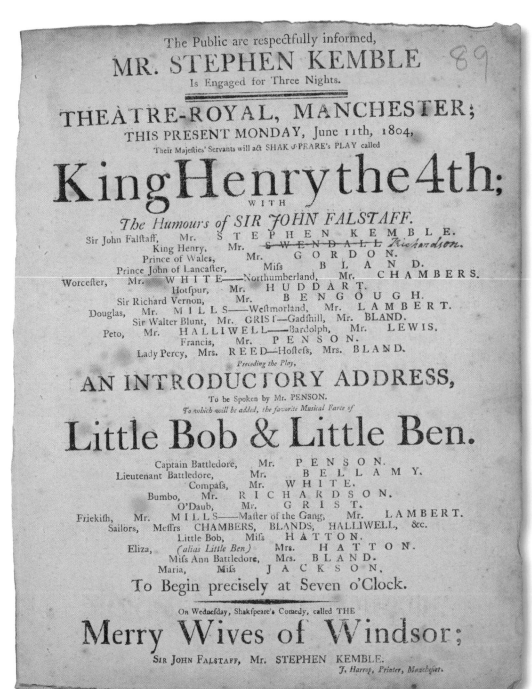

MANCHESTER.

The majority of the Library's Manchester playbills date from the period of the town's first Theatre Royal in Spring Gardens (1775–1807). Towards the end of this early period, while under the management of Thomas Ward and Thomas Ludford Bellamy (1771–1843), the theatre came under criticism for the paucity of good actors. This dissatisfaction was captured in the publication of Manchester's first stage review, *The Townsman*, written by James Watson (1775–1820), which appeared in twenty-four irregular issues between 1803 and 1805. This collection of 108 playbills dating from 2 December 1803 (the first night of the new season) to 5 December 1804, bears Watson's book label on the front pastedown, and would appear to have been assembled by him during this controversial period.

The playbills provide a detailed insight into the evenings' entertainments. Typically beginning at 'a Quarter before Seven precisely', the programme offered three events per evening, which changed on a daily basis. Amusements ranged from the more usual comedies, tragedies and farces to musical interludes, pantomimes, dances, acrobatics and regimental bands. In addition to listing the star turns and other cast members, the playbills reveal those responsible for the 'scenery, machinery, music, dresses and decorations', and provide evidence of production and management details. These include the employment of the 'benefit' system, which was used to supplement insufficient salaries, for both acting members of the company and front-of-house staff. Despite Watson's criticisms of the quality of the Theatre Royal's resident performers, the members' benefit receipts were up for the 1804 season, and a number of 'Country Stars' also enjoyed success. These included Stephen George Kemble (1758–1822), famed for his portrayal of Sir John Falstaff, and William Henry West Betty (1791–1874), otherwise known as the Young Roscius, who satisfied the contemporary fashion for juvenile performers by tackling such great roles as Hamlet and Richard III.

Julie Ramwell

13.8 Dickens on stage

*Theatre Royal (Manchester: Peter Street), For the Benefit of Mr.
Leigh Hunt, 'Who after years of ill health and hard struggle, is not,
without this assistance, released from difficulty by a Pension granted
late in life.' ... On Monday Evening, July 26, 1847, will be presented,
Ben Jonson's Comedy of Every Man in his Humour*
Manchester: Lowes and Co., printers, 14, Lloyd Street, 1847
502 × 250 mm
R199828

It was at the third Theatre Royal in Peter Street, in the
summer of 1847, that Charles Dickens (1812–70) headed
'the most easily governable company of actors on earth',
in a star-studded performance of Ben Jonson's *Every Man
in His Humour*. Dickens reprised the role of Bobadil, a
part which he had first taken in September 1845 at Fanny
Kelly's theatre in Dean Street, Soho, and which had been
revived successfully on a number of occasions. Many of
Dickens's close friends, and two of his brothers, played
alongside him. John Forster (1812–76), Dickens's literary
adviser and chosen biographer, appeared as Kitely; Douglas
Jerrold (1803–57), the playwright and journalist, as Master
Stephen; and John Leech (1817–64), illustrator of Dickens's
A Christmas Carol, as Master Matthew.

The evening was designed to raise funds for Dickens's
old friend, the poet Leigh Hunt (1784–1859), who was the
author's alleged inspiration for the improvident Harold
Skimpole in *Bleak House*. A second production, at Liverpool,
took place two days later. Jonson's comedy headed the
bill on both occasions, but the accompanying entertain-
ment varied. In Manchester, Dickens delivered a prologue
written by Sergeant Thomas Noon Talfourd (1795–1854),
copies of which were available for sale. He later performed
a two-character interlude with Mark Lemon (1809–70),
entitled *A Good Night's Rest*, and the evening concluded
with John Poole's (1786?–1872) farce, *Turning the Tables*, in
which George Cruikshank (1792–1878) made an appear-
ance. Other notable cast members included the literary
critic George Henry Lewes (1817–78), the Manchester-born
artist Frank Stone (1800–59) and the painter Augustus Egg
(1816–63). The receipts for the two performances totalled
just over £500, and Leigh's benefit fund was boosted by
400 guineas.

Julie Ramwell

THEATRE ROYAL,

MANCHESTER.

DRESS CIRCLE	SEVEN SHILLINGS.
PIT STALLS	SEVEN SHILLINGS.
UPPER CIRCLE	FIVE SHILLINGS.
PIT	THREE SHILLINGS.
GALLERY	TWO SHILLINGS.
UPPER GALLERY	ONE SHILLING.

The Performance to commence at Seven o'Clock exactly, by which time it is particularly requested that the whole of the Audience may be seated An interval of five minutes between the close of each piece and the commencement of the Overture to the next.

FOR THE BENEFIT OF

MR. LEIGH HUNT,

"Who, after years of ill health and hard struggle, is not, without this assistance, released from difficulty by a Pension granted late in life."

"It is proposed to devote a portion of the proceeds of this Benefit to the assistance of another celebrated Writer, whose literary career is at an end, and who has no provision for the decline of his life."—*Circular originally issued in London.*

On Monday Evening, July 26, 1847,

Will be presented, Ben Jonson's Comedy of

EVERY MAN IN HIS HUMOUR.

Kitely	Mr. JOHN FORSTER.
Old Knowell	Mr. G. H. LEWES.
Young Knowell (His Son)	Mr. FREDERICK DICKENS.
Wellbred	Mr. T. J. THOMPSON.
Master Stephen	Mr. DOUGLAS JERROLD.
Master Matthew	Mr. JOHN LEACH.
Justice Clement	Mr. DUDLEY COSTELLO.
Downright	Mr. FRANK STONE.
Captain Bobadil	Mr. CHARLES DICKENS.
Cash	Mr. AUGUSTUS DICKENS.
Formal	Mr. AUGUSTUS EGG.
Cob	Mr. GEORGE CRUIKSHANK.
Brainworm	Mr. MARK LEMON.
Mrs. Kitely	Miss EMMELINE MONTAGUE.
Bridget	Mrs. A. WIGAN.
	(Of the Theatre-Royal English Opera House)
Tib	Mrs. CAULFIELD
	(Of the Theatre-Royal, Haymarket.)

Previous to the Comedy, an ADDRESS, written for the occasion by Mr. Sergeant TALFOURD, will be spoken by Mr. CHARLES DICKENS.

Prior to the Comedy, the Overture to	"Fra Diavolo."
Prior to the Interlude the Overture to	"La Gazza Ladra."
Prior to the Farce, the Overture to	"Massaniello."

MUSICAL DIRECTOR & LEADER - MR. SEYMOUR.

After the Comedy, the Interlude called

A GOOD NIGHT'S REST;
OR, TWO O'CLOCK IN THE MORNING.

Mr. Snobbington	Mr. CHARLES DICKENS.
The Stranger	Mr. MARK LEMON.

To conclude with Mr. Poole's Farce of

TURNING THE TABLES

Mr. Knibbs	Mr. GEO. CRUIKSHANK.
Jeremiah Bumps	Mr. CHARLES DICKENS.
Edgar de Courcy	Mr. DUDLEY COSTELLO.
Tom Thornton (His Friend)	Mr. FREDERICK DICKENS.
Jack Humphries	Mr. G. H. LEWES.
Miss Knibbs (with a Song)	Miss ROMER.
Patty Larkins	Mrs. A. WIGAN.
Mrs. Humphries	Mrs. CAULFIELD.

No Seats will be reserved in the Dress Stalls or Upper Circle after the termination of the first act.

NOTICE.—The Address written by Mr Serjeant Talfourd, and spoken by Mr. Charles Dickens, will be published in Manchester, on Monday Evening, by Mr. Abel Heywood, and Messrs. Simms and Dinham. It will also be on Sale at the Theatre after the first act of the Comedy. Price One Shilling; the profits in aid of the benefit.

LOWES AND Co., PRINTERS, 14, LLOYD STREET, MANCHESTER.

13.9 The Manchester Man

Mrs George Linnaeus Banks, 'The Manchester Man', *Cassell's Family Magazine* (1875), 65–76, 129–40, 193–204, 257–68, 321–31, 385–96, 449–60, 513–25, 577–91, 641–55, 705–20
London: Cassell Petter and Galpin, 1875
265 × 200 mm
Edward L. Burney Book Collection / R144543, p. 200: A fight between Jabez Clegg and Laurence Aspinall, with Chetham's Hospital in the background

Manchester has a rich literary heritage, but perhaps the novel most closely associated with the city is *The Manchester Man* by Mrs G. Linnaeus Banks (1821–97). This enduring work first appeared in serialized format in *Cassell's Family Magazine* from January to November 1875, before being published in three volumes the following year. The story of a 'self-made man', Jabez Clegg, fitted well with the magazine's taste for moralistic and domestic literature, which appeared alongside general interest articles on cookery, dress, table decorations and 'Women Who Work'. Mrs Banks's tale, which was printed in double columns, with wood-engravings by William Harcourt Hooper (1834–1912) after Charles Green (1840–98), was introduced as a 'very remarkable Serial Story, founded on facts connected with a modern historic period'. Attention was drawn to the number of characters who 'are actual persons, many of them well known to Manchester people'.

It is this interweaving of authentic historical detail into the narrative of the plot for which Mrs Banks's work is most celebrated. Set in the early nineteenth century, *The Manchester Man* incorporates landmark events such as the Peterloo Massacre (1819), amid a wealth of 'local colour',

including events ranging from the tragic capsizing of the *Emma* on the Irwell in 1828, to visits to the Theatre Royal in Fountain Street. Many incidents are drawn from Mrs Banks's own family history. Among the local residents immortalised by her pen are the eccentric clergyman the Rev. Joshua Brookes (bapt.1754, d.1821) and the actress Sophia McGibbon née Woodfall (d.1852), who lodged with the the author's family when in Manchester. For the aid of readers who 'care to discriminate fact from fiction', an 'elucidating Appendix' became a feature of the published editions.

Although Isabella Varley was brought up in Manchester, on becoming Mrs G. Linnaeus Banks she embarked on a nomadic existence accompanying her journalist husband around the country. Her interest in local history extended beyond her birthplace, and fewer than a third of her published novels and stories are set in the North West. Other locations include Durham, Birmingham, Yorkshire, Wiltshire and Wales. She maintained a strong affection for Manchester, however, often contributing to local papers and magazines. A testimonial performance on her behalf was held at the town's Comedy Theatre in September 1895.

Julie Ramwell

13.10 Rylands cotton mill

Rylands and Sons Ltd, promotional brochure, *c.*1932
160 × 256 mm
Rylands and Sons Ltd Archive, RYL/1/3/8

The John Rylands Library was built upon the profits of the Lancashire cotton industry. John Rylands developed the family firm, Rylands and Sons, into the largest textile enterprise in Britain. One reason for this extraordinary success was 'vertical integration': rather than specialising in one particular branch of the industry, as most firms did, Rylands and Sons controlled the entire operation, from importing raw cotton to retailing the finished goods in its own shops; it even owned a colliery to supply coal to its mills. This meant that it was insulated from recession in any particular sector of the industry, it was not dependent on external suppliers, and it could retain the profits from each stage of the process.

John Rylands is generally considered to have been a good employer; he built houses, schools and chapels for his workers, and undertook many other charitable works. However, during the nineteenth century conditions throughout the industry were extremely harsh, as the novels of Elizabeth Gaskell and the writings of Friedrich Engels testify. Although legislation gradually outlawed child labour and reduced the very long hours that staff were required to work, even in the early twentieth century cotton mills were noisy, dusty and dangerous places, with little attention paid to the health or safety of employees.

This photograph from a Rylands and Sons publicity brochure shows the interior of a weaving shed at Wigan Mills, *c.*1932. At least forty workers are visible here, all but two of whom are women. The Lancashire cotton industry was unusual for the period in that married women formed a large proportion of the workforce. Because they could not be heard above the noise of the machinery, they communicated by 'mee-mawing' – silently using exaggerated movements of the mouth – and lip-reading.

John R. Hodgson

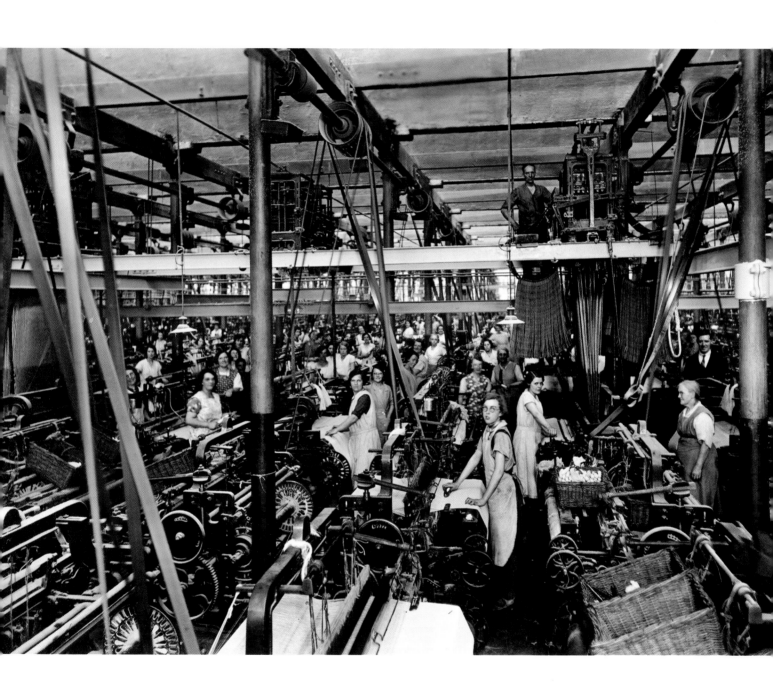

It behouyth vs by many trybulacyons to entre in to the kyngdome of heuen/He brynge all vs that suffred dethe/oure lozde Jhesus. AMEN.

Thus endeth this treatyse shewynge the .xii. pfytes of trybulacyon . Enpzynted at Westmyster iy Caxtons hous.By me Wynkyn the wozde.

Peter of Blois, *A lytyll treatyse whiche is called the xii profytes of trybulacyon*
(Westminster: Wynkyn de Worde, *c.*1499). Spencer 15416.1, colophon

Notes on contributors

Philip Alexander FBA is Professor Emeritus of Post-Biblical Jewish Literature at The University of Manchester. His research interests include the history of Judaism, early Jewish Bible interpretation and the interaction of Judaism and Christianity in Late Antiquity. He directed the AHRC-funded Rylands Cairo Genizah Project.

Jeanette C. Allotey is Lecturer in midwifery at The University of Manchester. She has a PhD in the history of midwifery practice and is the current chair of De Partu, a history of childbirth research group.

Guyda Armstrong is Senior Lecturer in Italian at The University of Manchester. Her research is mainly focused on Boccaccio, but wider interests include the history of the book, digital humanities, translation studies, the plurilingual literary cultures of medieval and Renaissance Europe, and feminist critical approaches to literary and translation studies. She was the Principal Investigator for the British Academy-funded Manchester Digital Dante Project.

Fran Baker is an archivist at The University of Manchester Library, where she curates the literary and social and political history archives. She has an MPhil in English and was a co-founder of the Group for Literary Archives and Manuscripts.

Stacy Boldrick is Curator of Research and Interpretation at the Fruitmarket Gallery, Edinburgh, and an Honorary Fellow, University of Edinburgh. She curated 'Art under Attack: Histories of British Iconoclasm' (Tate Britain, 2013) and writes about medieval and contemporary art.

George Brooke is Rylands Professor of Biblical Criticism and Exegesis at The University of Manchester. He has published extensively on the Dead Sea Scrolls and also has research interests in Semitic Studies and the use of the Old Testament in the New Testament.

Michelle P. Brown FSA is Professor Emerita of Medieval Manuscript Studies, School of Advanced Study, University of London. She is also a Visiting Professor at University College London and Baylor University, Texas. She was formerly the Curator of Illuminated Manuscripts at the British Library. She has published, lectured and broadcast widely on medieval cultural history.

Carol J. Burrows holds an MA in Modern Languages and Cultures and is the Heritage Imaging Manager at The University of Manchester Library. She is also an Adviser to the Board of The Islamic Manuscript Association.

Daron L. Burrows is University Lecturer in Medieval French at the University of Oxford and a Fellow of St Peter's College. His research interests include textual editing, manuscript studies, and Anglo-Norman literature and language.

Caroline Checkley-Scott is Collection Care Manager at The University of Manchester Library where she is responsible for the conservation and preservation of the collections. She has worked at the British Library and the Wellcome Library, London. Her research interests include the history of the book and non-destructive methods of animal species identification of parchment.

Georg Christ is Lecturer in Medieval and Early Modern History at The University of Manchester. His research interests include Venice and trade in the late medieval and early modern Eastern Mediterranean, Mamluk history and news- and knowledge-management in the late medieval and early modern period.

Dorothy J. Clayton FSA, FRHistS is Honorary Research Fellow in the School of Arts, Languages and Cultures, The University of Manchester. She was formerly Head of Scholarly Publications in The University of Manchester Library and Editor of the *Bulletin of the John Rylands Library*, 1990–2013. Her published work focuses on late medieval political history. She also studies the Home Front during the First and Second World Wars.

Matthew Cobb is Professor of Zoology in the Faculty of Life Sciences at The University of Manchester. He also studies the history of science in the seventeenth and twentieth centuries.

Kate Cooper is Professor of Ancient History at The University of Manchester. She writes and teaches about the world of the Mediterranean in the Roman period, with a special interest in daily life and the family, religion and gender, social identity, and the fall of the Roman Empire.

Lisa M. Crawley currently works in the Records Management Office at The University of Manchester. Formerly she was an archivist cataloguing the Mary Hamilton Papers at The University of Manchester Library. She has a PhD on the subject of African American Women during the Civil War and Reconstruction period. She is currently carrying out research prior to writing a biography of Mary Hamilton.

Grayson Ditchfield FRHistS is Professor of Eighteenth-Century History, University of Kent, Canterbury. He has published extensively on eighteenth-century British political and religious history, and edited the two-volume *Letters of Theophilus Lindsey* (2007, 2012).

Suzanne M. Fagan is a cataloguer in the Heritage Imaging Team at The University of Manchester Library where she is responsible for cataloguing digital images. She has an MA in Heritage Interpretation and her research interests include visual culture and museology.

Alba Fedeli is a post-doctoral researcher at the Institute for Textual Scholarship and Electronic Editing, University of Birmingham. Her research focuses on early Qur'ānic manuscripts and she is currently preparing an electronic edition of Qur'ānic manuscripts in the Mingana Collection at the University of Birmingham.

Elaine Feinstein Hon DLitt, FRSL, is a poet, novelist and biographer as well as a translator of Russian poets. Her first versions of Marina Tsvetaeva's poetry were published by Oxford University Press in 1970; a much enlarged edition, *Bride of Ice*, was published by Carcanet in 2009.

Majella Franzmann is Pro-Vice Chancellor, Faculty of Humanities, at the University of Curtin, Australia, and Fellow of the Australian Academy of the Humanities. Her early research focused on the *Odes of Solomon* and other Syriac texts. More recently her research includes many aspects of Gnosticism, especially the texts from Nag Hammadi and the Manichaeans.

Elizabeth Gow is Manuscript Curator and Archivist at The University of Manchester Library where she is responsible for Non-Western Manuscript and Papyrus collections. Her research interests include the life of Enriqueta Rylands.

Tim Grass FRHistS is an assistant tutor at Spurgeons College, Croydon, and Assistant Editor of *Studies in Church History*, the regular publication of the Ecclesiastical History Society. He writes extensively on church history.

Crawford Gribben FRHistS is Professor of Early Modern British History in Queen's University Belfast. He has written widely on the history of evangelical millennial belief.

Stella K. Halkyard is Visual Collections and Academic Engagement Manager at The University of Manchester Library, where she curates the Art, Photography and Object Collections. Her research interests include the material cultures of art and literature, portraiture, and the history of photography.

Lotte Hellinga FBA was formerly a Deputy Keeper at the British Library and has published extensively on early printing and the transition from manuscript to print, including *William Caxton and Early Printing in England* (2010). She was co-editor of Volume 3 (1400–1557) of *The Cambridge History of the Book in Britain* (1999) and compiler of the extensive eleventh volume, 'England', of the *Catalogue of Books Printed in the XVth Century now in the British Library* (2007).

John R. Hodgson is Manuscripts and Archives Manager at The University of Manchester Library, with over twenty years' experience as a professional archivist. He is currently undertaking a PhD (part-time) on the Earls of Crawford and the development of their manuscript collections during the nineteenth century.

Caroline Hull was a Post-Doctoral Research Fellow at the John Rylands Library between 1993 and 2000. She worked extensively with the Library's collections of medieval manuscripts, including particularly French MS 5 and the impressive examples of medieval book covers. Since then she has worked as a freelance art historian and for the past decade she has served as the Assistant to the Cathedral Dean at Lancaster Cathedral.

Charles Hulme trained as an engineer, and later as a librarian. He was for many years a member of the Computer Support team at The University of Manchester Library, and in 1995 designed and published the Library's first website. He has studied the railways of Manchester, and other fields of local history, and has published extensively about these topics on the internet. He is the author of the Library's publication *Rails of Manchester* (1991) and his essay on Manchester sculptor John Cassidy was published in the Library's *Bulletin* (2013).

William Hutchings is Honorary Research Fellow in the School of Arts, Languages and Cultures at The University of Manchester. He was formerly Senior Lecturer in English. His principal research area is eighteenth-century poetry, and he has published on William Collins, William Cowper, Thomas Gray and James Thomson. He has also written extensively on the teaching of literature. His most recent publication is *Living Poetry* (Palgrave Macmillan, 2012).

Ian Isherwood CBE is Professor Emeritus of Diagnostic Radiology, The University of Manchester. He is a neuroradiologist and was a pioneer in the development of Computed Tomography and Magnetic Resonance Imaging. He has lectured internationally and published widely in these fields. He is a former President of the European Association of Radiology and of the British Institute of Radiology.

Peter K. Klein is Professor Emeritus of Art History, Universität Tübingen, Germany. He has taught at the Universities of Pittsburgh, Lexington, Geneva, Paris-Nanterre, Los Angeles and Marburg. His areas of study and publication include medieval book illumination (especially Apocalypses and Beatus manuscripts), Romanesque sculpture, cloisters, and Spanish art history (medieval to modern).

Katrin Kogman-Appel, Evelyn Metz Memorial Professor of Art, Ben-Gurion University of the Negev, is a scholar of medieval Jewish book culture. Her work focuses on manuscript illumination of the fourteenth and the fifteenth centuries in Iberia and Ashkenaz.

Peter F. Kornicki FBA is Professor of Japanese at the University of Cambridge and Deputy Warden of Robinson College, Cambridge. He has published extensively on the history of the book in East Asia.

Simon H. Lavington FIEE, FBCS is Professor Emeritus of Computer Science at the University of Essex. He was a founder member of the Department of Computer Science in The University of Manchester. He was on the ICL-sponsored committee that first proposed a national archive for the history of computing, and was instrumental in its being established in Manchester. He has published widely on the history of the computer since 1975.

Richard A. Leson is Assistant Professor of Art History at the University of Wisconsin-Milwaukee. He is currently writing a book entitled *The Material Life of Jeanne of Flanders*, an exploration of the possessions and material traces of the Franco-Flemish noblewoman who was the probable recipient of the Psalter-Hours, Rylands Latin MS 117.

Grevel Lindop was formerly Professor of Romantic and Early Victorian Studies at The University of Manchester. He has written extensively on modern and Romantic poetry, and has edited works by Chatterton, De Quincey and Robert Graves. His *Selected Poems* appeared in 2001.

Gareth Lloyd is an archivist at The University of Manchester Library, where he curates archives relating to the Christian Church. He has a doctorate from Liverpool University and has published and lectured extensively in Britain and North America on the history of Methodism and related evangelical movements.

Henry A. McGhie is Head of Collections and Curator of Zoology at Manchester Museum, The University of Manchester. He is interested in connecting natural history museums with environmental sustainability, and has written widely on bird ecology, collections and natural history exhibitions.

Robyn Marsack DPhil has been Director of the Scottish Poetry Library in Edinburgh since 2000. She was formerly an editor for Carcanet Press, and has contributed essays on Edwin Morgan to various publications.

John D. Milner was formerly Principal Director of the Assessment and Qualifications Alliance. His research interests focus on late medieval political history on which he has published papers, most recently, 'The English Commitment to the 1412 Expedition to France' in *The Fifteenth Century XI: Concerns and Preoccupations*, ed. Linda Clark. His current major project is a biography and political study of Thomas, duke of Clarence, Henry IV's second son.

Peter D. Mohr FRCP was formerly Honorary Curator, Manchester University Medical Museum; Honorary Lecturer in Medicine, The University of Manchester; and a consultant neurologist, Salford Royal Hospital.

Nigel Morgan is Emeritus Honorary Professor of the History of Art in the University of Cambridge and a former fellow of Corpus Christi College. He has published extensively on illuminated manuscripts of the later Middle Ages.

Vrej N. Nersessian was formerly Head of the Christian Middle East section at the British Library (1975–2011). He has published extensively on early Armenian books. His most recent major published work is *A Catalogue of the Armenian Manuscripts in the British Library Acquired Since the year 1913 and of Collections in Other Libraries in the United Kingdom* (2012).

Tim J. O'Brien FRAS is Professor of Astrophysics and Associate Director at The University of Manchester's Jodrell Bank Observatory. In addition to his work focusing on the study of stellar explosions, he is also very active in public engagement with research.

Alison Aplin Ohta is Director of the Royal Asiatic Society of Great Britain and Ireland. Her areas of study include Islamic bookbindings and the art and architecture of the Islamic world with particular reference to the Mamluk period, 1250–1516.

Nigel F. Palmer FBA is Emeritus Professor of German Medieval Studies at the University of Oxford. He has written extensively in the area of German and Latin manuscript studies and has also published on printing from woodblocks and on blockbooks, with emphasis on the relationship between the materiality of the book and its literary content.

James N. Peters is an archivist at The University of Manchester Library. He is responsible for the Library's scientific, medical and University's institutional archive collections.

Andrew Phillips read History at The University of Manchester, where he continued for his Master's degree in Medieval Studies. Specialising in the eastern Mediterranean in the Late Middle Ages, he encountered Rylands Latin MS 53 and was immediately enthralled by its story. Now in employment, Andrew may one day return for his PhD.

John V. Pickstone (1944–2014) was Professor Emeritus in the Centre for the History of Science, Technology and Medicine, The University of Manchester. He also originated the Manchester Histories Festival and The University of Manchester Heritage Programme. He published extensively

on the recent history of medicine, on Manchester history, and on Ways of Knowing. He sadly passed away during the production of this book.

Peter E. Pormann is Director of the John Rylands Research Institute and Professor of Classics and Graeco-Arabic Studies. Recent publications include *Mirror of Health: Medical Science During the Golden Age of Islam* (London: Royal College of Physicians, 2013), *Epidemics in Context: Greek Commentaries on Hippocrates in the Arabic Tradition*, Scientia Graeco-Arabica 8 (Berlin: De Gruyter, 2012), and with Peter Adamson, *The Philosophical Works of al-Kindī* (Karachi: Oxford University Press, 2012).

Edward Potten is Head of Rare Books at Cambridge University Library. He was formerly responsible for the early printed collections at The John Rylands Library, The University of Manchester, where he taught about the history of the book, the arrival of the printing press and incunable editions of Dante. He has published on the use of liturgical books in the fifteenth century, and seventeenth-century book production and collecting.

Julie Ramwell is a Special Collections Librarian (Rare Books) at The University of Manchester Library. She was formerly a Rare Books Cataloguer at Chetham's Library, also in Manchester. Her research interests include provincial printing and local history.

Gwen Riley Jones is Senior Photographer at The University of Manchester Library, where she is responsible for the digitisation of items from the Special Collections. Her research interests include historical and contemporary photography, portraiture and the everyday. She is a practising photographer outside of her work at the Library and has published and exhibited internationally.

Ian Rogerson is Professor Emeritus and former University Librarian at Manchester Metropolitan University. He has been an Honorary Research Fellow at the John Rylands Research Institute since 1994 and has contributed several articles to the *Bulletin* of the JRL. He is currently writing on the illustrators of Andrew Lang's *Colour Fairy Books*; and the *Fairy Books* of Joseph Jacobs.

Alexander R. Rumble FRHistS was formerly Reader in Palaeography in the School of Arts, Languages and Cultures, The University of Manchester. His areas of study and publication include Anglo-Saxon charters, Domesday Book, medieval dated and datable manuscripts, and English onomastics.

Michael Schmidt OBE, FRSL is Professor of Poetry at the University of Glasgow and Writer in Residence at St John's College, Cambridge. He is editorial and managing director of Carcanet Press and a director of The University of Manchester Library's Modern Literary Archives Programme.

Sophie Schneideman is an international rare book and print dealer, based in London and specialising in the Art of the Book, i.e. book illustration, private presses, fine binding, fine printing and *livres d'artistes*, particularly of the nineteenth and twentieth centuries.

Stefan Schorch is Professor of Biblical Studies, Martin-Luther-University Halle-Wittenberg, Germany. His areas of study include the textual history of the Hebrew Bible, Hebrew language and Samaritan literature.

Alan Shelston was Senior Lecturer in English Literature at The University of Manchester until his retirement in 2002. He is an Honorary Fellow of the John Rylands Library, the author of *Elizabeth Gaskell: A Brief Life* (2010), and joint editor of *Further Letters of Mrs Gaskell* (2002).

Donna M. Sherman is a Special Collections Librarian at The University of Manchester Library where she curates the Map Collection. She has an MA in Library and Information Management and a background in Visual Arts. She has worked with the University's cartographic collections since 2008 and is a member of the Map Curator's Group of the British Cartographic Society.

Julianne Simpson is Rare Books and Map Collections Manager at The University of Manchester Library. She has previously worked in London, Oxford and Melbourne and completed the MA in the History of the Book at the University of London in 1997. Her research interests include the international book trade in the sixteenth century, the study of libraries in the early modern period and the recording of provenance in library catalogues.

Ursula Sims-Williams is Curator of Iranian Collections at the British Library. Her research interests focus on the pre-Islamic Iranian and the Zoroastrian collections. She co-curated the recent exhibition 'The Everlasting Flame: Zoroastrianism in History and Imagination' (School of Oriental and African Studies, 2013).

Renate Smithuis is Lecturer in medieval Jewish studies, Religions and Theology, School of Arts, Languages and Cultures, The University of Manchester. She was formerly the research associate of the Rylands Cairo Genizah Project.

Jacqueline Suthren Hirst is Senior Lecturer in Comparative Religion (South Asian Studies) at The University of Manchester. While her specialist interests lie in Advaita Vedanta, she has also published on Ramayana traditions and is interested in the way they act as intertexts, not least in the Sufi Indo-Islamic romances.

Stefania Travagnin is Rosalind Franklin Fellow, Assistant Professor of Religion in Asia and Director of the Centre for the Study of Religion and Culture in Asia, Faculty of Theology and Religious Studies, University of Groningen, the Netherlands. Her research and publications address different aspects of religion in modern and contemporary China.

Janet L. Wallwork works currently in the University Archives and Records Centre, and has been involved with the John Rylands Library and its collections for more than forty years. She holds an MPhil in English from The University of Manchester. She is researching the history of nineteenth-century Manchester and has recently edited five books on the topic.

Roger S. Wieck is Curator of Medieval and Renaissance Manuscripts at the Morgan Library & Museum, New York. He has also held curatorial positions at the Walters Art Museum in Baltimore and at the Houghton Library of Harvard University.

Christoph Winterer is the editor of the web-based *Handschriftencensus Rheinland-Pfalz* and has published on a wide range of medieval art-historical topics, including monographs on the Göttingen Sacramentary from Fulda and the Hitda-Codex from Cologne. In 2013 he curated an exhibition on Archbishop Hatto I of Mainz (891–913), and is currently preparing one on the early medieval music of the canonesses at St Servatius, Quedlinburg.

Further reading

Introduction

Barker, Nicolas, *Bibliotheca Lindesiana: The Lives and Collections of Alexander William, 25th Earl of Crawford and 8th Earl of Balcarres, and James Ludovic, 26th Earl of Crawford and 9th Earl of Balcarres*, 2nd edn (London: Bernard Quaritch for the Roxburghe Club, 1978).

Dibdin, Thomas Frognall, *Bibliotheca Spenceriana: or, A Descriptive Catalogue of the Books Printed in the Fifteenth Century and of Many Valuable First Editions in the Library of George John Earl Spencer*, 7 vols (London: Longman, Hurst, Rees, 1814–23).

Farnie, D. A., 'Enriqueta Augustina Rylands (1843–1908), Founder of the John Rylands Library', *BJRL*, 71:2 (1989), 3–38.

Farnie, D. A., 'John Rylands of Manchester', *BJRL*, 75:2 (1993), 2–103.

Gow, Elizabeth, *Enriqueta Rylands: Who Do You Think She Was? Discovering the Founder of the John Rylands Library* (Manchester: John Rylands University Library, 2008).

Guppy, Henry, 'In Memoriam: Mrs Enriqueta Augustina Rylands', *BJRL*, 1:6 (1908), 351–9.

Guppy, Henry, 'The John Rylands Library: A Record of Twenty-One Years' Work', *BJRL*, 6:1–2 (1921), 11–68.

Guppy, Henry, *The John Rylands Library, Manchester, 1899–1924: A Record of Its History with Brief Descriptions of the Building and Its Contents* (Manchester: Manchester University Press, 1924).

Guppy, Henry, *The John Rylands Library, Manchester, 1899–1935: A Brief Record of Its History with Descriptions of the Building and Its Contents* (Manchester: Manchester University Press, 1935).

Hodgson, John (ed.), *A Guide to Special Collections of the John Rylands University Library of Manchester* (Manchester: JRULM, 1999).

Hodgson, John, '"Carven stone and blazoned pane": The Design and Construction of the John Rylands Library', *BJRL*, 18:1 (2012), 19–81.

Lister, Anthony, 'The Althorp Library of Second Earl Spencer, now in the John Rylands University Library of Manchester: Its Formation and Growth', *BJRL*, 71:2 (1989), 67–86.

McNiven, Peter, 'The John Rylands Library, 1972–2000', *BJRL*, 82:2–3 (2000), 3–79.

O'Sullivan, Michael, 'Josephinism, Orientalism, and Antiquarianism in the Life and Works of Count Karl Reviczky, 1737–1793', unpublished MPhil dissertation, University of Cambridge, 2012.

Taylor, Frank, 'The John Rylands Library, 1936–72', *BJRL*, 71:2 (1989), 39–66.

Tyson, Moses, 'The First Forty Years of the John Rylands Library', *BJRL*, 25:1 (1941), 46–66.

White, Eric Marshall, 'New Provenances for Four Copies of the 36-Line Bible', *Book Collector*, 62:3 (2013), 403–34.

Chapter 1

Appadurai, Arun (ed.), *The Social Life of Things: Commodities in Cultural Perspective* (Cambridge: Cambridge University Press, 1997).

Cavello, Guglielmo (ed.), *A History of Reading in the West* (Cambridge: Polity Press, 1999).

Chartier, Roger, *On the Edge of a Cliff* (Baltimore: Johns Hopkins University Press, 1994).

Fischer, Steven Roger, *A History of Reading* (London: Reaktion Books, 2003).

Fischer, Steven Roger, *A History of Writing* (London: Reaktion Books, 2003).

Griffiths, Antony, *Prints and Printmaking: An Introduction to the History and Techniques* (London: British Museum Press, 2010).

Kirschenbaum, Matthew, *Mechanisms: New Media and the Forensic Imagination* (Cambridge, Mass.: MIT Press, 2008).

Kubler, George, *The Shape of Time* (New Haven: Yale University Press, 1962).

Kwint, Marius (ed.), *Material Memories: Design and Evocation* (Oxford: Berg, 1999).

Miller, Daniel, *Stuff* (Cambridge: Polity Press, 2010).

Mitchell, W. J. T., *Picture Theory* (Chicago: Chicago University Press, 1994).

Pointon, Marcia, *Portrayal and the Search for Identity* (London: Reaktion Books, 2012).

Turkle, Sherry, *The Second Self* (Cambridge, Mass.: MIT Press, 2005).

Turkle, Sherry (ed.), *Evocative Objects: Things We Think With* (Cambridge, Mass.: MIT Press, 2011).

Chapter 2

Alexander, Jonathan J. G., *Studies in Italian Manuscript Illumination* (London: Pindar, 2002).

Alexander, Jonathan J. G. and Paul Binski (eds), *The Age of Chivalry: Art in Plantagenet England 1200–1400* (London: Royal Academy of Arts in association with Weidenfeld and Nicolson, 1987).

Camille, Michael, *Image on the Edge: The Margins of Medieval Art* (London: Reaktion Books, 1992).

Camille, Michael, *Master of Death: The Lifeless Art of Pierre Remiet, Illuminator* (New Haven: Yale University Press, 1996).

Hobson, Anthony, *Apollo and Pegasus: An Enquiry into the Formation and Dispersal of a Renaissance Library* (Amsterdam: Van Heusden, 1975).

James, Montague Rhodes, *A Descriptive Catalogue of the Latin Manuscripts in the John Rylands University Library*, with an introduction and additional notes by Frank Taylor (Munich: Kraus Reprints, 1980).

Klein, Peter K., *Beato de Liébana: La ilustración de los manuscritos de Beato y el códice de Manchester* (Valencia: Patrimonio ediciones, 2002).

Kogman-Appel, Katrin, *Illuminated Haggadot from Medieval Spain: Biblical Imagery and the Passover Holiday* (University Park: Pennsylvania State University Press, 2006).

Leson, Richard A., 'Heraldry and Identity in the Psalter-Hours of Jeanne of Flanders (Manchester, John Rylands Library, Ms. lat. 117)', *Studies in Iconography*, 32 (2011), 155–98.

Loewe, Raphael, *The Rylands Haggadah. A Medieval Sephardi Masterpiece in Facsimile* (London: Thames and Hudson, 1988).

Mochi, Cristina, 'Il messale di Pompeo Colonna: antichità ed egizianismi a Roma', in Stefano Colonna (ed.), *Roma nella svolta tra Quattro e Cinquecento* (Rome: De Luca editori d'arte, 2004), 439–52.

Morgan, Nigel, *Early Gothic Manuscripts [II]: 1250–1285*, A Survey of Manuscripts Illuminated in the British Isles, 4 (London: Harvey Miller, 1988).

Stones, Alison, *Gothic Manuscripts: 1260–1320. Part One*, A Survey of Manuscripts Illuminated in France, 3 (Turnhout: Harvey Miller, 2013).

Wieck, Roger S., *Painted Prayers: The Book of Hours in Medieval and Renaissance Art*, 3rd printing with updated bibliography (New York: George Braziller in association with The Pierpont Morgan Library, 2004).

Winterer, Christoph, 'Das Evangeliar der Walbecker Kanoniker aus dem 11. Jahrhundert, Latin MS 88 der John Rylands University Library, und die Handschriften seines künstlerischen Umfeldes',

in Berthold Heinecke and Christian Schuffels (eds), *Walbecker Forschungen* (Petersberg: Imhof, 2010), 173–207.

Chapter 3

Alexander, Jonathan J. G. (ed.), *The Painted Page: Italian Renaissance Book Illumination, 1450–1550* (Munich: Prestel Verlag, 1994).

Blockbücher des Mittelalters: Bilderfolgen als Lektüre. Gutenberg-Museum, Mainz, 22. Juni 1991 bis 1. September 1991 (Mainz: P. von Zabern, 1991).

Eisenstein, Elizabeth L., *The Printing Revolution in Early Modern Europe*, 2nd edn (Cambridge: Cambridge University Press, 2005).

Füssel, Stephan, *Gutenberg and the Impact of Printing*, trans. Martin Douglas (Aldershot: Ashgate, 2005).

Hellinga, Lotte, *William Caxton and Early Printing in England* (London: British Library, 2010).

Jensen, Kristian (ed.), *Incunabula and Their Readers: Printing, Selling and Using Books in the Fifteenth Century* (London: British Library, 2003).

Kampen, Kimberley van and Paul Saenger, *The Bible as Book: The First Printed Editions* (London: British Library, 1999).

Lowry, Martin, *The World of Aldus Manutius: Business and Scholarship in Renaissance Venice* (Oxford: B. Blackwell, 1979).

Palmer, Nigel F., 'Blockbooks: Texts and Illustrations Printed from Wood Blocks', *Journal of the Printing Historical Society*, n.s. 11 (2008), 5–23.

Parshall, Peter, *Origins of European Printmaking: Fifteenth-Century Woodcuts and Their Public* (New Haven: Yale University Press, 2005).

Steinberg, S. H., *Five Hundred Years of Printing*, new edn revised by John Trevitt (London: British Library, 1996).

Suarez, Michael F. and H. R. Woudhuysen, *The Oxford Companion to the Book* (Oxford: Oxford University Press, 2010).

Chapter 4

Andrews, William Loring, *Roger Payne and His Art: A Short Account of His Life and Work as a Binder* (New York: De Vinne Press, 1892).

Barker, Nicolas, 'Collector's Piece IV: A Register of Writs and the Scales Binder. II: The Scales Binder', *Book Collector*, 21 (1972), 356–79.

Behrens-Abouseif, Doris, *Cairo of the Mamluks: A History of the Architecture and Its Culture* (London: I. B. Tauris, 2007).

Bodleian Library, *Textile and Embroidered Bindings*, with an introduction by Giles Barber (Oxford: Bodleian Library, 1971).

Diehl, Edith, *Bookbinding: Its Background and Technique* (New York: Dover, 1980).

Dowd, Anthony, *The Anthony Dowd Collection of Modern Bindings*, with a foreword by Allen Freer (Manchester: John Rylands University Library of Manchester, 2002).

Foot, Mirjam M., *The Henry Davis Gift: A Collection of Bookbindings. Vol. 2: A Catalogue of North-European Bindings* (London: British Library, 1983).

Foot, Mirjam M., *Pictorial Bookbindings* (London: British Library, 1986).

Hobson, G. D., *English Binding Before 1500* (Cambridge: Cambridge University Press, 1929).

James, David, *Qur'ans and Bindings from the Chester Beatty Library: A Facsimile Exhibition* (London: World of Islam Festival Trust, 1980).

Needham, Paul, *Twelve Centuries of Bookbindings, 400–1600* (New York: Pierpont Morgan Library and Oxford University Press, 1979).

Reed, Ronald, *Ancient Skins, Parchments, and Leathers* (London: Seminar Press, 1972).

Chapter 5

Butcher, David, *The Stanbrook Abbey Press 1956–1990*, with an introduction by John Dreyfus and a memoir of Dame Hildelith Cumming by the Abbess of Stanbrook (Lower Marston, Herefordshire: Whittington Press, 1992).

Chambers, David and Martyn Ould, *The Daniel Press in Frome* (Hinton Charterhouse: Old School Press, 2011).

Franklin, Colin, *The Ashendene Press* (Dallas: Bridwell Library, Southern Methodist University, 1986).

Franklin, Colin, *The Private Presses*, 2nd edn (Aldershot: Scolar Press, 1991).

Harrop, Dorothy A., *A History of the Gregynog Press* (Pinner: Private Libraries Association, 1980).

Hornby, Charles Harry St John, *A Descriptive Bibliography of the Books Printed at the Ashendene Press, MCCCXCV–MCMXXXV* (Chelsea: Ashendene Press, 1935).

MacCarthy, Fiona, *The Simple Life: C. R. Ashbee in the Cotswolds* (London: Lund Humphries, 1981).

Peterson, William S., *The Kelmscott Press: A History of William Morris's Typographical Adventure* (Oxford: Clarendon Press, 1991).

Riley, David W., '"A Definite Claim to Beauty": Some Treasures from the Rylands Private Press Collection', *BJRL*, 72:1 (1990), 75–88.

Tidcombe, Marianne, *The Doves Press* (London and New Castle, Del.: British Library and Oak Knoll Press, 2002).

Chapter 6

Barber, Peter and Tom Harper, *Magnificent Maps: Power, Propaganda and Art* (London: British Library, 2010).

Blaeu, Joan, *Blaeu's The Grand Atlas of the 17th Century World*. Introduction, captions and selection of maps by John Goss; foreword by Peter Clark (London: Studio Editions in co-operation with Royal Geographical Society, 1997).

Brewer, H. W., 'Manchester', *The Graphic: An Illustrated Newspaper*, 40 (July to December 1889), 576.

Burland, C. A., 'A Note on the Desceliers' Mappemonde of 1546 in the John Rylands Library', *BJRL*, 33:2 (1951), 237–41.

Carlucci, April and Peter Barber (eds), *Lie of the Land: The Secret Life of Maps* (London: British Library, 2001).

Davies, John, 'Uncle Joe Knew Where You Lived: The Story of Soviet Military Mapping, Part One', *Sheetlines*, 72 (April 2005), 26–38.

Edney, Matthew, *The Mitchell Map, 1755–1782: An Irony of Empire* (University of Southern Maine: The Osher Map Library and Smith Centre for Cartographic Education) [www.oshermaps.org/special-map-exhibits/mitchell-map, accessed November 2013].

Foxell, Simon, *Mapping England* (London: Black Dog Publishing, 2008).

Harley, John and David Woodward, *The History of Cartography, Vol. 1: Cartography in Prehistoric, Ancient and Medieval Europe and the Mediterranean* (Chicago: University of Chicago Press, 1987).

Hodgkiss, Alan G., *Discovering Antique Maps* (Princes Risborough: Shire Publications Ltd., 2007).

Nordenskiöld, Adolf Erik, *An Account of a Copy from the 15th Century of a Map of the World Engraved on Metal, which is Preserved in Cardinal Stephan Borgia's Museum at Velletri* (Stockholm: A. L. Norman, 1891).

Potter, Jonathan, *Collecting Antique Maps: An Introduction to the History of Cartography*, (London: Jonathan Potter Ltd, 2001).

Roeder, Charles, 'William Green', *A Plan of Manchester & Salford: Drawn from an Actual Survey by William Green: begun in the year 1787 and compleated in 1794* (Manchester: Geo. Falkner and Sons of The Deansgate Press, 1902) [accompanying material].

Wainwright, Martin, 'Tank Tracks to Trafford: How USSR Planned to Invade Manchester', *The Guardian*, 25 August 2009. See www.theguardian.com/artanddesign/2009/aug/25/ussr-planned-invasion-manchester-exhibition, accessed 16 December 2013.

Watt, David, 'Soviet Military Mapping', *Sheetlines*, 74 (December 2005), 9–12.

Wyke, Terry, 'Mapping Manchester', *Historical Maps of Manchester: Maps from the Eighteenth Century, with an Introduction by Terry Wyke*. [CD Rom] (Warrington: Digital Archives Association, c.2006).

Chapter 7

Armstrong, Karen, *The Bible: The Biography* (London: Atlantic Books, 2007).

Bagnall, Roger S., *Early Christian Books in Egypt* (Princeton: Princeton University Press, 2009).

Cooper, Kate, *Band of Angels: The Forgotten World of Early Christian Women* (London: Atlantic Books, 2013).

Crown, Alan D., *Samaritan Scribes and Manuscripts*, Texts and Studies in Ancient Judaism, 80 (Tübingen: Mohr Siebeck, 2001).

Elliott, J. Keith, 'The Biblical Manuscripts of the John Rylands University Library of Manchester', *BJRL*, 81:2 (1999), 3–50.

Hull, Caroline S., 'Rylands MS French 5: The Form and Function of a Medieval Bible Picture Book', *BJRL*, 77:2 (1995), 3–24.

Kartveit, Magnar, *The Origin of the Samaritans*. Supplements to *Vetus Testamentum*, 128 (Leiden: Brill, 2009).

King, Karen L., *The Gospel of Mary of Magdala: Jesus and the First Woman Apostle* (Santa Rosa, Cal.: Polebridge Press, 2003).

Rumble, Alexander R., 'The Rylands, the Bible and Early English Literature: An Illustrated Note', *BJRL*, 77:3 (1995), 205–18.

Tuckett, Christopher M. (ed.), *The Gospel of Mary* (Oxford: Oxford University Press, 2007).

Wallenstein, M., 'A Dated Tenth Century Hebrew Parchment Fragment', *BJRL*, 40 (1957–58), 551–8.

Chapter 8

Berger, Patricia, *Empire of Emptiness: Buddhist Art and Political Authority in Qing China* (Honolulu: University of Hawaii Press, 2003).

Déroche, François, *The Abbasid Tradition: Qur'ans of the 8th to 10th centuries AD* (London: Nour Foundation, 1992).

Déroche, François (ed.), *Islamic Codicology: An Introduction to the Study of Manuscripts in Arabic Script* (London: Al-Furqān Islamic Heritage Foundation, 2006).

Ditchfield, Grayson M., *The Letters of Theophilus Lindsey (1723–1808)*, 2 vols (Woodbridge: Boydell Press, 2007–12).

Field, Clive D., 'Sources for the Study of Protestant Nonconformity in the John Rylands University Library of Manchester', *BJRL*, 71:2 (Summer 1989), 103–39.

Lattke, Michael S., *Odes of Solomon: A Commentary*, trans. Marianne Ehrhardt (Minneapolis: Fortress, 2009).

Mack, Phyllis, *Heart Religion in the British Enlightenment: Gender and Emotion in Early Methodism* (Cambridge: Cambridge University Press, 2008).

McLeod, William Hewat, *Early Sikh Tradition: A Study of the Janam-Sākhis* (Oxford: Clarendon Press, 1980).

Reeve, John (ed.), *Sacred. Books of the Three Faiths: Judaism, Christianity, Islam* (London: British Library, 2007).

Smithuis, Renate and Philip S. Alexander (eds), *From Cairo to Manchester: Studies in the Rylands Genizah Fragments* (Oxford: Oxford University Press, 2013).

Stewart, Sarah (ed.), *The Everlasting Flame: Zoroastrianism in History and Imagination* (London: I. B. Taurus, 2013).

Suthren Hirst, Jacqueline and John Zavos, *Religious Traditions in Modern South Asia* (Abingdon: Routledge, 2011).

Chapter 9

Allotey, Janette C., 'English Midwives' Responses to the Medicalisation of Childbirth (1671–1795)', *Midwifery*, 27:4 (2011), 532–8.

Archer, Patricia, 'From the Beginning: An Historical Review of Medical Art', *Journal of Audiovisual Media in Medicine*, 12 (1989), 51–62.

Cobb, Matthew, *The Egg and Sperm Race: The Seventeenth-Century Scientists Who Unravelled the Secrets of Sex, Life and Growth* (London: Free Press, 2006).

Crawley, Lisa M., 'A Life Recovered: Mary Hamilton 1756–1816', *BJRL*, 90:2 (2014), forthcoming.

Graham-Smith, Francis, *Unseen Cosmos: The Universe in Radio* (Oxford: Oxford University Press, 2013).

Kornicki, Peter F., 'The Japanese Collection in the Bibliotheca Lindesiana', *BJRL*, 75:2 (2006), 209–300.

Lavington, Simon, *A History of Manchester Computers*, 2nd edn (Swindon: British Computer Society, 1998).

Lavington, Simon, *Alan Turing and His Contemporaries: Building the World's First Computers* (Swindon: British Computer Society, 2012).

Leitch, Diana M. and Alfred Williamson, *The Dalton Tradition: Produced in Conjunction with an Exhibition to Mark the 150th Anniversary of the Royal Society of Chemistry* (Manchester: John Rylands University Library, 1991).

Lovell, Bernard, *Astronomer by Chance* (Oxford: Oxford University Press, 1992).

Mearns, Barbara and Richard, *The Bird Collectors* (London: T. & A. D. Poyser, 2002).

Smyth, A. L., *John Dalton, 1766–1844: A Bibliography of Works By and About Him with an Annotated List of his Surviving Apparatus and Personal Effects* (Manchester: Literary and Philosophical Publications Ltd, 1966).

Thackray, Alfred, 'John Dalton', in Charles C. Gillispie (ed.), *Dictionary of Scientific Biography*, vol. 13 (New York: Charles Scribner's Sons, 1971), 537–47.

Chapter 10

Adamjee, Qamar, 'Strategies for Visual Narration in the Illustrated *Chandayan* Manuscripts', unpublished doctoral thesis, New York University Institute of Fine Arts, 2011.

Feinstein, Elaine, *A Captive Lion: The Life of Marina Tsvetayeva* (London: Hutchinson, 1987).

Ferdowsi, Abolqasem, *Shahnameh: The Persian Book of Kings*, translated by Dick Davis (London: Penguin Classics Deluxe Editions, 2007).

Jones, Kathleen, *Norman Nicholson: The Whispering Poet* (Appleby: The Book Mill, 2013).

McGonigal, James, *Beyond the Last Dragon: A Life of Edwin Morgan*, 2nd edn (Dingwall: Sandstone Press, 2012).

Nicholson, Norman, *Collected Poems*, ed. Neil Curry (London: Faber and Faber, 1994).

Owen, Wilfred, *The Complete Poems and Fragments*, ed. Jon Stallworthy (London: Chatto and Windus, 1983).

Pickford, Cedric E., 'The *Roman de la Rose* and a Treatise Attributed to Richard de Fournival: Two Manuscripts in the John Rylands Library', *BJRL*, 34 (1952), 333–65.

Schoenfeldt, Michael (ed.), *A Companion to Shakespeare's Sonnets* (Oxford: Blackwell, 2006).

Shelston, Alan, *Brief Lives: Elizabeth Gaskell* (London: Hesperus Press, 2010).

Sherbo, Arthur, 'The Proof-Sheets of Dr Johnson's Preface to Shakespeare', *BJRL*, 35 (1952–53), 206–10.

Tsvetaeva, Marina, *Bride of Ice: New Selected Poems*, translated from the Russian by Elaine Feinstein (Manchester: Carcanet Press, 2008).

Vine, Guthrie, 'The Miller's Tale: A Study of an Unrecorded Fragment of a Manuscript in the John Rylands Library in Relation to the First Printed Text', *BJRL*, 17 (1933), 333–47.

Chapter 11

Alderson, Brian W., 'Tracts, Rewards and Fairies: The Victorian Contribution to Children's Literature', in Asa Briggs, *Essays in the History of Publishing in Celebration of the 250th Anniversary of the House of Longman, 1724–1974* (London: Longman, 1974), 245–82.

Cox, Marian Roalfe, *Cinderella: Three-hundred and Forty-five Variants of Cinderella, Catskin, and Cap o'Rushes* (London: David Nutt for the Folklore Society, 1893).

Engen, Rodney, *Laurence Housman* (Stroud: Catalpa Press, 1938).

Engen, Rodney, *The Age of Enchantment: Beardsley, Dulac and Their Contemporaries* (London: Scala, 2007).

Hughey, Ann Conolly, *Edmund Dulac, His Book Illustration: A Bibliography* (Potomac, Md.: Buttonwood Press, 1995).

Lancelyn Green, Roger, *Andrew Lang* (London: Bodley Head, 1962).

MacLean, Ruari, *The Reminiscences of Edmund Evans* (Oxford: Clarendon Press, 1967).

Muir, Percy Horace, *English Children's Books 1600–1900* (London: Batsford, 1954).

Robinson, William Heath, *My Line of Life* (London and Glasgow: Blackie and Son, 1938).

Shaw, Hugh (ed.), *George Cruikshank*, catalogue of an exhibition held at the Victoria & Albert Museum, London, 28 February–28 April 1974, with an introduction by William Feaver (London: Arts Council of Great Britain, 1974).

Spencer, Isobel, *Walter Crane* (London: Studio Vista, 1975).

Tatar, Maria M., *The Hard Facts of Grimms' Fairy Tales* (Princeton: Princeton University Press, 2003).

Warner, Marina, *From the Beast to the Blonde: On Fairy Tales and Their Tellers* (London: Chatto, 1994).

White, Cilon, *Edmund Dulac* (London: Studio Vista, 1976).

Wolfe, Humbert (ed.), *A Winter Miscellany* (London: Eyre and Spottiswoode, 1930).

Zipes, Jack David, *The Oxford Companion to Fairy Tales* (Oxford: Oxford University Press, 2000).

Zipes, Jack David, *Breaking the Magic Spell: Radical Theories of Folk and Fairy Tales*, revised and expanded edn (Lexington: University Press of Kentucky, 2002).

The following periodical titles are useful:

Children's Books History Society Newsletters and *Occasional Papers* (CBHS, 1996–).

Marvels & Tales: Journal of Fairy-Tale Studies (Wayne State University Press, 1987–).

Studies in Illustration (Imaginative Book Illustration Society, 1995–).

Chapter 12

Allmand, Christopher T., *Henry V* (New Haven: Yale University Press, 2011).

Allmand, Christopher T., *The 'De Re Militari' of Vegetius: The Reception, Transmission and Legacy of a Roman Text in the Middle Ages* (Cambridge: Cambridge University Press, 2011).

Bergen, Henry (ed.), *Lydgate's Troy Book, A.D. 1412–42*, Early English Text Society Extra Series, xcvii, ciii, cvi, cxxvi (London: EETS, 1906–35).

Bush, Michael, *The Casualties of Peterloo* (Lancaster: Carnegie Publishing, 2005).

Dmitrieva, Olga and Tessa Murdoch (eds), *Treasures of the Royal Courts: Tudors, Stuarts & the Russian Tsars* (London: V&A Publishing, 2013).

Hale, J. R., *Renaissance War Studies* (London: Hambledon Press, 1983).

Joy, Frederick W., 'Queen Elizabeth's New Year's Gifts', *Notes and News*, 6th series, 9 (1884), 241–2.

Manley, Keith A., 'Thomson, Richard (1794–1865)', *Oxford Dictionary of National Biography* (Oxford: Oxford University Press, 2004) [www.oxforddnb.com/view/article/27321, accessed 14 November 2013].

Poole, Robert, '"By the law or the Sword": Peterloo Revisited', *History*, 91 (2006), 254–76.

Turner, Ralph V., *Magna Carta: Through the Ages* (Harlow: Longman, 2003).

VADS Online Resource for Visual Arts [www.vads.ac.uk/index.php, accessed 16 December 2013].

Wilson, Guy, 'Military Science, History and Art', in Pia Cuneo (ed.), *Artful Armies, Beautiful Battles: Art and Warfare in Early Modern Europe* (Leiden: Brill, 2001).

Chapter 13

Axon, Geoffrey R., 'Martin Marprelate and Manchester', *Manchester Review*, 4 (Winter 1946), 448–9.

Axon, William E. A., 'What Was the First Book Printed in Manchester?', *Transactions of the Lancashire and Cheshire Antiquarian Society*, IV (1886), 13–15.

Burney, E. L. (E. Lester), 'Mrs. G. Linnaeus Banks, 1921–1897', *Manchester Review*, 11 (Autumn/Winter 1968–69), 211–24.

Burney, E. L. (E. Lester), *Mrs. G. Linnaeus Banks: Author of 'The Manchester Man' etc.* (Didsbury, Manchester: E. J. Morten, 1969).

Bury, Thomas Talbot, *Coloured Views on the Liverpool and Manchester Railway*. Reprint of the original edition, with an historical introduction by George Ottley (Oldham: Hugh Broadbent, 1977).

Harland, John, 'The Oldest Manchester Directories', in *Collectanea Relating to Manchester and its Neighbourhood, at Various Periods, Remains Historical & Literary Connected with the Palatine Counties of Lancaster and Chester* (Manchester: Chetham Society, vol. 68, 1866).

Hodgkinson, J. L. and Rex Pogson, *The Early Manchester Theatre* (London: A. Blond for the Society for Theatre Research, [1960]).

Hulme, Charles, *Rails of Manchester: A Short History of the City's Rail Network* (Manchester: John Rylands University Library, 1991).

Kidd, Alan, *Manchester: A History*, 4th edn (Lancaster: Carnegie Publishing, 2006).

Nicholas, R., *City of Manchester Plan: Prepared for the City Council*. Pref. by William Philip Jackson and by Ottiwell Lodge (Norwich: published for the Manchester Corporation by Jarrold and Sons, 1945).

Powell, Michael and Terry Wyke, 'At the Fall of the Hammer: Auctioning Books in Manchester 1700–1850', in Peter Isaac and Barry McKay (eds), *The Human Face of the Book Trade: Print Culture and its Creators* (Winchester: St Paul's Bibliographies, 1999).

Ramwell, Julie, 'Printed Books News: Dickens on Stage', *News from the Rylands: The Newsletter of the Special Collections Division of The John Rylands University Library of Manchester*, 7 (Spring 2004), 11.

Ramwell, Julie 'Printed Books News: Medical Annotations', *News from the Rylands: The Newsletter of the Special Collections Division of The John Rylands University Library, The University of Manchester*, New Series, 1 (Autumn 2004), 10–11.

Ramwell, Julie, 'Printed Books News: Manchester Theatricals', *News from the Rylands: The Newsletter of the Special Collections Division of The John Rylands University Library, The University of Manchester*, New Series, 4 (Summer 2006), 16–17.

Sutton, C. W., A report of a lecture 'Book Auctions in Manchester in the Eighteenth Century', delivered to the Lancashire & Cheshire Antiquarian Society on 10 December 1909; see *Transactions of the Lancashire & Cheshire Antiquarian Society*, 27 (1909), 189–91.

Taylor, Andrew, 'Mapping Manchester: One Man's Contribution to City Centre Maps', *The Cartographic Journal*, 41:1 (2004), 59–67.

Wyke, Terry and Nigel Rudyard (comps), *Manchester Theatres*, Bibliography of North West England, 16 (Manchester: Bibliography of North West England, 1994).

Index